The Handbook of Photographic Equipment and Techniques

ADRIAN HOLLOWAY

Pan Books Ltd London and Sydney

The Handbook of Photographic
Equipment and Techniques was
conceived, edited, and designed by
Dorling Kindersley Limited, 9 Henrietta
Street, London WC2

Project Editor **Richard Dawes**
Editor **Phil Wilkinson**
Designers **Chris Meehan, Calvin Evans,
Isobelle Pover**
Design Assistant **Rosamund Gendle**

Managing Art Director **Stuart Jackman**
Managing Editor **Joss Pearson**
Editorial Director **Christopher Davis**

First published 1981 by Pan Books Ltd,
Cavaye Place, London SW10 9PG
2nd printing 1982
Copyright © 1981 by Dorling Kindersley
Limited, London
Text copyright © 1981 by Adrian
Holloway
ISBN 0 330 26523 7

Holloway, Adrian
 The handbook of photographic equipment and
 techniques.
 1. Photography – Apparatus and supplies
 I. Title

771 TR196

Printed in Italy by A. Mondadori, Verona.

Contents

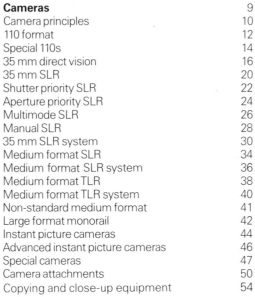
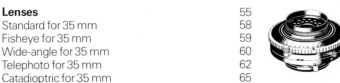
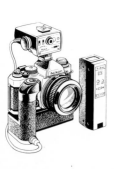

CONTENTS

Introduction

Using the right tools for the task in hand is a fundamental requirement in any technically based creative medium. It is probably nowhere more critical than in the art of photography, where success depends on understanding and controlling so many variable factors – from the lighting of the subject, through all the camera and lens controls, to film response.

In many cases, the right equipment is essential to a particular effect, whether it is a multiple image with strobe flash, for example, or simply a facility for time exposures on your camera. More often, it is a question of quality – however steady your hand or careful your composition, a hand-held shot of a landscape on a pocket camera will never match the quality of one with a larger format camera and a better lens, on a tripod. But beyond creating an effect, or improving quality, the vital requirement of any equipment is that it should allow you creative control, and suit your level of skill, and your particular approach.

In selecting equipment, the amateur is very much at the mercy of persuasive marketing. Even a seasoned photographer may be bewildered by the ever increasing barrage of new, sophisticated equipment and glossy sales literature. The temptation to invest in innovations that turn out to be over-priced and over-rated is often strong. Today, the range of possibilities open to the photographer is greater than ever before. But the result is too often confusion, or wasted effort and expense.

The purpose of this book is to clear up the confusion, and provide the photographer with a clear, comprehensive guide to choosing and using the right tools for his own work. It covers the whole range of cameras, lenses and accessories, in all formats, lighting, studio, and darkroom equipment, and films and darkroom materials. Each entry describes and illustrates the function and principles of the particular item, and then presents the variables that will influence your final choice – the different features available, handling requirements, applications, compatibility with other equipment, and advantages and limitations in use.

Buyer's Guides (see below) are an important feature of the book: they direct you to the right model, from the right manufacturer, at the right price, and list the critical points to check when buying the equipment.

How to use the book

If you are starting out in photography or have little idea of what equipment would be useful to you at your present level of expertise, you may want first to use the book to familiarize yourself with the camera formats, types of lenses, and wealth of accessories available. If on the other hand you are interested in moving into a particular area – say 35 mm SLR photography, or medium format work, or processing your own film – you should turn to these main sections and read them through.

More often, you may have a specific question: What lens should I buy next? Should I trade in my camera for a better model? What new filters might improve my photography? In this case, you should use the Handbook to compare the information given on the new item you are considering with that given on your existing equipment. You will find it useful to refresh your memory in this way, as to what can be done with the equipment you are currently using, before making a choice. If you are looking for a single item, you can scan through the section covering it, or simply use the index.

When you have narrowed down your search to the type of item you want, you should study the particular information on that item closely. Suppose you have decided to buy a medium format TLR camera. Examine again the features that may be offered, and their virtues. Then turn to the Buyer's Guide, and consider the manufacturers recommended there, and the price ranges given. Note the points listed under "Points to look for", and inquire about these when at the camera store.

Buying equipment

Once you have identified the type, make and model you want, you still have to decide where to obtain it, in your own particular market. You may save money

Using the Buyer's Guides
The Buyer's Guides tell you roughly what you can expect to pay for an item, and recommend reliable manufacturers across the price range. Coded letters indicate price levels, as shown in the chart, right. Sterling values have been adjusted against US dollar values to reflect the generally higher cost of photographic equipment in the Sterling market. Recommended manufacturers are grouped according to which section of the price range they fall into, their approximate position being indicated by an asterisk rating. One asterisk stands for the lower end of the price range, two for the middle, and three for the top end. This classification is not intended to denote relative quality or value for money; it simply acts as a price guide. The Buyer's Guides also list points you should look out for and inquire about when you are buying.

	Buyer's Guide price chart	
Price code	**US dollars**	**£ Sterling**
A	under 15	under 10
B	15–30	10–20
C	30–75	20–50
D	75–150	50–100
E	150–250	100–175
F	250–350	175–250
G	350–500	250–375
H	500–750	375–500
I	750–1000	500–650
J	1000–1250	650–850
K	1250–1500	850–1000
L	1500–2000	1000–1500
M	over 2000	over 1500

by going to discount stores, using mail order, or answering small advertisements in journals or on bulletin boards. With really expensive items, the Buyer's Guides occasionally advise you to rent, rather than buy, if the equipment is for occasional use. Large camera stores will often rent equipment.

You may also consider buying secondhand, which can enable you to buy a better model for the same price. Advice on buying secondhand items is given in the Appendices. It is worth reading the regular equipment-testing reports in journals. You can also use the journal advertisements to identify small local manufacturers who may supply an item that is difficult to trace. In general though, it is wiser to buy from major manufacturers, unless the Buyer's Guide suggests buying locally.

Wherever you buy from, there are two golden rules: right, from the start, buy the *very best* you can afford; and always try to *use* the equipment first. Borrow from a friend, rent the item for a few days from a reputable dealer, or take the equipment on trial, particularly if it is expensive. Darkroom equipment can often be tried out in photography clubs, school or college darkrooms, or community centers.

Choosing a camera

A camera is likely to be the most expensive item of equipment you will buy, so, above all, buy a model that is suitable for the kind of pictures you want to take. This applies whether you are buying your first camera or are thinking of changing model or format.

Don't try to save money by picking a camera that restricts you, or is cheaply made. On the other hand, don't lay out a great deal of money for a model that offers more facilities than you really require. In particular, avoid a high degree of automation, particularly if you are a beginner. This kind of camera can prevent you learning the essentials of exposure and creative use of the camera controls.

Look carefully at the pages on cameras in this book and compare the features discussed against a list of your own likely requirements. Try to handle some of the most likely cameras as you narrow down your choice. Are you likely to want to expand your interests in the future? This will determine whether you choose a camera backed by a restricted range of accessories, or buy your way into an extensive camera system. The question is particularly relevant if you are planning to start out in 35 mm SLR photography.

Pocket and compact cameras

Pocket 110 cameras use small (16 mm) film and are designed almost exclusively for amateurs taking colour prints. If you want a better quality, more adaptable camera which is still portable and quick to use, a 35 mm direct vision camera may suit you. The choice of film in the format is wide, and enlargements are more satisfactory. The trend in 35 mm direct vision models is toward automation, higher quality, interchangeability of lenses, and compactness. Automatic exposure rangefinder focusing, and the facility for electronic flash are now common; autowinders, built-in flash, and autofocus are growing more popular.

35 mm SLR cameras

A 35 mm SLR will open up a much wider range of possibilities. The prime advantages of the SLR are its viewing system, which allows you to see clearly the image that the lens will convey to the film, and its flexibility of application. Most SLRs form part of a system, which allows you to expand the range of your camera by adding interchangeable lenses and a range of accessories.

Medium and large format cameras

A larger format than the popular 35 mm size can provide the image quality necessary for commercial enlargement for reproduction. As a result, medium and large format cameras are designed with the professional user in mind. However, medium format cameras, available in SLR and TLR versions, attract a growing number of serious amateurs. As with 35 mm cameras, comprehensive camera systems are available to complement some models.

Expanding your range

If your starting point is a reliable 35 mm SLR model, aim to build up a basic kit comprising at least the following items: two or three other lenses, an electronic flash gun, several filters, a tripod, and a carrying case. When buying filters, choose some for special effects, as well as skylight or UV, neutral density, and polarizing filters. If your budget will take it, an additional camera body is also useful.

When you have been taking photographs for some time, you may want to specialize in a particular field of photography. Before purchasing equipment, you should check whether your basic equipment is of good condition. You must then identify which special lenses (and adaptors), special filters, and exposure accessories will help you most. It is usually best to buy new equipment from the manufacturer of your camera system. But if he does not offer the item you require, it may be worth starting again with another system, especially if you were forced to economize originally. (Compare the information given in this book on the various systems.) Alternatively, look for other reliable makes of accessories; but make sure they are compatible with your equipment, both in fittings, and in quality.

If you are thinking of printing your own work, build your darkroom set-up around the best enlarger you can afford, and choose it with as much care as you did the camera that forms the heart of your camera system.

Looking after your equipment

The fault-finding guide in this book will help you identify the causes of common types of equipment failure, and of unsuccessful results. To get the best out of photographic equipment, you must look after it. Have cameras overhauled occasionally, so the moving parts are kept working reliably. If a lens seems to lose sharpness, send it to a specialist who may be able to tighten up the elements. Keep all equipment clean, cool, and dry; and use sturdy cases. Replace batteries regularly, and remove them when equipment is out of use. Above all, never force the controls, or attempt to mend a camera yourself.

Cameras
110/35 mm direct vision, SLR/medium, large format/ instant picture/special

Choosing a camera can be bewildering. Designs vary according to the film size used, the method of focusing, and the mode of operation. Before buying a camera, decide on the kind of photography you want to pursue and assess your requirements according to these categories. The table below shows the camera types and the tasks to which they are best suited. The simplest cameras are the almost extinct 126 and the small 110 models. Ideal for snap shots, these cameras are built for ease of operation and portability. The picture success rate is high and many beginners start with this type of camera.

You can obtain better picture quality with larger film, such as 35mm. Most 35mm cameras also have better lenses than their smaller counterparts. Compact 35mm cameras with fixed lenses are easy to use and can give good results, but most serious amateurs and many professionals prefer a 35mm SLR camera. There is a wide choice of models to suit most budgets, and most manufacturers offer accessories to complement their cameras. This type of camera, backed by a choice of lenses and accessories, can tackle almost any subject. SLR viewing also provides advantages over the compact camera's direct vision viewfinder.

Some photographers prefer a larger format. Medium format cameras meet this requirement. Both SLR and TLR models are available. The film size gives even better image quality for enlargements than 35mm. Cameras are generally more expensive, but quality is high, and the range of accessories for SLRs is wide. Large format cameras are made for a number of film sizes. The most popular size is 4ins × 5ins. Baseboard models are portable, while monorail designs are best for high quality studio photography.

	35 mm direct vision	35 mm d.v. (system)	35 mm SLR (basic)	35 mm SLR (system)	Medium format (basic)	Medium format (system)	Large format baseboard	Large format monorail	Instant picture
Snap shots	●		●						●
General purpose	●		●	●	●	●			●
Informal portraits	●		●	●	●	●			●
Studio portraits		●		●		●	●	●	●
Landscape		●		●		●	●		
Nature (animals)		●		●		●			
Nature (close-up)		●		●		●			
Macro				●		●		●	
Interiors		●	●	●		●	●	●	
Still life		●	●	●		●	●	●	
Reportage	●		●	●		●			
Action	●		●	●	●	●			

Camera principles

A camera is basically a light-tight box incorporating a lens, a shutter, an iris diaphragm or aperture, and some method of holding the film. It also has a viewing system, through which you compose the picture. The lens forms an inverted image of the subject on the film. Adjustable lenses have a focusing control enabling you to sharpen the image by altering the distance between the lens and the film plane. This allows you to take sharp pictures at a variety of subject distances. When you press the shutter release, the shutter opens to expose the film to light. As this happens, the light passes through the diaphragm. Shutter speed and diaphragm aperture are usually adjustable, so that you can vary the duration and brightness of light reaching the film. You control the shutter speed with a dial marked.

in seconds, and the aperture with a ring calibrated in f stops. By using these controls you can compensate· for variations in subject lighting and produce correctly exposed pictures in a range of conditions. Most cameras have an exposure meter to measure light, and either advise you on correct exposure, or set it for you automatically. Viewing systems either use a separate viewing window (direct vision), or show you the image formed by the lens. Reflex cameras use a mirror system to show you the taking lens image (single lens reflex) or viewing lens' image (twin lens reflex). Cameras also differ in the size and type of film they use. Pocket 110 cameras take compact 16mm film in a plastic cartridge, 35mm cameras use film in cassettes, while medium format cameras accept roll film.

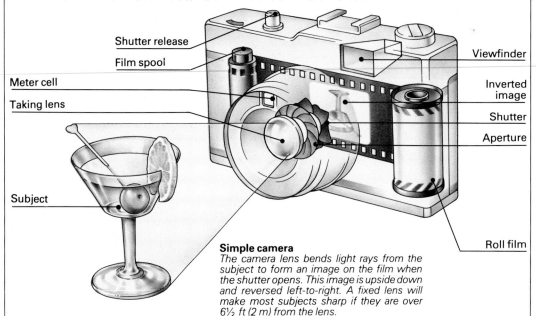

Shutter release
Film spool
Meter cell
Taking lens
Subject

Viewfinder
Inverted image
Shutter
Aperture
Roll film

Simple camera
The camera lens bends light rays from the subject to form an image on the film when the shutter opens. This image is upside down and reversed left-to-right. A fixed lens will make most subjects sharp if they are over 6½ ft (2 m) from the lens.

Viewfinders
Direct vision cameras use a viewing window. TLRs have a separate viewing lens. With view cameras and SLRs, you see the subject through the taking lens.

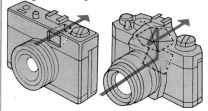
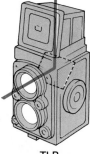
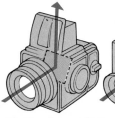

Direct vision 35mm SLR TLR Medium format SLR View camera

Shutter

The shutter allows you to control exactly when you take a picture, and the time for which light falls on the film. The widely used diaphragm, or between-the-lens shutter consists of a group of interlocking metal leaves inside the lens. The focal plane shutter, mostly found on SLR models (35 mm and medium format) and some large format cameras, has two blinds which pass across the film. Their speed, and the gap between them, control exposure time.

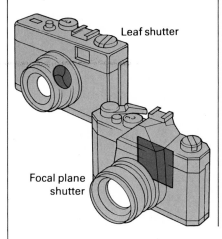

Leaf shutter

Focal plane
shutter

Metering

Many cameras have built-in exposure metering. Some 35mm direct vision cameras have light sensitive cells on the camera body or around the rim of the lens. On automatic cameras the metering cells are linked directly to the camera controls and program them accordingly. Cameras with through-the-lens (TTL) metering give more accurate light readings. They have light-sensitive cells built into the camera around the mirror, in the pentaprism, or near the focal plane. This enables the meter to read the strength of the light as it falls on the film. A calculator converts the reading to recommended camera set-tings and the information is displayed in the viewfinder.

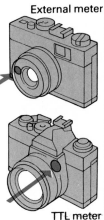

External meter

TTL meter

Film speed

Some films react very quickly to light, others react slowly. The speed of a film's reaction to light is expressed in terms of an ASA/ISO or DIN number. The higher the number the faster the film. ASA/ISO numbers have a simple arithmetical base: doubling sensitivity doubles the ASA/ISO number. With DIN numbers, doubling sensitivity increases the speed rating by three.

Exposure

The amount of light which reaches the film is controlled by the combination of shutter speed and aperture size. Shutter speeds form a sequence in which speed is doubled (and exposure halved) at each higher setting. Aperture settings follow the f-number sequence, common to all lenses. With each higher f number, aperture is reduced and exposure halved. A lens' maximum aperture may fall outside the standard sequence. The diagram, right, shows how you combine these related scales in order to keep exposure constant, while varying the settings. Thus 1/15 sec at f16 will give the same exposure as 1/30 sec at f11. If you enlarge the aperture by four stops, you also have to increase the shutter speed four times. This relationship allows you to use camera settings to produce a variety of effects. For example, you can increase shutter speed to freeze action, or increase aperture for selective focus.

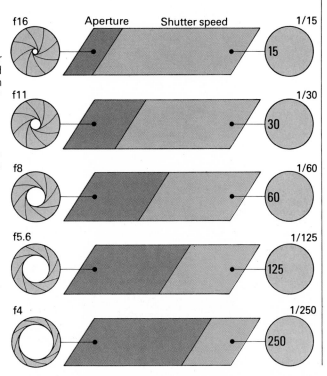

f16 Aperture Shutter speed 1/15 15

f11 1/30 30

f8 1/60 60

f5.6 1/125 125

f4 1/250 250

110 format

These cameras use miniature (16 mm) film contained in a sealed cartridge. 110 film is easy to load but is not suitable for processing by the user. Economical bulk processing and improvements in simple lenses and small films have made this format of camera very popular. Basic 110s have a fixed lens with a focal length of 25 mm or 28 mm. This gives you a broader angle of view than the standard lens on a 35 mm camera and makes for extensive depth of field. The short focal length of a standard 110 lens allows you to focus on subjects as close as 1½ ft (0.5 m). Some models have additional built-in lenses for long-distance (tele) and close-up shots. A few incorporate a zoom lens. This gives you a choice of focal lengths, normally between 25 mm and 42 mm or 50 mm. Most 110s have a direct vision viewfinder, usually with parallax correction marks (below). A few have SLR viewing. Models with metering operate under a range of light conditions and are easy to use as they set exposure automatically. Non-metering cameras are cheaper, but provide less control over exposure, so that success depends to a large extent on the weather. All models are designed for use with electronic or bulb flash. You can buy 110s with plastic or metal bodies.

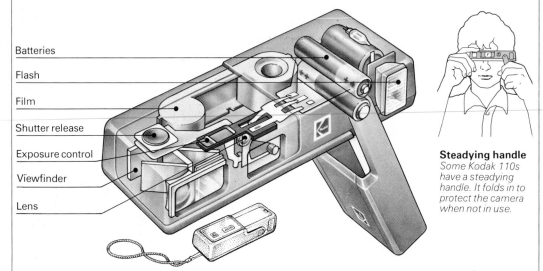

Batteries

Flash

Film

Shutter release

Exposure control

Viewfinder

Lens

Steadying handle
Some Kodak 110s have a steadying handle. It folds in to protect the camera when not in use.

Body design

110 cameras are available in several different shapes. Most common is the flat, wafer-shaped body, which is compact and convenient to carry. This shape can cause camera shake and the similarity (from the front) between lens and viewfinder can be confusing. Other styles, such as the Kodak "handle" version and those with the older, upright shape, help to reduce these problems. Developments like SLR viewing (p. 14) have also dictated body shape.

SLR

Direct vision

Pocket

Parallax error

When you use the camera less than 6 ft (2 m) from the subject, the viewfinder and the lens have different views of the scene (below). This leads to incorrect framing, or parallax error.

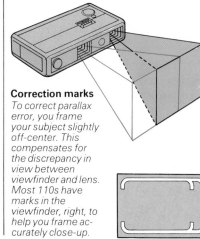

Correction marks
To correct parallax error, you frame your subject slightly off-center. This compensates for the discrepancy in view between viewfinder and lens. Most 110s have marks in the viewfinder, right, to help you frame accurately close-up.

Exposure

Non-metering 110s use weather symbols (below) to help you select the correct exposure. Metering models measure the light reflected from a subject and set exposure. Some can be set manually. Lights in the viewfinder (right) warn of incorrect exposure.

Weather symbols

Exposure warning lights

Focusing

The simplest cameras have fixed focus lenses. Better models allow a degree of focus selection. Some have a control with distance symbols, or a scale in feet or meters. Upright cameras have a distance scale on the lens. A few 110s use rangefinder focusing (p. 16).

Distance symbols Distance scale

Focusing distance indicator

Supplementary lenses

Some 110s take a close-up attachment, below left. Others have a second lens built-in. Cameras with tele, close-up, or "macro" lenses are available. A lens control, below right, enables you to bring the second lens into use.

Lens control

Normal

Tele effect

Close-up effect

Flash

Flash allows you to shoot at any time, day or night, indoors or outdoors. Some 110s take bulb flash, either in the form of a rotating cube (four flashes) or as a bar (eight flashes). Others take electronic flash, or have this kind of flash built-in. Electronic flash is the most convenient and easy to use and is more economical if you use flash frequently. When buying any off-camera flash equipment, check that its fittings are compatible with your camera. Different fittings are available to suit different types of 110. It is also worthwhile to find out the times taken by different flash units to recharge after firing.

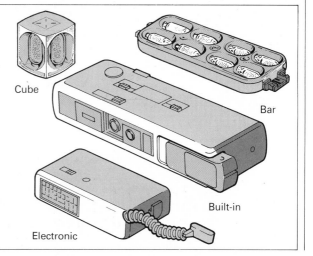

Cube

Bar

Built-in

Electronic

Special 110s

There is a wide range of sophisticated 110 cameras on the market. Features available include coupled rangefinders for precise focusing, and controls for both aperture and shutter speed settings. The range includes compact cameras for the fashion-conscious and heavy-duty "all-weather" models. 110s with built-in motor drive are also available. At the top end of the price range you can buy 110s with reflex viewing and zoom lenses. These extra features are expensive, so compare their cost with that of a better quality compact 35 mm camera.

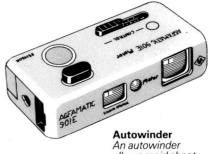

Autowinder
An autowinder allows rapid shooting of moving subjects.

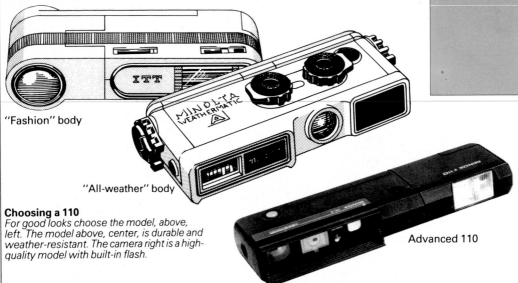

"Fashion" body

"All-weather" body

Advanced 110

Choosing a 110
For good looks choose the model, above, left. The model above, center, is durable and weather-resistant. The camera right is a high-quality model with built-in flash.

110 zooms

110 zoom cameras are compact and versatile. The lens allows you to change image size without changing viewpoint. You alter its focal length by means of a zoom ring. They all offer a wide range of shutter speeds. Some models have a close-up facility, so that you can shoot subjects as near as 10 in (0.25 m). A 110 zoom with SLR viewing makes focusing easy and prevents parallax error.

Zoom range
A 110 camera with a zoom lens can offer a range of focal lengths between normal and short telephoto. The pictures above show effects at 25 mm, left, and 50 mm, right.

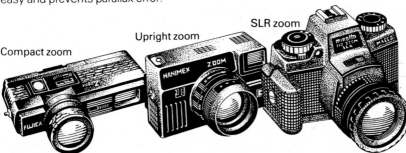

SLR zoom

Upright zoom

Compact zoom

110 system

The only 110 camera with its own system of lenses and accessories is made by Pentax. In addition to a standard lens it is backed up by an 18 mm wide-angle and a 50 mm telephoto lens. You can use the wide-angle for broad interior shots, architecture, and landscapes. Its wide angle of view and extensive depth of field make it ideal for shooting in situations where the camera-to-subject distance is limited. The long lens has a narrower angle of view, which makes it useful for shooting action from a distance. It is also good for outdoor portraits where there is a distracting background. The camera's exposure system is automatic and it offers a wide range of shutter speeds. Additional accessories include electronic flash, automatic film winder, a range of filters, a tripod, and a carrying case.

Flash

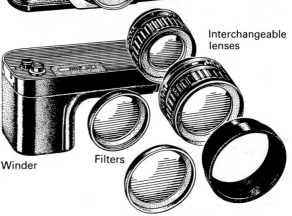

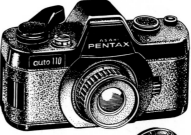
Interchangeable lenses

Winder Filters

Compact SLR
Compared with its 35 mm counterparts, the 110 SLR and its range of accessories are very small, fitting the hand comfortably. But the protruding lens makes it less compact than most pocket cameras. Its construction is sturdy and its finish attractive.

126 cameras

The 126 camera (right) is inexpensive and takes film in cartridges which are easy to load. This film gives a large image and you can get sharper enlargements than you can with 110 film. Many models have fixed focal length lenses and only one exposure setting. Some allow limited exposure adjustment, usually by means of a dial with weather symbols. When using a 126 camera with fixed focus avoid subjects, such as close-up portraits, which are nearer than 4 ft (1.2 m) from the camera. Focus is poor at short range, right. A 126 camera is best for shooting groups and landscapes.

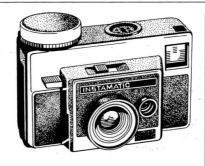

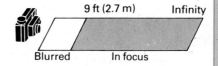
9 ft (2.7 m) Infinity

Blurred In focus

35 mm direct vision

Direct vision cameras use the same range of cassette film as 35mm SLRs, but are generally simpler and cheaper. The viewfinder is separate from the lens which takes the picture and so a clear image stays in view when you release the shutter. However, the viewfinder does not show the effects of changing aperture, or of filters, and close framing may lead to parallax error (p.12). The lens is nearly always fixed, with a focal length of 38mm-45mm. This gives you a slightly wide angle of view compared to that of a standard lens on an SLR camera, and also gives greater depth of field. On simple models focus is fixed. On others

you focus with the aid of a scale bearing distance symbols or measurements in feet and meters. The best models have rangefinder focusing or autofocus. A few use weather symbols as a rough exposure guide, but most meter light, usually with a cadmium sulfide (CdS) cell. They show in the viewfinder whether you have set the "correct" exposure. Many models select exposure automatically, but the control you have over aperture and/or shutter speed and ASA (ISO) speed varies across the range. Most cameras take a tripod, and all allow you to use flash. Some models have built-in electronic flash.

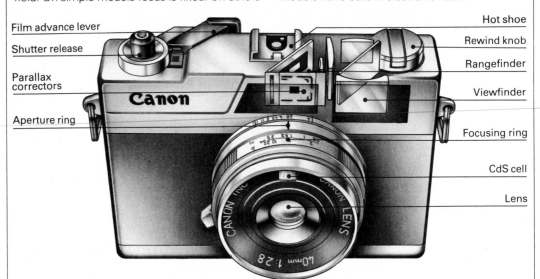

Film advance lever

Shutter release

Parallax correctors

Aperture ring

Hot shoe

Rewind knob

Rangefinder

Viewfinder

Focusing ring

CdS cell

Lens

Viewing and focusing

Viewfinders often have framing lines plus extra parallax correction marks for close-ups. With a rangefinder camera you see a double or split image in the center until focus is correct. A mirror system aligns the two images as you focus on the subject.

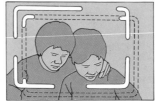

Parallax correction marks

Leaf shutter

A between-the-lens leaf shutter is often used on fixed lens models. It can give speeds from 1/30 sec to 1/650 sec, plus B setting.

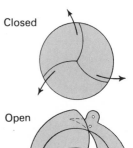

Closed

Open

Focused

Unfocused

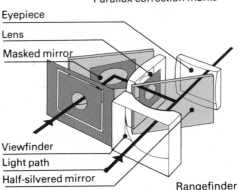

Eyepiece

Lens

Masked mirror

Viewfinder

Light path

Half-silvered mirror

Rangefinder

Automatic

This kind of camera automatically selects a "correct" exposure. Using a cadmium sulfide (CdS) cell which normally works with ASA (ISO) speeds of 25-500, it meters incoming light. It then adjusts shutter speed or aperture setting, or both. There may be an indicator in the viewfinder to warn you that there is insufficient light. Choose a model that gives you a good range of exposures.

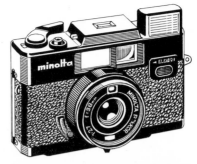

BUYER'S GUIDE

Names to look for
(Price range D-E)
 *Agfa
 **Fujica, Minolta, Olympus, Yashica
***Canon, Konica, Mamiya, Rollei, Vivitar

Points to look for
● Sturdy book
● ASA range (25-500 preferable)
● Accurate rangefinder (especially over short distances)
● Off-camera flash socket *and* hot shoe, or built-in flash
● Firm film wind
● Shutter lock for when exposure incorrect
● Tripod socket

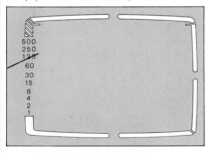

Heavy-duty
This automatic camera has an electronic shutter and built-in flash. It is highly resistant to water, dust, and sand, and is light and compact.

Built-in autowinder
This motorized model is useful for action sequences. Its built-in autowinder also positions the first frame for shooting.

Multi-function lever
A door covers the lens, viewfinder, and meter cell when this camera is not in use. A multi-function lever moves the lens into position, switches on the metering, cocks the shutter, and transports the film.

Aperture priority

You set the aperture and the camera selects the shutter speed. This appears in the viewfinder, below. A choice of apertures allows you to alter depth of field. You can also set the aperture to give a shutter speed for a specific purpose – to freeze action, for example. There is usually a low-light warning to help you avoid underexposure.

BUYER'S GUIDE

Names to look for
(Price range D-E)
**Minox, Olympus, Vivitar

Points to look for
● Good ASA range
● Accurate rangefinder
● Maximum aperture of at least f2.8
● Cable release facility
● Off-camera flash *and* hot shoe, or built-in flash
● Self-timer
● Backlighting compensation

Shutter priority

You select the shutter speed and the camera sets the aperture. You see the setting in the viewfinder, below. Different speeds freeze action, create blur, or simply reduce the effects of camera shake. Adjust the speed to give the aperture for the depth of field you want. With a fast speed (and a wide aperture) you can focus selectively.

500
250
125
60
30
15
8
4
2
1

1.7
2.8
4
5.6
8
11
16

Shutter speed range
This model's electronic shutter offers speeds from 1/8 sec to 1/500 sec.

Self-timer
A self-timer – useful for self portraits – delays exposure for up to 15 seconds.

BUYER'S GUIDE

Names to look for
(Price range D-E)
 **Fujica, Minolta, Vivitar
***Canon, Olympus

Points to look for
● ASA range
● Shutter speed range
● Self-timer

Manual

Manual 35 mm direct vision cameras allow you to select a combination of aperture and shutter speed to suit the subject. Exposure metering is provided by a silicon cell near the lens which measures the light reflected by the subject. You set your chosen aperture and speed, and a needle or LED in the viewfinder warns of under- or overexposure. You can then adjust exposure until the camera indicates an appropriate setting. These cameras have light, well-made bodies. They are less versatile than 35 mm SLRs, but more sophisticated than 110 and 126 pocket cameras. One drawback is that the range of models available is small, and few manufacturers distribute internationally.

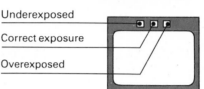

Underexposed

Correct exposure

Overexposed

Autofocus

Many 35 mm DV cameras now have automatic focusing. As you press the shutter, the focusing mechanism moves the lens to a point where it focuses the subject on the film. This action takes less than 1/1000 sec, so it is possible to focus on moving subjects. There are two autofocus systems. The Visitronic system works best in bright light. The infrared system works well in all lighting conditions, but you must aim its sensor accurately.

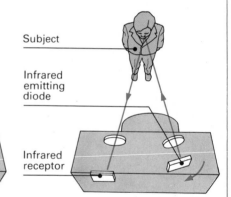

Subject

Movable mirror

Focusing mechanism

Fixed mirror

Subject

Infrared emitting diode

Infrared receptor

Visitronic system
An image is sharpest when it has greatest contrast. Two receptors compare image contrast from different viewpoints. A mirror turns to superimpose the images, and the rotation is linked to the focusing mechanism. When the images coincide, contrast and sharpness are greatest, mirror movement stops, and the lens is focused.

Infrared system
As you press the shutter, an infrared beam scans the subject. After the beam strikes the subject it is reflected back to the camera. The camera measures the amount of time this takes and uses the information to calculate the distance between subject and lens. The camera is then able to focus the lens to the correct distance.

Interchangeable lens models

These cameras represent the top of the direct vision range. The choice of lenses means that you can use a variety of viewpoints, and so create very different images. Leica produces a high quality model with a useful range of lenses. The field of view given by four of these is shown in the viewfinder. The camera design prevents noise, vibration, and mirror bounce. The quietness of the shutter makes the camera ideal for nature photography, and its smooth operation allows you to take hand-held shots at slower speeds than with an SLR. A motor winder is available, and there is a range of other accessories.

Minolta offers a medium-priced model with TTL metering, while the Soviet Union makes a range of low-priced cameras. A very compact model from Bronica is backed by a choice of 28 mm, 40 mm, and 85 mm lenses.

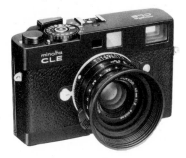

TTL metering model
The compact direct vision camera above is the only interchangeable-lens model to offer TTL metering. Its silicon cell meters light falling on the film plane. Aperture-priority exposure is supplemented by a manual override and dedicated flash is an optional extra.

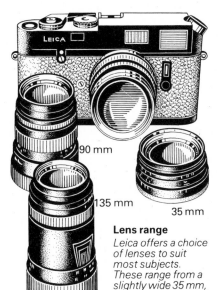

90 mm

135 mm

35 mm

Lens range
Leica offers a choice of lenses to suit most subjects. These range from a slightly wide 35 mm, through a standard 50 mm, to the short telephotos, 90 mm and 135 mm.

35 mm

Field of view
The Leica view selector helps you to choose the lens you require for the particular framing effect you want. Situated on the front of the camera, it reflects into the viewfinder markings which show the field of view given by other lenses in the Leica range. With lenses ranging from 35 mm to 135 mm, you can achieve strikingly different effects.

50 mm

Light meter
The Leica meter is coupled to the top of the camera, right. Its measuring area corresponds to the picture area of the 90 mm lens, so that you must reflect this frame of view in the viewfinder when metering.

90 mm

Alternative models
A number of direct vision cameras with interchangeable lenses are exported by the USSR. Some accept Leica lenses and all have rangefinder focusing. All are inexpensive.

135 mm

35 mm SLR

The 35mm SLR (single lens reflex) camera is the most versatile of still cameras. You can tackle almost any subject with it – from portraits to action, from underwater to landscape, from close-up to long-distance shots. This adaptability results from the wide range of lenses available for the 35mm format and from the sensitive TTL (through-the-lens) metering used in most modern SLRs. You have a narrower choice of lenses with other formats, and the exposure range is usually more restricted. Metering, where available, may be less reliable than with SLRs.

The reflex viewing system ensures accurate framing and focusing up to the moment you release the shutter. It allows you to view the scene through the lens that takes the picture, so that parallax error is eliminated. When you change lenses, the new angle of view is immediately visible, and some models allow you to preview depth of field at various apertures. These and other benefits have made the 35mm SLR universally popular. Its potential is more often limited by the user's ability than by lack of sophistication in the camera.

A light, compact but durable design and reliable operation are available across the range, but an important factor separates budget-priced from more expensive models. At the top end of the range you buy your way into a comprehensive system of lenses and accessories. Cheaper models offer a narrower choice, but even so are generally well backed by equipment.

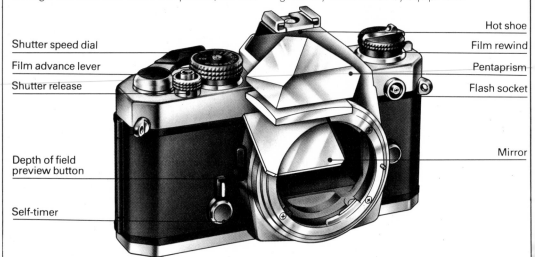

Shutter speed dial
Film advance lever
Shutter release
Depth of field preview button
Self-timer

Hot shoe
Film rewind
Pentaprism
Flash socket
Mirror

SLR principle

The SLR principle is the same throughout the wide range of models. You see in the viewfinder virtually the same picture as you record. Light from the subject passes through the lens and is deflected by a mirror on to a ground-glass screen. The lens inverts the image, the mirror reverses it. A pentaprism then adjusts the image, so you see it correctly aligned. What you see is as sharp as it will appear on film.

Pentaprism viewing system
The silvered internal surfaces of this five-sided glass block reflect light from the image into the viewfinder. Interchangeable pentaprisms are available.

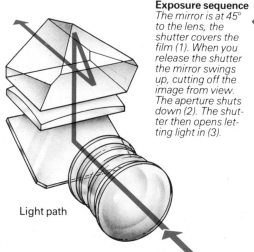

Light path

Exposure sequence
The mirror is at 45° to the lens, the shutter covers the film (1). When you release the shutter the mirror swings up, cutting off the image from view. The aperture shuts down (2). The shutter then opens letting light in (3).

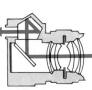

1 Viewing

2 Aperture set

3 Exposure

Metering

Almost all 35 mm SLRs use a through-the-lens (TTL) meter to measure light. A cell-system, usually of cadmium sulfide (CdS) or silicon, lies behind the mirror, beneath it, or in the pentaprism. There are three main types of cell. Center-weighted cells give priority to the center of the picture, their sensitivity decreasing toward the edges. Averaging cells reduce information taken from the whole image to an average. Center-spot cells read only a small central area.

 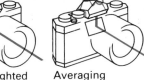

Center-weighted Averaging Center-spot

Focusing

An SLR allows you to see the subject as it will appear on the film, so that you can judge focus very accurately. By adjusting a ring on the lens that gives subject distances in feet and meters, you obtain a sharp image on the focusing screen. A few expensive models take a wide variety of interchangeable focusing screens. These meet a range of requirements – from architectural to close-up work.

Most lenses for the SLR format have a fully automatic diaphragm. This shuts down only when you release the shutter, allowing you to set any aperture and still view with the diaphragm wide open. As the scene remains at full brightness, focusing is easy. Another benefit is that with the aperture fully open you have minimal depth of field and so can concentrate on your main subject. This is known as maximum aperture focusing. An increasing number of SLRs have a button which you use to preview the depth of field that you will have at the selected aperture.

Focusing screens
A common design has three focusing aids. The split-image gives precise focus. The inner microprism ring helps you to focus rapidly. Long lenses and close-up work call for the fine matte outfield.

Split screen with microprism collar

Architectural
A grid makes this screen useful whenever accurate image alignment is important. It is ideal for architectural photography and also for copying.

Low-light
The combination of a matte outfield with a 12 mm diameter microprism focusing spot gives a very bright image to help you focus when lighting is poor.

Clear-center
The simple design of this screen – a 12 mm clear circle is set in a matte outfield – allows you to view and focus without distraction in the image center.

Focal plane shutter

A focal plane shutter is used on 35 mm SLR cameras. It consists of two blinds, of metal or cloth, which move over the film during exposure. A metal shutter travels vertically, a cloth shutter horizontally. When you release the shutter, the first blind moves, allowing light to fall on the film, and the second follows close behind. The gap between the blinds, and their rate of travel, determine exposure time.

1/60 sec or slower

Cloth shutter Metal shutter

Position of shutter
The shutter lies in front of the focal plane, which is where the lens forms a sharp image.

Flash synchronization
When you use speeds of 1/125 sec (with vertical shutter), 1/60 sec (with horizontal shutter), or longer, one blind finishes its travel before the other starts, above. This allows the whole frame to be properly exposed for flash. With faster speeds, the blinds travel simultaneously, masking part of the frame from the flash.

Shutter priority SLR

With a shutter priority SLR you set the shutter speed and the camera automatically selects the aperture to give you appropriate exposure. The choice of shutter speed allows you to interpret a wide range of moving subjects accurately. If you take a lot of candid shots, or are interested in sports or nature photography, this kind of camera is ideal. Keep the shutter set on 1/125 sec or faster and you will always be ready to shoot if pictures occur suddenly. If you want to blur motion, you can quickly adjust shutter speed. If you want to freeze action, or if you are using a long lens without a tripod, you should select the fastest shutter speed that the light allows.

The major drawback of shutter priority cameras is that your chosen shutter speed will not always produce the right aperture for the depth of field you want. Choosing fast shutter speeds, in order to capture sudden movement, will give you wide apertures and shallow depth of field. The problem is accentuated by long lenses and short focusing distances. Before shooting, you should check the aperture that the camera selects in the viewfinder, and use the depth of field preview if your model has one. Depending on available light, you may be able to remedy the situation by turning the shutter speed dial until the aperture you require appears in the viewfinder. But if you set a small aperture and want a crisp image be sure to offset the effects of a slow shutter speed by using a tripod to steady the camera.

There are very few shutter priority cameras on the market. All are of sound construction and most offer as standard such features as depth of field preview, film speed lock, and battery check. A model with manual override allows you to select both aperture and shutter speed as necessary.

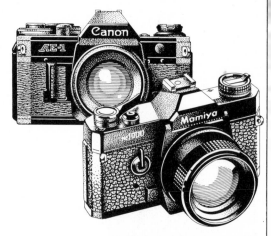

Setting
Turn the aperture ring to auto and set the shutter speed you require. The camera then selects the aperture, which appears in the viewfinder, right.

Lens setting

Shutter setting

Manual override

Manual override is an important feature on this type of SLR. A switch on the camera body cancels out the auto system, so you can interpret the subject as you wish, or compensate for difficult lighting. Most models give an indication in the viewfinder, below, that the camera is on manual. A recommended aperture still appears when the manual override is in use.

Backlighting

TTL meters take an average light reading, so if the main area of interest is in shadow it becomes underexposed. A backlighting compensation button increases your chosen exposure by 1½ stops, to allow for this. This compensation may not suit all shooting conditions.

Backlighting effect
The picture on the right did not take into consideration the effect of light from behind. The main subject was underexposed. Backlighting compensation was used successfully in the other shot to bring the cat into prominence.

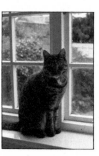

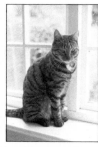

Using shutter priority
Automatic aperture setting allows you
to concentrate on your choice of shutter
speed. You can freeze or blur action, or
use long exposures to achieve unusual
effects. A shutter priority camera,
backed by a motor drive, is ideal for
action and sports photography.

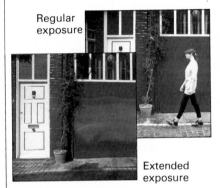

Regular
exposure

Extended
exposure

Shutter speed effects
*A slow shutter speed blurs action, top right,
while a fast speed freezes the subject, right.
The person in the picture, above, right, dis-
appears when the same scene is given a very
long exposure, above, left. She does not
remain in the scene long enough to be re-
corded on film. You can use a timed (T) or
bulb (B) shutter setting to do this.*

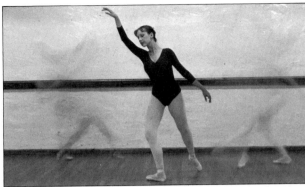
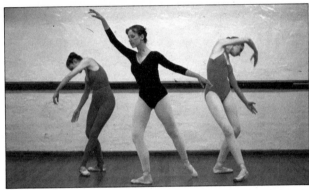

Blurred action

Frozen action

Automatic features
Manufacturers have developed a
number of automatic features on
shutter priority cameras. They include
automatic film loading and wind-on.
Automatic film loading avoids the loss of
pictures caused by the film not passing
through the camera. You place the film
in the camera and align it across the

shutter area. When you close the
camera, it automatically winds the film
on to its starting position. Some
cameras have a built-in autowinder
which winds on the film after you
release the shutter. Some makers offer
a separate winder, below, left.

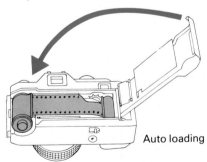

Auto loading

Autowinders

LED check
*On one model an
LED (light-emitting
diode), right, indi-
cates when the
winder has posi-
tioned the film
correctly.*

Aperture priority SLR

With this kind of camera you choose the aperture and the camera automatically sets the shutter speed. Control over aperture gives you the depth of field you want, and by adjusting aperture you can shoot a series of pictures with very different results. With only one control to set, you can concentrate more on your subject, but you should not neglect the aperture's effect on shutter speed. Always check this in the viewfinder. If you don't, you may use too slow a speed to avoid the blur caused by camera shake or subject movement. A number of models have an LED over- and underexposure warning system in the viewfinder. To set a particular shutter speed, adjust the aperture until the required speed appears in the viewfinder. To compensate for slow speeds when using small apertures, use a fast film or uprate a slower one. Models with manual override allow you to set both aperture and shutter speed, but you can still rely on automatic shutter control if you are short of time.

Aperture priority controls

First, set the film speed. This will normally correspond to the speed of the film in use, but you may want to uprate in poor light. After setting the aperture, turn the shutter speed dial to automatic. The speed set by the camera will light up, right. The camera meters subject brightness as you shoot, so that exposure stays accurate right up to this point.

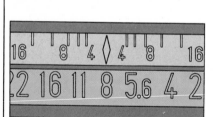

Aperture setting

Manual override

This control, available on a number of models, allows you to set the shutter speed manually. It enables you to work with difficult light conditions, where contrast may be high, and to interpret subjects in your own way. When you set the shutter speed dial to "M" or "Manual" (right) the viewfinder still shows the exposure you have set. But it also tells you by how much your chosen settings are over or under what the camera would recommend in the aperture priority mode.

Setting lens and camera controls
Set the aperture, left, then the shutter speed dial, right, to "A" or "Auto". The camera then matches shutter speed to aperture.

"Auto" setting

Manual setting

Continuous shutter choice
On one model you use buttons to raise or lower shutter speed, elevator-style, right.

Viewfinder readout

Metering

Aperture priority automatics meter light in several ways. One system uses two methods. The averaging method covers the entire picture area but emphasizes the center. This is suitable when the scene is uncomplicated and the light is evenly distributed. Alternatively, the spot method meters a small, circular central zone. This allows you to meter selectively. The camera stores the reading it takes from one area and then uses this information when you reframe to take in the whole scene. Another metering system, less commonly used, measures light falling on the film during exposure. The camera uses this data in choosing a shutter speed to match your aperture setting.

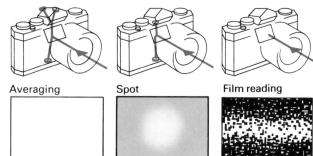

Averaging Spot Film reading

Memory lock
A memory lock, left, gives you exposure compensation for backlit scenes. Center the main subject and push the lever toward the lens to register the reading. Then recompose, taking in the whole scene, to achieve overall exposure.

Using aperture priority

Aperture priority cameras give you control over depth of field, allowing you to interpret a scene in a variety of ways, A wide aperture gives you selective focus, right, separating the main subject from a distracting background. When depth of field is limited by close focusing with a long lens, use a small aperture. This extends depth of field, far right, and may improve image sharpness. For best effect stop the lens right down and focus on the hyperfocal point (the closest point that is sharp when the lens is focused on infinity).

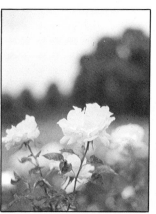

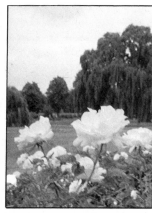

Selective focus Extensive depth of field

Interchangeable magazines

New on the market, the aperture priority 35 mm SLR, right, has interchangeable film magazines. You do not have to carry several camera bodies if you want to use more than one type of film. The magazines are light and make it very easy to change film type. In addition the camera offers a wide choice of eye-level and waist-level viewing. Both types of finder are built-in, and both offer comprehensive viewfinder displays. The camera also has an integral motor drive for single or serial shots.

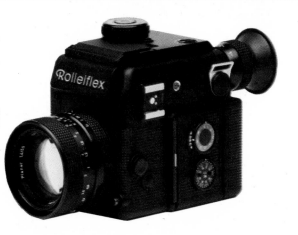

Multimode SLR

Multimode cameras give you a choice of up to six exposure modes. In this way they combine the advantages of the different types of 35mm SLR. There is only a handful of multimodes on the market, but all are of high quality. Models with three modes offer shutter priority, aperture priority, and manual control. The most sophisticated models also have a fully automatic mode, a stopped-down metering mode, and an automatic flash mode. Whichever mode you use, you see in the viewfinder the aperture and shutter speed selected. These appear as an LED readout below the frame or as a combination of a readout and an LED scale. Over- and underexposure warnings may also appear. Some models match the bright-ness of the data to prevailing light conditions, so that you avoid a dim readout with a bright image and a distracting glare with a dull image. Multi-modes have a wide exposure range, some offering a shutter speed range of 1/1000 sec to 30 secs. The film speed range may be as wide as 6 ASA (ISO) – 12800 ASA (ISO). Most models have a depth of field preview button and a multiple exposure facility. There may also be an eyepiece shutter to cut out stray light during remote control shots. Multimodes are versatile but expensive. If you buy a single priority or basic manual camera you can spend what you save on additional lenses. At the same time a simpler camera helps you learn more because you have to work harder.

Shutter priority

This mode is most useful in action and sports photography, because a fast shutter speed allows you to freeze movement, right. You set the camera to the shutter speed mode and select the speed you require. You may also have to set the aperture ring to automatic. The shutter speed you select and the aperture set by the camera appear in the viewfinder. If the shutter speed you have chosen risks over- or under-exposure, a warning light flashes beside the frame on some models.

Lens setting

Camera setting

Shutter priority readout

Aperture priority

Aperture priority gives you control over depth of field, right. A wide aperture highlights a selected area of a picture, while a small aperture gives clear focus throughout a scene. This control is particularly useful for portraits, landscapes and close-ups. You turn the camera setting ring to automatic and set the aperture you require. The camera will then select a shutter speed that gives accurate exposure, and the aperture and shutter speed will appear in the viewfinder as shown right.

Lens setting
Camera setting

Aperture priority readout

Stopped-down

Some manufacturers offer a stopped-down auto mode. This is particularly useful for close-up and macro photography, right, and when you want to set the camera on a microscope. You can use this mode with reverse-mounted lenses and uncoupled accessories such as auto bellows (p. 54). Set the camera as for aperture priority and depress the stop-down button on the body. The camera then automatically sets the shutter speed. Shutter speed and aperture both appear in the viewfinder.

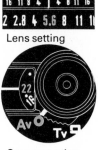
Lens setting
Camera setting

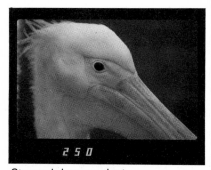
Stopped-down readout

(XD11 in USA)

Fully automatic

The fully automatic mode allows you to forget the problems of exposure completely (except where light is unfavorable), as the camera sets both aperture and shutter speed. The viewfinder tells you the settings the camera has selected. This enables you to concentrate on picture framing and composition. All you have to do, having set the ASA speed, is put the camera on automatic, and shoot. This mode is ideal for candid shots, right, and for subjects you see suddenly.

Lens setting

Camera setting

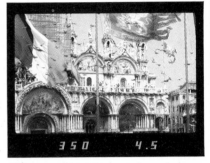

Fully automatic readout

Automatic flash

Some multimode cameras offer an automatic flash mode, but you must use a flash gun suited to your camera. First, you switch the camera to the auto flash setting, and focus. The working aperture selected by the gun's selector, together with the synchronized shutter speed, are then transmitted to the lens and the camera. The gun also takes account of the subject distance. When the flash is sufficiently charged it switches off and aperture and shutter speed appear in the viewfinder.

Lens setting

Camera setting

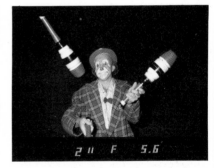

Automatic flash readout

Manual

Multimode cameras have a manual mode which allows you more freedom than the automatic program. This mode is well suited to special exposure effects and to bracketing techniques. You set the dial to manual and can then take over and adjust the aperture and shutter speed combination as on a regular manual model. All cameras give an LED readout in the viewfinder when set on manual. Some indicate the settings you have made, others the settings that the camera advises.

Lens setting

Camera setting

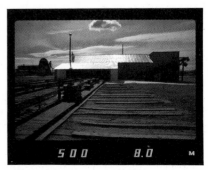

Manual readout

Manual SLR

Manual 35 mm SLRs give you total exposure control. Their TTL metering provides accurate light reading, but you can choose to ignore the exposure recommended in the viewfinder and combine aperture and shutter speed in the way you want. This allows you to select your exposure effects and to make rapid and subtle adjustments to meet changing light conditions. Bracketing, to achieve different tonal and color effects, is another advantage you have with manual operation. Most manual models have a shutter speed range of 1 sec to 1/1000 sec, but a few offer 10 secs to 1/2000 sec. Flash synchronization at 1/60 sec or 1/125 sec is normal, and these speeds are indicated on the shutter speed dial by color or asterisks. Manual SLRs also often have depth of field preview and multiple exposure facilities. The range of manual models and prices is wide.

Manual controls

Use the aperture to control depth of field and shutter speed to control the effects of camera shake or subject movement. You often have to strike a balance between these two variables, rather than give priority to one setting.

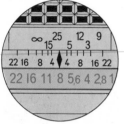

Aperture control Shutter speed control

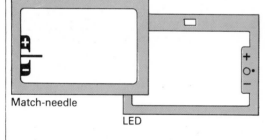

Match-needle

LED

Metering

Turn on the meter to obtain a light reading. The switch is usually incorporated in the film advance lever, in the shutter release, or on the camera top. A match-needle or LED system in the viewfinder tells you if your chosen settings will give "correct" exposure. All manual models tell you if you risk over- or underexposure, and some indicate the discrepancy to a half-stop.

Spot metering aid
Some models have a viewfinder with a slightly darkened center. The meter bases its reading on this area of the frame. If your camera has a memory lock, you can meter selectively, as with an off-camera meter.

Camera-top meter switch

Built-in meter switch

Using the manual SLR

Manual cameras are, with the exception of multimodes, the most adaptable of 35 mm SLRs. The fine adjustments of exposure made possible by sensitive metering and wide ASA and shutter speed ranges allow you to produce very different pictures from the same subject. The effects you can obtain in this way are frequently more impressive than those you achieve by relying on automatic exposure. Manual models operate under a broad range of light conditions. They allow you to respond accurately and rapidly to fast-changing light, and you will not regret the lack of ˉ automatic exposure.

Film speed range

Use slow film, with its fine grain and very sharp definition, for close-up work and micrography.

A medium film is useful for most general purpose outdoor photography. Definition is still sharp.

Fast film, with high sensitivity and coarse grain, is ideal for atmospheric shots in poor light.

Selective exposure

High-key
Deliberate overexposure (exposing for shadows) gives a high-key effect, with the image dominated by reflected white light. Slight overexposure can heighten this effect in a potentially high-key subject.

Normal
Normal exposure gives a result which has greater contrast than high- or low-key images.

Low-key
If you expose for subject highlights, you can produce a low-key picture, weakly lit and dominated by shadows. This can give a dramatic or mysterious quality, which is particularly effective in portraits and landscapes.

Multiple exposure

Some models have a button which cancels the film advance, enabling you to expose the same frame more than once. You can create interesting effects, such as superimposing different subjects or recording one subject from various viewpoints. The multiple image, right, consists of two exposures on one frame.

Multiple exposure button

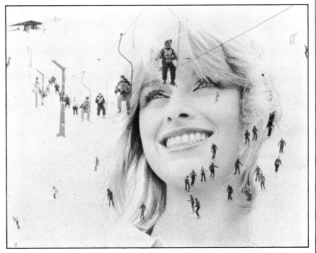

Multiple exposure effect

35 mm SLR system

All top SLR manufacturers produce a range of lenses and accessories to complement their cameras. It is worthwhile buying your way into a quality system, however modestly you start. Then your subsequent choice will be wide and all the elements will be truly compatible. The system shown here is designed to meet every need. Some of the items are expensive, however, and you will probably have to balance your priorities against your budget. A basic system should include an SLR body, 24 mm, 50 mm, 135 mm, and 70-240 mm (zoom) lenses, a selection of filters for color and black and white photography, a tripod, a cable release, a flash gun, a light meter, hoods, caps, and cases, a gadget bag, and camera and lens care equipment.

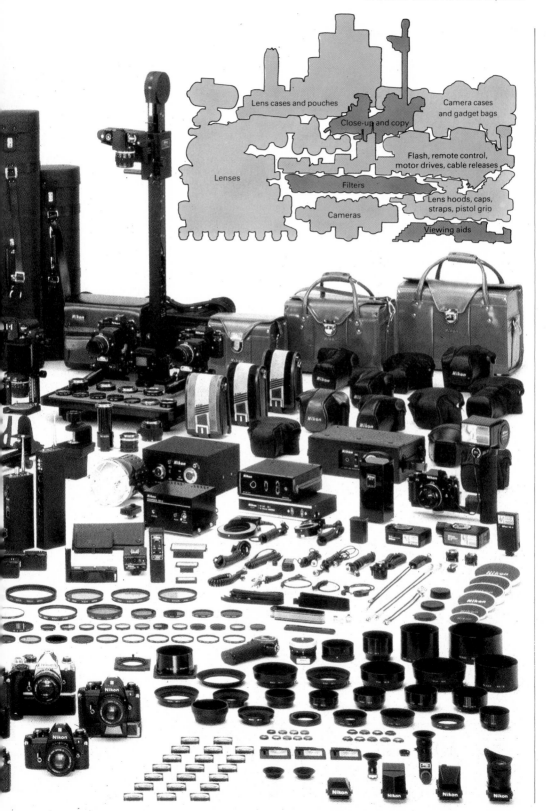

Lens cases and pouches

Camera cases and gadget bags

Close-up and copy

Lenses

Flash, remote control, motor drives, cable releases

Filters

Lens hoods, caps, straps, pistol grio

Cameras

Viewing aids

35 mm SLR system

You will save money and avoid disappointment if you buy into a 35mm SLR system that will serve both current and foreseeable long-term interests. The chart below shows the extent of the systems offered by a selection of major manufacturers across the price range. Use it to narrow down your search, then examine the maker's specifications, and, if possible, handle the equipment. The major systems all include standard, wide-angle, and long lenses, but no two offer exactly the same choice of focal lengths. There is no standard lens mount either, and so compatibility be-

tween lenses and cameras may influence your choice of system. The major makers each produce bayonet-mount lenses for their cameras only, while Pentax also offer screw lenses compatible with Fujica, Yashica, and other cameras. Pentax also makes K-mount lenses, which fit Ricoh bodies. Lenses from the other major firms will fit cheaper SLRs if you use adaptors. Specialist lens makers, such as Hoya and Vivitar, produce lenses for the major brands of camera.

The choice of very wide-angle, short fisheye, and fast standard lenses is limited in some sys-

	Cameras	Standard lenses	Wide-angle lenses	Telephoto, catadioptric lenses	Zoom lenses	Fisheye lenses	Special lenses
Canon	Manual Aperture priority Shutter priority Multimode	50mm/f1.2 (macro)	17-35mm	85-1200mm	Wide-angle Standard Telephoto	7.5mm 15mm	Macro High-mag macro Shift
Fujica	Manual Aperture priority Multimode	55mm/f1.6	24-35mm	100-400mm	Wide-angle Standard Telephoto	16mm	Macro
Konica	Shutter priority	40mm/f1.8 50mm/f1.4	21-35mm	85-1000mm	Wide-angle Standard Telephoto	15mm	Macro
Minolta	Manual Aperture priority	50mm/f1.2	17-45mm	85-1600mm	Wide-angle Standard Telephoto	7.5mm 15mm	Macro
Nikon	Manual Aperture priority Shutter priority	50mm/f1.2 (macro)	13-35mm	85-2000mm	Wide-angle Standard Telephoto	6mm 8mm 10mm 16mm	Macro Medical Shift Low-light
Olympus	Manual Aperture priority	50mm/f1.4 (macro)	18-35mm	85-1000mm	Standard Telephoto	8mm 16mm	Macro Shift
Pentax	Manual Aperture priority	40mm/f2.8 50mm/f1.2	15-35mm	85-2000mm	Wide-angle Standard Telephoto	17mm	Macro Shift
Ricoh	Aperture priority	50mm/f1.4	28-35mm	135-200mm	Wide-angle Standard Telephoto	16mm	—
Yashica	Aperture priority	50mm/f1.2	15-35mm	85-1000mm	Wide-angle Standard Telephoto	15mm 16mm	Macro Medical Shift Low-light

tems. Catadioptrics of over 300mm are also rare, although more makers are entering this area. Long telephotos, by contrast, are well represented, some makers including 2000mm lenses. Most systems offer at least one macro lens, but only a few have a very short version for high-magnification work. Other close-up equipment, including bellows and reversing rings, is also widely available. If you often shoot in poor light or at very close range, you may look to a system that includes viewing screens and hoods. All the manufacturers represented below offer at least one motor drive. Motor drives can create in turn the need for bulk film backs. Most systems feature

250-frame backs, while two include 750-frame versions. Cases from camera systems are often more costly than those from specialist firms. They have the advantage, however, of being designed to take that system's components.

Viewing	Motor	Remote	Close-up	Copying	Backs	Cases
9 screens Booster head Waist finder Speed finder	5 f.p.s. 3.5 f.p.s. Autowinder (1.5 f.p.s.)	Remote control switch for motor drive	Bellows Reversing rings Tubes	2 stands	Data 250 bulk 750 bulk	Hard and soft (camera and lens)
Right-angle finder	Autowinder (2 f.p.s.)	—	Bellows Reversing rings Tubes	—	Data	Camera
Right-angle finder	Autowinder (1.5 f.p.s.)	—	Bellows Reversing rings Tubes	Stand Slide copier	—	Camera
—	Autowinder (2 f.p.s.)	—	Bellows Reversing rings Tubes	2 stands Slide copier	Data	Soft (camera and lens)
19 screens Low-light head Waist, action, and magnification finders	3.5 f.p.s. 6 f.p.s.	Yes Intervalometer	Bellows Tubes	Stand Slide copier	Data 250 bulk 750 bulk	Hard and soft (camera and lens)
13 screens Right-angle finder	5 f.p.s.	Control box for motor drive	Bellows Tubes	Stand	250 bulk	Hard and soft (camera and lens)
9 screens Right-angle finder	5 f.p.s. 5.5 f.p.s. Autowinder (2 f.p.s.)	Yes	Bellows Tubes	Stand Slide copier	Data 250 bulk	Hard and soft (camera and lens)
—	Autowinder (2 f.p.s.)	—	Bellows Tubes	—	Data	Hard (camera and lens)
7 screens	5 f.p.s.	Yes	Bellows Tubes	2 stands	Data 250 bulk	Hard and soft (camera and lens)

Medium format SLR

Medium format SLR cameras use 70 mm roll film in either 120 or 220 size, or smaller-sized cut film. The 120 size normally gives 12 exposures, while the 220 gives 24 exposures. Most models have the 2¼ ins × 2¼ ins (6cm × 6cm) format. Other sizes, such as 2¼ ins × 2¾ ins (6cm × 7cm), often described as the ideal format, and 1½ ins × 2¼ ins (4.5 cm × 6 cm), are also available. Medium format cameras combine the advantages of SLR viewing with those of a large negative image size. The image you obtain – at least four times the size of that produced by a 35 mm SLR – allows substantial enlargement without loss of picture quality.

Most manufacturers supplement their cameras with a range of accessories, including viewfinders, hoods, and interchangeable film backs. The viewfinders include a pentaprism, which corrects the reversed image produced by the lens.

Interchangeable backs enable you to switch your film from black and white to color, or from slide to negative, at any time, even in mid-roll. Instant-picture film backs are also available. These are particularly useful in the studio for checking exposure and composition effects.

All medium format SLRs have the benefit of a range of high-quality lenses, each having an automatic diaphragm. Most of these use a bladed shutter, which, in conjunction with the camera's focal plane blind, allows you to synchronize flash with fast shutter speeds. Other models use focal plane shutters.

Medium format SLRs are bulkier, heavier, and slower to use than 35 mm cameras. They are also far more expensive. However, their construction is invariably durable, and their lens quality and accessories are usually excellent.

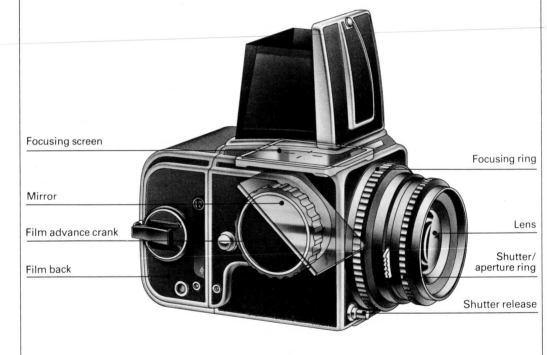

Focusing screen

Mirror

Film advance crank

Film back

Focusing ring

Lens

Shutter/
aperture ring

Shutter release

SLR principle

You use the same lens for viewing, focusing, and taking the picture. The mirror inside the camera reflects the image on the viewing screen, right, so that it is laterally reversed. The aperture stays open as you focus. When you press the shutter, the mirror swings up, blocking incoming light from the focusing screen. The lens stops down to its preset aperture and the focal plane blind drops away. The shutter then opens, exposing the film to the image-forming light, far right.

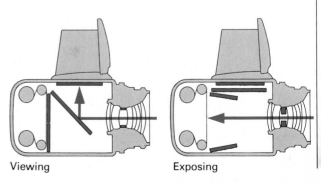

Viewing

Exposing

Camera types

Most manufacturers produce a basic 6 cm × 6 cm camera, and some make cameras with a 6 cm × 7 cm format. Cameras with extra features are also available. Fixed wide-angle lenses are useful for the specialist in architectural and landscape photography. A built-in motor drive is an asset when shooting a continuously moving subject. The focal plane type, with shutter speeds of up to 1/2000 sec, is also useful for action shots. Some models feature TTL metering, although this is unusual on medium format SLR cameras. A 6 cm × 7 cm camera with revolving film back is also available. This feature makes framing easier when you turn the camera to shoot vertical format pictures.

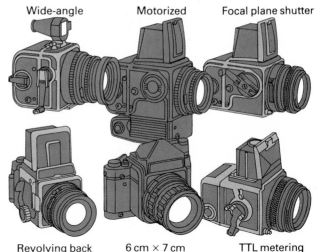

Wide-angle Motorized Focal plane shutter

Revolving back 6 cm × 7 cm TTL metering

Interchangeable backs

The camera holds roll film within a removable back. A slide-in plate prevents fogging when you change magazines in mid-film. You can buy 70 mm backs, taking 12 or 24 exposures, and bulk backs, giving up to 500 exposures.

Range of film backs
Look carefully at the range of backs your manufacturer offers. Not all produce the range shown here.

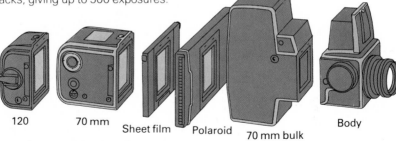

120 70 mm Sheet film Polaroid 70 mm bulk Body

Interchangeable viewfinders

You can exchange the standard focusing hood for other viewfinder types. The useful pentaprism (available with built-in metering) permits eye-level viewing of a correctly aligned image. The magnifying hood is very useful for focusing in bright sunlight. Sportsfinders, for action shots, are also available.

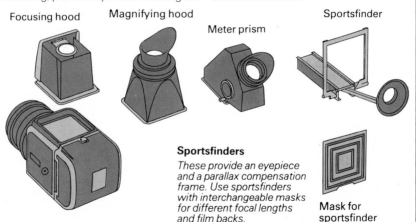

Focusing hood Magnifying hood Meter prism Sportsfinder

Sportsfinders
These provide an eyepiece and a parallax compensation frame. Use sportsfinders with interchangeable masks for different focal lengths and film backs.

Mask for sportsfinder

Medium format SLR system

There are only a few medium format systems. The top price Hasselblad system, shown here, provides you with all the equipment you are likely to need. But the amateur will probably look for a more moderately priced, if less extensive, alternative, such as the Bronica or Kowa systems. Choose one which does not restrict your development. Before starting to build up a system, decide what your current interests are and, if possible, plan for the future as well.

You will have little trouble in obtaining quality optics, but you will encounter some restrictions with medium format lenses. Many are slower than their 35 mm counterparts, f5.6 being a common maximum aperture. Focal length at the long end of the range is limited, mainly because of production costs. The longest lens in any system is usually 500 mm. Zooms and fisheyes are uncommon for the same reason. By way of compensation, there is a choice of lenses for close-up, infrared, and ultraviolet photography.

A number of accessories make your camera as versatile, if not more, than the 35 mm SLR. Interchangeable film backs, including those for instant picture film, allow you to work with a selection of formats and to change format in mid roll, while bulk backs increase your shooting capacity. Viewfinders, focusing screens, and eyepiece accessories extend your range of subjects. For close-up shots, extension tubes and an automatic bellows unit are available, while a ring flash gives you the best lighting for macrophotography. A microscope adaptor allows you to move into photomicrography. Other sophisticated accessories also increase the appeal of the system to the specialist. Among these are a motor drive, a remote control unit, and a time-lapse device. A camera housing for underwater photography and a frame finder for aerial use are also part of the broadest medium format systems. Cases for cameras and accessories are also available.

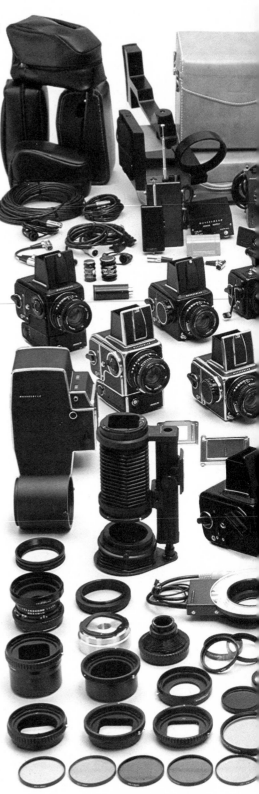

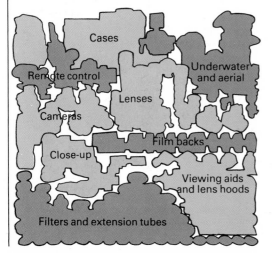

Cases

Remote control

Underwater and aerial

Lenses

Cameras

Film backs

Close-up

Viewing aids and lens hoods

Filters and extension tubes

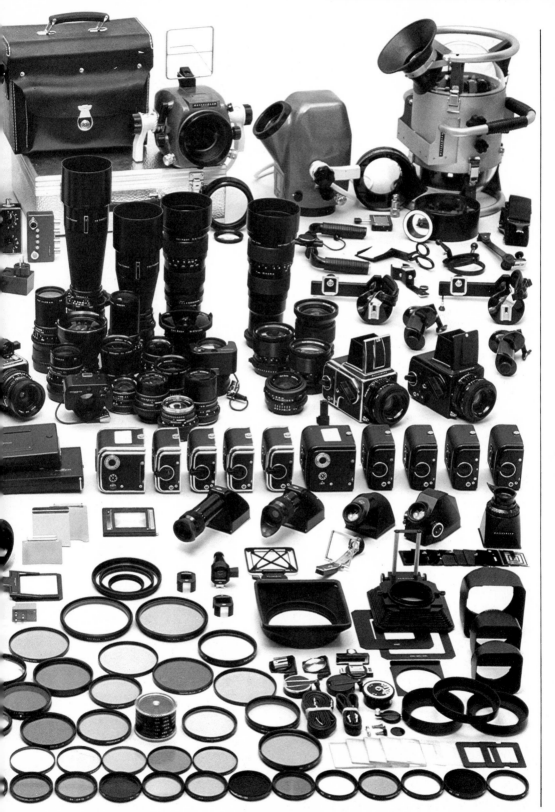

Medium format TLR

Twin lens reflex cameras have two lenses, of the same focal length, coupled together so that both move as you adjust focus. Interchangeable lenses are also supplied in coupled pairs. The upper, viewing lens may have a slightly larger aperture than the lower, taking lens. It is set at maximum aperture, for ease of focusing. This prevents you from previewing depth of field, but most models have a depth of field scale. In the top half of the camera, behind the viewing lens, is a mirror set at 45°. This reflects the image up on the focusing screen. You view the screen from above, holding the camera at waist level. This viewing system allows you to view the subject continuously, even during exposure. The lower lens incorporates a bladed shutter, synchronized for flash at most speeds.

Twin lens reflex cameras are not available with through-the-lens metering. Some models have a built-in meter with an external cell. Others require the use of an off-camera meter. Mamiya also makes an eye-level viewing attachment which incorporates a CdS meter.

The separation of the TLR's lenses causes parallax problems at close focusing distances, and the mirror laterally reverses the image you view. But the TLR handles very comfortably, and prices are reasonable for the format size. Another advantage is that the viewing system allows you waist-level, eye-level, or overhead shooting.

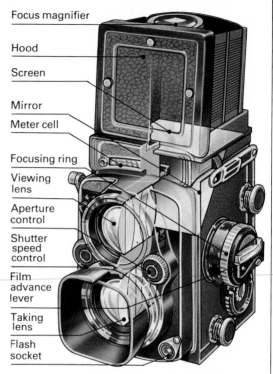

Focus magnifier

Hood

Screen

Mirror

Meter cell

Focusing ring

Viewing lens

Aperture control

Shutter speed control

Film advance lever

Taking lens

Flash socket

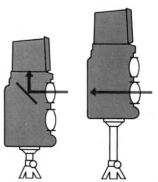

Sportsfinder

Viewfinder

The viewing and focusing screen, on top of the camera, shows a laterally reversed image. Basic models have a folding hood to shade the screen in sunlight. Most hoods convert into an eye-level sportsfinder. Pentaprism and magnifier attachments are available.

Pentaprism Magnifier

Parallax error

Because of the space between the TLR's two lenses, parallax error may result at close focusing distances. Correction guide marks in the viewfinder help you avoid this. Some cameras link these marks to the focusing control so you can make adjustments for different distances. A paramender, set between camera and tripod, also aids correction.

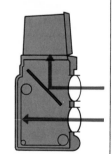

Paramender
This raises the camera by an amount equal to the distance between the lenses, above.

Parallax correction bar
On models with a bar in the focusing screen, below, the portion above the bar will be cut off the film. The figures help you avoid this.

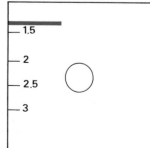

1.5

2

2.5

3

Types of TLR

There are three types of medium format TLR, each produced by different manufacturers. The fixed (standard) lens type is fairly simple to use and gives large image size. Models with interchangeable lenses also give high quality results, and a wide range of lenses and accessories is available. But the cost of the basic camera is higher and additional lenses are also expensive. Budget models use supplementary lens attachments to vary focal length. These models are compact and easy to carry, but image quality is lower than that of cameras with interchangeable lenses. This may not be too important if your enlargements do not exceed four times the negative size.

Interchangeable lens model

Fixed lens model

Supplementary lens model

Interchangeable lenses

Supplementary lenses

Picture quality

The large format size is a major advantage of this type of camera. The negative is four times larger than that on 35 mm film and requires much less enlargement to produce the same size of print, as shown below. Consequently focusing inaccuracies, minor subject movement, and the effects of grain are much less noticeable than with 35 mm cameras. Contrast is also improved and colors are often more brilliant. A further advantage is that the larger negative size gives more scope for cropping pictures. Everything else being equal, print quality is much better and big enlargements are easier.

35 mm negative
This 35 mm negative was magnified 40 times to give the print shown, right.

2¼ ins x 2¼ ins negative
This negative was magnified only 10 times to give the same size print.

Coarse grain
This detail, magnified × 20, shows the coarse grain.

Low grain
The detail, magnified × 13, shows the print's lower grain.

Medium format TLR system

Only one TLR manufacturer offers a system comparable in versatility to those for medium format SLRs. The range of equipment is adequate for both general photography and some specialist interests. It offers you a reliable and, in most cases, less costly alternative to the SLR. With a TLR you have uninterrupted viewing during exposure and you can always view at maximum aperture. Another advantage is that the large viewing screen allows fast waist-level framing. The cameras in the Mamiya system, below, are backed up by a range of lenses from 55 mm to 250 mm. These are sold in matched pairs (p. 38) and so are costly components of the system. Interchangeable heads and screens, and parallax correctors, overcome the disadvantages of the TLR viewing system; magnifying hoods and eyepiece correction lenses are also useful. Hard and soft cases for cameras and lenses, a flash gun which can be synchronized at all shutter speeds, and camera and flash supports, also form part of the compact system.

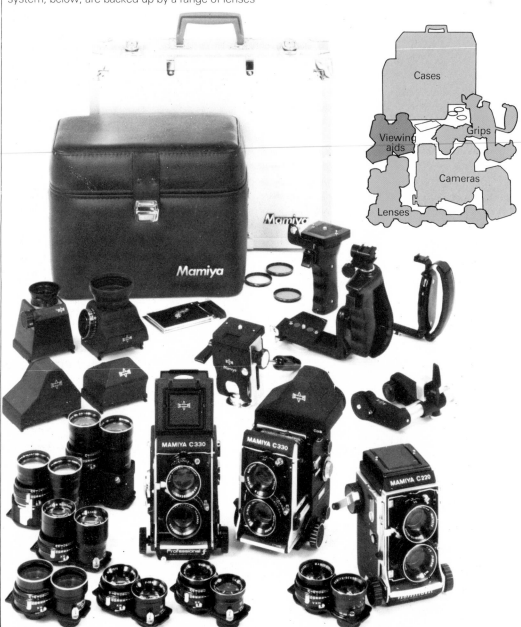

Non-standard medium format

All medium format cameras use roll film, but some produce images of a different size from the standard 6 cm × 6 cm. Image sizes range from 6 cm × 4.5 cm to 6 cm × 17 cm. These cameras are light, with a speed of operation approaching that of smaller models. Many are suitable for studio work. Viewing is by direct vision viewfinder or SLR screen, and some models use both. SLR viewing allows more accurate framing and focusing, and so is more effective for studio use. Models which also allow limited camera movements (pp. 42-3) are useful for correcting perspective and controlling depth of field. Interchangeable lenses are available for SLR and baseboard models.

Fixed format

Manufacturers provide a wide variety of formats, right. The range includes a panoramic 6 cm × 17 cm camera, and a versatile 6 cm × 8 cm baseboard camera with a handgrip for quick shooting and a bellows to allow camera movements. Direct vision and SLR models with 6 cm × 7 cm and 6 cm × 4.5 cm formats are also available.

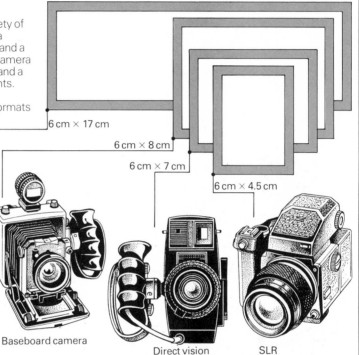

6 cm × 17 cm

6 cm × 8 cm

6 cm × 7 cm

6 cm × 4.5 cm

Panoramic camera

Baseboard camera

Direct vision

SLR

Variable format

The camera below accepts a range of film backs, enabling you to take pictures in a choice of formats. Variable viewfinder masks are available to suit these different formats. The camera has a system of accessories: film backs, lenses from 50 mm to 250 mm, extension rings, filters, and viewing aids.

Variable format camera

6 cm × 9 cm

6 cm × 7 cm

6 cm × 6 cm

6 cm × 4.5 cm

Choice of format

The large 6 cm × 9 cm format is widely used for press work. The 6 cm × 7 cm "ideal format" is also often used by professionals. Picture quality is good in all formats.

BUYER'S GUIDE

Names to look for
(Price range D-H)
* Mamiya, Omega, Pentax
** Bronica, Linhof

Points to look for
- Range of interchangeable lenses and good image size (SLR or baseboard models)
- Fast shooting (direct vision models)
- Choice of lenses
- Choice of viewfinders
- Camera movements possible
- Range of films available for format
- Basic lens included in price
- Rent the panoramic camera

Large format monorail

Large format cameras used on a monorail consist of a lens panel, a focusing screen, and a bellows system between them. They take 4 ins × 5 ins or 8 ins × 10 ins sheet film. The bottom rail allows you to move the lens and viewing panels independently, and is extendable, so that you can add extra bellows for close-up work or long focal length lenses. The large focusing screen, marked with a grid, allows very precise viewing, focusing, and image alignment. This and the large format make these cameras especially suitable for high quality still life and commercial work. You can shift and tilt lens and viewing panels independently to adjust the plane of focus. The range of camera movements gives you considerable control over perspective and depth of field, making these cameras ideal for landscape and architectural photography (although mobility may be a problem). It is best to use a monorail camera after experience with other formats.

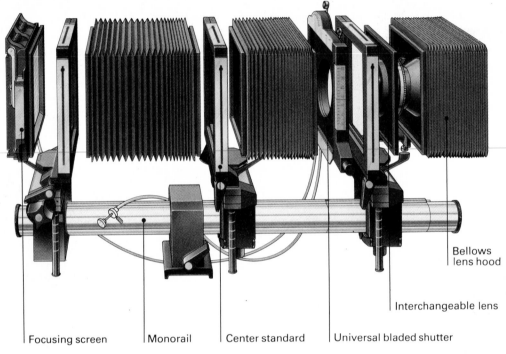

Focusing screen Monorail Center standard Universal bladed shutter

Bellows lens hood

Interchangeable lens

Choosing a monorail camera

A square rail offers firm locking of both camera panels, though focusing may be smoother on cylindrical rails. Look for cameras which support the lens at its optical axis, as this method gives the most accurate camera movements. The versatile modular design, below, allows you to support the camera from any side.

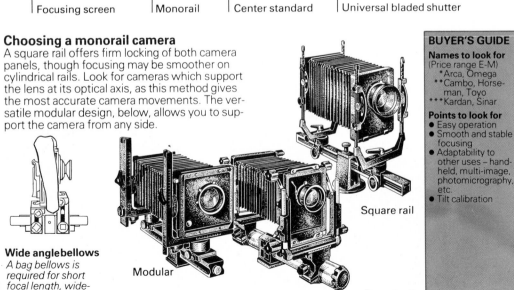

Wide angle bellows
A bag bellows is required for short focal length, wide-angle lenses.

Modular

Square rail

Round rail

Shutter

A behind-the-lens shutter makes your speeds consistent whichever lens you use. Situated between focusing screen and lens, below, it allows you to use lenses with and without their own shutters. The readout shows you all camera settings from behind the lens.

Shutter

Focusing screen

Lens

Metering units

Some systems offer a TTL exposure meter, below, to give working aperture metering of high sensitivity. A built-in probe allows you to meter selectively. This unit can also measure flash exposures. A calculator converts the light reading to camera settings.

TTL meter

TTL metering
The system, left, provides a large format camera with efficient built-in metering. It gives readings of continuous light and flash at the film plane.

Viewing and focusing

The monorail camera's large focusing screen enables you to see every change in the image. Various hoods, right, together with a binocular magnifier, are available to aid viewing.

Depth of field
Some cameras have a scale, left, to give you a check on depth of field when you stop down. You can adjust it for different lenses.

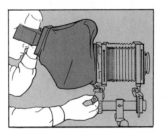

Bag bellows and magnifier
With bag bellows and magnifier you can move your view around the focusing screen.

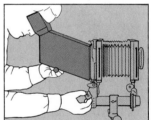

Reflex hood and magnifier
This hood uses a mirror system to give a corrected upright or horizontal image.

Baseboard cameras

Portable large format cameras are mounted on a baseboard. They accept interchangeable lenses and offer a range of camera movements. Scales on the baseboard make accurate focusing easy.

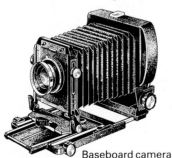

Baseboard camera

Camera movements

The three basic camera movements on a monorail camera are a lateral shift, a lateral swing, and a forward and backward tilt. Use them in conjunction to alter both depth of field and perspective.

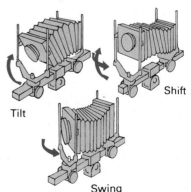

Shift

Tilt

Swing

Instant picture cameras

Most modern instant picture cameras give you a color print a few seconds after exposure. They use special film packs which contain their own developing system. A number of models are available, from simple "point and press" cameras to more sophisticated designs. Autofocus, automatic exposure, built-in flash, and SLR viewing are among the features available. All cameras have a lighten/darken control which enables you to adjust exposure. With peel-apart film, available in black and white and color, you must separate the negative from the print manually. Cameras which use only color integral film produce a dry result automatically. An instant picture model which offers a good close focusing distance and wide exposure range is the best choice.

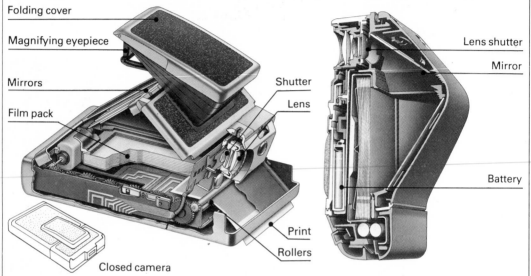

Folding cover
Magnifying eyepiece
Mirrors
Film pack
Shutter
Lens
Print
Rollers
Closed camera

Lens shutter
Mirror
Battery

Choosing a camera

Cameras designed for the amateur now generally use integral film. The range includes cameras with SLR viewing, and direct vision models are made in both upright and horizontal designs, below. Some have variable focus lenses. Peel-apart film is still available for use with interchangeable backs on medium and large format cameras.

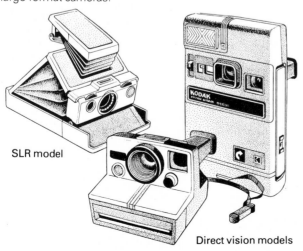

SLR model

Direct vision models

Lighten/darken control

This controls brightness and color. Use it in accordance with film manufacturers' advice to correct exposure, below, or for creative effect.

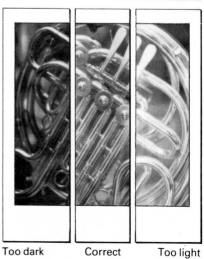

Too dark Correct Too light

Autofocus

Both direct vision and SLR models, below, are available with an autofocus mechanism. This uses ultrasonic signals to focus the lens to the subject distance. Ideal for rapid shooting, an autofocus model can improve both the speed and accuracy of your focusing. But an override control allows you the freedom to focus manually if you wish.

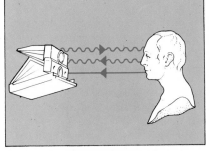

Autofocus principle

As you press the shutter, ultrasonic signals travel toward the subject, left, and bounce back. The camera measures the time this takes and uses this information to compute subject distance and focus the lens.

Autofocus SLR

Direct vision autofocus

Flash

All instant picture cameras either accept flash or have it built in. You can choose bar or electronic flash. Flash range varies according to the power of the gun, but 3½-10 ft (1.1-3 m) is common with electronic flash, while flash bars have a range of 4-10 ft (1.2-3 m). If you already have an electronic flash gun it may not be compatible with instant picture cameras. You must check this, as using the wrong gun can damage your camera circuitry.

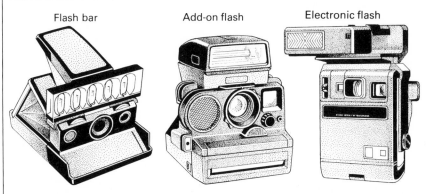

Flash bar Add-on flash Electronic flash

Accessories

The range of accessories available for instant picture cameras includes a cable release and a self timer, a flash diffuser, and telephoto and close-up attachments for the camera lens.

Self timer Tele lens

Lens attachments

Telephoto and close-up lenses increase the versatility of your instant picture camera. The lenses, left, are designed to fit easily over the camera's standard lens.

Flash diffuser

Close-up lens

Cable release

Advanced instant picture cameras

Designed primarily for the professional photographer, advanced instant picture cameras are expensive. They use large format film, offer interchangeable lenses and provide a range of accessories. They have more sophisticated controls than instant picture cameras designed for amateur use. Roll-film adaptors remove the restrictions of single sheets of instant picture film. Instant picture backs for conventional cameras can provide you with similar facilities, so you need only buy these cameras for specialist use. Some are designed especially for particular branches of photography. One of the most useful is the close-up camera, which you can adapt for copying, oscilloscope recording, and other professional applications. Cameras which produce multiple images, generally used for passport photographs, are also available.

Interchangeable lenses

The professional instant picture camera, below, accepts interchangeable lenses in a range of focal lengths. A close-up kit, with which you can focus down to 5½ ins (14 cm), is a recent addition to the scene. The camera is well equipped for quick and easy shooting with its pistol grip with built-in shutter release. You can also mount the camera on a tripod. Viewfinders are available to match different focal length lenses.

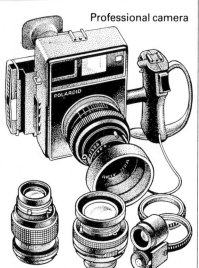

Professional camera

Close-up and copying

The close-up and copying camera is very easy to operate. Its design eliminates difficulties of focusing, lighting, exposure calculations and field size. A built-in ring flash provides even lighting. Frame attachments allow easy positioning for sharp focus as well as giving an outline to the resulting image.

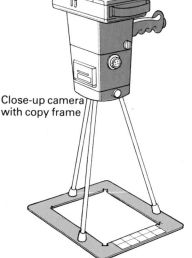

Close-up camera
with copy frame

Multiple-image camera

Multiple-lens cameras are available which produce two or four identical images on the same piece of instant picture film. The lenses have fixed focus and you can adjust both aperture and shutter speed. The camera has a pistol grip and you can also attach it to a tripod. It is ideal for miniature portraits for use on passports and identification cards.

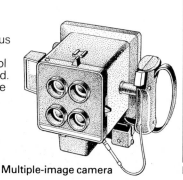

Multiple-image camera

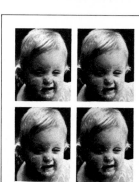

Multiple image

Special cameras

There are some types of photography which are much easier with a special-purpose camera. Several types of camera are available for taking discreet pictures unobserved. Reflex and direct vision subminiature cameras, and models which incorporate a pair of binoculars, are particularly useful for this.

For panoramic shots, a rotating camera is ideal. A model is now available which turns through 360°. Industrial and scientific photographers use high-speed cameras for analyzing objects which move very rapidly. Some of these cameras have also been used successfully by sports photographers. To produce 3D prints which you can look at without the aid of a stereo viewer, manufacturers have developed a special printing system and paper, and a four-lens camera. Attachments are also available for taking stereo pictures with an ordinary camera, but you require a 3D viewer to look at them. Special cameras are also made for aerial and underwater photography.

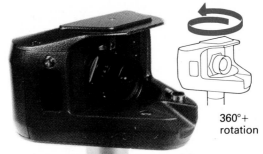

360°+ rotation

Rotating camera

Rotating camera
The model above allows you to shoot panoramic pictures by turning the camera through a full circle. A motor turns the camera body on a central axis, above right. It is also possible to rotate the camera through more than 360°, to allow for trimming.

Subminiature camera

These small cameras produce 8 mm × 11 mm negatives or slides. The tiny TLR model, below, has a framefinder for quick viewing. Some models have an external exposure meter. The direct vision camera, bottom, features a wide ½-1/1000 sec shutter speed range.

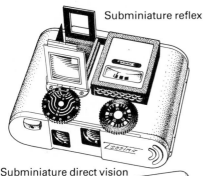

Subminiature reflex

Subminiature direct vision

Binocular cameras

The model below combines binoculars with a fixed focus 110 camera. It offers a limited range of aperture and shutter speed settings. Some models have interchangeable lenses.

Binocular camera

Candid shots
The disguised function of the camera, left, makes it ideal for candid shots.

Compact bellows camera

This compact 6 cm × 7 cm camera offers a built-in bellows for close-up work and a 1-1/500 sec shutter speed range. It has a high definition 80 mm f2.8 lens and split-image focusing.

Compact 6 cm × 7 cm camera

Picture quality
The subminiature cameras above have a wide range of adjustments and good lenses. They use very small film, but can produce enlargements of reasonable quality.

Stereo cameras

At the moment there is no true stereo camera on the market which will produce 3D effects on conventional photographic materials, though you may be able to obtain a secondhand three-lens camera, right, below. One maker plans to launch a four-lens stereo camera, right, quite soon. This creates pictures which you can look at without the aid of a special viewer. Its lenses take four separate pictures of the subject, and the printing process combines these to produce a 3D image. You can also take stereo pictures on a 35 mm SLR, using an adaptor which fits in front of the standard lens. It produces a pair of images on the film. With this method you require a stereo viewer. With the stereo slide, below, you can take two pictures, which you combine and look at through a special viewer.

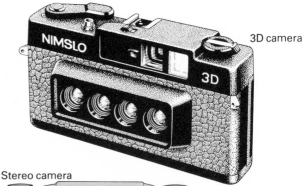

3D camera

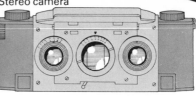

Stereo camera

Stereo slide

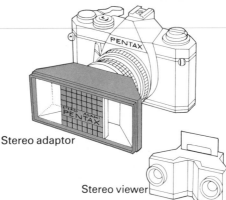

Stereo adaptor

Stereo viewer

High-speed camera

Built to order, the expensive camera below can shoot at a very high speed. It can produce sharp images at a rate of up to 65 exposures per second, capturing the movement of objects which travel very rapidly. This is useful in ballistic and industrial photography. The camera has its own range of accessories.

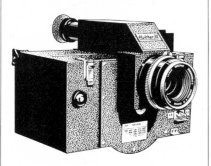

Multiple image cameras

These cameras produce two or four identical images of the subject from one shot. On the model below, four matched lenses fitted to a lens panel project four images onto the film. The interchangeable back allows you to change film easily and accepts both cut and instant picture film.

Interchangeable lenses
The lenses above give you two or four images per frame.

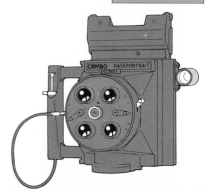

Underwater cameras

Purpose-built cameras for underwater use like the model, right, have their own system of lenses and accessories. Flash is essential for this kind of work. Several camera makers offer waterproof housings with external controls for their cameras. Housings, below, are made for both 35 mm and medium format models. Whether you use a special camera or a housing, do not take your camera deeper than the manufacturer recommends. Most housings are guaranteed to around 330 ft (100 m).

Flash head

Flash sensor

Batteries

Camera

Sensor lead

Bracket

Synch lead

SLR housing with flash bracket

Medium format housing

TLR housing

SLR housing

Aerial cameras

A 35 mm or 2¼ ins × 2¼ ins camera will give reasonable aerial shots, even helmet-mounted, right. But a special camera, below, is best, while Government surplus models are also useful. Shutter speeds of up to 1/2000 sec and high-resolution long lenses are indispensable.

Motor drive

Optical sight

Battery pack

Release

Aerial camera

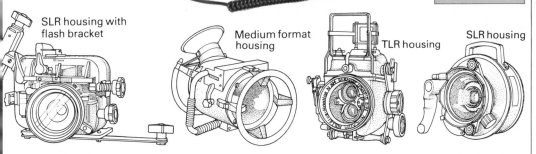

Camera attachments

SLR manufacturers produce a variety of attachments to make their cameras more versatile. Viewing aids include interchangeable focusing screens, heads, and eyepiece accessories designed to help you focus in a variety of situations. Top quality screens are made of ground glass, less expensive ones of plastic. They should give an image quality which matches that of the lens. Interchangeable viewing heads are also available.

Motor drives and autowinders make rapid shooting easy, and bulk film backs give you a generous supply of film for continuous motor drive shooting. Other film backs enable you to imprint data on the film edge for future reference. There is also a range of camera attachments for close-up and macrophotography. These include sets of extension tubes and bellows units which enable you to focus at very close subject distances. Other attachments help you keep the camera steady for hand-held shooting, or for copying. These attachments are made by both system and specialist manufacturers.

Focusing screens

Choose one screen for general photography, others for more specialized work. A matte outfield with a split-field aid (horizontal or diagonal) is most useful, but many other designs are available. Make sure that your camera system offers the screens you require. A screen should give a clarity of view which matches the quality of your lens. Ground glass is the best material; plastic is a cheaper alternative.

Removing screens
Take off the head and unfasten the retaining clips. Slide out the screen and place it in a protective envelope. Remove screens carefully and handle them at the edges only.

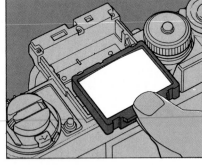

1

2

3

4

5

6

7

8

9

10

11

12

13

14

Focusing screen range

Some manufacturers provide a range of viewing screens. Designs cover all types of photography. Type 1, with split field and microprism center, is often fitted as standard, and types 9 and 10 are also useful in general photography. The diagonal split-field aid of type 10 suits scenes with strong horizontals. Type 2, for quick focusing, has a split-field aid, but lacks a microprism collar. The clear central area of type 3 suits lenses of small maximum aperture. The empty field of type 5 is ideal for use with long lenses. Screens with grids, like types 6 and 13, are helpful in architectural photography and copying, while type 12 provides less obtrusive guide lines for careful composition. Types 7 and 8 have generous areas of microprism, ideal for subjects in low light. Type 14 is for shooting stills for TV. For photomicrography, close-up, or high magnifications, use a screen like types 4 and 11, with central cross hairs.

Interchangeable heads

Most good camera systems offer a range of viewing heads. The waist-level type makes viewing easier for low-level shots. You can also hold it above your head to shoot over an obstruction. A high-magnification head enlarges the image, for more precise focusing. The speed finder allows you to switch quickly from eye-level to waist-level viewing. You can also buy booster and photomic heads which extend the camera's metering range, allowing you to use the TTL meter in low light.

Mounting heads
When mounting and removing heads, take care not to damage the ground glass screen. Slide the head in, right, and make sure it is held securely by the retaining catch.

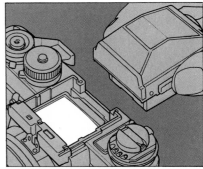

Booster head

Magnifying head

Photomic head

Speed finder

Waist-level finder

BUYER'S GUIDE

Names to look for
(Price range C-E; booster heads F-G)
**Canon, Minolta, Pentax
***Nikon, Olympus

Points to look for
- Ease of removal and attachment
- High-magnification type (most useful for general and specialist focusing)
- Meter booster plus correct screen (best for low light)
- Image brightness
- Flip-up magnifier (should accompany waist-level finder)
- Full-frame coverage
- Use of TTL meter possible
- Versatility (if buying only one extra head)

Eyepieces

If you wear glasses focusing can be a problem as they touch the rear of the camera and can mist up at the vital moment. Special eyepieces are available to help you avoid this. You can buy a dioptric correction lens, below right, from your camera manufacturer, or your optician can make one up to suit your vision. Eyepiece magnifiers, below left, are also available for use in close-up photography.

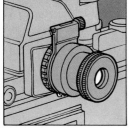

Eyepiece magnifier

Correction lenses

Right-angle viewer
With a waist-level finder, backlight can make focusing difficult. Some manufacturers offer a 90° viewer, above, for low-angle shots, which solves this problem. Some 90° finders also incorporate a magnifier.

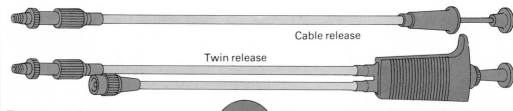

Cable release

Twin release

Exposure releases

With slow shutter speeds and when using a tripod, fire the shutter with an exposure release to avoid camera shake. A lockable cable, far right, is useful for very long exposures. For macro-photography use the double release, above, to control both aperture and shutter. The long pneumatic release, right, is useful for firing the shutter from greater distances. A soft release helps prevent camera shake; some designs accept a cable release.

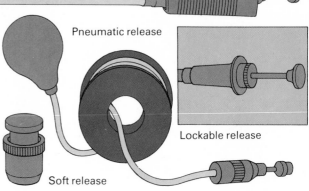

Pneumatic release

Lockable release

Soft release

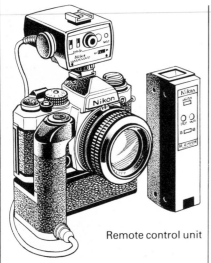

Remote control unit

Remote control

With a remote control unit coupled to a motor drive, above, you can fire the shutter from a distance. The control unit sends a radio signal to a sensor on the camera which triggers the shutter. The intervalometer, below, fires the shutter at regular pre-set intervals.

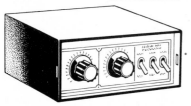

Intervalometer

Hand grips

Where a tripod would be inconvenient you can use a clamp or hand grip to hold your camera steady. The pistol grip, below, fits the hand well and has a trigger shutter release. With long lenses, a rifle grip, bottom, helps you take well-focused hand-held pictures.

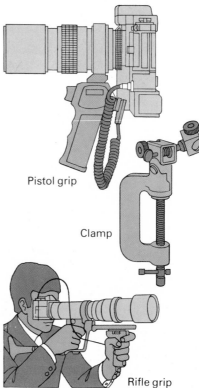

Pistol grip

Clamp

Rifle grip

Motor drives

The motor drive, right, can fire the shutter and wind on automatically, so you can take action sequences like the one below. The firing rate is normally between one and five frames per second, although some models offer six. The autowinder, below, gives between one and three.

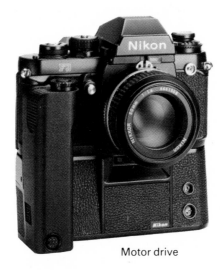

Motor drive

Autowinder

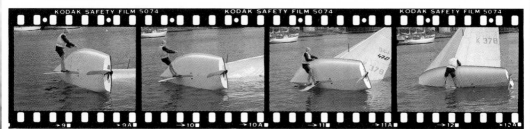

Camera backs

Some interchangeable backs, far right, allow you to print data on the film when taking a picture. You can record date, time, or exposure settings in this way. Bulk film backs, below, are invaluable if you take a lot of pictures with a motor drive. Some systems offer a 250-exposure back, and a few provide a back giving 750 exposures.

Date recorder

Time recorder

Data back

Bulk film back

Copying and close-up equipment

Most 35mm systems include accessories for close-up work. With a coupling ring you can reverse your standard lens for close focusing, but you may lose the automatic aperture facility. For high quality work, use a special macro lens (p. 77). For larger magnifications your lens must usually be nearer to the subject than the film. For this, use a set of extension tubes, or folding bellows. Extension tubes can give magnifications just above life size. Bellows allow magnifications of × 3 and greater, but with some you lose coupled metering. If you have a bellows it is easy to convert it to a slide copier. Copying equipment, including stands and tables, is also available.

Extension tubes and bellows

Extension tubes are available in sets of three and five, right. Bellows provide a similar function, but allow more flexible adjustment. Basic bellows are cheap and give magnifications up to × 4, but they allow movement of the lens panel only. Auto bellows enable you to move the camera as well, for easier focusing. They also have an automatic diaphragm facility, so you do not have to use a double cable release to control the lens aperture. Use a tripod in all cases.

Extension tubes

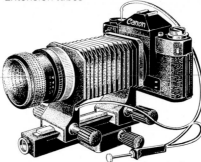

Auto bellows

Basic bellows

Bellows
A basic bellows, far left, allows only limited adjustment of focus. An auto bellows, above, allows you to move lens and camera independently. A focus rail aids fine focusing.

Copying equipment

Slide copiers are available in a number of sizes so you can copy different formats on 35 mm film. Some have an extension tube and you attach others to a bellows unit. Copying stands enable you to reproduce flat prints. Instant-picture copiers are also available.

Copy table

Tube copier

Bellows copier

Professional copiers

Lenses
standard/fisheye/wide-angle/long/zoom/ medium and large format

A camera lens redirects light rays coming from the subject so that they form an image on the film. A lens is made up of one or more glass (or plastic) elements. These can either have a converging or diverging effect on the light rays. Converging (convex) elements produce a poor image on their own, and lens manufacturers compensate for this by including weaker diverging (concave) elements. These extra elements improve the image quality, but increase the cost of the lens. However, too many elements can reduce lens performance, because they absorb some of the incoming light. Transparent coating, or "blooming", aids the passage of light. It also helps reduce "flare" (the result of reflected light being scattered in the lens) and improves contrast. But the quality of much modern glass makes blooming less necessary.

Types of lens
There are three main types of camera lens. Small 110s and some 35 mm direct vision cameras have one or two-element lenses which are fixed to the camera body and allow no focus adjustment. Many 35 mm direct vision cameras have fixed lenses of two or more elements, which you can focus between about 3 ft (1 m) and infinity. Some also allow limited aperture adjustment. 35mm and medium format SLRs usually have interchangeable multi-element lenses focusable

Single and multi-element lenses
The principles of the single- and multi-element lenses, below, are the same. But a greater number of elements corrects aberrations in the lens, improving quality.

from about 1 ft (0.3 m) to infinity, with a broad aperture range. Some of these lenses have wide maximum apertures, letting in a large amount of light. This makes focusing easier in low light, and allows you to use faster shutter speeds in dim conditions. But this feature can be costly.

Focal length
Lenses are designated by their focal length. The focal length is equivalent to the distance from the rear lens element to the film plane when the lens is focused on infinity. The focal length of a standard lens differs according to the format for which it is designed. This kind of lens produces a view of the subject similar to that of the human eye. Many photographers buy their camera with a standard lens. Additional lenses give your photography greater breadth, enabling you to shoot in a variety of situations. A telephoto lens makes the subject appear large and has a narrow angle of view. These qualities allow you to shoot distant subjects, or to select the important element in a confused scene. Catadioptric, or mirror, lenses compress the long barrel of the telephoto into a shorter length, for easier handling. A wide-angle lens allows you to include more in the frame than you can with a standard lens. Use one where space is restricted, or where you want to make perspective more dramatic. A zoom lens provides the convenience of a range of focal lengths in one barrel, allowing easy control of image size, perspective, and depth of field. If you want to extend your photography still further, a range of specialized lenses is also available, including macro lenses for close-up work.

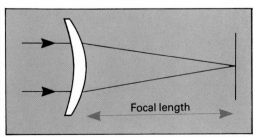

Single-element lens

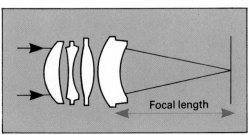

Multi-element lens

How a lens works

A camera lens collects the light rays from the subject and brings them together to form a sharp image on the film. The image formed in this way, below, is inverted and reversed left to right. You can observe this effect with some medium and large format cameras, but most others show a corrected image in the viewfinder. All lenses are described by their focal length: the distance between the rear of the lens and the focal plane.

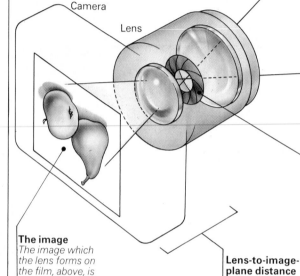

Camera

Lens

Subject

Aperture
Use the maximum aperture setting to focus, the minimum for the greatest zone of sharpness.

The image
The image which the lens forms on the film, above, is inverted and reversed left to right.

Lens-to-image-plane distance
With the lens set at infinity, this distance equals the focal length. Set for a near subject, above, the distance is usually shorter, so you must adjust the lens to focus.

Effect of aperture

At maximum aperture the image is bright, but depth of field (the zone of sharp focus) is at its shallowest. You should use this setting for focusing. Many lenses allow you to focus at the largest aperture, and then stop down automatically to the setting you require. Stopping down to minimum aperture improves depth of field. But because the aperture is very small, diffraction can occur, making contrast and definition poorer. A setting slightly above the minimum gives an image that looks sharper, with little loss of depth of field

Sharpness

Two factors control lens quality and image sharpness. These are the ability of the lens to show fine detail and its power to produce good image contrast. A lens must work well in both these areas if it is to produce an acceptably sharp image on the film. Some cheaper lenses produce uneven sharpness. The pictures, right, show how a lens can give acceptable sharpness in the center of the frame, but produce an image which is blurred at the edges. This effect is especially noticeable when you use large magnifications, as shown in the details, far right.

Edge of frame

Center frame

Depth of field

Depth of field is the distance between the nearest and furthest points in the subject that the lens renders as an acceptably sharp image. This distance varies according to the aperture you set. At large apertures, depth of field is very small, right. As you stop the lens down, depth of field increases, right center, until it reaches its maximum, far right, at the smallest aperture of this lens.

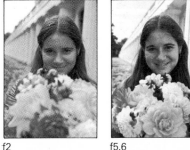
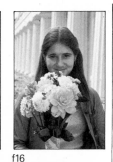

f2 f5.6 f16

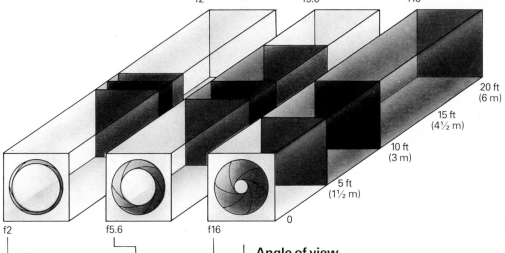

20 ft (6 m)
15 ft (4½ m)
10 ft (3 m)
5 ft (1½ m)
0

f2 f5.6 f16

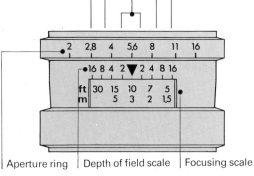

Aperture ring | Depth of field scale | Focusing scale

Depth of field scale

If you cannot view the image through the lens, use the depth of field scale on the barrel. This is calibrated in f stops, above. You first set focus and aperture. Then read off the distances on the focusing scale aligned with the aperture you have set. The two figures represent the nearest and furthest points which will be sharp in the picture.

Angle of view

The angle of view is the largest angle between two rays of light which will pass through the lens and form an acceptable image within a particular film format. Angle of view increases as focal length decreases, below.

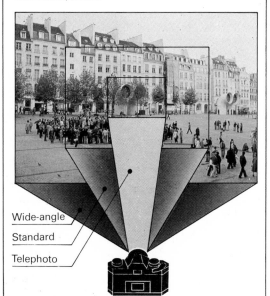

Wide-angle
Standard
Telephoto

57

Standard for 35 mm

By the strict definition of the term, a standard lens for the 35mm format has a focal length equivalent to the diagonal of 35mm film. This measurement is 50mm, and most SLR lens manufacturers make at least one lens of this length. Other focal lengths, such as 55mm and 58mm, are commonly described as standard, and lenses of 38mm and 40mm are standard for 35mm direct vision cameras. These slight differences have little effect on the image, although the shorter focal length on direct vision cameras may give a slightly wider view than SLR standard lenses. Lens speed varies considerably though, with maximum apertures ranging between f3.5 and f1.2. (Minimum aperture varies from f16 to f22.) Standard lenses are relatively cheap, give good image quality, and their large maximum apertures are useful in low light. Modern standard lenses have improved close focusing – look for a minimum focusing distance of at most 1½ ft (0.5m).

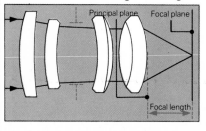

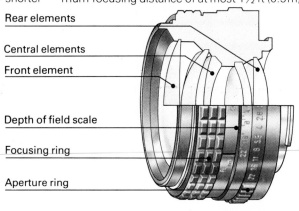

Rear elements

Central elements

Front element

Standard lens construction
Most modern standard lenses have a balanced combination of converging and diverging elements, giving large apertures and good image contrast. This compound structure, and high quality glass, minimize aberrations.

Depth of field scale

Focusing ring

Aperture ring

Angle of view
A standard lens gives you an angle of view which is roughly the same as that of normal human vision. The typical 50 mm lens, below, with an angle of view of 38°, produces an image which appears similar in size to the subject. This natural perspective makes the standard lens the most popular and versatile for general photography.

38°

Lens speed
You can buy standard lenses in a range of maximum apertures, from f3.5 down to f1.2. The wider the maximum aperture, the "faster" the lens. A fast lens is useful for taking hand-held pictures in low light, right. Because you can use a relatively fast shutter speed, you avoid the blur caused by camera shake. With a fast lens, you can also use a high shutter speed to freeze action.

Depth of field
You can obtain a wide depth of field range with a standard lens. At maximum aperture, it allows selective focus like a long lens, while at minimum aperture it will give you an extensive depth of field approaching that offered by some slightly wide-angle lenses.

m	0.6		0.8		1		1.3	2	2.5	4	8	
ft	2		2.5			3.5		5	7	10	20	∞
	16	11	8	4			4	8	11	16		

Depth of field scale
A scale, above, marked in f stops, shows how far depth of field extends in front of and behind the focused subject, so that you can choose the right aperture.

Low light

Fisheye for 35 mm

With focal lengths ranging from 18mm to 6mm, fisheye lenses give a very broad angle of view. Imposing a fisheye's wide vision on 35mm film results in a dramatic rounding of the image. This distortion increases as focal length decreases. With depth of field extending from a few inches to infinity you do not have to focus. Some fisheyes have normal aperture controls, while others use a group of built-in neutral density filters to regulate incoming light. You operate these with a regular aperture ring. Some have a range of integral filters which includes primary colors and ultraviolet. Fisheyes are specialized lenses, and their narrow range of applications and high cost make it preferable, even for professionals, to rent rather than buy them.

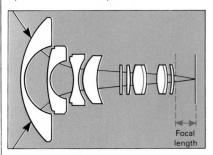

Focal length

Fisheye principle
The front elements of the lens refract the light into a cone. Then the convex rear elements form it into the characteristic rounded image. The maximum aperture of a fisheye lens is normally f2.8.

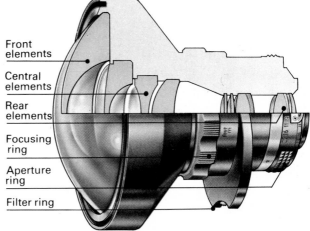

Front elements

Central elements

Rear elements

Focusing ring

Aperture ring

Filter ring

Angle of view
The fisheye's most striking feature is its angle of view. An 18 mm lens gives an angle of view of about 100°, while a 6 mm lens gives an impressive 220°. Take care not to include part of yourself in the picture! With short focal lengths the image is circular, but with 15 mm-18 mm fisheye lenses it fills the rectangular 35 mm format.

6 mm fisheye lens
The expensive 6 mm fisheye, left, with its panoramic 220° angle of view, has a strong, threaded bracket so that you can mount it on a tripod. A lens of this weight makes a sturdy tripod indispensable. Complete with a range of built-in color and skylight filters, it costs at least ten times as much as the camera it is attached to.

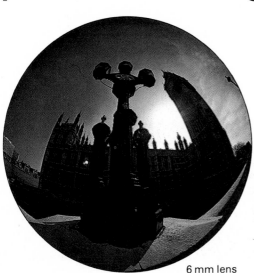

180°

220°

6 mm lens 17 mm lens

Wide-angle for 35 mm

All lenses with a focal length shorter than standard – around 50mm for the 35mm format – are, strictly speaking, wide-angle lenses. In practice the term applies only to lenses with focal lengths between 35mm and 15mm. There exists a group of lenses between 6mm and 17mm with a different construction from that of wide-angles. These are known as "fisheye" lenses. Lenses between 35mm and 50mm have little wide-angle effect.

A wide-angle lens allows you to frame a wider scene than you could with a standard lens from the same viewpoint. With a 35mm lens this difference is already apparent, and the angle of view widens progressively as focal length decreases. Where wide-angle focal lengths overlap with fisheye – at around 15mm – the effect is most marked. A wide angle of view allows you to shoot at close range, and in confined spaces, encompassing scenes that are beyond the scope of a standard lens. Another prime effect of a wide-angle lens is to increase depth of field, so that you can create pictures with a substantial amount of sharp foreground. At the same time the lens increases the apparent difference between foreground and background. This means that close subjects appear detached from their context and are brought into prominence. Exploit these effects to dramatize landscapes, or to make a portrait stand out against a natural background, and to take in a wide range of details in indoor shots. You can also frame broad architectural scenes, but be aware of the problem of converging verticals.

A wide-angle lens is an ideal first addition to your basic kit of camera and standard lens. Buy the best you can afford. Many wide-angles distort the image slightly, and this effect increases as focal length and price decrease. Cheap wide-angles lack the corrective elements to adequately counter these faults. Choose a 28mm or 24mm lens for versatility at reasonable cost.

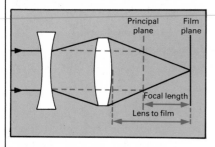

Wide-angle (retrofocus) construction
Diverging front and converging rear elements give a lens-film distance greater than focal length. This accommodates the SLR's mirror, shutter, and meter cells.

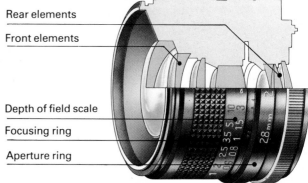

Rear elements

Front elements

Depth of field scale

Focusing ring

Aperture ring

Angle of view

A wide-angle lens has a focal length shorter than the diagonal of the film with which it is used. (A 50 mm lens, standard for 35 mm film, has a focal length equal to the format's diagonal.) This shortening of focal length increases the lens angle of view. With a 35 mm lens you have an angle of view of around 62°, while with a 15 mm lens it may be as much as 110°.

Effect of short focal length

The diagram compares the angle of view of a standard lens with those of wide-angle lenses. The standard gives you an angle of view of 46°. The 35 mm lens gives 62°, the 24 mm 84°, and the 15 mm 110°.

50 mm

35 mm

24 mm

15 mm

Depth of field

Given the same subject distance and aperture, a wide-angle lens provides far greater depth of field than a standard lens. The widest – 15 mm and 17 mm – allow you to shoot at f5.6 or f8 without focusing. You can use fast shutter speeds with these apertures, so avoiding the effects of camera shake but retaining a good depth of field.

Depth of field

The photograph below was shot with a wide angle lens set at a small aperture, to give extensive depth of field. The bold striping on the chairs is clear to the back of the picture.

Picture quality

With a cheap lens you risk loss of image contrast (below), fall-off of illumination, and distortion of elliptical shapes near the frame's edge. Buy from your camera's system or from a manufacturer with a range of wide-angle lenses.

Extensive depth of field

Image contrast

Perspective

The close viewpoint you obtain with a wide-angle emphasizes foreground and exaggerates lines converging toward the horizon. With a 35 mm lens the effects are marked only if there is an angular object in the foreground or lines converge strongly. A 24 mm lens increases apparent depth and emphasizes vanishing lines. Both effects are clear when you use the extra wide 15 mm and 17 mm lenses.

Linear perspective

Converging verticals

61

Telephoto for 35 mm

Telephoto lenses have focal lengths from about 85 mm to 1200 mm. They make distant subjects appear near and sharp, allowing you to fill the frame from far away. Depth of field and angle of view are far less than those of a standard lens. Telephoto lenses are sometimes long and heavy and can be difficult to hold steady. This makes blur a common fault on hand-held shots. To avoid blur, use a fast shutter speed where possible. Try to match shutter speed to focal length. For example, select speeds of 1/250 sec, or faster, when you are using a 250 mm lens.

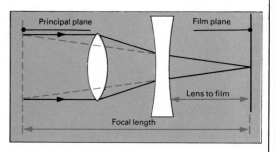

Telephoto principle
The telephoto design allows for a short lens barrel. The front elements of the lens make the incoming light rays converge. The rear elements make them diverge, bringing the image to a sharp focus.

Front elements

Central elements

Rear elements

Depth of field scale

Aperture ring

Focusing ring

Angle of view

The narrow angle of view of a telephoto lens allows you to compose a picture from a small area of what the naked eye sees. The diagram below shows the difference in angle of view between a standard lens and a range of telephotos. The 50 mm lens gives you a 46° view, while the shortest telephoto, the popular 85 mm, reduces the angle to 28°30′. Lenses of 1000 mm and 1200 mm give you angles of view of 2°30′ and 2°, respectively. They are expensive and it is best to rent them.

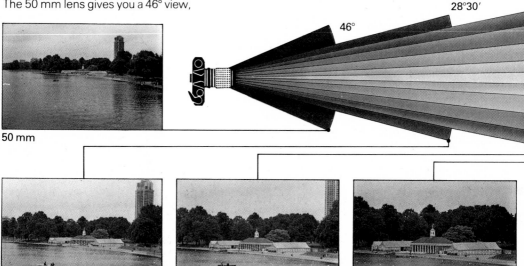

50 mm

85 mm

105 mm

135 mm

Magnification

The greater the focal length, the larger the image. If, from the same viewpoint, you shoot a scene using a 50 mm lens and a 1000 mm, the telephoto will give a magnification twenty times greater than that of the standard lens. A rough guide to magnification (where 50 mm length is standard) is to divide the focal length by 50. On this basis, a 135 mm lens gives a ×2.7 magnification, while a 1000 mm gives you ×20. Loss of image contrast is invariably a side effect of high magnification.

135 mm 50 mm 500 mm

Depth of field

In general, depth of field decreases as focal length increases. With short telephotos it is easier to focus selectively than with standard lenses. But with longer telephotos some of this effect is lost since both maximum aperture and minimum focusing distance decrease.

If your subject is in motion or you change viewpoints, you must refocus accurately. With lenses longer than 250 mm, depth of field is so limited that you can easily lose focus.

Depth of field range
The difference between the depth of field offered by a standard 50 mm lens and by a long lens is already apparent at 85 mm. The effect increases with focal length and at 1000 mm is very marked.

50 mm

85 mm 135 mm 400 mm 1000 mm

23°20′ 18° 12°20′ 6°10′ 2°30′

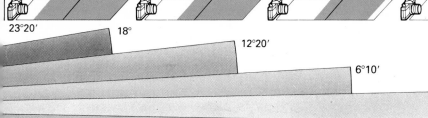

200 mm 400 mm 1000 mm

Perspective

Telephoto lenses enlarge distant elements of a scene, so that you can frame subjects which seem insignificant to the naked eye. In so doing, they also flatten linear perspective, appearing to compress foreground, midground and background. This effect increases with focal length, and can be dramatic, allowing you to amass details from different depths of a scene. It also reduces tonal contrast.

Aerial and linear perspective

The landscape, right, shows how a telephoto lens reduces tonal contrast. The series below shows how the compression of planes increases as you increase focal length and distance from the subject.

| 50 mm | 85 mm | 250 mm | 500 mm |

The telephoto range

The most popular lengths are 85 mm-250 mm. At 500 mm and longer, lenses of reflex design, see facing page, offer a more compact alternative. You can buy inexpensive lenses up to 250 mm, but check quality at longer lengths. Minimum focusing distance increases with focal length. It may be as much as 100 ft (30.5 m) at 1000 mm. Weight also increases (though less with some makes than with others), so that steadying the camera requires a tripod.

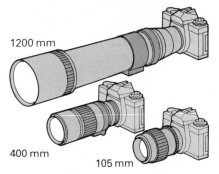

1200 mm

400 mm

105 mm

Choosing a telephoto lens

The table, right, gives the specifications you should consider when choosing a telephoto. The information relates to selected telephotos from two top makers. Intermediate focal lengths are also available. The range of telephotos varies widely from one manufacturer to another.

Focal length	Angle of view	Minimum aperture	Minimum focus	Construction (Groups-Elements)	Weight
85 mm	28°30′	f22	3 ft (0.85 m)	5-5	11 oz (310 gms)
105 mm	23°20′	f22	3½ ft (1 m)	4-5	15.3 oz (435 gms)
135 mm	18°	f32	4½ ft (1.3 m)	4-5	15.2 oz (430 gms)
200 mm	12°20′	f32	7 ft (2 m)	5-5	18.7 oz (530 gms)
400 mm	6°10′	f32	16 ft (5 m)	3-5	49.5 oz (1,400 gms)
1200 mm	2°	f64	150 ft (45 m)	4-5	215.5 oz (6,100 gms)

Catadioptric for 35 mm

Catadioptric (or reflex or "mirror") lenses use a combination of normal lens elements and mirrors to produce focal lengths between 250mm and 2000mm in a short lens barrel. Their effect is similar to that of telephotos, but their construction often causes a loss of central definition and a reduction in image contrast. Catadioptric lenses are lighter and therefore easier to hold steady than many telephoto lenses of equivalent focal length, so a tripod is not essential. A variable aperture of the diaphragm type is unsuitable for a catadioptric barrel, so you use a range of built-in neutral density filters to regulate incoming light. A normally marked aperture ring allows you to select the filter you want. The optical quality of some catadioptric lenses is good enough for them to be useful as telescopes. You can adapt them by adding a special eyepiece.

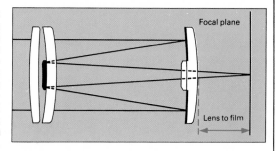

Catadioptric lenses
Light passes through the front element and strikes a rear mirror. This reflects it on to a frontal mirror, which sends it through the rear elements. Here the image is brought to a sharp focus. This "folding" of light gives very long focal lengths in a short lens barrel.

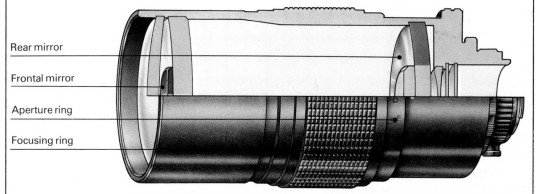

Rear mirror

Frontal mirror

Aperture ring

Focusing ring

Catadioptrics for action shots
Telephoto lenses longer than 250 mm are often unwieldy and may lead to camera shake. Compact catadioptric lenses are lighter than telephotos. Easier to handle, they are ideal for long-distance action photography, and particularly suitable for panning.

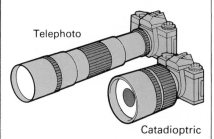

Telephoto

Catadioptric

Comparative weight
The two 500 mm lenses above, from the same manufacturer, show the striking difference in size between telephoto and catadioptric lenses. The telephoto, left, weighs 5 lbs 13½ ozs (2,650 gms). The catadioptric lens weighs only 1 lb 10 ozs (740 gms).

Picture quality
The multiple reflection of light by a catadioptric lens gives a duller image than you obtain with a telephoto. Another difference is the effect on out-of-focus areas, particularly if these are bright highlights. Catadioptric lenses cause ring-shaped distortion, above, while telephotos create pale disks.

Zoom for 35 mm

Zoom lenses, with their variable focal length, can each do the work of several conventional 35mm SLR lenses. They cover the wide-angle, standard, or telephoto ranges, with a few extending from slightly wide to short telephoto. Some zooms also have a macro (pp.68-9) facility. The change in focal length is continuous with all zooms, so that you can adjust angle of view and image size as you wish. You alter the focal length with either a turn or slide control. Zooms allow you to carry fewer lenses. In addition, they make it easier to achieve precise framing without changing your viewpoint. But picture quality is frequently poorer than that of lenses of fixed focal length. Autofocus zooms are soon to become available.

Zoom principle
Movable elements in the lens vary their position as you adjust the zoom control, to alter.focal length. Focus is held throughout the zoom – the subject remains sharp.

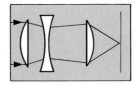

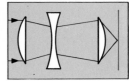
Wide-angle

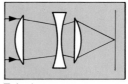
Telephoto

Standard

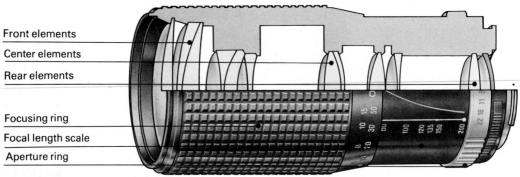

Front elements

Center elements

Rear elements

Focusing ring

Focal length scale

Aperture ring

Wide-angle
Most wide-angle zooms cover a focal length range between 24mm and 35mm. The more you pay the greater the range. These focal lengths give angles of view between 84° and 63° (right and below). With a lens of this kind you can cover a variety of subjects. A wide angle of view is very useful for landscapes and confined interiors.

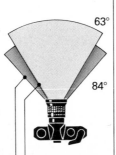
63°

84°

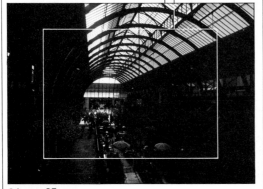
24 mm-35 mm

Standard
Standard zooms have focal lengths ranging from slightly wider than 50 mm to short telephoto. The range is normally between about 43 mm and 85 mm, with angles of view from 53° down to 28°. They allow wide framing with reasonable picture quality at one end of the range, and give a useful short telephoto effect at the other.

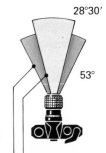
28°30'

53°

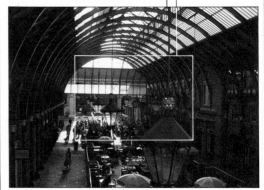
43 mm-86 mm

Tele

A telephoto zoom lens can provide all the long focal length effects you will require, and one of these versatile lenses is probably the best choice for your first zoom. A lens ranging from 85 mm to 250 mm or 300 mm is ideal. It allows you to fill the frame from a distant viewpoint and to tackle a wide range of subjects. Among these are portraits (85 mm-105 mm), candid shots (85 mm-135 mm), and wildlife photography (200 mm-300 mm). Very long zooms, starting around 300 mm, and extending to 1200 mm, are also available, but are not so often used as the shorter lenses. Telephoto zooms vary considerably in price.

8°15'
28°30'

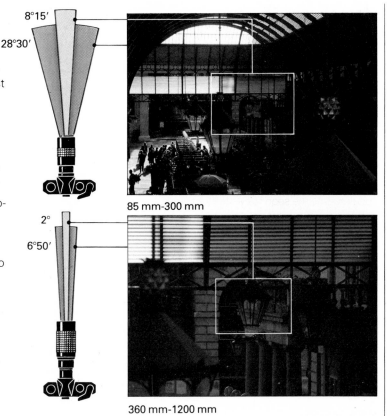

85 mm-300 mm

2°
6°50'

360 mm-1200 mm

Telephoto range
Telephoto zoom lenses give you an impressive choice of focal lengths. This allows you to fill the frame at considerable distances from the subject. The angle of view of tele zooms is very selective, right.

Uses

As well as giving a range of focal lengths, zooms can create unusual visual effects. Zooming the lens during exposure and altering the focus while zooming can create interesting effects. You can obtain the streaked quality, right, by combining zooming with a panning motion. Tilting the camera while zooming can give striking variations on this effect.

Zoom lens range
The selection of zoom lenses below comprises some of the most useful focal lengths.

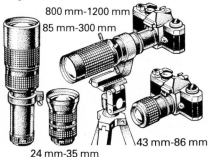

800 mm-1200 mm
85 mm-300 mm

24 mm-35 mm
43 mm-86 mm

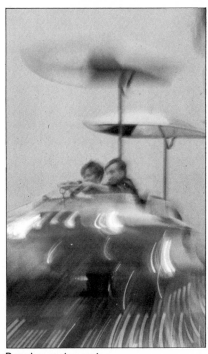

Panning and zooming

Macro for 35 mm

Macro lenses are designed to produce fine quality close-up pictures. You can use them for normal photography but they give their best results at very close focusing distances. A 50 mm macro attached directly to the camera gives magnifications of up to almost life size. With shorter focal lengths you can work much closer, achieving greater magnification. Focal lengths over 50 mm give less magnification, but allow space between the lens and the subject for lighting, filters, and other accessories. With all lenses, extension tubes and bellows (p.54) increase magnification. Bellows permit fine focusing. Macro lenses offer much better image quality than supplementary close-up or reversed standard lenses. They are corrected for edge-of-field distortion and give good color rendition. As in all close-up photography, the plane of sharp focus is shallow.

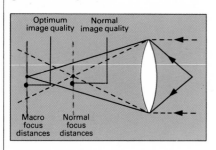

Macro principle
A macro lens will render subjects at any distance, including infinity, acceptably sharp. But it gives best image quality at very close range, focusing much closer than a normal lens of similar focal length.

Front elements

Central elements

Rear elements

Focusing ring

Aperture ring

Magnification

The pictures and chart below show the magnification you can achieve with various combinations of lenses, extension tubes and bellows. Most macro lenses fixed directly to the camera can magnify the image up to ×0.5 or ×0.7. Using extension tubes you can increase this to life size and beyond. With a bellows unit most focal lengths will provide magnifications of between ×3 and ×4, and some will give as much as ×10.

A standard lens with bellows will achieve up to ×3, but image quality is not good. Generally the longer a macro's focal length, the less its magnification power. Very short focal lengths provide high (up to ×20) magnification, and are best used with a bellows. A good compromise between magnification and versatility is provided by the 50 mm macro, which can also double as a standard lens for general photography.

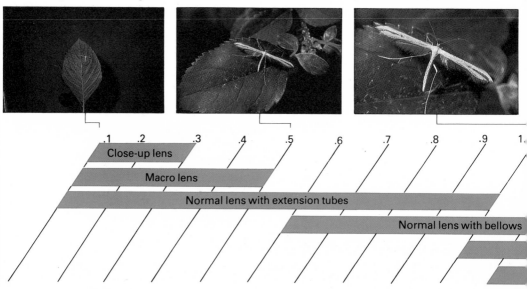

Macro focusing

Focusing is especially important in macro photography. You should ignore the normal focusing scale and the split-image microprism. Use the outer matte area, or, if your camera system provides one, a specially designed macro focusing screen. Select your viewpoint carefully. If you choose a flat subject and square your camera to it, more of the picture is likely to be sharp. A small aperture, for greater depth of field, will produce the best results, below right.

(Compare with large aperture result, below left.) When shooting out of doors, there is always a risk of subject movement. Fast shutter speeds are often essential, bottom left. This can conflict with the need for a small aperture, because the lighting may not be good enough for both. In this case you should use a fast film, together with flash, or ring flash if you are working very close to the subject. A ring flash helps you avoid blur and gives even lighting.

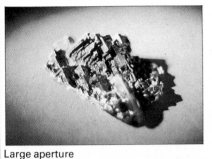

Large aperture

Small aperture

Fast shutter speed

50 mm

35-105 mm

150 mm

Lens range
The 50 mm and 100 mm lenses are most useful, and can also be used in general photography. Zoom lenses with a macro setting do not give such high quality.

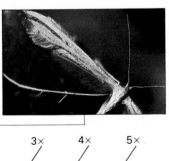

× 3× 4× 5× 6× 7× 8× 9× 10× 20×

Macro lens with bellows

Normal lens with microscope

Standard for medium format

Interchangeable lenses are available for both SLR and TLR medium format cameras, although some TLRs have fixed lenses. These lenses normally have their own built-in leaf shutter, synchronized for expendable and electronic flash. Most offer a good range of shutter speeds from 1 sec to 1/500 sec, plus B or T settings. Lens barrels are marked with aperture, distance, and depth of field scales, and in addition, some include shutter speed settings. Most lenses offer very good contrast and resolution. The lens quality in some SLR systems is excellent. Standard lenses for medium format have a focal length of around 80 mm. Maximum aperture is usually about f2.8, and the lens automatically stop down to give your preselected setting when you release the shutter.

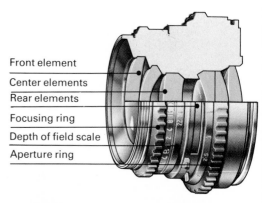

Front element
Center elements
Rear elements
Focusing ring
Depth of field scale
Aperture ring

Types of lens

SLR standard lenses are usually of 80 mm focal length and have a bayonet mount. Some manufacturers offer a 105 mm lens as standard. With more expensive SLRs, you can buy the body with a lens of alternative focal length, if you prefer. Standard lenses for TLRs have focal lengths of 75 mm-80 mm. They are sold in pairs, matched for focal length and angle of view.

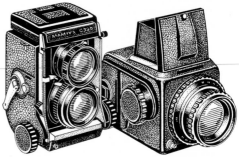

Twin lens reflex Single lens reflex

Angle of view

The angle of view of standard lenses for medium format is about 52°. right. Small differences occur when slightly different focal lengths are offered as standard by various manufacturers. This fluctuation is normally between 50° and 54°, but the 105 mm lens has an angle of view of 37°.

52°

Fitting the lens

Align the SLR lens carefully and make sure it is flush to the camera body. On some models the mirror must be in the down position before you attach the lens. On TLRs ensure that the lens shutter cocking lever connects with the lever on the body. Then fasten the lens catch to hold the lens securely in place.

Fitting SLR lens

Fitting TLR lens

Wide-angle for medium format

On medium format cameras, all lenses with a focal length shorter than 78mm are wide-angle lenses. In practice, manufacturers usually offer a wide-angle range extending from 38mm to 65mm. (Some makers also include a 30 mm fish-eye.) These lenses use the inverted telephoto design to provide a long back focus. This makes space for the upward swing of the SLR's large mirror. Wide angles for medium format have a maximum aperture of about f4, or even f2.8. A wide aperture gives a bright viewing screen, and makes focusing easier in poor light, but the lens is likely to be very costly. Their wide angle of view and good depth of field makes these lenses suitable for landscape photography, and for shots where the subject-to-camera distance is restricted. You must use flash guns and lens hoods which suit the wide angle of view. Most wide angles for medium format are of good quality and the best create minimal edge distortion.

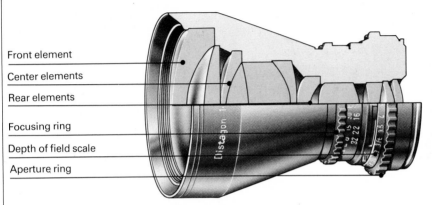

Front element

Center elements

Rear elements

Focusing ring

Depth of field scale

Aperture ring

Angle of view

On SLRs, below, a 30 mm fisheye gives a 180° angle of view. A 40 mm lens gives 88°, and a 50 mm wide angle 75°. On TLRs, bottom, 55 mm and 65 mm lenses give 70.5° and 63°, respectively.

Lens range

The range of focal lengths varies according to manufacturer. The more expensive basic cameras usually have a wider range. One manufacturer offers lengths from 38 mm to 60 mm, plus a 30 mm fisheye. Other ranges provide a choice of 40 mm and 60 mm lenses. The TLR lens range is also restricted to two wide-angle lengths.

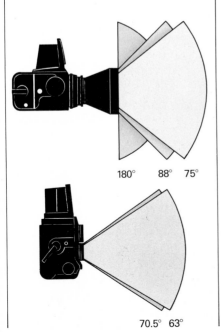

180° 88° 75°

70.5° 63°

55 mm TLR lens

55 mm SLR lens

30 mm fisheye

Telephoto for medium format

Most manufacturers of medium format SLRs provide a range of telephoto lenses with focal lengths between 100mm and 500mm. Maximum aperture may vary from f3.5 to f5.6, making for a noticeable difference in low light. A rather small maximum aperture often accompanies better image quality. Lenses up to 250mm are fairly compact, but longer lenses are bulkier and difficult to hold steady. Use them with a tripod or rifle grip. Lenses in the 300mm to 500mm range are expensive, but are well suited to high quality sports and wildlife photography. The choice of telephotos for TLRs is restricted to the lower end of the range, but quality is also high.

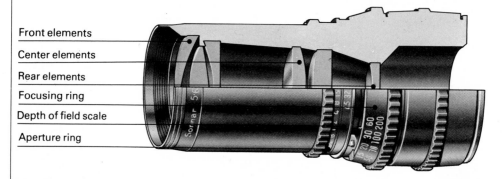

Front elements
Center elements
Rear elements
Focusing ring
Depth of field scale
Aperture ring

Angle of view

The longer the lens, the narrower the angle of view. On SLRs the 150 mm lens has a 30° angle of view; 250 mm and 500 mm give 18° and 9°. On TLRs, 135 mm and 250 mm give 33° and 18°.

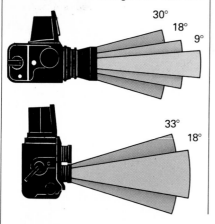

30°
18°
9°

33°
18°

Lens range

Most makers offer a number of telephotos in the 100-250 mm range, usually including 105 mm and 250 mm lengths. Only a few offer lenses between 250 mm and 500 mm.

Basic lens set
For SLRs: 500 mm, top, 250 mm second from top, 150 mm, center left. For TLRs: 135 mm, bottom, 250 mm, center right.

Zoom lenses

Some manufacturers offer zoom lenses in the long focal lengths. Weight and size are greater than those of fixed focal length lenses. The minimum length is 70 mm; some extend up to 250 mm. A zoom lens with a long range, such as 70-200 mm, is a useful and versatile lens. Although expensive, it can replace several conventional lenses.

70 mm-140 mm zoom

Standard for large format

The standard lens for large format (4 ins × 5 ins) cameras has a 150 mm focal length. This gives an angle of view of about 60°. But the angle of coverage is greater, (see below), and this discrepancy allows you to use camera movements (pp. 42-3) to control perspective and depth of field. Most of these lenses have built-in bladed shutters and a maximum aperture of around f5.6. They stop down to f32 or f45. Some standard lenses can be divided to form two lenses – one standard, the other long, below.

Fitting the lens
All large format lenses can be attached to a panel (left) which matches the camera size. A fixed clip at the bottom and a sliding clip at the top hold the panel firmly in place.

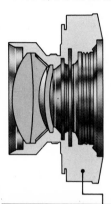
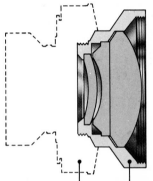

Convertible lens
When you detach the rear section, far left, you have a lens with a focal length up to three times that of the standard lens, left. The quality of the long lens is usually poorer, but it can be useful for soft-focus portraits. Results are compared below.

Long lens Standard lens

Covering power

A lens produces a circular field of light around the film frame, its brightness decreasing toward the edge. The lens' covering power determines the area of this circle over which the lens gives acceptably sharp definition and even illumination. This power depends on the type of lens and the aperture in use, increasing as you stop down. On all but short focal lengths, the angle of coverage is greater than the angle of view (the arc of the scene encompassed within the film format). This means that the usable portion of the light circle is greater than the image area, so that you can benefit from camera movements (pp. 42-3). For minimum illumination fall-off with camera movements, set the smallest suitable aperture.

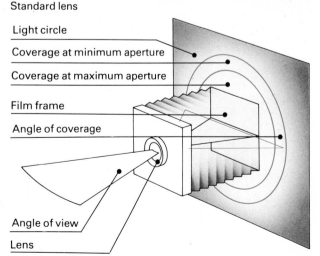

Light circle

Coverage at minimum aperture

Coverage at maximum aperture

Film frame

Angle of coverage

Angle of view

Lens

Wide-angle for large format

A lens shorter than 150mm is a wide-angle for the large format. The most common focal lengths are between 65mm and 90mm. Fall-off in illumination at the edge of the light circle is marked with these wide-angle lenses. This means that the use of camera movements (pp.42-3) is limited. Most of these lenses offer a maximum aperture of f5.6, but some are as fast as f4. A wide aperture helps you focus, particularly in low light, but image quality at the edge of the field is poor unless you stop down to shoot. This kind of lens often performs best at about two stops above minimum aperture. With a wide-angle lens on a monorail you must use a bag bellows (p.42) to provide a short distance between the lens and the camera's focusing screen.

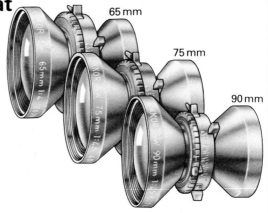

65 mm
75 mm
90 mm

Covering power

The covering power of these wide-angle lenses is less than that of standard lenses. If you use camera movements (pp.42-3), stop well down. Even at minimum aperture, illumination fall-off and loss of definition can occur. The diagrams, right, show the covering power of three wide-angle lenses at maximum and minimum aperture.

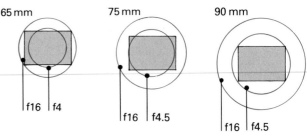

65 mm
f16 | f4

75 mm
f16 | f4.5

90 mm
f16 | f4.5

Picture quality

Large format wide-angle lenses are usually of symmetrical design. This reduces fall-off in illumination at the edge of the light circle, and helps image contrast. Even so, picture quality tends to decrease rapidly toward the edge of the image. Whenever you place the image off-center by using camera movements, check definition.

Loss of picture quality
Image quality is good if you center the film in the light circle, above, left. Camera movements can cause vignetting, above, right.

BUYER'S GUIDE

Names to look for
(Price range G-I)
 **Rodenstock,
 Schneider
***Nikkor, Zeiss

Points to look for
● 65 mm and 75 mm are the most useful focal lengths
● Wide maximum aperture
● Minimum aperture of f45
● Uniform illumination across the field
● Good angle of coverage at wide apertures
● Good image contrast
● Symmetrical construction
● Flatness of field
● Minimal distortion at edge of field
● Bag bellows required on monorail

Distortion

Large format wide-angles often produce distortion at the edge of the light circle. In general, circular shapes tend to become elliptical. They show the effects of barrel, right, or pincushion distortion, far right, depending on the position of the aperture within the lens.

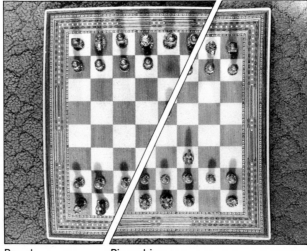

Barrel Pincushion

Long for large format

Long lenses for large format cameras are of tele-photo or symmetrical design. The telephoto type is most suitable for baseboard cameras, where it is difficult to extend bellows (p.54). The symmetrical type is best for monorail cameras or where substantial bellows extension is possible. Telephoto lenses are relatively short and have slightly larger maximum apertures than their symmetrical counterparts. Their focal length rarely exceeds 300mm, while symmetrical lenses offer up to 450mm. For general use a lens of about 250mm is best. The maximum aperture is normally f5.6, the minimum f32 or f45. Covering power increases with focal length, so that long lenses generally allow you to use an extensive range of camera movements (pp. 42-3).

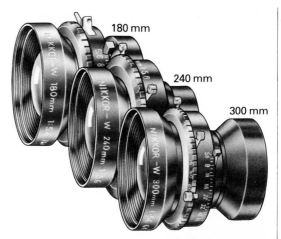

180 mm

240 mm

300 mm

Covering power
The covering power of large format long lenses does not increase substantially between maximum and minimum aperture. But since long lenses produce large image circles, you have more scope than with a wide-angle or standard lens for camera movements.

Picture quality
Large format long lenses have a wide angle of coverage relative to their angle of view. Illumination across the field and definition are normally good. However, image contrast varies and should be a prime consideration when you are choosing a long lens.

BUYER'S GUIDE

Names to look for
(Price range G-I)
**Rodenstock,
 Schneider
***Nikkor, Zeiss

Points to look for
- Telephoto design best for baseboard cameras, symmetrical for monorail
- Good shutter speed range (1 sec- 1/500 preferable)
- Auto opening of shutter
- Synch for M and X flash
- 240 mm best focal length for most uses
- 360 mm a useful good long lens

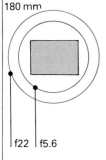

180 mm

f22 f5.6

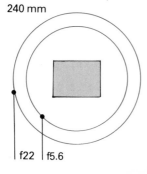

240 mm

f22 f5.6

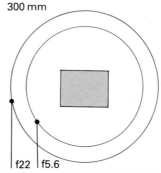

300 mm

f22 f5.6

Soft-focus long lens
A special soft-focus lens, ideal for high quality portraiture, is available in 200 mm, 250 mm, and 300 mm focal lengths. Interchangeable perforated disks control image sharpness. You should focus the lens at the working aperture. Stopping down reduces the soft-focus effect. The picture, right, shows the kind of result you can obtain.

Soft-focus lens

Soft focus effect

Special lenses for 35 mm

In addition to the wide range of lenses which are available for 35 mm cameras, there are a number of lenses designed to provide particular features. More than one manufacturer is developing an autofocus lens. The one illustrated here will allow you to shoot very rapidly with a 35 mm SLR, leaving you free to concentrate on composition. It can focus fast-moving subjects, and so is well-suited to action photography. Focal length choice is limited at present to standard (50 mm). Shift lenses are helpful in 35 mm architectural and landscape photography. They consist of a wide-angle (28-35 mm) lens, which can be racked on its mount to give rising or cross front movements similar to those offered by large format cameras. More specialist lenses are generally very expensive, and best rented unless required for regular professional use. These include very long surveillance lenses used for photographing still, distant subjects, and medical lenses, ideal for close-up work. High-magnification macro lenses provide a less costly aid for the close-up photographer. For wide, panoramic views, there is a camera with a special high-quality lens which rotates during exposure.

Autofocus lens

The prototype autofocus 50 mm f2 lens, right, will fit a wide range of SLR cameras. It will focus automatically from 3 ft (1 m) to infinity. Manual focusing is possible for shorter distances. The auto-focus mechanism will respond instantly to focus the subject, even when you are aiming the camera. The mechanism is battery powered and you can turn it on and off easily with a switch on the side of the lens.

Autofocus lens

Shift lens

Shift lenses for 35 mm offer a lateral shift (cross front movement) on the mount, of up to ± 11 mm. You can use the shift vertically (rising front movement) to frame tall buildings without tilting the camera, to avoid converging verticals. The horizontal shift can help avoid unwanted reflections, below. Shift lenses do not allow automatic aperture control. Image quality is improved generally by stopping down (f8 or more).

Shift lens

BUYER'S GUIDE

Autofocus
Names to look for
Ricoh
Points to look for
● Rent to test before buying
● Balance with camera
● Battery life
● Check market for new focal lengths

Shift lenses
Names to look for
(Price range G-J)
**Pentax, Rokkor, Zuiko
***Canon, Nikkor
Points to look for
● Range of movements
● Small minimum aperture
● 28 mm focal length most effective
● Check weight
● Balance with camera

Without shift

With shift

Surveillance lens

The 2000 mm reflex lens, below, is used for police and military work, and astronomic and wildlife photography. It records distant subjects not seen by the naked eye. Nearest focusing distance is about 60 ft (18.3 m). Its angle of view is 1°10′, and depth of field is also very limited. Use it on a tripod as it is very heavy and unwieldy.

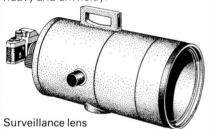

Surveillance lens

High-magnification macro

These lenses magnify up to × 20, depending on focal length. They must be used with special bellows and adaptor.

Macro adaptor
You must attach your macro lenses to an adaptor, left, so that they will fit to the front of the bellows unit.

Medical lens

The medical lens, below, provides a complete close-up kit, with ring flash for sharp hand-held shots and uniform, shadow-free illumination, and a focusing light. Focal lengths of 120 mm and 200 mm are available. Auxiliary attachments give magnifications beyond × 2. The lens allows you to print magnification data on the film.

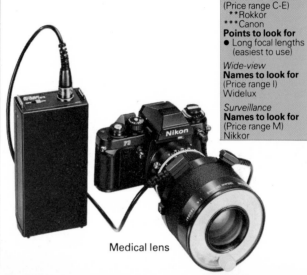

Medical lens

Wide-view effect

Wide-view lens and camera

The camera, right, uses a rotating wide-angle lens to give a panoramic 140° view. The focal length is 26 mm and the lens has a maximum aperture of f2.8. It can produce high-quality images up to 24 mm × 59 mm, without the image distortion which you normally get with a wide-angle lens. Use the camera with a tripod, to avoid sloping horizons and to keep your hands out of the picture.

Wide-view camera

Lens movement
The wide-view lens turns in its mount through an angle of 140° during each exposure.

Lens attachments

Lens attachments extend the range, alter the focal length, or improve the performance of certain lenses. Supplementary close-up lenses, which allow you to work at very close focusing distances, are best suited to lenses between 35mm and 135mm (for the 35mm format). Reversing rings have a similar function. You insert one between a reversed lens and the camera to increase lens-to-film distance. (When you re-verse a lens, you may lose automatic diaphragm and meter coupling.) Certain manufacturers also make macro attachments matched to their lenses. Focal length converters can produce wide-angle or telephoto effects. But the resulting image quality does not match that of a lens of equivalent focal length. Other important lens accessories are hoods and caps. A hood reduces "flare", while a cap protects the lens.

Close-up attachments

A supplementary close-up lens magnifies an image by between × 0.2 and × 0.7. The greater the power of the supplementary and the focal length of the lens, the greater the magnification. The strength of close-up lenses is expressed in diopters, or closest focusing distance. Reversing rings come in a range of sizes. Manufacturers' macro attachments give best quality.

Converters

A wide-angle converter normally reduces the focal length of a lens by about one third to a half. Tele(photo) converters can also produce striking results but they reduce the maximum usable aperture. Attachments are available that simulate the effect of a fisheye lens. Their construction is rudimentary, and so you must be prepared for inferior picture quality.

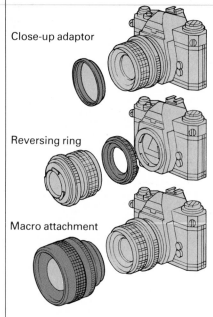

Close-up adaptor

Reversing ring

Macro attachment

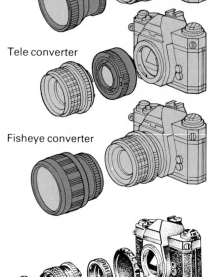

Wide-angle converter

Tele converter

Fisheye converter

Hoods and caps

Lens hoods are available for all focal lengths. Make sure that you buy the correct size for the focal length – otherwise vignetting will occur. Hoods come in metal and rubber, in round or square shape. Collapsible rubber hoods are also useful, as you can dispense with their effect quickly. Caps are essential for protecting lens surfaces and mounts, even if you use a lens case.

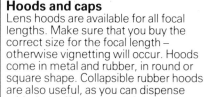

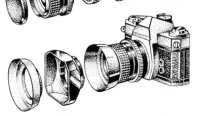

Accessories
filters/tripods/protective cases/light and flash meters

After you have chosen a basic camera and a lens, you will soon want to extend the range of your photography. You will want to select a number of accessories. These may at first seem to be luxury items, but if you use them correctly, they can give you far more control over your picture making than you have with just a camera and lens. Buy only the accessories you really need, and then you will probably be able to afford the best. Quality accessories give the most consistent performance, last longer, and have a higher exchange value if you decide to modify your system. It is a good idea to start by buying a good carrying bag or case. This will protect your equipment, and also enable you to carry it all around with you for location photography. It is always best to shoot with all your lenses and accessories at hand. If you do this, you will be prepared for unexpected subjects and situations. Many of the most interesting shots are taken in this way.

Filters
Filters provide a useful and reasonably inexpensive way of making your camera and lenses more versatile. They are invaluable in many photographic situations. You can use them to correct color or tonal rendition, or to add false color to an image. A skylight filter is particularly useful to reduce haze and make distant colors stronger. You can also leave it permanently on the lens, to protect the lens surface. Polarizing filters can cut out glare, reduce contrast, and improve color when required. Neutral density filters reduce the intensity of the light entering the lens. This enables you to use fast film in strong light, and gives you more flexibility to alter exposure when you want to manipulate depth of field. Another group of filters distorts the image various ways. They allow you to soften focus, to create multiple-image effects, and to exaggerate highlights. Some filters are made of glass, and have a metal frame which you screw on the lens. Gelatin filters are used with a special holder.

Tripods and stands
If you use a tripod, more of your pictures will be sharp. You will find this especially noticeable if you make big enlargements, or take color transparencies and view them on a large screen. A tripod also brings into your scope subjects which would otherwise have presented insurmountable exposure problems. You will be able to use long exposures which would have produced blurred results if you had used a handheld camera. Very dim interiors, night shots, and double exposure effects will all be possible and you will be able to create special effects by zooming and panning during long exposures. Long lenses are also much easier to use with a tripod than handheld. Tripods are also invaluable for studio use together with various stands and supports for equipment.

Off-camera meters
If your camera has a TTL (through-the-lens) exposure meter, you will notice that it is sometimes difficult to get an accurate reading. With an off-camera exposure meter, you can choose where and how to take light readings of difficult subjects. The result will be a smaller number of exposure errors. Using an off-camera meter will also improve your understanding of lighting, and how it influences the tone and color of your pictures. If you do much flash photography, you can also use a special meter for flash.

Filters

Filters alter the nature, quality, or brightness of light reaching the film. They serve two functions: either to correct and strengthen the image, bringing it closer to "reality", or to alter it·for creative effect. In black and white work, filters can control tone; in color, they can correct light-balance and shift color subtly or boldly. With all films, they can soften, mask, multiply, or distort the image. Each filter works best with particular subjects, lighting, films, and exposure techniques.

Most filters are glass or plastic disks, but a few are square. The round type usually have a metal frame, but, like the square, can be bought unmounted. Inexpensive filters can be cut from sheet gelatin or acetate.

You can use filters with any camera, but only through-the-lens viewing, found mainly on SLR models, allows you to preview the effect. All filters reduce incoming light to a degree. Although TTL (through-the-lens) meters take account of this, they can be unreliable. The filter factor method of calculating exposure, below, is more accurate.

How filters work

Light passing through a filter can change in a variety of ways. It may be partially absorbed, selectively diffused, collectively dispersed, diffracted, or refracted. Filters exist for each effect, and you can use two or more in conjunction to extend their range. All filters reduce the light reaching the film, but not all call for exposure compensation.

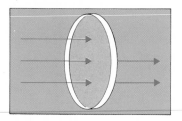

Absorption filters
An absorption filter absorbs some light wavelengths. It passes its own color, but absorbs the others.

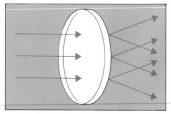

Diffusion filters
A diffusion filter scatters light. A diffuse halo surrounds each point affected, creating a soft image.

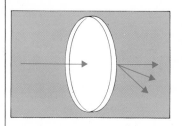

Dispersion filters
A dispersion filter bends light, separating its component colors. It may reveal the full spectrum.

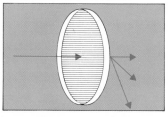

Diffraction filters
A diffraction filter fans out the spectrum. Its effect is greatest at the red end of the spectrum.

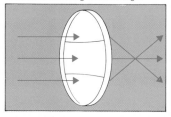

Refraction filters
A refraction filter acts similarly to a prism. It forms multiple images from a single subject.

Fitting filters

You usually fit filters just in front of the lens, within a lens hood, or in a holder. With large-diameter lenses, or for close work, you can set the filter behind the lens. Fisheyes and catadioptrics often have built-in filters.

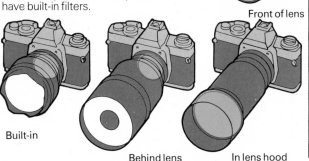

Front of lens

Built-in

Behind lens In lens hood

Filter factor

Even with TTL metering, a filter's effect on exposure can be unpredictable. For more precise control, refer to the filter factor provided by the manufacturer. The chart, below, recommends exposure changes for a range of filter strengths using 400 ASA film.

Filter factor	f-stop change	Or change ASA to
1	+½	300
2	+1	200
4	+2	100
8	+3	50

Color filters

Color filters are used in both black and white photography (below) and color (pp. 82-5). In black and white work the effect is to lighten subject colors matching the filter's own, and to darken complementary colors. A red filter, for example, absorbs the blue and green components of light, passing only red to the film. Blue and green become darker, red lighter. This effect heightens contrast – darkening a sky in relation to clouds, for example. With color film the same filters create color effects rather than tonal changes. Use them to add single or multiple color casts to a scene, or, in the case of strong primary color filters, to create a vivid, monochromatic effect. There are also color conversion filters to match lighting to film color balance.

Composition of light
A prism separates the wavelengths of white light, revealing its constituent colors. White light combines the three primary colors, red, blue, and green. Mixing two of these produces complementary colors—cyan, yellow and magenta. Color filters pass only their own color.

Correction filters

Panchromatic black and white films respond to the whole visible spectrum, but the tones recorded may not match natural brightness. In the color shot, below, sky and trees are contrasted. The unfiltered black and white scene loses the sky's tone. A yellow filter darkens the sky, which is of a complementary color, and a red strengthens this effect. A green filter also darkens the sky, but it lightens the trees (which are of its own color), restoring their tonal value.

Color No filter Yellow filter Red filter Green filter

Contrast filters

Two colors that are well contrasted in a color picture, right, may produce the same or a similar tone in a black and white picture when no filter is used. To separate the two tones, add a filter that matches one of the colors. This lightens the areas in the matching color, recreating a contrast. For the filtered shot, far right, an orange was used to make the lettering stand out from the background.

Color No filter Orange filter

Conversion filters

Color films are balanced to suit the color temperature (p. 127) of specific light sources – either daylight (K5500), or tungsten artificial light (K3200). If you are shooting with the wrong film for the available light, a color cast may appear on the final result. To prevent this, you should use a conversion filter. This alters the color temperature of the light, to match your film's color balance.

Fluorescent light filters

Pictures taken on daylight film under fluorescent tubes often show a green cast. On film balanced for tungsten light this cast will be blue. To correct this effect you can buy filters for various different types of tubes, such as "cold white" and "warm white" tubes. Some manufacturers publish tables with filter and exposure recommendations for different tubes and film.

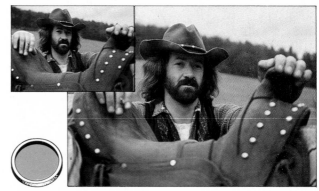

Light-balancing filters

Light balancing filters produce a similar effect to conversion filters, but create subtler changes. There is a range of filters to give a warmer (redder), or cooler (bluer) tone to the scene. Where the results are critical, make a series of tests before commencing, as is often difficult to predict the effect of these filters accurately.

Reciprocity correction filters

Reciprocity failure, caused by very short or very long exposures, brings about contrast changes and color casts. These are most marked at speeds less than 1/1000 sec (with electronic flash) and above 1 sec. You can correct color negatives when printing, but color slide film can be corrected beforehand with compensation filters.

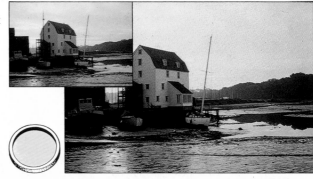

Strong single color filters

Strong single color filters are available in the primary colors, red, blue and green, and in a range of related colors. They were originally designed for black and white work (p. 81), and are made by all major manufacturers. When you use them with color film they create striking color changes, often producing a bizarre effect. Filter factors for strong single colors are usually high, in some cases up to 9 f-stops. When using these filters, it is best to choose subjects with high contrast and bold shapes. This will allow you to alter the color and balance of a scene in the most dramatic way.

Primary color effects
The series below compares an unfiltered shot with a strongly filtered blue scene and supernatural red and green effects. Filter factors are high, so use long exposures and a tripod to get the effects you require.

Strong single color filter

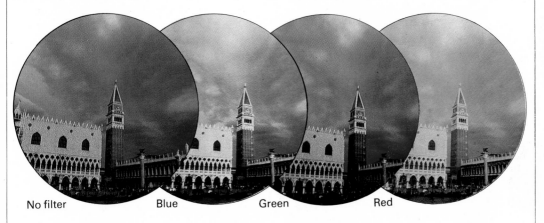

No filter Blue Green Red

Pale single color filters

You can use pale filters to remove a color cast, but they are most effective when you want to emphasize a color effect already present. They give a delicate look to a scene, and combine well with soft focus filters. You can buy them in a wide range of colors, from sepia and yellow to mauves and pinks. Filter factors range from 1.5 to 4.

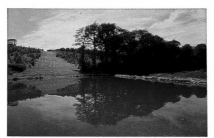

Pale single color filter

Pale color effects
The pictures, right, show the effects of pale filters on a landscape shot, above. The blue filter corrects the green cast, creating a more natural scene. The pink, green, and yellow filters each enhance the scene in their own way.

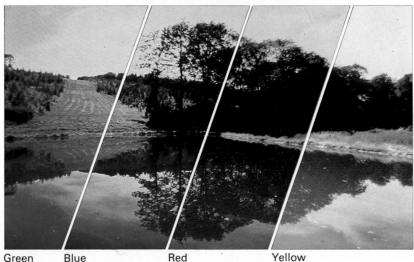

Green Blue Red Yellow

Graduated filters

The density of these filters changes across their surface. They compress a subject's brightness range to make it more acceptable to your film. They are particularly useful for toning down a bright sky, or dazzling snow or water. For best results, choose a filter that matches the scene's predominant color.

Dual color filters

With these filters you can produce images with a striking two-color effect. Use them to enrich color already present, to create unusual contrasts, or to strengthen a subject which has weak color. To achieve a gentle gradation of color, set a wide aperture; for a more marked division between the colors, stop well down. The contrasting colors of these filters have similar filter factors, so the exposure effect is the same for the component parts. You can make your own dual color filter by joining two pieces of gelatin.

Dual color filters
A good choice of color combinations allows you to enhance many kinds of subject.

Graduated effect
The series below shows the results obtained with three graduated filters – light brown, mauve, and yellow.

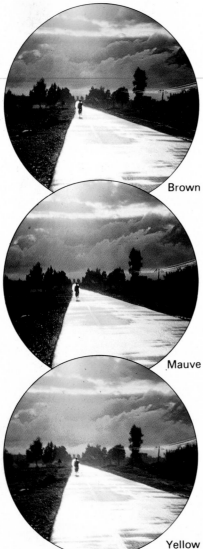

Brown

Mauve

Yellow

Triple color

Center spot filters

Filters with a clear center spot are available in a range of colors covering most of the spectrum. They allow you to create a vignette around the main subject. By selecting a wide aperture you can soften the circular edge of the center spot. A long lens also softens the contours, as well as magnifying the central area. A wide-angle lens has the opposite effect, emphasizing the division between the main area of interest and the vignette.

Center spot effect
The scene right was shot without a filter. A center spot filter was used in the picture above, right, to accentuate the main subject.

Filter

No filter

Skylight, UV, and IR filters

Color photographs taken in open shade in sunny days often show a bluish haze. A skylight filter reduces this effect. It may be left on the lens permanently, to protect it from dirt and abrasions. The haze softens contrast in black and white work. To correct this, use a UV (ultraviolet) filter. This kind of filter is not recommended for color photography, except in extremely bright conditions. IR (infrared) filters are used with infrared film (p.136), black and white or color, to control contrast. You can also use red, green, or yellow filters with IR color film.

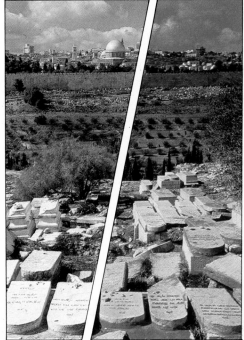

Regular film IR film/green filter

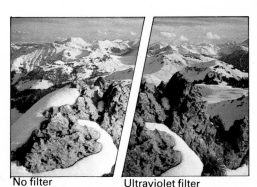

No filter Ultraviolet filter

Ultraviolet effect
In the shot above, left, no filter was used. The filtered scene shows stronger contrast and distant colors.

Infrared color effect
The scene, above, left, was enhanced by the effect of a green filter with infrared film, above, right.

Polarizing filters

Polarizing filters, or polarizing screens, are among the most useful filters you can buy. They are especially effective when you want to include non-metallic reflective surfaces, such as water, glass or plastic, in your pictures. They reduce or remove reflections and make it easier to photograph objects through windows and glass showcases. They also help counteract the effects of mist and haze. You can use them with both black and white and color film. On the latter they do not normally create a color cast, unless the filter is old, when a slight green cast may result. Polarizing filters make colors appear brighter, with better contrast, and they are particularly effective in darkening the color of bright blue sky. On black and white film they improve contrast and tonal rendition. They are designed to rotate in a holder and their 2.5-3 filter factor (equal to a 1½-2 stop exposure increase) applies under all conditions and to all degrees of rotation.

Polarization

In its natural form, light travels in vibrating waves. When reflected, it loses most of its random vibrations, and vibrates in a single plane. This reflected light is called polarized light. A polarizing filter can pass these single-plane vibrations, but you can also make it cut them out by slowly rotating the filter through 90 degrees. This will leave only non-polarized light, which passes through the lens and forms the image.

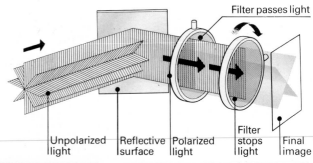

Filter passes light

| Unpolarized light | Reflective surface | Polarized light | Filter stops light | Final image |

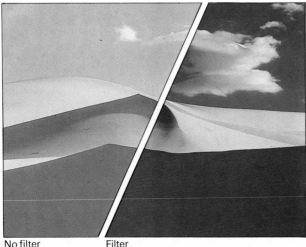

No filter Filter

No filter Filter

Polarizing effect

The filter increases color saturation in blue sky, left, and reduces reflections, above. If the filter has a handle, point this toward the sun. Otherwise turn the filter and change viewpoint, to observe the effect.

Neutral density

These filters reduce the amount of light reaching the film, without affecting color or tonal balance. Use them with black and white or color film when strong light would otherwise produce overexposure, or restrict your use of wide apertures, as in the unfiltered shot, right, and slow shutter speeds. Filters with densities of 0.3, 0.6 and 0.9 are most useful, as they alter exposure by one, two and three stops. A filter factor table, right, shows the exposure effect of other neutral density filters.

Density	Exposure increase (f stops)
0.1	⅓
0.2	⅔
0.3	1
0.4	1⅓
0.5	1⅔
0.6	2
0.7	2⅓
0.8	2⅔
0.9	3
1.0	3⅓

No filter Filter

Distortion filters

Distortion filters allow you to produce many interesting results by altering the structure or quality of the light before it reaches the lens. They may reduce image sharpness but the wealth of special effects they produce makes up for this. They can extend a subject's visual possibilities in several ways. Prismatic filters can produce unusual patterns or shapes, or create color-filled flares from single bright highlights. Diffusing filters help you to produce at will effects which are normally associated with weather or lighting conditions. Split field attachments are also available. These allow you either to show both background and foreground in focus, or to put half the picture out of focus. You can obtain further interesting effects by combining distortion and color filters, though it is essential to check image sharpness as this deteriorates when you add more filters.

When using distortion filters, camera settings, especially the aperture control, are important, and the focal length of the lens you use also has a direct effect on performance. A camera with SLR viewing enables you to see and adjust filter effects easily, but you should not rely too heavily on the TTL meter, which may be inaccurate with filters. It is better to consult filter factor tables.

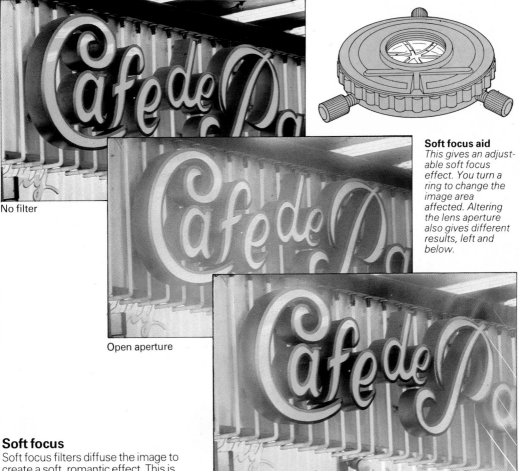

No filter

Open aperture

Lens stopped down

Soft focus aid
This gives an adjustable soft focus effect. You turn a ring to change the image area affected. Altering the lens aperture also gives different results, left and below.

Soft focus

Soft focus filters diffuse the image to create a soft, romantic effect. This is often useful in portraits, landscapes and close-ups of still-life. These filters are most effective when you are shooting against the light, and especially when combined with a weak pastel filter chosen to suit ambient lighting. You can buy these filters in a range of strengths. Weaker filters partially diffuse the image while stronger ones give overall mistiness. You do not need to apply a filter factor with soft focus filters. You can reduce the filter's effect by stopping down the lens and using short focal lengths. Long lenses and wide apertures help enhance the effect of soft focus filters.

Fog filters

A fog filter reduces contrast, giving a misted effect. Several strengths of filter are available, but you can intensify the effect by reducing the aperture. If you stop down too far, however, you may lose the fog effect altogether. Increasing subject distance also increases the effect. To simulate dense fog you can use more than one filter at once. Whatever technique you apply, the loss of contrast is always greater in the distance than in the foreground. Fog filters can also be used with color filters.

Fog effect
A fog filter reduces color and softens contours, right. No filter factor is necessary.

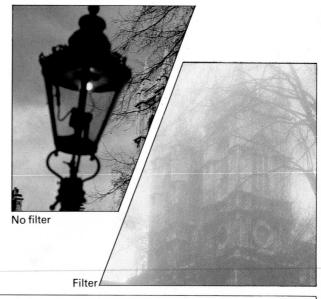

No filter

Filter

Split-field filter

A split-field filter can make near and far points in a scene appear sharp at the same time. Focus on the background with the clear half, so that the close-up section focuses on the foreground. You may have to turn the filter in its holder to align it with the divisions between background and foreground in the subject.

Split field
Without attachment, left; with, below.

Prismatic filters

Most prismatic filters have a diffraction grating comprising thousands of minute lines ruled on their surface. These form ridges which distort and multiply the image, separating its light into the colors of the spectrum. Some of these filters, like the starburst (or cross-screen) type, affect only highlights. They form star-like radiations from a single point of light, such as the sun or a street lamp. Another group of filters have prismatic facets on their surface. These separate the incoming light to form several identical images. With these filters, choose a subject with a clear background, to avoid overlapping. The multiple images appear closer together with wide-angle lenses, farther apart with long lenses. You can get the best results with 80-250 mm lenses. Rotate the filter to find the best position. No filter factor applies with any of these filters, but SLR viewing helps you control the effect accurately.

Prism
A simple prism gives striking blurred color effects.

Multifacet
These produce different numbers of identical images.

Multicolor
Colored segments can differentiate parts of a scene.

Starburst
This kind of filter gives up to 16 rays from a single point.

Diffraction
This filter produces vivid bands or streaks of light.

Diffraction
This splits star-shaped radiations into colored flares.

89

Exposure effect filters

You can achieve a wide variety of unusual filter effects by combining color filters with multiple exposure techniques, or by using masking filters of various kinds. You can also filter flash light and combine this effect with that produced by a lens filter. You will require a reliable tripod for all the techniques, and a filter holder is necessary for some. It is best to use a camera with a multiple exposure facility, although if your model does not allow this you can use the following method. When you load the film mark the position of the cassette's edge on the reverse of the film. Wind on a few frames, make the first exposure, and then bring the film back to the original alignment mark. Now wind on to your first exposure position and re-expose. Repeat the procedure as many times as necessary. The method can lack accuracy, and requires patience, but this should not deter you from attempting multiple exposure effects. To save film, load a short length into a reusable cassette for each experiment. Varying exposure levels and filter color can create ghosted images or saturated color, which can provide interesting alternatives to balanced color.

Multiple exposure

You can enliven a whole range of unadventurous images by shooting the same scene through a series of different colored filters. Subjects with some motion – such as smoke or running water – often yield good results. Primary color filters give the most striking effects, but you can use pastel shades or combine both kinds. You can obtain adequate results by relying on your TTL meter's reading, but you will normally improve the effect by increasing exposure by one stop. Always use a tripod for multiple exposure shots.

Triple primary color effect
The scene left was shot three times – with a different primary color filter each time.

Red Green Blue

Pre-shaped masks

Pre-shaped masks have part of their area blacked out, leaving a clear portion for the image. Their shapes range from a simple cameo, ideal for softening a subject, particularly a portrait, to a binocular effect (right). Masks are available in two sizes, allowing you to alter the balance between image and mask. You have further control in that the smaller the aperture you use the harder the mask's outline becomes. Also, the brighter the image you choose the more pronounced the contrast.

Pre-shaped masks

Color back filter

To contrast background and foreground color use two complementary filters, one on the lens, the other on the flash-gun. The flash lights the foreground, but leaves the background unaffected.

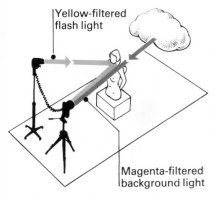

Yellow-filtered flash light

Magenta-filtered background light

Color back effect
In the color back set-up, left, the camera combines light reflected from the background and passed through a magenta filter with flash light passed through a yellow filter on the flash.

Exposure masks

The mask technique involves blanking out part of the image area by using a filter with an opaque section. For a single mask shot you have to turn the filter after shooting. In this way you can combine two halves of a scene. For double mask effects you use two filters, one with an opaque center and a clear surround, the other with the opposite. You also require a filter holder, a tripod, and, ideally, a lens between 50 mm and 105 mm. If you want a small central image use a wide-angle lens.

Single mask
The scene left was obtained by turning the filter through 180° after the first exposure.

Double mask

The effect right was obtained by super-imposing a main subject with the surround blacked out on an image with a masked central area.

The versatility of filters

Increasingly persuasive advertising makes it seem that you only need to mount a filter on your lens and shoot to achieve instant success. Your results will be more satisfying, however, if you are aware of the possibilities of each filter. A starburst filter highlights points of bright light on a dark background, and is ideal for a street scene at night, below, left. A fog filter can be used to soften hard light. In the picture, bottom, left, it turns strong, directional light into soft,

radiant patches. With a filter holder (p. 93) you can use more than one filter at once. A diffraction filter and a prismatic filter combine to create a striking pattern from bold shapes and an uncluttered background in the shot, below, right. Try using a filter in conjunction with a zooming technique. A strong color filter was used in this way to dramatize the zoom shot, bottom, right.

Filter pouch

Protect your filters when you are not using them with a padded pouch, right and below. A light interior makes for easy identification of the filter you require.

Mounting filters

The way in which you attach a filter to the lens depends on the material in which the filter is made, its size, and the diameter of the lens. Most filters fit over the lens's surface. Many glass filters have a threaded mount that screws directly on the lens. Others require an adaptor which again screws on the lens or slides over it. Gelatin or plastic filters can be taped over the lens, set in a holder, or simply held in front of the lens. Always handle filters by their edge.

Never touch the surface, especially that of gelatin filters. Although they seem more durable than gelatin, glass filters are also damaged easily. Clean them with a fluid recommended by your filter manufacturer, using a special cleaning tissue.

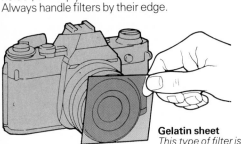

Gelatin sheet
This type of filter is available in small squares which you attach to the lens with adhesive tape. Don't touch the surface of the filter.

Simple ring filter
Some firms produce filters mounted in a threaded ring. These are quick to use but each filter restricts you to one lens size.

Adaptor
This comprises two metal rings. To fit the filter, you sandwich it between the two rings and attach the assembly to the front of the lens. The adaptor slips over or screws on the lens. Be sure to buy the size that suits your lens.

Adaptor ring Filter Ring

Filter holder
At least one manufacturer offers a wide range of compatible filter accessories. The range includes a special filter holder with a selection of adaptor rings to suit lens diameters between 49 mm and 58 mm.

Filter system
The filter holder, right, comprises an adaptor ring and a filter frame. The frame allows you to use two filters at once. You can turn the filters in the frame – essential when you are using a polarizing filter.

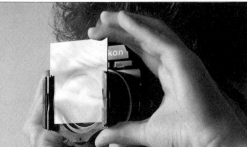

Adaptor ring Filter frame Filters

Tripods

You cannot usually take hand-held shots on a standard lens at shutter speeds below 1/30 sec without risking camera shake. A camera which feels too heavy – often a result of using a long lens – or too light, has the same effect. So do close-up shots and unusual viewpoints, even at faster shutter speeds. Use a tripod and a cable release in each case. This allows you to manipulate camera, subject, and lighting accurately. The more adjustable the tripod the more control you have. Always set one of the tripod's legs toward the subject, with the lens over the leg, and allow the tripod to settle before taking a picture.

Most tripods extend to 6ft (1.8m) or, less often, 9ft (2.7m). You can normally raise the center column, and better models have a geared crank for this purpose. Use the column for fine height adjustments only. Raising it substantially reduces the tripod's stability. Models with braces between center column and legs are generally more stable. The tripod is topped by a plate with a camera screw of ¼ in or ⅜ in in diameter. (These sizes are international.) Some take both sizes, so that you can use cameras of different formats.

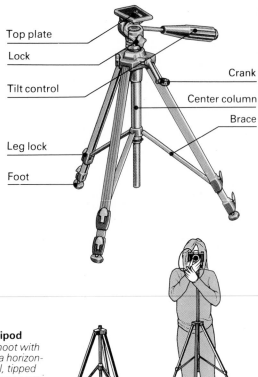

Top plate
Lock
Crank
Tilt control
Center column
Brace
Leg lock
Foot

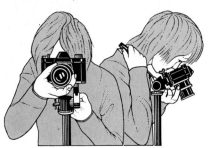

Using a tripod
You can shoot with the camera horizontal, vertical, tipped down, or in any position between. A reversible column allows you a low viewpoint. If you raise it for a high view, or shoot in wind, add weight.

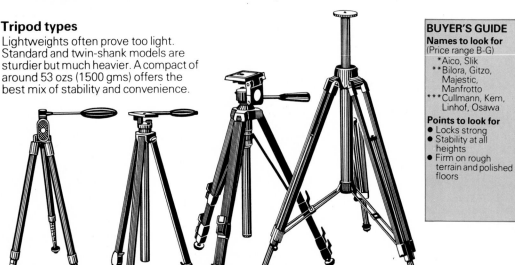

Tripod types
Lightweights often prove too light. Standard and twin-shank models are sturdier but much heavier. A compact of around 53 ozs (1500 gms) offers the best mix of stability and convenience.

Lightweight Compact Standard Twin-shank

Heads

Fixed to the tripod by a locking screw, heads range from the compact tilt-top to the precise balance head. A compromise is the two-way or three-way pan and tilt head. A balance head has a smoother action, while a quick-release head is valuable when you need to change cameras frequently.

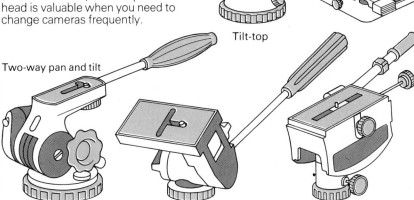

Quick-release

Tilt-top

Two-way pan and tilt

Three-way pan and tilt

Balance head

Legs

Tripod legs are telescopic, tubular and normally round or square in section. They are usually made of light alloy. A three-section design is most common, with each section about 2 ft (0.6 m) long. You lock the legs at the required length by a rubber or metal twist collar, a locking screw, or a quick-action lever. Rubber or plastic feet provide a firm grip on uneven or slippery surfaces.

Shielded metal spikes are best for outdoor work.

Miniature tripods

Light and space-saving – the legs on some models fold – these are used mostly for table-top work. Alternatively, you can place them on a flat surface or against your chest for long exposures. The simplest kind takes the camera horizontally only. A ball-and-socket head gives a wider range of positions.

Monopods

Where a tripod would take too long to set up, use a monopod. This normally has four to six sections and a camera screw or a top plate. Use downward pressure and you can expose for up to 1/8 sec.

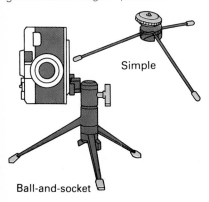

Simple

Ball-and-socket

Studio tripods and stands

Heavy-duty tripods and stands are indispensable for the large format cameras used in studios. Studio tripods are made in aluminum alloy or, less often, wood, and are up to 9ft (2.7m) high. Wooden models usually have twin-shank legs, which are sturdy, but the leg extensions should also be twin-shank. Center-column braces give extra strength, but tripods without these allow lower viewpoints because you can spread the tripod legs further. You can take advantage of this range if the manufacturer incorporates a special short column. Studio tripods may offer other features such as power-wound center columns and gearheads to make the adjustment of heavy cameras easy and precise. Extra-long center columns increase your choice of camera positions. Most studio tripods have a spirit level set in the top. This is of great value when adjustment is critical. You can make your tripod more versatile by adding attachments such as side-arms and outriggers. These provide well-balanced off-center support for your camera, whatever its weight. Large, strong interchangeable heads are available to match the durability and precision required of studio tripods. Dollies with castors enable you to move the whole assembly around.

Types of studio tripod

The two basic designs, with twin-shank and regular telescopic legs, are scaled-up versions of smaller tripods. Power-wind and gearheads make main adjustments precise and smooth. Center columns are usually geared and hand-cranked. A power lift holds the column where it is stopped.

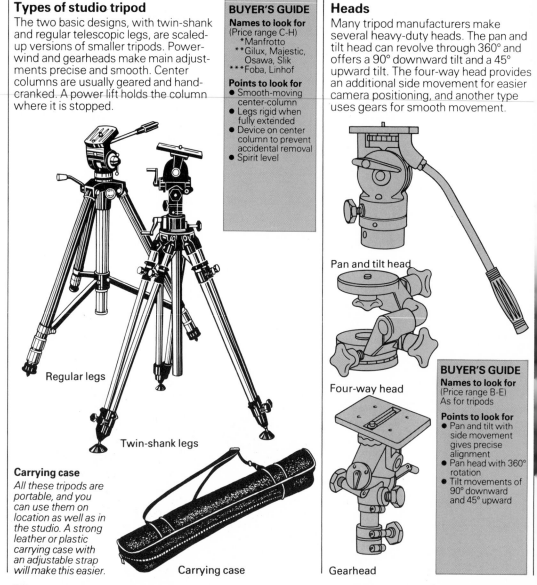

Regular legs

Twin-shank legs

Carrying case
All these tripods are portable, and you can use them on location as well as in the studio. A strong leather or plastic carrying case with an adjustable strap will make this easier.

Carrying case

Heads

Many tripod manufacturers make several heavy-duty heads. The pan and tilt head can revolve through 360° and offers a 90° downward tilt and a 45° upward tilt. The four-way head provides an additional side movement for easier camera positioning, and another type uses gears for smooth movement.

Pan and tilt head

Four-way head

Gearhead

Attachments

A range of attachments is available to increase the scope of your tripod. It includes long center columns, for added height, and dollies, which enable you to reposition the whole assembly in the studio. By adding outriggers you can shoot from difficult viewpoints.

Studio stands

Studio stands are made in durable chromed tubing. They accept cameras of different formats and adjust to a variety of positions. The maximum working height is normally between 8 ft (2.4 m) and 10 ft (3 m). Some have pneumatic braking, so that the camera remains steady when you adjust height. Outriggers and extension arms increase a stand's versatility.

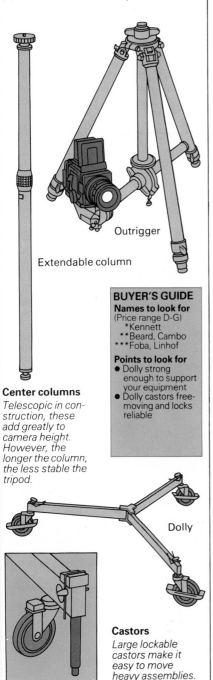

Outrigger

Extendable column

Center columns

Telescopic in construction, these add greatly to camera height. However, the longer the column, the less stable the tripod.

Dolly

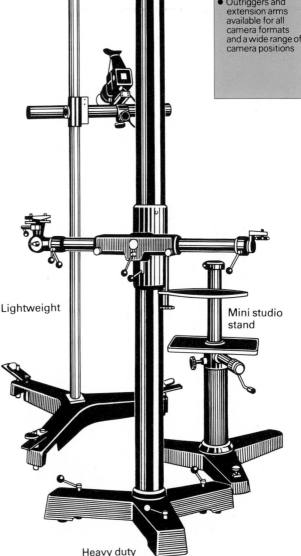

Lightweight

Mini studio stand

Castors

Large lockable castors make it easy to move heavy assemblies.

Heavy duty

Protective cases

Your camera, lenses, and other equipment will last longer and work better if you store and transport them properly. There are many kinds of protective bag, case, and trunk on the market to take all formats of camera and accessories. In addition to protecting your equipment they keep it all in one place, often in neat compartments, saving you setting-up time. Choose a case that allows you to add more equipment later, but make sure that all the items are held securely, and do not damage one another. You can buy protective cases and bags in leather, plastic, canvas, wood, or light metal. All equipment cases should be durable, easy to carry, and water-repellent if not waterproof.

Whatever material you choose, your bag or case is likely to be weakest at the seams or joints, where the strap or handle is attached, and around the fastenings. Repair is usually easier on leather than on other materials. An advantage of canvas and plastic bags is that they are light by comparison. Plastic has the added benefit of resisting the elements well. Camera manufacturers often make their own equipment bags and cases, but it is worth comparing their prices with those of specialist makers.

Lens cases

You can buy lens cases in hard or soft leather, or rigid plastic. Hard leather cases should have a strap. They are best if you want to carry one or two lenses as a supplement to your mounted lens. They are also useful if you have a soft gadget bag in which equipment might bump together. You can use a soft case to protect the lens in a rigid gadget bag. Plastic cases are inexpensive and useful for storing lenses in a cupboard or in a rigid equipment container.

Leather case

Clear plastic case

Pouch

Camera and lens care

If your camera and lenses become excessively dirty it is best to have them cleaned by a specialist camera repairer. You should clean the lens surfaces and the camera interior regularly with a blower brush or aerosol cleaner. Use lens cleaning fluid sparingly. If you use tissue, avoid heavy pressure as it can damage the lens coating.

Camera cases

Most cameras up to medium format have a specially designed case. Many SLR cases let you use the camera while in the case, by slipping down the front panel. Cases are available in soft or hard leather, or plastic. Soft cases are light but not so robust as hard cases. Some cases accommodate a long lens.

Medium format SLR case

TLR case

Compact 35 mm case

Soft SLR case

Hard case for SLR with long lens

Gadget bags

You can choose between a soft bag with side pockets for smaller accessories, or a more rigid bag. The latter are usually compartmented or have a lift-out accessory section. Soft bags are available in leather, canvas or plastic, rigid bags in leather or plastic. All should be durable, light, and big enough to take all your photographic equipment. Strong, reinforced seams are particularly important. A soft bag should have a padded base to give extra protection. Zipped sides or large side pockets give good access to all equipment, and fastenings should be strong, secure, and easy to open. Variable dividers make the bag more versatile. A wide, adjustable shoulder strap is important for comfortable, safe carrying.

Compartmented insert

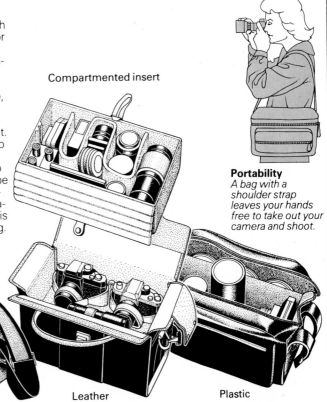

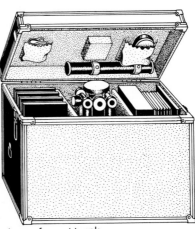

Portability
A bag with a shoulder strap leaves your hands free to take out your camera and shoot.

Nylon Leather Plastic

Gadget cases

Reinforced cases, usually in aluminum, are available for equipment from 35 mm to large format. The smaller, document case type is best for 35 mm equipment but many will serve for medium format gear. These cases normally have a foam insert, which you cut to shape, to prevent the equipment from moving around. (You can also adapt a deep document case by adding foam padding.) A few cases are made in wood or leather. Large, trunk-like cases are used for 4 ins × 5 ins and 10 ins × 8 ins technical and monorail cameras. Compartments accommodate the whole range of equipment.

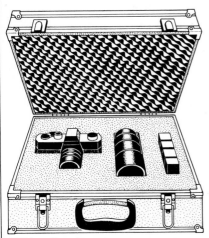

SLR/medium format case

Large format trunk

Off-camera meters

Built-in camera metering is most reliable with frontlit scenes of even brightness. With more contrasty scenes, or backlit subjects, it can be wildly inaccurate. Override devices such as exposure compensation and exposure holds can help this problem but are not always fully accurate. An off-camera meter provides the answer. It allows you to make highly selective exposure measurements, using either reflected or incident light readings, or a combination of both. Most off-camera meters use a cadmium or silicon cell, which sets up a resistance to a current passing through it. The greater the amount of light, the greater the resistance in the cell. The meter measures this and calculates light intensity. Once you have set the appropriate film speed on the meter you can read off recommended exposure settings on the calculator scale. Some meters have a selenium cell, which generates a small electric current when light falls on it. The meter uses the strength of this charge to measure the amount of light.

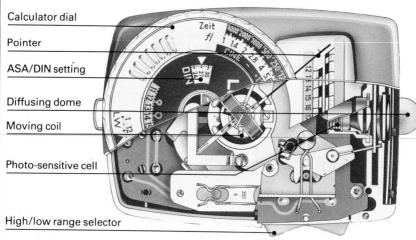

Calculator dial

Pointer

ASA/DIN setting

Diffusing dome

Moving coil

Photo-sensitive cell

High/low range selector

Types of meter

The selenium meter is simple and reliable and does not require a battery. It lacks sensitivity at lower light levels, but in stronger light it is more accurate. Cadmium and silicon meters require a battery which you should change once a year. These meters are sensitive to a wide range of light levels, but cadmium cells suffer from over-sensitivity to red light and can be slow in responding. Auto meters are quick and simple to use. They display recommended exposure, often as a digital read-out. Spot meters are useful with long lenses, or for highly selective readings.

Selenium

Auto

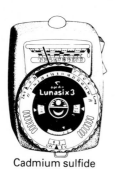

Cadmium sulfide Spot

Meter choice
The selenium cell type, above, requires no battery. The cadmium sulfide meter, far left, has a needle readout. The spot meter, center, has a very narrow angle of view (1°-9°) for accurate measurement. The auto meter gives rapid readings.

Reflected and incident readings

Most modern exposure meters, including some spot meters, allow you to make both reflected and incident readings. To make reflected readings you simply point the meter cell directly toward the subject and read the meter's needle or digital display. Make sure you are reading from the most important area of detail. Reflected readings work well when the subject is evenly lit and lacks extremes of tone and color. But small areas of extreme brightness tend to be averaged out. In more difficult conditions, when tone and lighting are less uniform, it is best to use incident read-ings. Most exposure meters have an incident light attachment which you can clip on the sensitive cell. This is a small white semi-circular dome which extends the meter's acceptance range. To make incident readings, you place this adaptor over the cell and aim the meter toward the subject's main light source from the camera position. If you use this method the film will record subject brightness more accurately. Improvements will be particularly noticeable on color reversal film and whenever your subject has a dark or light bias.

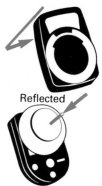

Reflected

Incident

Duplex readings

Duplex readings are useful for subjects with a wide brightness range, such as backlit scenes having strong lighting and bright highlights. Taking duplex readings will help you to obtain more balanced exposure with clearer details.

Spot meter readings

A TTL meter averages a dark scene with a brightly lit area, so significant detail is lost, below left. Using a spot meter enables you to take a selective reading to bring out detail, below right. Use one whenever specific details are important.

TTL Duplex

Making a duplex reading
To make a duplex reading, fix an incident light attachment to the cell, point the meter at the subject and take a reading. Take a second reading pointing the meter toward the camera and average the two readings.

TTL Spot

Making a spot reading
When using a spot meter, you must view the subject carefully through the eyepiece. Aim the meter precisely, or the narrow angle of view will cause misalignment. A frame in the finder shows the measuring area.

Accessories

Various accessories are available to give your meter a wider range of applications. A spot-probe attachment, far right, gives precise readings for close-up work and macrophotography. A booster, right, increases the meter's sensitivity. It allows you to use the meter where accurate readings are otherwise difficult to obtain. You can even make through-the-lens readings on a camera without TTL metering by holding a booster to the viewfinder.

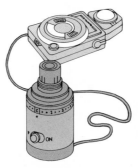

Flash meters

The effect of flash lighting on film is a product of both intensity and duration of the light. Conventional meters measure only light intensity, as the duration of normal light is continuous. Special meters are therefore available for flash which can also measure duration. Some of these have a built-in bladed shutter for very accurate measurement of duration. With typical meters you can take incident readings from the subject position. You program the meter with the appropriate film speed and it indicates the required aperture. On automatic meters an LED or LCD provides an immediate readout. Some have a rotating head,

so you can point the light sensor in any direction and still see the readout. Manual meters have a needle which registers flash strength. You use a calculator on the meter to find the correct lens aperture. Most meters have a 12-stop aperture range, which goes far beyond the range of most lenses. They usually give readings to the nearest ⅓ stop, though some LCD models are accurate to one-tenth of a stop. Flash meters are expensive, costing about five times as much as a conventional light meter. But if you shoot a lot of color slide film with electronic flash you can save a lot on materials with a flash meter.

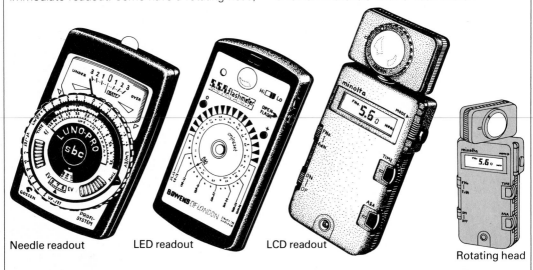

Needle readout LED readout LCD readout Rotating head

Using a flash meter

Set the camera shutter to the correct synch speed, and the meter to the film speed rating. You then fire the flash via the trigger cord or the manual button on the flash head. Digital meters give an immediate readout of the aperture setting you require. On manual meters you observe the needle position, transfer

this information to the calculator, and read off the aperture. With a single main light source, below left, take a direct reading. If you are using two or more lights, take an averaged reading by pointing the meter toward the camera, below right.

BUYER'S GUIDE

Names to look for
(Price range D-G)
*Bowens
**Sekonic
***Gossen, Minolta

Points to look for
- Aperture calibration from f2.8 to f180
- Accuracy to one-third of a stop
- Cordless type most convenient
- LED or LCD readout helps avoid error
- Readout shows for at least 30 secs
- Battery level warning

Single-light reading

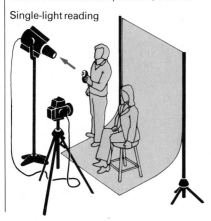

Averaged reading

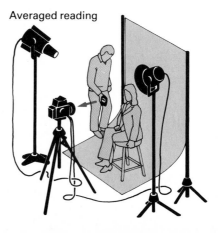

Lighting and studio
flash/tungsten lighting/ studio equipment and set-ups/slide projectors

Artificial lighting can extend your control over your pictures. Flash is the most widely used light source. With a simple camera, flash is often essential to cope with a variety of lighting conditions. Even with a wide camera exposure range, a flash gun will extend your scope. It enables you to shoot indoors or at night without long exposures, to fill shadows, freeze movement, light small, close subjects, adjust color and contrast, and create other special effects. All cameras can use flash, and most accept electronic flash guns. Guns range widely in price, the more costly models being more versatile and offering a good choice of accessories.

Studio lighting
Certain subjects, particularly still-life, portraits, and interiors, require fully controlled lighting. The best way to achieve this is with a group of lamps. You can use either tungsten or flash lighting. Tungsten runs off the mains, is easy to adjust, and works independently of the camera, so that you can use any shutter speed. The disadvantage is that tungsten equipment gets very hot. Flash lighting stays cool during operation. It is also portable, and slave and trigger units are available, so that you can fire the flash units remotely. The main disadvantage of flash is that its brief dur-

ation makes its effect difficult to judge. When taking color pictures, it is important to use the correct film with artificial lighting. The color temperature (p.127) of tungsten lighting is different to that of daylight, so that you must use tungsten film. Flash lighting has the same color temperature as daylight, and in this case you can use normal film.

Using a studio
A room or area which you can set aside permanently for studio work allows you to leave equipment in place between sessions. The basic equipment – lights, stands, and backgrounds – need not be expensive, and is easily adaptable. You can make some items, such as background and subject supports, diffusers and reflectors.

Slide projectors
This section of the book also includes slide projectors. Those with interchangeable magazines are most convenient. They range from models with manual slide change, to sophisticated autofocus units. At the professional end of the range, projector systems allow you to dissolve one image into another, to link two projectors, and to synchronize slides with tapes.

Lighting effects
Direct light, as from a spot, below, gives a bright, contrasty effect with hard shadows. You can use a diffuser, right, below, or bounced light, far right, to produce softer illumination. A flood light with a reflector, right, also gives soft lighting: the broader the reflector, the softer the result.

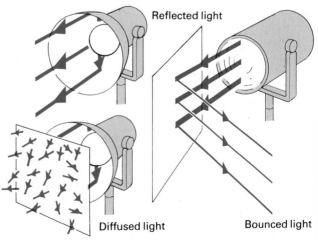
Reflected light

Bounced light

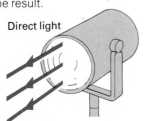
Direct light

Diffused light

Electronic flash

An electronic flash gun can provide the cheapest form of artificial lighting, and the more you use it, the better the value. It will produce at least 100 flashes before you recharge or replace the battery. With manual flash guns you adjust the lens aperture to control exposure, but you can buy automatics which you can program to give the correct exposure for most subjects.

Most flash guns are small and compact. Flash strength varies, but do not expect size to reflect strength. Flash duration is normally 1/1000 sec or less. This speed can freeze action, but you must select a shutter speed which allows the shutter to be fully open when the flash fires (p.21). On cameras with a focal plane shutter this may be as slow as 1/60 or 1/125 sec, while on between-the-lens leaf shutters it can be as high as 1/500 sec. On cameras with two synchronization settings, you must also check that you have selected correctly for electronic flash. When you fire the flash, it takes time to recharge. Recycling time varies from 8 to 10 seconds on manual guns and 2 to 3 seconds on advanced models. A gun with a synch connection can be used on or off the camera.

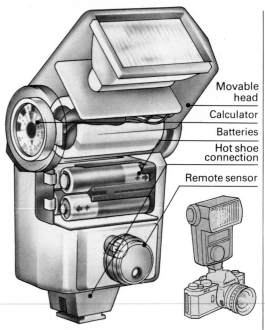

Movable head

Calculator

Batteries

Hot shoe connection

Remote sensor

Light quality
You can soften flash light by adding a diffuser, or bouncing the light off the ceiling. Using two flash units will give a more three-dimensional effect.

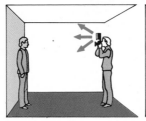

Diffused flash

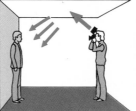

Bounced flash

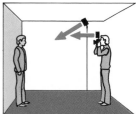

Using two units

Manual units
Most manual units have fixed heads. You place them in the hot shoe on top of the camera. They usually have a simple calculator enabling you to gauge the aperture you require. Flash duration is usually about 1/1000 sec and range will depend on the film speed in use as well as the power of the flash gun. On most guns one set of batteries should give about 250 flashes.

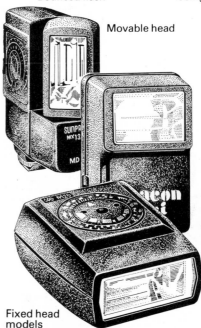

Movable head

Fixed head models

Flash calculator
A simple table on the manual unit, left, enables you to calculate the correct aperture. You estimate subject distance and read off the aperture setting for the film speed you are using.

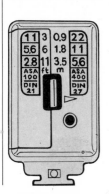

Automatic units

Automatic units, below, adjust flash to suit subject distance at your working aperture, so that you can achieve consistently accurate exposures. Some do this by varying flash duration, others by varying flash power. Certain units allow fine manual adjustment of power, so that you can select an aperture to give the required depth of field, or balance flash output with available light.

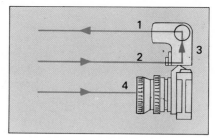

Auto principle
The flash (1) reflects back to a sensor (2) and the unit measures subject lighting (3). When it has received enough light, the flash switches off, so light reaching the lens (4) is constant.

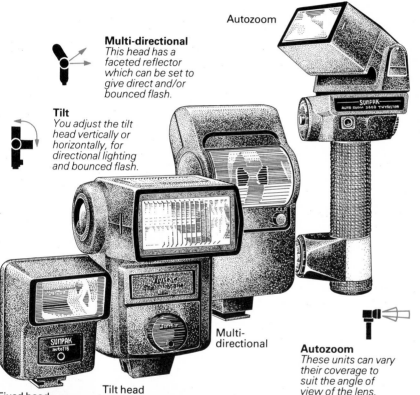

Autozoom

Multi-directional
This head has a faceted reflector which can be set to give direct and/or bounced flash.

Tilt
You adjust the tilt head vertically or horizontally, for directional lighting and bounced flash.

Multi-directional

Fixed head

Tilt head

Autozoom
These units can vary their coverage to suit the angle of view of the lens.

BUYER'S GUIDE

Names to look for
(Price range A-C)
 *Hanimex
 **Agfa, Aico, Hitacon, Sunpak
***Philips, Rollei

Points to look for
● Power at least 40 with 100 ASA film
● Speed of recycling (no more than 10 secs)
● Hot shoe and synch cord connections
● Movable head
● Flash calculator
● Number of flashes per set of batteries
● Light coverage matches your lens' angle of view

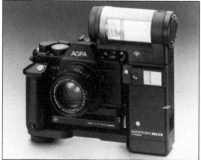

Twin flash
The unit above uses a movable reflector for bounced flash. An additional fill-in flash improves bounced flash results.

Special units

Some tasks require special flash units. A soft light placed close to the subject is best for macrophotography. For this, you should use a ring flash, which fits over the lens barrel. Different sizes are available to suit different lens diameters. Units are also available for infrared photography. These provide a flash using only the infrared part of the spectrum.

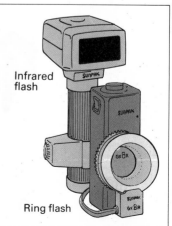

Infrared flash

Ring flash

Rechargeable units

Some large portable flash guns use a rechargeable battery pack as a power source. They are not heavy, and a shoulder strap makes them easily portable. Recharging time, via your power supply, varies between 3 and 10 hours. A powerful gun will deliver 8000 flashes from a single long charge. Smaller units take less time to recharge and usually give 500-1000 flashes. Accumulator guns give around 100 flashes, and recycle slowly.

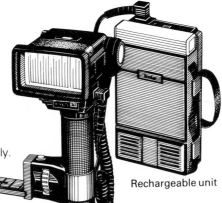

Rechargeable unit

Strobe units

Strobe units, right, give a rapid series of flashes, and are used for studio photography, mainly by professionals. The price range of strobe units is very wide. A simple model costs a fraction of the price of a sophisticated unit. Flash frequency is usually adjustable between 1 and 40 flashes per second to suit the speed of a moving subject. You can use the lower frequencies to synchronize the unit with a motor drive. The faster frequencies are ideal for creating stop-action sequences with a striking multiple-image effect. Usually, several units are used in conjunction with a separate synchronizing box. Some strobes offer "open flash". You can use the unit without synch with the camera, leaving the shutter open.

Strobe units

Trigger units

If you want to light a scene with several cordless flash units, you can use a light-sensitive slave unit or a sound-sensitive trigger. Any sharp noise will fire a sound trigger, whereas a slave reacts to the light from the prime flash gun and fires the others instantaneously.

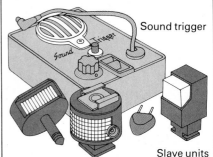

Sound trigger

Slave units

Flash choice
The chart, right, shows the features you can expect to find on different types of flash gun. If you want a manual or semi-auto model, choose one with an adjustable head, for bouncing flash. Automatic models give more flashes per set of batteries and greater range. Whatever degree of automation you want, look for a gun with a good aperture range and rapid recycling.

	Manual	Semi-automatic	Automatic	Recharge-able
Guide no.	15-25	15-25	20-40	28-40
Max. flash distance (ft) (m)	30 / 9	40 / 12	50 / 15	50 / 15
Max. angle of coverage	50	50	60	60
Aperture range	f2.8-f5.6	f2.8-f5.6	f2.4-f11	f4-f11
Batteries	Alkaline	Alkaline	Nicad	Nicad
Recycling time (secs)	8-10	10	2-6	0.3-8
Flashes	150-250	150-250	250-350	100-8000

Electronic flash system

Some manufacturers supplement their basic flash gun with a range of accessories to make the gun more versatile. Base your system on a flash gun of good power with an adjustable head. It should offer a choice of power source – battery, power pack, or main supply. A manual adaptor overrides the gun's thyristor circuitry to give you more control over lighting. Soft light diffusers and reflectors allow you to vary the flash effect, and make bounced flash more predictable. Adaptors for regulating the flash angle to suit the angle of view of the lens are also useful. Most systems also offer filters to clip over the gun. These alter the light's color temperature to match your film's color balance. They can also create colored lighting effects. A quick-release grip allows you to use the gun off the camera when necessary.

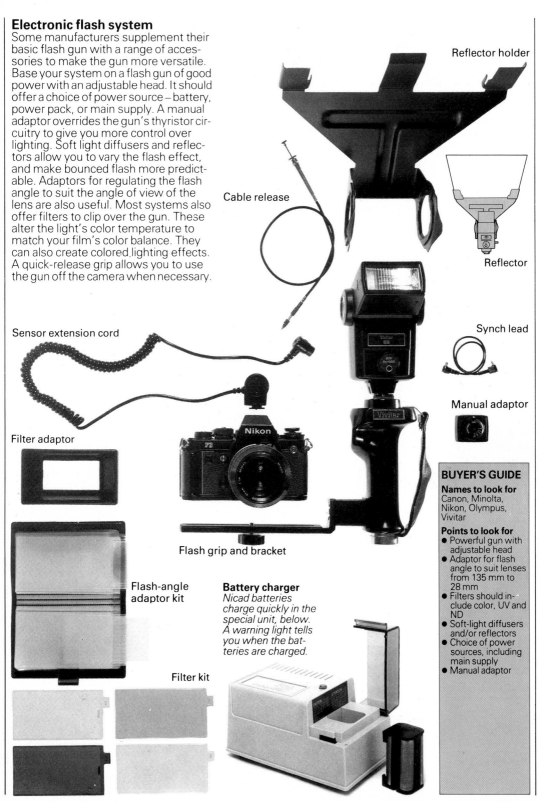

Reflector holder

Cable release

Reflector

Sensor extension cord

Synch lead

Manual adaptor

Filter adaptor

Flash grip and bracket

BUYER'S GUIDE

Names to look for
Canon, Minolta, Nikon, Olympus, Vivitar

Points to look for
● Powerful gun with adjustable head
● Adaptor for flash angle to suit lenses from 135 mm to 28 mm
● Filters should include color, UV and ND
● Soft-light diffusers and/or reflectors
● Choice of power sources, including main supply
● Manual adaptor

Flash-angle adaptor kit

Battery charger
Nicad batteries charge quickly in the special unit, below. A warning light tells you when the batteries are charged.

Filter kit

Studio flash

Two types of studio flash unit are available. There are compact models which you can use both in the studio and on location, and heavier units for studio use only. Compact types have one or more lights which you attach to a power source incorporating a control unit. They allow you to fit heads of different strengths, and are portable. The large studio flash units give a stronger light. They are heavier and not portable. On these units you link the power pack to the flash head and camera shutter by means of synchronization leads. Kits with more than one head can have a slave unit which fires each head automatically, so you can dispense with some of the leads. Flash heads are normally balanced for daylight color film, are quick to recycle and accept a variety of reflectors for different lighting effects. Units with a control switch enable you to vary flash strength easily.

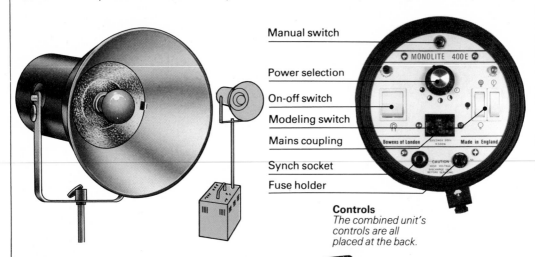

Manual switch

Power selection

On-off switch

Modeling switch

Mains coupling

Synch socket

Fuse holder

Controls
The combined unit's controls are all placed at the back.

Flash types
Some models incorporate power source and flash head in one unit. Some lights require a free-standing tripod, while you connect others to a portable power pack. To achieve a good light balance, you can vary settings from full to one-quarter power. Modeling lights allow you to preview effects. They adjust to your chosen power setting and recycle rapidly.

Deep Shallow

Reflectors
A deep reflector, far left, gives strong lighting with clear shadows, good for most studio photography. For color work shallower units, left, give the softer light often required.

Umbrellas
Umbrellas spread and diffuse flash light, softening its effect. The square type gives even softer lighting than the standard model, and the diffuser gives almost shadowless illumination. This type has a double skin and the flash is contained within its structure. Some umbrellas are reversible, one side producing a slightly warm color shift, the other side neutral.

Reflective materials
Some umbrellas are made of nylon, others of PVC-backed foil. Opaque materials reduce the effect of light loss. Patterned surfaces create even illumination, and gold coloring gives the light a warm tinge.

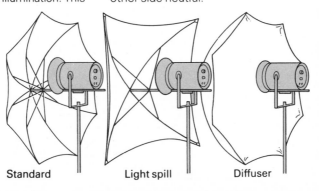

Standard Light spill Diffuser

Lighting heads

Many heads are available to help you create a variety of effects. Keylights and snoots provide a concentrated light with sharp shadows. The spot projector head gives an adjustable controlled beam. At the other end of the scale, soft lights give a wider, diffused beam. Filters and honeycomb materials help you change the strength and extent of the light, while barn doors control light spillage.

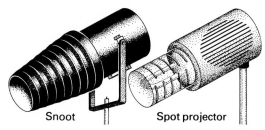

Snoot Spot projector

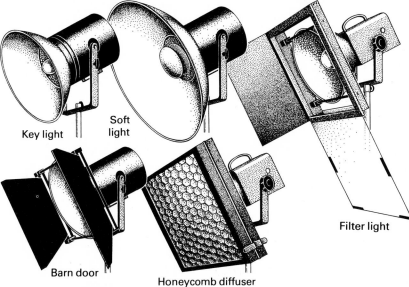

Key light Soft light

Barn door Honeycomb diffuser

Filter light

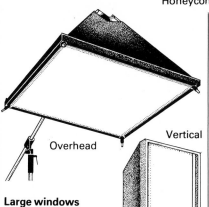

Overhead Vertical

Large windows

These lights are useful because you can fit a large power-ful soft light to them. This is ideal when you require bright, shadowless illumi-nation. You can use them on their side, right, or with a boom pole, above, to light your subject from overhead.

Power units

These powerful units are for studio use and run off an AC supply. Some have fixed capacity, but you can vary power by linking units together. If you use more than one head per power pack, the strength is divided between the heads.

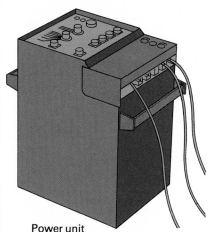

Power unit

Expendable flash

You can only use an expendable flash bulb once. A small electric charge ignites the bulb and generates a bright, brief light. Bulbs of various sizes and powers are available, but convenient multiple cubes, bars and flipflash units are replacing small single bulbs. Multiple units give you a number of flashes without removing bulbs. You must set the correct exposure when using flash. Most cameras which accept cubes or bars do this automatically. But on some you adjust the aperture, using the manufacturer's flash factors. And if you use bulbs in a flash gun, you must be able to set your camera to "M" synchronization, so the shutter opening coincides with the flash's peak.

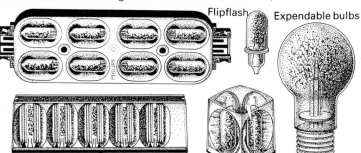

Flipflash Expendable bulbs

Bar Cube

Types of bulb
A flash cube gives four flashes. After firing, the cube turns automatically so that another bulb is ready to fire. On some cameras you cannot press the shutter until you remove or change a used cube. Flash bars and flipflash units give 8 to 10 flashes. You reverse the attachment when half the bulbs are expended. Single bulbs are also available for use with a flash gun, and with studio flash.

Flash range

Flash illumination falls off with distance. For brighter lighting, stand closer to the subject, or use more than one bulb. The flipflash unit, right, allows you to fire up to four bulbs simultaneously. On medium speed film, one bulb usually gives correct exposure at subject distances between 3 ft and 9 ft (1 m to 3 m). Two bulbs increase the range by about 40 per cent (see diagram).

Flash factor
Divide the guide number given for your film speed by the subject distance and set the aperture nearest the result. With more than one bulb, increase exposure, as left.

Number of bulbs	Multiply by	Guide numbers		
		64	100	120
2	1.4	90	140	168
3	1.7	109	170	204
4	2	128	200	240

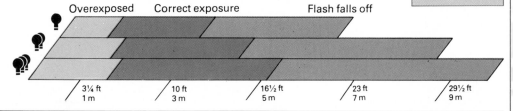

Overexposed Correct exposure Flash falls off

| 3¼ ft / 1 m | 10 ft / 3 m | 16½ ft / 5 m | 23 ft / 7 m | 29½ ft / 9 m |

Studio bulb flash

Professional photographers sometimes use big bulb flash guns to light large areas, particularly if the atmosphere is smoky or dusty. They give even light over a wide arc, and are especially effective with wide-angle lenses. The unit, right, takes four bulbs which you can fire individually or in groups of two, three, or four. You trigger them with a normal synchronization lead.

Tungsten lighting

There are two types of tungsten studio lighting. Tungsten filament bulbs are similar to household bulbs, but are more powerful. Tungsten halogen lighting uses more expensive round and tube-shaped bulbs, right. It is more efficient than tungsten filament lighting, easily portable and ideal for location work. You must handle the bulbs with care. A sudden knock can damage them, and grease marks on the bulb surface will also reduce working life. If you use them carefully the bulbs do not discolor and so maintain a constant color temperature, whereas tungsten filament lamps blacken with use. Both types of light are available as floodlights to give an overall soft light, and as spotlights for a contrasty, directional effect.

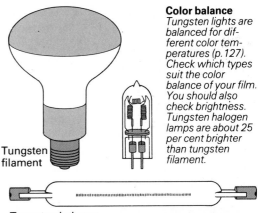

Tungsten filament

Tungsten halogen

Color balance
Tungsten lights are balanced for different color temperatures (p. 127). Check which types suit the color balance of your film. You should also check brightness. Tungsten halogen lamps are about 25 per cent brighter than tungsten filament.

Floodlights
The floodlight produces a diffused light with soft shadows, below. The more open the reflector, the softer the light. Both tungsten halogen and tungsten filament floods give a bright, even light.

Floodlight effect

Floodlight

Broad light

Floodlight types
Variations on the standard flood, above, include a broad light, left. The soft light, below left, gives uniform, almost shadowless illumination.

Soft light

Spotlights
Spotlights use a fresnel lens to produce a bright beam of light, giving strong shadows, below. A device on the rear allows you to adjust the light circle. A small beam intensifies contrast.

Spotlight effect

500W spotlight

150W spotlight

Mini spotlight

Spotlight types
A 500W spot, top, plus several 150W spots, above, can cope with most situations. The small spot, left, can highlight details.

111

Lighting attachments

Lighting companies make a number of attachments which fit in front of spots and floodlights, and provide changes in the nature and direction of the light. Square and umbrella-shaped diffusers, right, soften the light to give an almost shadowless effect. This is useful with subjects where shadows would obscure form or details. Scrims control the amount of light: each one you add reduces illumination by one stop. Half scrims are also available, so you can vary the lighting of different parts of a subject. Snoots reduce the size of the light circle, creating a directional beam, while barn doors provide an adjustable light area, from a broad spread of light to a narrow slit giving crisp shadows. You can also use barn doors to stop light aimed at the subject spilling across the camera lens.

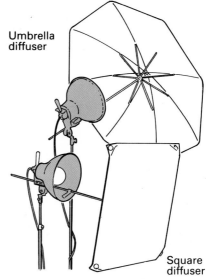

Umbrella diffuser

Square diffuser

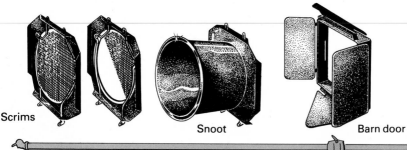

Scrims

Snoot

Barn door

Studio booms

Stands and booms

To support your lighting units, use stands which allow adjustments from ground level to about 8 ft (2½ m). Most stands comprise a telescopic pole on fixed or folding tripod legs. Fixed legs are usually strongest and have castors, making them best for studio work. Folding legs are useful on location. Special low-level tripods are also available. Booms give greater versatility. A heavy counterweight allows you to use a large lamp. With the clip, below, you can position lamps easily without using a stand.

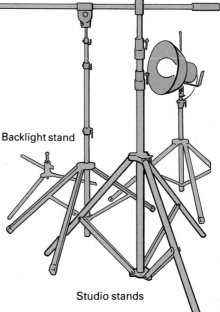

Backlight stand

Studio stands

Lighting clip

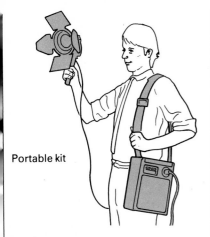

Portable kit

Batteries

Rechargeable batteries for tungsten lighting are available in belts or power packs with straps. Power duration with a 250W lamp varies from 25 to 60 minutes, and recharging takes 1 to 7 hours. The color temperature of battery-powered lighting can vary, so check performance if color is critical.

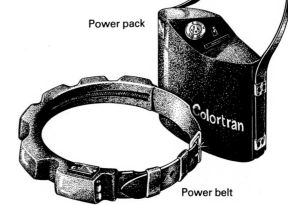

Power pack

Power belt

Portable kits

Compact lightweight single lamp kits, above, include a rechargeable battery and a 250W tungsten halogen lamp with barn doors. They are ideal for location work and you can use them either for direct light, or for light-painting techniques in big interiors.

Multiple kits

Large kits are available with two or more heads, lighting stands, a power pack, cables, a mains lead and a carrying case. Use them for all types of location work that need careful selective lighting. When running the lighting from the power pack you can use 250W lamps, while mains power will run lamps of up to 650W.

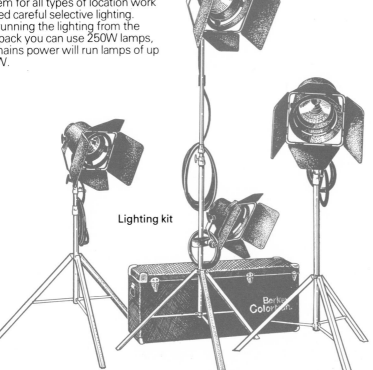

Lighting kit

Studio accessories

In studio work, you often have to make items required for a particular set-up yourself. But purpose-built accessories can at least provide the basics. Look for adaptability in all you buy. Background papers come in a multitude of colors – white is the most useful, as you can vary its tone and color with your lighting. Rolls are more convenient than sheets. Solid screens that can double as tables, reflectors, and diffusers save money and space as against individual items. To support papers, screens, lights, props, and cameras, you require a good range of adjustable holders, clamps, and stands that will secure your equipment firmly. The special effects machines available can create exciting images, but it is best to rent such expensive items.

Backgrounds

Paper rolls provide the most convenient method of creating plain and colored backgrounds. Their cost is high but you can extend their life by supporting them correctly. The larger rolls are very heavy and demand especially firm support. Frame tables take small rolls up to 6 ft (2 m) in width, giving a flat base for still life sets. You can also use folding stands, far right, for still life. You should store larger rolls, below, in a paper holder near ceiling height. This can be fixed to a wall or free standing. A ladder, below right, is also useful for supporting your studio equipment and cameras.

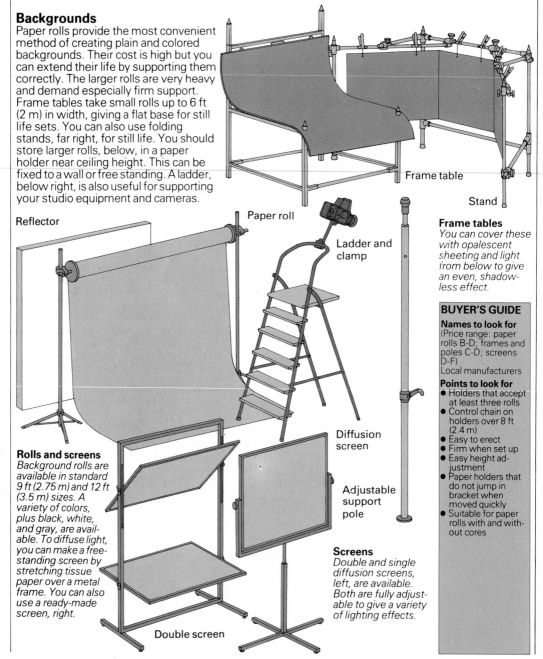

Frame table

Stand

Reflector

Paper roll

Ladder and clamp

Diffusion screen

Adjustable support pole

Double screen

Frame tables
You can cover these with opalescent sheeting and light from below to give an even, shadowless effect.

Rolls and screens
Background rolls are available in standard 9 ft (2.75 m) and 12 ft (3.5 m) sizes. A variety of colors, plus black, white, and gray, are available. To diffuse light, you can make a free-standing screen by stretching tissue paper over a metal frame. You can also use a ready-made screen, right.

Screens
Double and single diffusion screens, left, are available. Both are fully adjustable to give a variety of lighting effects.

Special effects machines

There are several machines widely employed in the film industry which you can also use for special studio effects. These machines are expensive and you should rent them from firms which supply film and theater productions. Wind machines are used in portraiture for their effect on hair and clothes. The fog generator, below, right, creates a variable mist, which you can use to mask unwanted background detail. It also creates aerial perspective and can produce a sinister or surreal atmosphere. With a cobweb fan, below, left, you can simulate the effect of cobwebs.

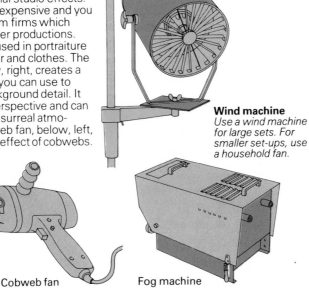

Wind machine

Wind machine
Use a wind machine for large sets. For smaller set-ups, use a household fan.

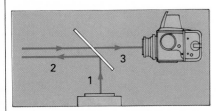

Cobweb fan

Fog machine

Front projection

Front projection is a more skilled technique than back projection (p.118). In addition to a conventional camera and projector, you require a half-silvered mirror and a highly reflective projection screen. With this equipment you can create location backgrounds in the studio and fit them into any still subject. Modern front projection units incorporate both camera and projector, removing the difficult task of aligning camera and projector on the same axis.

Projection unit
The combined unit is mounted on its own adjustable stand, for comfortable operation.

Aligning the camera
The image from the projector strikes the mirror, 1, and passes on to the screen, 2. It is reflected directly back to the camera, 3, to give a combined image like the one below.

Front projection effect

Front projection unit

Simple sets

Simple home or outdoor sets give you precise control over your images. By varying lighting, backgrounds, composition, props, and viewpoint, you can explore a wide range of subjects.

You do not require a large amount of equipment to start out. If you own a camera with a reasonable selection of accessories, and a reliable tripod, your biggest expenditure will be on lighting. You will have to choose between tungsten and flash lighting, or use a combination of these. You can shoot on daylight color film with flash whereas tungsten lighting requires its own type of film. Flash lights stay cooler and you can vary their strength easily. For simple set-ups, tungsten lighting is useful as a back-up. Two or three small flash units with modeling lights can provide the main source of light. Diffusers and reflectors will add versatility to your lighting.

A number of colored paper rolls, with sturdy supports, can provide a choice of background. If your budget is limited, buy white and black rolls and use colored gels over the lights. A drape can also act as a background and is required in any case to shut out daylight.

Most of the equipment in a simple studio of the type shown right is useful for a number of situations. Certain subjects, however, require particular equipment. For portraits, an off-camera meter is important. To preview results, you may want to use an instant picture camera or film back. Floor coverings, in addition to background materials and drapes are useful. If you want to use back projection, for unusual backgrounds, you must have a projector and screen. Furniture, a mirror, and other household props are often required in portraits. For still life you require a small table, and a lightbox for shadowless illumination. Boxes and wooden blocks are also useful for constructing sets for still life.

Home studio
Choose a room with generous dimensions. A good height is important as it will allow you to take low-angled shots without including the wall and ceiling join. If there is a window, cover it with a blind or heavy drape. Paint the walls a pale, neutral shade, or white, to avoid unwanted color reflections. Carpet prevents your tripods and stands from slipping. It also helps keep the room quiet.

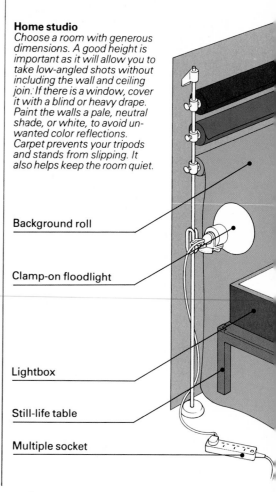

Background roll

Clamp-on floodlight

Lightbox

Still-life table

Multiple socket

Outdoor sets
Equipment for outdoor sets must be light, easy to handle, and packed in sturdy, waterproof cases. Depending on your subject, you may require portable lighting, folding windshields doubling as reflectors and backgrounds, and supports, as well as camera, tripod, and accessories. For nature photography, a hide is useful. Many nature reserves have their own; in other areas you must build one and camouflage it yourself. (Leave it up for a while before use.) For wildlife, your camera must have a quiet shutter. A long lens and a tripod are vital, and a zoom is useful. Remote control may save the need for a hide, and help to leave the habitat undisturbed. For insects, close-up equipment and flash are required, and for plants you must have a windshield.

Hide

The hide
Whether you buy a ready-made hide or make your own, you should still camouflage it on site with materials from the habitat. A long viewing slit and a reliable tripod allow you to cover a wide range of subjects. Trigger devices, placed in the path of your subject, either alert you, or fire the camera.

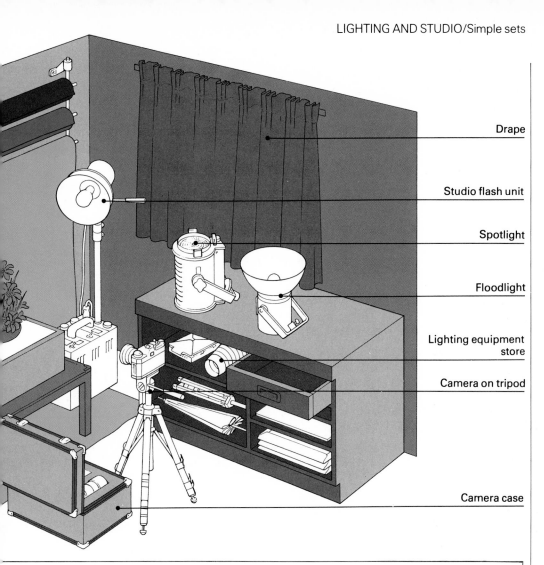

Drape

Studio flash unit

Spotlight

Floodlight

Lighting equipment store

Camera on tripod

Camera case

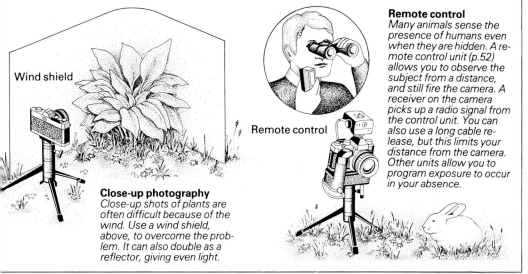

Wind shield

Remote control

Remote control
Many animals sense the presence of humans even when they are hidden. A remote control unit (p.52) allows you to observe the subject from a distance, and still fire the camera. A receiver on the camera picks up a radio signal from the control unit. You can also use a long cable release, but this limits your distance from the camera. Other units allow you to program exposure to occur in your absence.

Close-up photography
Close-up shots of plants are often difficult because of the wind. Use a wind shield, above, to overcome the problem. It can also double as a reflector, giving even light.

Professional studio

The set-up, right, shows a professional photographer's studio, although some professionals use an even greater array of equipment. For maximum flexibility, a studio at this level should have as much floor space as possible. A good basic size for a studio is 20ft × 20ft (6.1m × 6.1m), as this allows you to shoot full-length figures comfortably with a standard lens. Sealed and sanded boards are the best material for the floor. Avoid slippery surfaces like polished linoleum. Carpet provides an acceptable surface, with the additional advantage of quietness, but the pile may inhibit the movement of camera and lighting supports. A vibration-free surface is also essential. Keep the floor area uncluttered, and, if possible, remove skirting boards, so that you can place tables and flats close to the walls.

Use matte white paint on the ceiling and walls. White paint allows you to use bounced lighting techniques. You also avoid the color casts that sometimes result from colored walls. A high ceiling is best, as it permits low shooting angles. You will require a generous number of power points, plus four-way extension cords, for your lights and other accessories. For heating, use fan heaters or oil-filled radiators.

Base your studio equipment on the best camera you can afford. A large format camera, together with either a 35mm or medium format camera, provide the most useful combination. Sturdy stands and off-camera and flash meters are also essential. Electronic flash is excellent as a basic light source. It provides strong, controllable light, and the flash heads do not get too hot in continuous use. With flash lighting you can use one type of film for both studio and location work. For large sets you will require big power packs, while smaller units are suitable for portraiture and still life. You should equip these units with a range of attachments so that you can vary the quality of the light. Umbrellas, snoots, barn doors and large diffusers are all useful. A few tungsten lights allow you to use blur, as well as mixed lighting.

You can create light shields and reflectors by painting flats white on one side and black on the other. You can also make a portable diffuser by stretching tracing paper across a frame. Colored gels allow you to vary lighting effects further.

Use wide paper rolls in a range of colors for backgrounds. Preserve these by storing them on special holders. As paper becomes soiled, cut it from the roll and use it to make reflectors, or to protect clean paper laid on the floor. You can use a projector to create unusual backgrounds by projecting images on the back of a translucent screen. This technique, known as back projection, is much simpler than front projection (p.115).

You should start to collect props related to your main areas of interest. The most important props for general use are wooden blocks of various sizes. These act as supports and counterweights. It is also important to have at hand such items as scissors, tape, string, and cleaning materials.

Storage and administration

Some parts of the studio should be reserved for non-shooting uses. Set aside one area of the room for studio administration, right. Set up a bench where you can tackle paperwork, and a pinboard for posting exposure and reciprocity charts and other information. Adequate storage space is also essential. Have specific places for different items of equipment, accessories, and props. Wall-mounted storage units are useful as they allow more floor space. Otherwise, place your storage units flush against a wall so that they do not clutter the shooting area. Drawers, far right, are particularly useful for storing both equipment and props. Keep lenses in covered trays lined with foam rubber. These provide protection and easy access. Leave lens caps on, and covers on other equipment, when not in use.

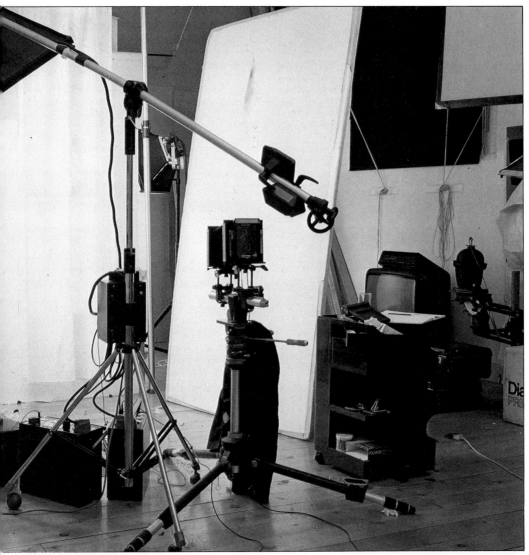

Administration area

Storage area

Slide projectors

If you want to take pictures on slide film you will require a projector to view the results. This is an expensive purchase, but slides are cheaper to produce than prints, and color saturation and clarity are greater. The major manufacturers produce models varying in complexity for the 110, 35mm, and 2¼ ins × 2¼ ins (6cm × 6cm) formats. Manual and automatic types are available, as well as autofocus models. All models are portable, and carrying cases are often available to hold projector, leads, magazine and bulbs. A projector's quality depends on its lens and its moving parts. A good lens is especially important: a good quality camera lens is wasted if your projector lens is poor. Look particularly at the edge of the projected slide. This is where any lack of image sharpness, or color fringing will show up. You should also check the projector's moving parts. Avoid noisy cooling fans and lenses with push-pull focusing. On automatic models the gate should be strong and must be able to cope with all types of slide mount, even when they are old.

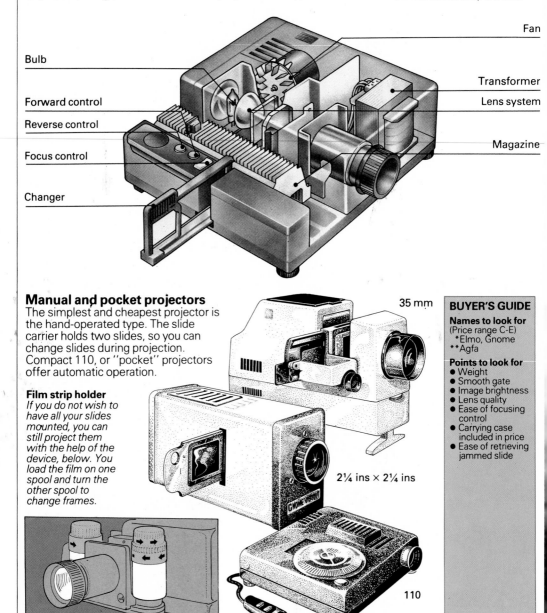

Bulb

Forward control

Reverse control

Focus control

Changer

Fan

Transformer

Lens system

Magazine

Manual and pocket projectors
The simplest and cheapest projector is the hand-operated type. The slide carrier holds two slides, so you can change slides during projection. Compact 110, or "pocket" projectors offer automatic operation.

Film strip holder
If you do not wish to have all your slides mounted, you can still project them with the help of the device, below. You load the film on one spool and turn the other spool to change frames.

35 mm

2¼ ins × 2¼ ins

110

BUYER'S GUIDE
Names to look for
(Price range C-E)
 *Elmo, Gnome
**Agfa

Points to look for
● Weight
● Smooth gate
● Image brightness
● Lens quality
● Ease of focusing control
● Carrying case included in price
● Ease of retrieving jammed slide

Semi-automatic projectors

With this type you can load your slides into a straight or circular magazine which you fit on the projector. You operate the slide changer manually and the magazine automatically moves along to align the next slide. Most models allow you to move the magazine forward or in reverse. These projectors vary greatly in quality, especially in terms of even illumination and lens sharpness. They can give good results at a reasonable price.

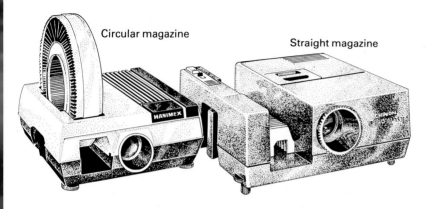

Circular magazine

Straight magazine

Automatic projectors

An automatic projector allows you to change slides at the touch of a button. Models are available which take straight or circular magazines. You can move the magazine forward or back, and many models have a remote control lead so you can correct focus and change slides without sitting next to the projector. You should also be able to project a single slide easily, without setting up a magazine. More expensive models have cast metal bodies which makes them more robust than plastic types. At the top of the price range are professional models, which are durable and will run for long periods without overheating. Their manufacturers offer a range of accessories, including interchangeable lenses, dissolve units, and tape-slide synchronizers (pp.122-3). There are also cheaper, plastic-bodied projectors offering adequate facilities for the serious amateur.

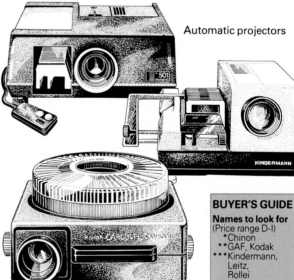

Automatic projectors

Reverse slide change

Forward slide change

Focus control

Remote control
This unit, left, has buttons for forward and reverse slide change, and a focus control which moves the lens.

Gravity feeder
Gravity feed, above, reduces wear on horizontal circular trays.

Autofocus projectors

Focus shifts can often occur during projection when a slide drops into a slightly different position to its predecessor. To avoid this, some automatic projectors use an automatic focusing device, so you do not have to adjust the focus control continuously.

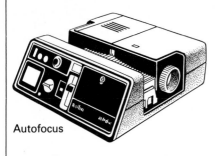

Autofocus

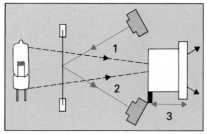

Autofocus principle
The autofocus mechanism enables the projector to compensate for changes in the distance between slide and lens. A light beam from an auxiliary light source (1) strikes the transparency and is reflected back to a sensor (2). This is connected to the focusing mechanism, which moves the lens back and forward (3) in order to focus it.

Interchangeable lenses

A number of automatic projectors have optional or interchangeable lenses. Some offer a fixed 90 mm lens with a slightly wide aperture as an alternative to the normal 85 mm. Interchangeable lens models provide a range of lenses for different projection distances. Focal lengths between 28 mm and 300 mm are available, and there is also a 70-120 mm zoom.

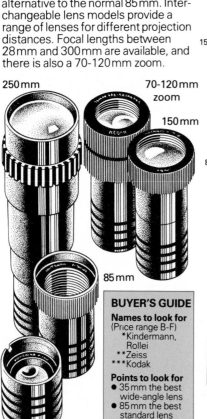

250 mm

70-120 mm zoom

150 mm

85 mm

35 mm

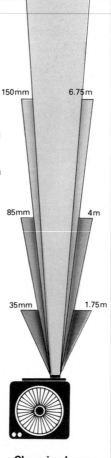

250 mm 11 m

150 mm 6.75 m

85 mm 4 m

35 mm 1.75 m

Changing lenses
The diagram shows focal lengths for a range of distances.

Screens

Matte screens are the least bright, but you can view them from any angle. Beaded screens are brighter, and are useful in rooms that cannot be fully blacked out. Silvered screens are more efficient, but you have to sit near the line of the projector. A carrying bag, below, is useful for your screen.

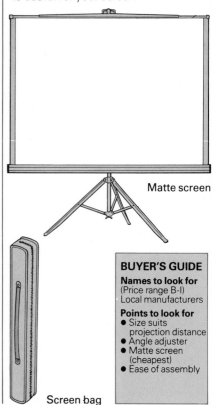

Matte screen

Screen bag

Projector systems

Projector systems vary from the basic two-lens projector, to sophisticated consoles for multi-screen shows. You can build up a projection system by buying accessories individually. Most important are a tape-slide synchronizer, a quick-change control and a variable dissolve unit. A quick-change control allows you to link two projectors, and with a synchronizer you can also program them and add a sound track. A dissolve unit can cross-fade two pictures, so one appears out of the other. Alternatively, you can use a console incorporating these controls. Projection units with an accompanying still/cine camera are also available.

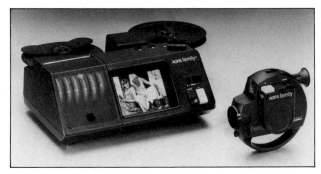

Still/movie projector
The Agfa system above incorporates a camera for both still and Super-8 movie photography. You use the same screen to view either kind of picture, and you can stop a movie to concentrate on a shot. The system has a connection for sound.

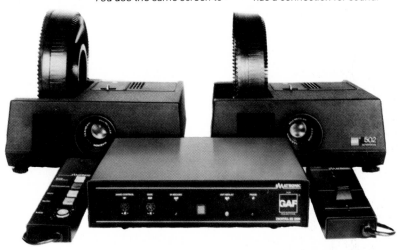

Dissolve system
A full dissolve system has two projectors, a console and a hand control unit. This one has a tape connection facility.

Twin-lens model
The twin-lens projector, above, gives a dissolve effect without extra equipment.

Hand viewers

Hand viewers provide a cheap and convenient way to view slides. They are ideal for previewing. Some models allow you to stack a limited number of slides in order. Main-operated models give better image quality than battery models.

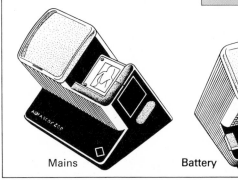

Mains Battery

Slide storage

Film manufacturers usually return your processed slides in cardboard or plastic mounts. Professional labs return film unmounted, so you can choose which shots to mount and which type of mount you want to use. Three types are currently available. Cardboard is cheap but not good for frequent projection or long term storage. Plastic mounts are more durable. Mounts with a glass covering over the film give the best protection and hold the film completely rigid. You can fix all mounts together by hand, but special mounters are available to make the job easier. You must store your mounted slides correctly, taking care to protect them from damp and dust. Keep them in your projection trays, in plastic sleeves, or in a specially designed slide box or cabinet.

Mounting

You can seal cardboard mounts by hand or with a mounter. You can assemble plastic mounts by hand, and both open and glass-covered types snap together easily under finger pressure. A mounter makes film alignment simpler with all kinds of mount.

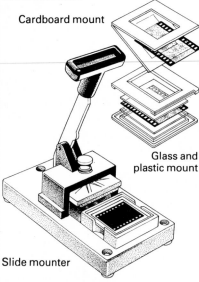

Cardboard mount

Glass and plastic mount

Slide mounter

Slide sorting

You can use a lightbox while sorting slides. A sloping desk type is most comfortable. Mark each slide's edge for correct alignment during projection.

Storage

If your projector trays have covers or are of the non-spill type, they are ideal for slide storage. Plastic sleeves in an album or filing cabinet are cheaper. Slides are easily scratched in these sleeves, so a box may be better. A cabinet with a built-in lightbox is probably the soundest investment.

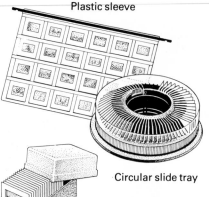

Plastic sleeve

Circular slide tray

Storage box

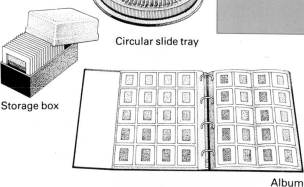

Album

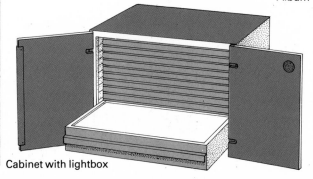

Cabinet with lightbox

BUYER'S GUIDE

Names to look for
Mounts
Local manufacturers
Kodak

Sorting desks
**Kaiser, Kenro, Macbeth, Wata

Points to look for
Mounts
- Glass-covered plastic mounts
- Mounter (for easier alignment)

Storage
- Sleeves (for economy)
- Wooden boxes (durable, reasonably priced)
- Cabinets (for large collections)

Film and darkroom materials
color and black and white film and paper/chemicals

Using the right film for the lighting conditions, subjects, or effects you have in mind can be critical. In the darkroom, the right combination of printing paper and processing chemistry is equally important. In both cases, the choice depends on understanding the properties of the different materials, and on your personal experience of using them. Once you have decided which type of film or paper/processing combination you like to work with, it is best to stay with it and get to know it thoroughly.

How photographic materials work
Both black and white and color photography depend on the light-sensitive properties of silver halides. These darken when exposed to light in proportion to the amount of light received. Since an image is composed of different intensities of light, it can be recorded on a silver halide emulsion coated on a film or paper base. The very brief camera exposure causes only minute, invisible changes. But when these are accelerated by chemical development, visible grains of black silver form. This image is a negative. It is also possible to form a positive silver image by fogging (exposing) and developing the so far unexposed halides. This is known as "reversal processing".

The emulsion design determines the characteristics of a film or paper. Fast films (high ASA) use emulsions that respond quickly to light, forming large clumps of black silver. Panchromatic emulsions are sensitive to the whole spectrum; orthochromatic ones to blue and green light only (and some emulsions are blue sensitive only). Color materials use three different emulsions superimposed on the same base. One records blue light, one green light, and one red light. The three silver images (negative or positive) receive different colored dyes (formed in processing).

Color relationships
To understand color materials, you must know something of the relationships between primary and complementary colors. By mixing or "adding" light of the three primary colors you can create all other colors. Two primaries make one of the complementary colors – yellow (red plus green), magenta (red plus blue), or cyan (blue plus green). All three primaries make white light (see below left). This principle of color formation is known in photography as "additive synthesis" and is used in some color printing methods. Most color materials use "subtractive synthesis", in which the three complementary dye layers act like superimposed filters. Each absorbs or "subtracts" one of the primary colors of light, and passes the two that make up its own color. Two dyes superimposed subtract two primaries; three subtract all three, leaving black or gray.

Additive synthesis

Subtractive synthesis

Color film

Before you choose a color film, you must first decide on the format (see below) and type of image you want. Color film is designed to produce either a negative or positive (slide) image. Color slides produce a positive directly from exposure and processing. Color negatives require a second stage of printing to make a positive with similar colors to the original subject (pp.128-9).

Both types of film are based on the same principle. On top of the film backing and base are three layers of light-sensitive emulsion – hence the name "tripack" (see facing page). These layers are balanced for contrast and speed (determined by the size of silver halide clumps used in manufacture), and each is made selectively sensitive to one primary color of the spectrum – blue, green, or red. When you expose the film in your camera, each layer is affected according to the color content of the subject. A predominantly blue subject, for example, will affect the blue-sensitive layer most. A subject with a good mix of colors should affect all three layers to a similar degree. With either system, the three dye layers must be superimposed on top of each other – on a film base for a transparency, and on a paper base for prints – to produce a full-color positive end result.

Another factor that should influence your choice of film is its speed. In low-light conditions, where you do not want to use any supplementary lighting, you will probably want to use a fast (high ASA/DIN number) film (one which responds quickly to light, because it has large clumps of silver halides). If you are shooting in bright conditions it is best to load your camera with a slower film. The other major factor governing film choice, especially important with slide film, is that of color balance (see facing page).

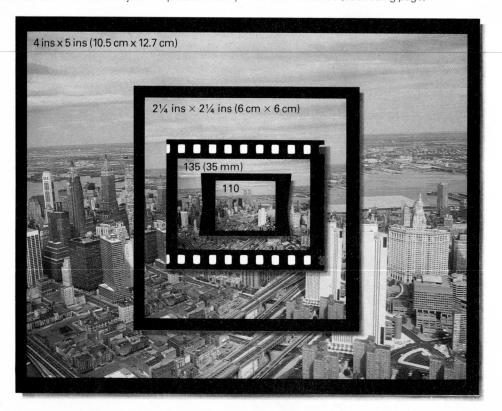

4 ins x 5 ins (10.5 cm x 12.7 cm)

2¼ ins × 2¼ ins (6 cm × 6 cm)

135 (35 mm)

110

Film sizes

Color films are commonly available in all sizes from 110 to 4 ins × 5 ins (10.5 cm × 12.7 cm). 8 ins × 10 ins (20.4 cm × 25.4 cm) sheet film is also made. Not all film types are available in every size. Film in sizes up to 2¼ ins × 2¼ ins (6 cm × 6 cm) is produced in rolls of varying length. 110 film is packaged in sealed cartridges and sold in lengths of 12 and 24 exposures. Film for 126 cameras is available in similar cartridges and lengths. Film for 35 mm cameras is supplied in light-tight cassettes of either 20 or 36 exposures. You can buy some types of film in large roll lengths for loading into bulk film magazines. Roll film for medium format comes in 12 or 20-exposure rolls, and some bulk film lengths are available (pp.200-01).

Tripack film structure

All color film has three black and white emulsion layers (see right). Each one is made of silver halide crystals sensitive to one of the three primary colors. Dye coupler molecules are also present in each layer (or added in processing). These have the ability to form a colored dye complementary to the color sensitivity of that layer. The first emulsion layer is blue-sensitive and has yellow-forming couplers. Next comes a yellow filter, which stops any blue light reaching the lower layers. The next emulsion layer is green-sensitive linked to magenta-forming couplers. The bottom emulsion layer is red-sensitive linked to cyan-forming couplers. The strength of color produced by these dye coupler molecules is directly proportional to the strength of the silver image. Under the last emulsion layer there is an antihalation layer to stop light reflecting back from the film base.

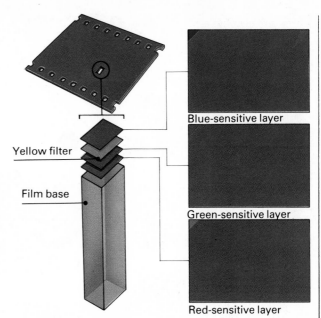

Yellow filter

Film base

Blue-sensitive layer

Green-sensitive layer

Red-sensitive layer

Color temperature

The color temperature of your light source will influence the appearance of the final image. Color temperature is measured in Kelvins. The chart below shows the color temperatures of the most common light sources. Daylight films are designed for color temperatures between 5200K and 5800K. This is the color temperature of average daylight in central latitudes. Special films, balanced for 3200K to 3400K, are available for use with tungsten lighting.

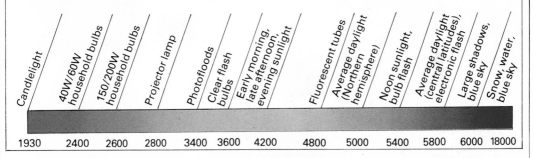

Candlelight	40W/60W household bulbs	150/200W household bulbs	Projector lamp	Photofloods	Clear flash bulbs	Early morning, late afternoon, evening sunlight	Fluorescent tubes	Average daylight (Northern hemisphere)	Noon sunlight, bulb flash	Average daylight (central latitudes), electronic flash	Large shadows, blue sky	Snow, water, blue sky
1930	2400	2600	2800	3400	3600	4200	4800	5000	5400	5800	6000	18000

Color film response

Because the two main types of lighting (daylight and tungsten) have very different color qualities (see above), there are two types of color slide film available to match them – type B tungsten, and daylight film (the latter is also balanced for electronic flash and blue flash bulbs). Used in daylight, tungsten film will produce a cold, blue result, right, not the well-balanced result of daylight film, far right. Daylight film used in tungsten light produces a warm, orange result. If you find yourself in the wrong lighting conditions for the film in your camera, you can use filters (p.82). Color negative film can be corrected in printing.

Color film and paper principles

Color materials are all similar in structure. They have three silver halide layers, each sensitive to a limited band of spectral wavelengths – blue, green, or red. Exposure produces latent images in each layer, which can be developed to black silver negatives. Processing results in dye images, colors complementary to the sensitivity of each layer. With negative film, the dyes are linked to the silver negative. With slide film, you must reverse the image: after developing the silver negatives you expose (fog) the unexposed halides to form latent positives, and development then forms linked silver and dye positives. The silver images are removed to leave the final color result. You can print both negatives and slides. Negatives are enlarged on negative/positive paper; slides are printed either on reversal paper (which works in a similar way to slide film), or on silver dye-bleach paper (which has built-in dyes that are bleached away to leave the color positive image).

Color relationships

The *primary* colors of light are blue, green, and red. Subtracting one primary from white light (which contains all colors) leaves a new color, the *complementary* of the missing primary. Color materials initially record a subject by its primary color content; but the final image forms in complementary dyes.

Color circle

This circle shows the color relationships schematically. Colors placed opposite each other are said to be complementary (together they make white light). Yellow is complementary to blue, magenta to green, and cyan to red.

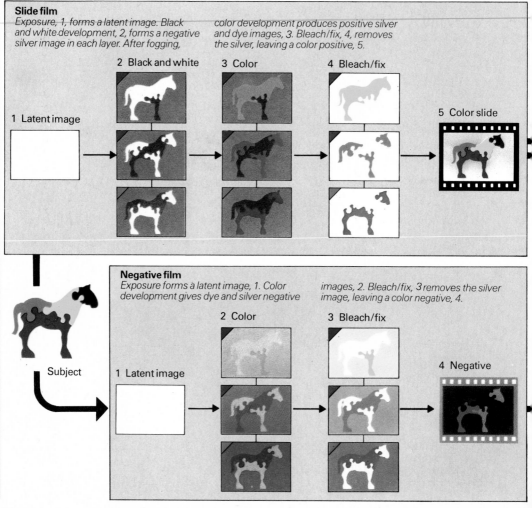

Slide film

Exposure, 1, forms a latent image. Black and white development, 2, forms a negative silver image in each layer. After fogging, color development produces positive silver and dye images, 3. Bleach/fix, 4, removes the silver, leaving a color positive, 5.

1 Latent image
2 Black and white
3 Color
4 Bleach/fix
5 Color slide

Negative film

Exposure forms a latent image, 1. Color development gives dye and silver negative images, 2. Bleach/fix, 3 removes the silver image, leaving a color negative, 4.

Subject
1 Latent image
2 Color
3 Bleach/fix
4 Negative

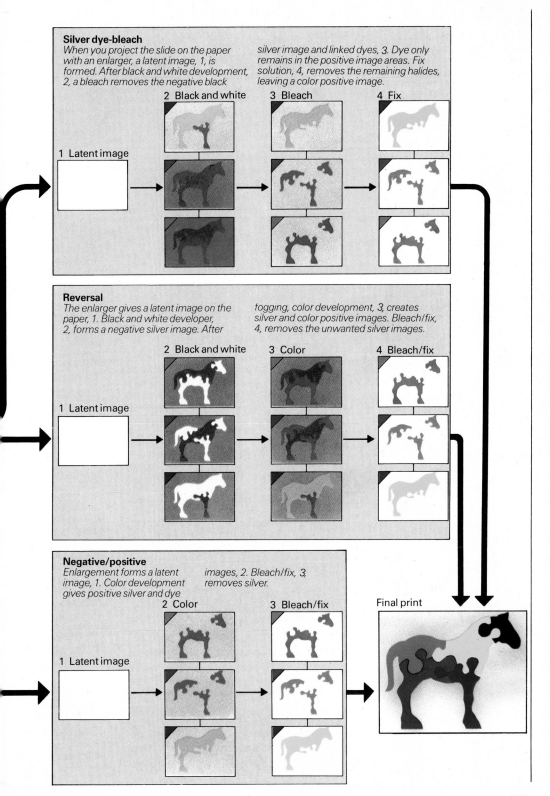

Silver dye-bleach

When you project the slide on the paper with an enlarger, a latent image, 1, is formed. After black and white development, 2, a bleach removes the negative black silver image and linked dyes, 3. Dye only remains in the positive image areas. Fix solution, 4, removes the remaining halides, leaving a color positive image.

1 Latent image

2 Black and white

3 Bleach

4 Fix

Reversal

The enlarger gives a latent image on the paper, 1. Black and white developer, 2, forms a negative silver image. After fogging, color development, 3, creates silver and color positive images. Bleach/fix, 4, removes the unwanted silver images.

1 Latent image

2 Black and white

3 Color

4 Bleach/fix

Negative/positive

Enlargement forms a latent image, 1. Color development gives positive silver and dye images, 2. Bleach/fix, 3, removes silver.

1 Latent image

2 Color

3 Bleach/fix

Final print

Color slide film

Color slide or transparency film is also known as color positive film because you obtain a film image with positive image dyes after camera exposure and film processing. To see slides at their best, you need a projector. Because you view them by transmitted light, color saturation is high and the brilliance of the subject greater than with a print of the same scene. As there is normally no printing stage with slide film, camera exposure is critical. If you are in any doubt, it is best to underexpose by about half a stop. This will increase color saturation and slightly sharpen contrast (see below). You can set the ASA/DIN selector on your exposure meter, if using a 200 ASA film, for example, at 150 ASA. The absence of a printing stage also means that you must take care to avoid color casts. If casts do occur, you can use a weak complementary filter to compensate when you are projecting slides.

Before choosing a particular brand of slide film, right, there are four things to consider. First, each brand has a slightly different color bias – some tend toward warm coloration, some toward a cooler effect, above. Second, if you're likely to shoot in tungsten lighting, select a film balanced to counter the excessive orange content, rather than use daylight film with an appropriate filter. Third, faster, higher-ASA films tend to have coarser grain, which affects the definition of the projected image. Fourth, you must decide whether you want to process the film yourself. Color slide film is available in two types – substantive and non-substantive. The latter does not have color couplers incorporated in the film emulsions, and must be processed by the manufacturer (p. 201). Processing is included in the cost of this type of film. Always take great care when handling slides – a damaged print can always be reprinted, but a damaged slide is lost forever.

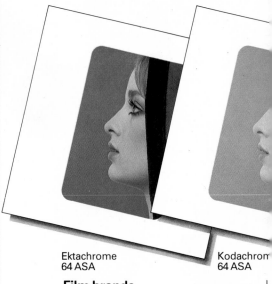

Ektachrome
64 ASA

Kodachrom
64 ASA

Film brands
Color reproduction varies slightly between the major manufacturers of slide film. The pictures, above, were taken with balanced lighting and filtration. Kodak films tend to exaggerate blue, especially in subject shadow areas. Skin tones are good, blues and reds bright. Greens can contain too much black. Fujichrome gives bright greens and reds, and a slightly desaturated blue. Sakurachrome produces warm flesh tones, good blues and reds, but weak green. Agfachrome offers bright blues and greens and a slightly desaturated red.

2 stops underexposed Correct exposure 2 stops overexposed

Exposure range
The exposure range of most slide film under average light conditions is restricted to about one stop either side of the ideal setting. Outside this limit color and details are affected noticeably. Underexposure results in an overall increase of density, above, left, with black predominating.

Overexposure produces a desaturation of color, above, right. The exposure tolerance depends on the subject contrast. If contrast is high, exposure tolerance is low, and vice versa. When contrast is very high, it is impossible to reproduce both highlight and shadow detail in one image.

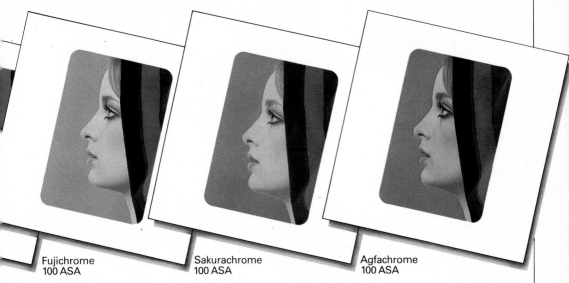

Fujichrome
100 ASA

Sakurachrome
100 ASA

Agfachrome
100 ASA

Choosing slide film

The table below shows which speeds of film, daylight and tungsten, are available for different camera formats. The availability of a wide range of films is important, particularly if you take pictures in a variety of lighting conditions. This may influence your choice of camera if you are starting out in photography. The 35 mm format has the best range. You can also buy bulk film for this format for use in 250- and 750-exposure magazines. This film is also available for medium-format cameras. The range for 110 cameras is restricted.

Film speed	110 (16 mm)	35 mm	2¼ ins x 2¼ ins (6 cm x 6 cm)	4 ins x 5 ins (10.2 cm x 12.7 cm)
16 ASA		Kodak		
25 ASA		Kodak Others		
50/64 ASA	Agfa Kodak Others	Agfa Kodak Others	Agfa Kodak Others	Agfa Kodak Others
80/100 ASA		Agfa Fuji Kodak Sakura Others	Fuji Sakura Others	
160/200 ASA		Kodak Others	Kodak	Kodak
400 ASA		Kodak Fuji		
40-160 ASA (Tungsten)		Agfa Kodak Others	Agfa Kodak Others	Agfa Kodak

Color negative film

Color negative film produces an image with colors complementary to those of the original scene. The second stage in producing a positive result is printing (which forms a positive image of the negative on paper). Finished prints take longer to produce than slides, but this second stage allows much greater control over the image's final appearance. Any slight color cast due to minor inaccuracies in processing, or the color content of your light, can be filtered out.

Laboratories will process and print your film, but they tend to produce images of a standard size, cropping, and filtration. If you develop the film yourself (all color negative film is user-processable), you will have more control over quality as well as being able to take advantage of the exposure latitude offered by color negatives (see facing page). There are slight variations in the color rendition between different brands of film, and some are compared below. Your main considerations when choosing film types (see facing page) should be their speed (and therefore apparent graininess), and the type of lighting you are likely to be shooting in. You can use most color negative film in daylight and tungsten conditions. Some 400 ASA film, in particular, is known as "universal" because of this feature. There are also "L" (long-exposure) tungsten films and "S" (short exposure) daylight films.

Film brands
Brands of color negative film, below, show slight differences in contrast and color rendition. You can either accentuate or minimize these effects during processing and printing.

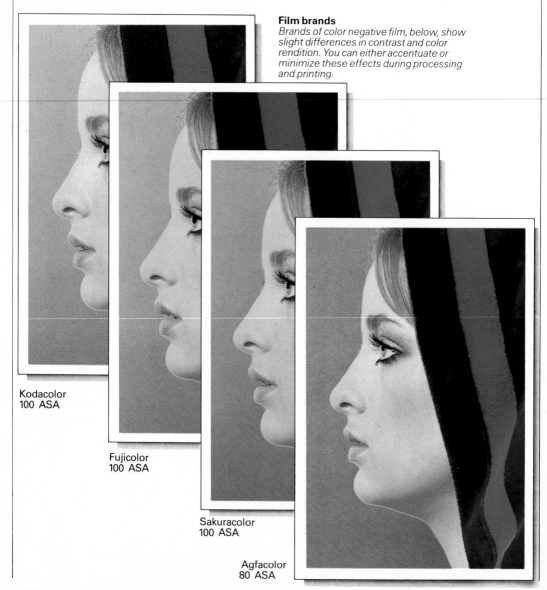

Kodacolor
100 ASA

Fujicolor
100 ASA

Sakuracolor
100 ASA

Agfacolor
80 ASA

Exposure range

Color negative film has a wider exposure latitude than color slide film, offering a greater range of image contrast. With careful processing and printing, you can create a good positive from a negative that is up to 2 stops under- or over-exposed, below. Professional laboratories will usually correct exposure errors in your negatives by 1 or 1½ stops, but printers may not want to do so.

Underexposed by 2 stops

Uncorrected Corrected

Correct exposure

Correct exposure

Overexposed by 2 stops

Uncorrected Corrected

Film choice

The chart below shows the types of daylight color negative film available for different formats. Tungsten films are also listed. The word "others" signifies manufacturers who do not distribute internationally. Both 35 mm and medium formats are well provided for, with a variety of film options. There is also a good range of negative films available for 110 cameras.

Film speed	110 (16 mm)	35 mm	2¼ ins x 2¼ ins (6 cm x 6 cm)	4 ins x 5 ins (10.2 cm x 12.7 cm)
40 ASA		Others	Others	
64 ASA		Others	Others	Others
80 ASA	Agfa Kodak Others	Agfa Kodak Others	Agfa Kodak Sakura Others	Agfa Sakura
100/125 ASA	Agfa Fuji	Agfa Fuji Kodak Sakura Others	Fuji Kodak Others	Fuji Kodak
400 ASA	Agfa Fuji Kodak Sakura	Agfa Fuji Kodak Sakura Others	Fuji Kodak Sakura	
32-125 ASA (Tungsten)	Kodak	Kodak	Fuji Kodak	Fuji Kodak Sakura Others

Instant picture film

All instant picture film comes in ready-to-load packs of 8 or 10 exposures and emerges as single prints. After exposure, the film passes through rollers in the camera, which break a pod of processing chemicals built into each individual exposure "packet". The major advantage of this film system is that you can retake the shot, if necessary, while the subject is still available. For this reason, professional photographers often use instant picture film backs on medium- and large-format cameras to check lighting and exposure before exposing conventional film.

There are two forms of instant picture material – peel-apart and integral. With the peel-apart system, you pull the film out of the camera, and after about a minute you peel the developed black and white or color print away from the backing material. With the integral dry print process, the camera ejects a flat, sealed plastic print, which develops a color image within one to five minutes.

The major drawback with instant picture film is that, in most cases, you do not have a reusable negative from which to make further prints. Also, all instant picture film is balanced for daylight/flash, not tungsten light, and the film types are not interchangeable – you must use the appropriate camera.

Color rendition is very susceptible to temperature fluctuations, light quality, color, and strength, and the age of the film.

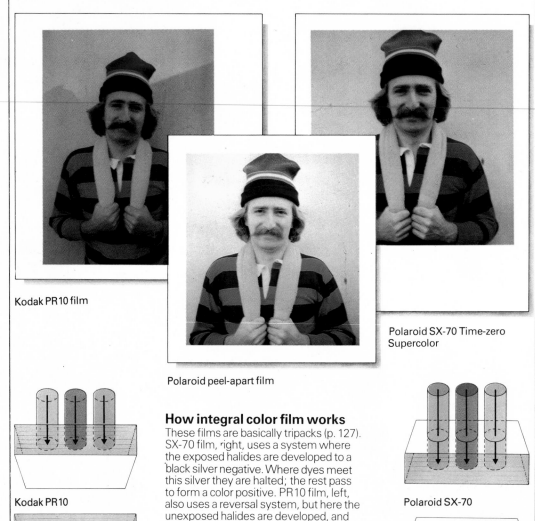

Kodak PR10 film

Polaroid peel-apart film

Polaroid SX-70 Time-zero Supercolor

Kodak PR10

Polaroid SX-70

How integral color film works

These films are basically tripacks (p. 127). SX-70 film, right, uses a system where the exposed halides are developed to a black silver negative. Where dyes meet this silver they are halted; the rest pass to form a color positive. PR10 film, left, also uses a reversal system, but here the unexposed halides are developed, and this activates dyes to form the positive. Because SX-70 dyes travel upward and PR10 dyes downward (necessitating a different camera design), the films *must* be used in the correct cameras.

Exposure range

The exposure range of instant picture color film is only about one stop either side of the ideal setting. Use the L/D control in difficult lighting/temperature conditions – otherwise leave it set at normal as all cameras use automatic exposure.

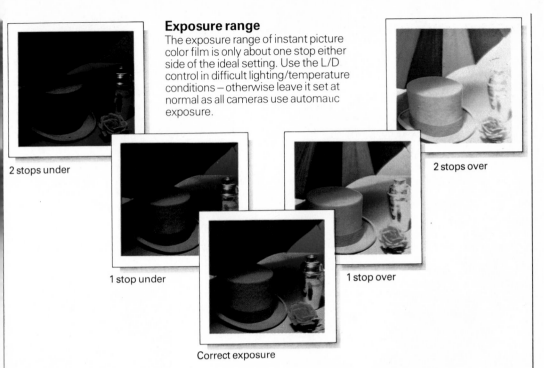

2 stops under

2 stops over

1 stop under

1 stop over

Correct exposure

Choosing instant picture film

The chart below shows the range of instant picture films, their speeds, uses, and the formats for which they are available. When choosing black and white peel-apart film, bear in mind that, with one exception, contrast is softer than with conventional film. But results do show much less grain and blacks tend to be richer. Peel-apart film for 8 ins × 10 ins (20 cm × 25 cm) backs requires a separate processor.

Result	Product name	Use	Size (ins/cm)	Speed (approx)
Color print	Polacolor 2 Type 58	Camera/back	4 x 5/10.2 x 12.7	75 ASA
	Polacolor 2 Type 668	Camera/back	3¼ x 4¼/8.3 x 10.8	75 ASA
	Polacolor 2 Type 88	Camera	3¼ x 3⅜/8.3 x 8.6	75 ASA
(Integral)	SX-70 Time-zero	Camera	3½ x 4¼/8.7 x 10.5	n.a.
	Kodak PR10	Camera/back	3¾ x 4/9.7 x 10.2	150 ASA
B & w high-speed print	Type 57	Camera/back	4 x 5/10.2 x 12.7	3000 ASA
	Type 107C	Camera/back	3¼ x 4¼/8.3 x 10.8	3000 ASA
	Type 87	Camera	3¼ x 3⅜/8.3 x 8.6	3000 ASA
	Type 47	Camera/back	3¼ x 4¼/8.3 x 10.8	3000 ASA
Positive/negative	Type 55 Pos/neg	Camera/back	4 x 5/10.2 x 12.7	50 ASA
	Type 665 Pos/neg	Camera/back	3¼ x 4¼/8.3 x 10.8	75 ASA
B & w fine grain print	Type 52 Polaplan	Camera/back	4 x 5/10.2 x 12.7	400 ASA
	Type 42 Polaplan	Camera/back	3¼ x 4¼/8.3 x 10.8	200 ASA
B & w high contrast print	Type 51 High contrast	Camera/back	4 x 5/10.2 x 12.7	125 or 320 ASA
B & w ultra high speed print	Type 410	Camera/back	3¼ x 4¼/8.3 x 10.8	10000 ASA
Transparency	Type 46L	Camera/back	3¼ x 4/8.3 x 10.2	800 ASA
	Type 146L	Camera/back	3¼ x 4/8.3 x 10.2	100 or 200 ASA

Special color film

There are a number of color films designed for specialist uses. Some of these can also be effective in general photography. Infrared and photomicrography films are primarily for scientific work, but create unusual colors with other subjects. Slide duplicating films, and negative films for high contrast or very long or short exposures, mainly serve professionals. For the darkroom, there are films to produce slides from negatives (print film), and negatives from slides (internegative film) for printing on neg/pos paper.

Special films are often available only in bulk cans, 120 rolls, or sheet form. Some, like duplicating film, require modified processing; others use processing chemistry no longer compatible with conventional films. For instance, photomicrographic and infrared films must be processed with E4 chemistry. Shooting with these films may also pose problems. Results are difficult to predict, and metering can be inaccurate, so that bracketing is advisable. Speeds may be slow, requiring bright light and a fast lens.

Special slide films

Duplicating films are slow, with low contrast, for copying slides. Ektachrome IR film records infrared radiations – from growing plants, for example – and is used with various color filters. Kodak photomicrography film is contrasty, for high-magnification images. Ektacolor print film is for darkroom work.

Image effects
Infrared film, below left, gives a striking color distortion when used with a yellow filter. Photomicro film, below right, promotes color and contrast.

Special color negative films

Very long or short exposures can cause shifts in color balance (reciprocity failure). Color negative films designed to offset this are marked "S" (short) or "L" (long). Kodak Vericolor Commercial is a high contrast film, giving bright color. Various low contrast internegative films are available.

Infrared film

Photomicrography film

Uprating effects

By shooting at a higher ASA than recommended and then extending development, you can increase ("uprate" or "push") a film's speed. Most color films will accept uprating by 1 or 2 stops (x2 or x4 normal ASA), with a slight increase in contrast. This can add brilliance to a dull scene. Uprating further will produce contrast fall-off and color casts (particularly with color negatives). You can also downrate ("pull") films, to reduce contrast. The slide image, right, is shown rated normally, center, uprated 2 stops, bottom, and uprated 6 stops, top.

Color papers

Different color papers are required for printing negatives (negative/positive paper) or slides (positive/positive types). Neg/pos papers work similarly to color negative film, altering the color of the exposed negative to form a positive print. Kodak and similar neg/pos papers require type A processing chemistry, while some Agfa papers require type B (pp. 138-9). Negative/positive papers are the cheapest, and available in the widest range. Processing is fairly simple. Most neg/pos papers are matched to the dye characteristics of their manufacturer's films. But it is possible to "cross-print" on other brands of paper, with varying results.

There are two kinds of pos/pos paper for printing slides. Reversal papers work similarly to slide film, using a re-exposure (fogging) stage during processing. These papers have very low contrast, to compensate for the higher contrast often found in slides. You can print any film brand, but should avoid overexposed or contrasty subjects.

Silver dye-bleach, or SDB, papers work quite differently: the dyes are incorporated in the emulsion during manufacture, and processing involves bleaching away unwanted dye areas to leave a positive. SDB paper is very slow, requiring long exposures, but sharpness and color quality are excellent. Processing requires few stages and these materials are tolerant of temperature variations. Excessively contrasty subjects should be avoided.

In general, color papers are available in a limited range of textures, and they come in only one contrast grade. Resin-coated types are now the most common, although a few fiber-based negative/positive papers are available.

It is important to store and handle color papers correctly. Most require refrigerated storage for best results, but SDB papers can be stored in a paper safe, as the dyes are very stable. All color papers will fog if handled under safelighting intended for black and white work. Depending on the manufacturer's specification, you should use either amber or sodium safelights or, better, work in complete darkness.

Every box of color printing paper has a label which gives the manufacturer's recommendations for exposure and filtration settings. When you use a new packet, or change to a different brand or type of paper, you may have to alter these settings to suit the new paper's characteristics. The label on the packet will show the basic filtration required for subtractive printing (for example, 15Y, 10M) and tricolor/additive printing (for example, red 60, green 40, blue 40). Cibachrome packets recommend subtractive filtration settings for each of the main film brands.

Choosing color papers

The table below shows the different types of color printing paper available. Both resin-coated and fiber-based papers are included. The table also shows the types of paper surface manufactured. These range from matte, through the smooth luster and "silk" surfaces, to the bright, glossy papers which are widely marketed by all manufacturers.

	Brand	Process	Gloss	Matte	Silk	Luster
				Surface		
Neg/pos	Agfa	Agfacolor	●	●	●	●
	Kodak	Ektaprint 2 or 3	●	●	●	●
	Fuji	Ektaprint 3	●		●	
	3M	Ektaprint 3	●		●	
	Sakura	Ektaprint 3	●			
(Fiber-based)	Lange Bartel (West Germany)	Agfacolor	●	●		
	Luminos (USA)	Agfacolor	●			
	Oriental (Japan)	Oriental P35	●			
Reversal	Agfachrome	Agfa 61	●			●
	Ektachrome RC14	Ektaprint R-14	●			●
	Sakurachrome	Ektaprint R-14	●			
Silver dye-bleach	Cibachrome	Cibachrome	●			●
	Fuji	Cibachrome	●			

Color film processing chemicals

Manufacturers supply chemicals for color negative and slide film in kit form, and you must choose the correct one for your particular film. You will find the process you require indicated on the film container.

In order to process slide and negative film to produce a permanent image, you must first convert the exposed silver halides in the emulsion layers to black metallic silver, using a developer. Color development uses the oxidation by-products of development to activate color couplers (p.127) located in the emulsion. (Some slide film has to be processed by the manufacturer because these couplers are added during processing.) With color negative film, there is only one developer, which produces both the black and white and color images. With slide film, first development gives a silver negative; after fogging, color development follows. The next stage for both film types is bleaching, which removes the unwanted silver image. This bleach usually contains a fixing solution, and is known as a "blix" solution.

For accurate processing, you must monitor carefully the temperature and concentration of each solution, the amount of agitation you give, and the time each stage takes.

Negative processing chemistry

Color negative processing follows similar principles to slide film, but there are only two chemical baths. The first, color development, forms a negative silver image and a dye image. The dye is produced in proportion to the density of the silver image formed at the same time. The second bath is a bleach/fix. This removes the silver image and any unused halides which remain. The final negative can be confusing to look at, because it has a built-in orange mask. This is compensated for during printing. As with reversal chemistry, you should only use the amount of solution required to cover the film. It is also important to use chemicals that are compatible with your film. Some processes, such as Agfa AP70 and Kodak C-41, are compatible. Uprating of negative films beyond one stop is not advised.

BUYER'S GUIDE

Names to look for
Agfa, Kodak, Paterson

Points to look for
- Compatibility with your film
- Financial saving with bulk purchases
- Containers properly sealed
- Liquid chemicals (easier to work with than dry)
- Non-toxic solutions (toxic materials require good darkroom ventilation)

Slide processsing chemistry

By far the most common processing chemistry for slide film is E-6. In general, for slide film you require four chemical stages (usually with washes between each). The first is a black and white developer, and this is followed by either a separate fogging solution, or one combined with the color developer (some older kits require you to take the film out of the tank and fog it to light). The next chemical stage is color development. At this point be careful of underdevelopment, as this may cause color casts and weak blacks. The last stage in slide processing is bleach/fix, which is usually combined in one solution but in some older kits they may be separate. During black and white and color development, the temperature of the solutions must be within the range recommended.

Containers and storage

If you store your chemicals carefully you will greatly prolong their working life. You should always keep solutions in a cool, dark, dry place. Avoid radiant heaters, direct sunlight and chemical fumes. Manufacturers often supply chemicals in large plastic containers with a sealed screw top. These are suitable for storing stop baths, fixers, and bleach/fixers. These solutions are not affected by air, so it does not matter if your containers are partly empty. Developers, though, quickly oxidize in contact with the air, losing their developing properties. You must therefore store them in tight, stoppered bottles. Accordion bottles are best. You can push these down to exclude the air as you use up the developer.

BUYER'S GUIDE

Names to look for
Agfa, Kodak, Tetenal/Beseler, Unicolor

Points to look for
- Compatibility with your film
- Chemical reversal (fogging by white light more time-consuming)
- Financial saving with bulk purchases
- Containers tightly sealed
- Liquid chemicals (easier to work with than dry)

Color paper processing chemicals

Color papers use a similar tripack principle (p.127) to color film. Because of this, processing chemicals and processing stages are also similar. Silver dye-bleach paper, though, requires different processing chemistry, as the dye layers are actually there in the paper structure and you do not require a color developer (see below). As with chemicals for color film processing (see facing page), chemicals for color paper processing are sold in kit form.

You can process all color papers in either trays, tanks or drums. Drums are the most convenient method. They are relatively easy to maintain at the correct processing temperature and use very little chemical solution. This means that you discard the chemicals after one use, so they are always fresh. Once you have loaded the drum, you have the added advantage of being able to work in normal lighting. Whatever the system, allow time for the chemicals to drain away after each stage. With tray processing, start removing the paper from the solution about 15-20 seconds before the recommended time; with drum processing, about 10 seconds. When washing prints, use running water. Some chemicals are acidic, so wear protective gloves.

Negative/positive processing
The two main neg/pos processes are Kodak Ektaprint 2 or 3 (type A) and Agfacolor PA or 85 (type B). Chemical kits for Kodak and Agfa papers are also made by independent manufacturers. Lesser known paper manufacturers also supply kits (based on the Agfa process). Tray processing with Agfa chemicals has seven stages: color development, stop bath, rinse, bleach/fix, wash, stabilizer, and rinse. This takes 17-18 minutes at 77°F (25°C). Drum processing requires an extra preliminary stage of warming the drum. The Ektaprint 3 tray process has four stages: color development, bleach/fix, wash, and stabilizer. This takes 8 minutes at 88°F (31°C). Drum processing involves prewarming the drum, and a pre-stabilization wash. Ektaprint 2 omits stabilization.

Positive/positive (reversal)
Reversal papers require chromogenic reversal processing (similar to slide processing pp.130-1). The sequence takes longer and is more complex than SDB processing. Black and white development is followed by fogging (to reverse the image), color development, bleach/fix, and wash. Kits are supplied by the manufacturer, and also independently. All reversal papers use basically the same processing, so you can use kits from Agfa, Kodak, or others. Some kits require you to expose the paper to white light; with others the reversal is done chemically. Processing time is about 16-20 min, at 86°F (30°C). The stages are: presoak; black and white development; wash; (reversal exposure;) color development; rinse; bleach/fix; wash.

Positive/positive (silver dye-bleach)
The SDB (Cibachrome) process works on an entirely different principle from the reversal process, and is simpler. The dyes are already present in the paper. After exposure, a black and white developer creates a negative silver image. Then a dual-purpose bleach removes the silver image and the dyes associated with it, to leave a positive dye image that only requires fixing. Processing kits, right, are supplied by the manufacturer. The chemicals are in liquid form, and you make up one-shot solutions for each printing. Drum processing is recommended (but you can use trays) in the following sequence: development, wash, bleach, wash, fix, wash. This takes about 12 minutes at 86°F (30°C).

Black and white film principles

Black and white films contain light-sensitive silver halide crystals. Exposure in the camera causes these halides to darken, creating small amounts of black metallic silver in the crystals. The longer the exposure, the more darkening of the crystals takes place. In this way the variations in a scene's brightness are recorded as different densities on the film. The image thus created is not visible but latent. Development is required to make the image permanent and visible. The developer magnifies the silver image many thousands of times – this renders the image visible. But the process is not complete. Some of the silver halide crystals are not fully used by exposure. These remain sensitive to light. They must be removed before you view the image, otherwise they will darken, making the image invisible. To prevent this you use a fixer. This converts all the unused silver halides into soluble salts, which you later remove when you wash the film. A stop bath between the developer and fixer stops development at an exact point. It also helps prolong the fixer's life.

Some black and white films produce an image in dye, rather than black silver. These films (see facing page) give improved image resolution.

When you have processed your film, you will be left with a negative image of the subject. Bright areas of the film (highlights) affect the film most, and appear darkest. The dark areas of the subject have least effect, so they appear light on the film. You can reverse the tones of the negative by printing. To do this you can either place it in contact with another emulsion (contact printing), or project its image on an emulsion, with an enlarger. Contact printing produces an image the same size as the negative. Projection printing allows you to reduce or enlarge an image at will.

If you want to produce black and white slides for projection on a screen, you can use a reversal processing kit to make a positive image on the film. If you use this method, you must rate the film at three times its stated speed. Not all print films are suitable for reversal processing. You will get the best results if you use slow film.

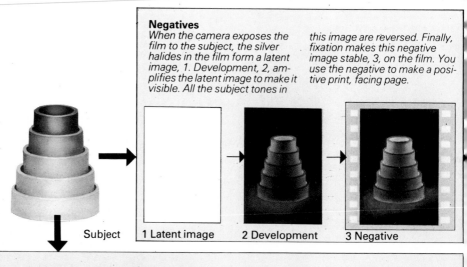

Negatives
When the camera exposes the film to the subject, the silver halides in the film form a latent image, 1. Development, 2, amplifies the latent image to make it visible. All the subject tones in this image are reversed. Finally, fixation makes this negative image stable, 3, on the film. You use the negative to make a positive print, facing page.

Subject | 1 Latent image | 2 Development | 3 Negative

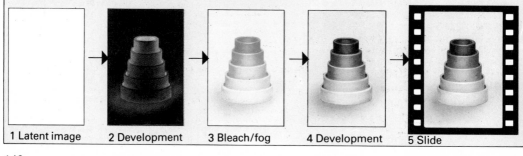

Slides
Some black and white negative films allow you to produce a positive slide for projection on a screen. (There are also films designed specifically for slides, Agfa's Dia-Direct and Kodak's direct positive film.) Camera exposure creates a latent image, 1, on the film. You then use a developer, 2, to produce a black silver negative image. Next bleach the film, 3, to remove the silver image. This does not affect the remaining unexposed halides, which you fog to light. Fogging creates a positive latent image, which the second developer, 4, renders visible. The final result is thus a positive transparency, 5.

1 Latent image | 2 Development | 3 Bleach/fog | 4 Development | 5 Slide

Non-silver negative films

Some recently introduced black and white films produce a color dye image instead of the usual black metallic silver image. These films are compatible with the C-41 color negative process. But you can also obtain a special full processing kit for Ilford non-silver negative films, designed with the amateur in mind. The total processing time is 26 minutes at 86°F (30°C). Dye-image films still use silver halides to produce the latent image, but the halides are removed by the developing chemicals. You print the resulting dye image on regular bromide paper to create a normal black and white print with a full range of tones.

This type of film has a very wide exposure tolerance. This means that it accepts exposure errors much more readily than regular black and white films. You can also expose it at a wide range of ASA speeds. This allows you to choose either the fine grain available at a slow speed, or to select a higher speed with slightly coarser grain. At all speeds, however, grain is finer than on conventional black and white films. Films are available that you can rate at between 400 ASA and 1600 ASA, and between 125 ASA and 1600 ASA. You can uprate the latter to 3200 ASA, although grain at this speed may be too coarse for some situations.

Positive print

When you expose the negative to printing paper, 1, a latent image forms. Development, 2, amplifies the effect of exposure, making the image visible. Dense areas in the negative represent highlights in the subject. Because they stop the greatest amount of light, these areas appear as highlights in the print, 3. Conversely, highlights in the negative become dense in the print.

1 Latent image 2 Development 3 Print

The formation of the silver image

Films are covered with a light-sensitive material which is a mixture of silver halides and gelatin. The gelatin allows processing solutions to act on the halides without disturbing the image. The illustrations, right, show what happens to the halides at different stages in the processing cycle. Developing agents affect the unexposed as well as the exposed halides, but the exposed crystals are affected much more quickly. Developing time is therefore adjusted, with the result that only exposed crystals are affected.

Latent image
Camera exposure weakens the structure of the halides, and tiny particles of black metallic silver are formed.

Development
Development accelerates the growth of the black metallic silver, until it produces a visible image of the subject.

Fixing and washing
Fixation converts the unused silver halides to soluble salts. These are removed from the film by washing.

Black and white film

Black and white film is available for every camera format, the widest choice of types being in 35 mm. The first consideration in selecting a film is its speed (sensitivity to light). This is determined by the size, type, and thickness of silver halides in the emulsion. Speed ratings of conventional black and white films range from 20 ASA to 1200 ASA. The popular medium speed films (125 ASA and 200 ASA) suit most conditions and have good image quality, grain, and resolution. Slower films (100 ASA or below) have finer grain and higher contrast. In average to bright light, they will render fine detail, and they give almost grain-free enlargements. Fast films (400 ASA and above) are grainy and of lower contrast. Use them in low light, or to gain higher shutter speeds when you are shooting moving subjects.

If you require a faster film than you have available, you can "uprate" your film — set a higher ASA on the dial, and compensate with longer development when processing. Results with conventional films will show increased grain and contrast. The new dye-image films can be rated at any setting from 125 ASA (or 400 ASA) up to 1600 ASA without affecting the quality of the final image.

With tungsten lighting, the speed of black and white film is reduced by ½ – 1 stop. With flash speed

Grain

The black silver particles in film group together to produce a pattern of grains which you can see when the negative is enlarged. Graininess is affected by film speed (the faster the film, the coarser the grains) and the type of developer used. To produce fine-grain results, you must use a fine-grain developer. The details below show the effects of fine-grain, extra-fine-grain (or solvent type), and high-energy developer.

Magnification
All the details on this page are magnified 30 times from 35 mm negatives.

	Extra-fine grain *Grain is finer, speed and contrast lower.*	**Fine grain** *Grain is fine, film speed and contrast normal.*	**High energy** *Grain is coarser, the image less distinct.*
Slow film *With 32 ASA film, right, extra-fine-grain developer gives the finest grain. High energy developer gives a very contrasty result.*			
Medium-fast film *The details, right, shot on 400 ASA film, all show coarser grain than the 32 ASA results. But the fine-grain developers improve this.*			
Ultra-fast film *With 1250 ASA film, right, grain is very coarse. The enlarged image is broken up, even with extra-fine-grain developer.*			

is the same as in daylight, but there is sometimes a drop in contrast. A 10 per cent longer development corrects this. With very long or very short exposures, you must correct most films for reciprocity failure. Use a wider aperture and shorter development.

110 and 126 film is sold in 12 and 20 exposure lengths packed in cartridges. 35 mm film is packed in cassettes in 20 and 36 exposure lengths. (Ilford produce a 72 exposure cassette.) You can also buy popular films in bulk lengths of 5m, 17m, or 30 m. A 30 m length will fill 18 cassettes of 36 exposures at about half the price of pre-loaded cassettes. 2¼ ins × 2¼ ins (6 cm × 6 cm) rollfilm is available in 120 (12 exposure) and 220 (20 exposure) lengths. 4 ins × 5 ins (10.2 cm × 12.7 cm) cut film is available in packets

of 50 or 100 sheets. The short side of each sheet is notched to indicate the emulsion surface.

Most black and white films used in the camera are panchromatic (sensitive to all colors). Panchromatic film is suitable for all types of work. However, it has a high sensitivity to blue, so on hazy days or in snow it is best to use a UV, skylight, or pale yellow filter. It is least sensitive to green, and any mass of green, such as grass, will appear too dark on the print unless you use a light green or yellow filter. Orthochromatic (sensitive to blue and green) and blue-sensitive films are sold in sheet form for studio and darkroom work.

Development

The type of developer you use, the time of development, the temperature, and the degree of agitation all affect the performance of black and white films. An increase in time, temperature, or agitation produces an increase in contrast. A decrease in any of these factors, or the use of exhausted developer, causes a loss of contrast and density. The three details, right, were shot on 400 ASA film and show the effects of different degrees of development.

Underexposed/ overdeveloped
Grain is coarse, but contrast and density are high.

Normal exposure and development
Grain, image contrast, and density are all acceptable.

Overexposed/ underdeveloped
Grain is fine, but contrast and density are low.

Choosing black and white films

The chart shows the range of black and white panchromatic films available from international manufacturers. Adox films are available by mail order only. In addition, local manufacturers produce some black and white films for the smaller formats.

A wide range of 125 ASA and 400 ASA films is available. There is a good choice of films in 35 mm and larger formats, but the choice of black and white 110 films is very limited.

BUYER'S GUIDE
Names to look for
(Price range A)
Local manufacturers
Adox, Agfa, Ilford, Kodak
Points to look for
● Low light capability (400 ASA and above)
● Fine grain (32 to 50 ASA)
● Chemicals or development facilities available
● Bulk film availability

ASA	20	25	40	50	100	125	200	400	1250	Variable
110					Kodak					
35 mm	Adox	Agfa	Adox	Ilford	Adox Agfa	Ilford		Agfa Ilford Kodak		Agfa Ilford
2¼ ins x 2¼ ins (6 cm x 6 cm)	Adox	Agfa	Adox	Ilford	Adox Agfa	Ilford Kodak		Agfa Ilford Kodak	Kodak	
4 ins x 5 ins (10.2 cm x 12.7 cm)		Agfa			Agfa	Ilford	Kodak	Agfa Ilford	Kodak	

Special black and white film

Most of these films were designed originally for scientific, professional, or printing reproduction work. But the unusual or high quality images they can produce give them wider application. There are two main types: 35 mm films (often in bulk) for camera work, and sheet films for the darkroom. Of the first group, infrared film produces the most striking images, particularly with landscape. Ultra-high speed recording film gives atmospheric, grainy effects with low-light subjects; reversal films allow you to shoot slides directly; while various duplicating films are available, including a high-contrast type. Darkroom films are usually slow, and blue-sensitive or orthochromatic. They include films for duplicating, contacting, and enlarging, and films which radically alter the tonal range of the original: lith and line film, which convert continuous tone into abstract, high-contrast images; autoscreen which forms a dot image resembling newsprint, and equidensity film. Most of these require special development, and involve several stages of image derivation.

Equidensity (Agfacontour) film

This unique darkroom film has two emulsion layers. One forms a negative image, the other a positive. The result is that both highlights and shadows record black, but one chosen mid-tone value records as clear film. Complex image derivations are possible, below, to give results similar to line separations, or to solarization.

Equidensity film effect

Autoscreen film

This is a lith film, prefogged in manufacture with a fine cross-screen. It converts a normal image, below left, into one composed of different-sized dots, below right. It is used mainly for photo-silkscreening and lithography.

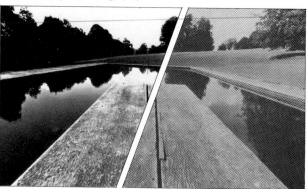

Normal Autoscreen

Infrared film

Black and white IR film has extended sensitivity, into the infrared region of the spectrum. Used with an IR filter over the lens (to exclude visible light), it gives unusual tonal effects. Green foliage appears white, blue sky black. Used with infrared flash, below, it records subjects in darkness.

Reversal film

Direct positive, panchromatic camera films are designed for shooting black and white slides, or copying color or black and white originals. They have medium speed and fine grain, and are sold only in 35 mm rolls. Alternatively, you can use normal negative film, reversal processed (pp. 140-1). Slow films will normally give the best results.

Black and white papers

Regular black and white printing papers have a silver bromide emulsion on a paper base, and are blue-sensitive, requiring orange safelighting. (Panchromatic bromide papers are also available, p. 147). Resin-coated papers are now commoner than fiber-based types, and are easier to use – total processing time is reduced, glazing is not required for a glossy finish, and prints will dry in air without curling. Bromide papers come in a range of sizes, surfaces, and contrast grades (see below) and in single or double-weight (fiber-based) or medium-weight (resin-coated). Glossy paper is available in all makes, types, and sizes. It can be given a high gloss or semi-matte surface according to the method of drying. A high gloss gives rich blue-blacks, but retouching is difficult. Matte surfaces are ideal for retouching, but blacks look grayer. Other paper surfaces, such as luster, stipple, silk, and matte, vary slightly between manufacturers. Base tints of regular papers include white, ivory, and cream.

Paper grades

Bromide papers come in a range of contrast grades (from 0 to 5, or 1 to 6). Low-contrast, or soft, papers give weaker blacks and reproduce more tones of gray than high-contrast, or hard, papers. Hard papers require longer and more accurately timed exposures than soft. Grade 2 (normal) suits negatives of average contrast. The prints, below, show the effect of enlarging a normal-contrast negative on six grades, from soft to very hard (left to right).

0 1 2 3 4 5

Choice of papers

The chart below shows sizes, grades, and surfaces of paper from three international makers. Some may have to be ordered specially. Other widths of roll are also made. Papers are sold in boxes, or smaller packs of 25/50 sheets. Not all grades are available in small packs.

Size	ins cm	5x7 12.7 x 17.8	8x10 20.3 x 25.4	8¼x 11¾ 21x29.7	11x14 27.9x35.6	16x20 40.6x50.8	Roll 20x1200 50.8x3000
Glossy		Ilford 0-5 Kodak 1-4 Agfa 2-3	Ilford 0-5 Kodak 1-4 Agfa 1-6	Ilford 0-5 Kodak 1-4	Ilford 2-4 Kodak 1-4 Agfa 2-6	Ilford 1-4 Kodak 1-4 Agfa 2-6	Ilford 5 Kodak 1-3
Matte or Semi matte		Ilford 2-3	Ilford 2-4				Ilford 2-4
Luster		Kodak 1-3	Kodak 1-3	Kodak 1-3	Kodak 1-3	Kodak 1-3	
Stipple Velvet			Ilford 2-4				
Silk		Agfa 2-4	Agfa 2-3				

(Column header "Sheet" spans 5x7 through 16x20.)

Special black and white papers

Many papers are manufactured with emulsions or bases differing from those of normal bromide paper. Panchromatic bromide papers are useful for accurate tonal reproduction of color originals. Multigrade papers allow you to vary contrast grade by altering enlarger filtration, providing a convenient alternative to buying paper in different grades. Chlorobromide papers give a warm brown image instead of the colder blue/black of bromide paper. Expensive stabilization papers contain developing agents in the emulsion and are used for quick proofing (with a special processor) in press work. The most popular special papers are the high-contrast types: lith and line papers (which may be hard to obtain), used to reduce continuous tone negatives to stark, totally simplified

prints, and document and other copying papers, useful for contact-printing original graphic work. Reversal paper (also high-contrast) gives a positive print direct from a positive original or slide.

Papers with colored bases, or unusual base materials, are sold mainly by specialist suppliers. Colors include silver, gold, and a range of strong tints; the developed image is black on the colored base. You can use fabric dyes on fiber-based papers for similar results. Linen bases can give a canvas-like look to prints. Opalescent plastic-based materials can be viewed as normal prints in reflected light, or backlit as large transparencies. Aluminum-based materials are rigid, durable, and very costly. Mural papers give extra-large prints with strong texture, for wall display.

Multigrade paper

This variable-contrast bromide paper has a dual emulsion which, with the correct filters, can provide a set of contrast grades, below, similar to conventional papers (p. 145). Blue-sensitive halides give the high-contrast effect, green-sensitive ones the low-contrast effect. Contrast is controlled with enlarging filters – magenta to control the green-sensitive layer, yellow to control the blue-sensitive layer. Normal-contrast negatives are printed with no filtration (grade 2). Starter kits include all the necessary items: 25 sheets of paper, the filters, a calculator disk (to assess exposure), and chemicals for processing. For gelatin filters, you require a holder which clips to the enlarger lens; the larger, acetate filters are placed in the filter drawer. Some enlarger heads incorporate multigrade filters; you can also use the filter settings on a color head. Multigrade papers are available in all standard sizes, fiber-based or RC, and in glossy or pearl surfaces.

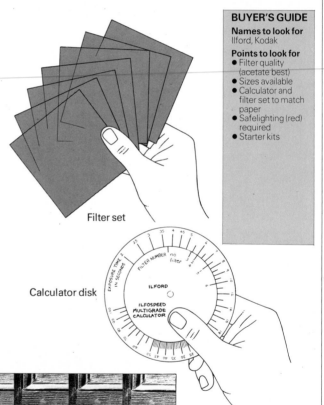

Filter set

Calculator disk

ILFORD
ILFOSPEED
MULTIGRADE
CALCULATOR

BUYER'S GUIDE

Names to look for
Ilford, Kodak

Points to look for
- Filter quality (acetate best)
- Sizes available
- Calculator and filter set to match paper
- Safelighting (red) required
- Starter kits

Using multigrade paper
The prints, left, show contrast results with Ilford filters. You can also use color head settings (filtrations in brackets). With a calculator, above, you set the filter and exposure time scales to values used for a test print, and read off settings for different contrasts.

| 1(45Y) | 2(30Y) | 3(15Y) | 4(50M) | 5(75M) | 6(100M) | 7(170M) |

High contrast papers

As well as ordinary grade 5 bromide, there are various specialist high-contrast papers. Lith paper is now hard to obtain. It is a slow, orthochromatic paper which, like lith film (p. 144), must be processed in special lith developer. With normal development, it gives high-contrast prints with rich blacks. Reduced development gives sepia or yellow-toned prints of lower contrast. Line papers (like line film, p. 144) can be processed in ordinary concentrated print developer. They give rich black, high-contrast prints, but cannot give sepia tones. Document papers are matte, neutral black, extra-lightweight papers for contact printing. These and similar materials are used largely in graphic design, for copying plans, drawings and lettering.

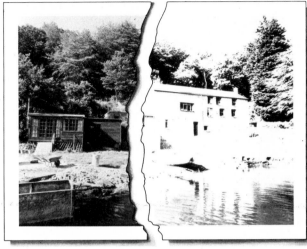

Normal contrast (bromide) High contrast (line)

Reversal paper

Reversal or direct positive paper is a blue-sensitive, high-contrast bromide paper which gives a positive print directly from a slide or positive original. Its unique emulsion requires only normal bromide development and fixation to give the positive. Reversal paper is available either in enlarging weight, or as light-weight contact paper for copying flat originals such as maps or artwork by the reflex printing method (with a yellow filter). The paper gives high contrast, unless "flashed" (pre-exposed) to achieve gray tones.

Panchromatic papers

You can make monochrome prints from color negatives on regular bromide paper. But results may be contrasty, because this paper is sensitive only to blue light. Other colors may print at the wrong density – reds will go black, for example. Panchromatic bromide paper is sensitive to the whole visible spectrum and gives monochrome prints with a good range of tones from color negatives. But you must work with only a dim green safe-light or, better still, in complete darkness. Pan papers are available in three grades, and in various sizes and surfaces.

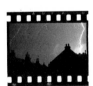

Slide

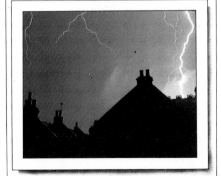

Reversal print

Regular bromide

Panchromatic

Black and white processing chemicals

The three main chemical solutions required for black and white processing are developer (to form the silver image), stop bath (to halt development), and fixer (to remove unexposed halides, fixing the image). Of these, the developer has the greatest effect on the final result. Optional processing chemicals include replenishers (to top-up solutions), hypo eliminator (to clear fix from the film and speed washing), and a wetting agent (added to the final rinse to reduce drying marks). For more advanced work you may require intensifiers or reducers, to adjust negative density.

There are many types of developers, and each brand also has its own characteristics. Universal types can be used, at different dilutions, for films or papers, but are not recommended for small format film. Fine-grain developers are best for most films, but general purpose types may suit large format and

very fast film. Print developers are available to give cold, neutral, or warm blacks, and there are also chlorobromide and variable contrast types. High-speed developers are made for both films and papers, as are the special lith developers required with lith materials. Reversal and dye-image chemicals are sold as kits.

You can buy most chemicals as concentrated liquids, which are convenient to use. Powders are cheap, and store well, but mixing them is time consuming. You can also make up some formulae yourself. When mixing chemicals, follow instructions with care, wear gloves, and work in a well-ventilated room. Store stock solutions in full, airtight bottles at room temperature. You should use your developers on a "one-shot" basis – discarding each solution after use (unless you are bulk processing quantities of film of one type).

Universal developers

These developers are convenient because you can use them, at different dilutions, for both films and papers. With film, however, they have some limitations. They allow quick processing but do little to control grain – their chemistry is a compromise between the requirements of the different materials. They are best limited to large formats, and are not recommended for 35 mm or fast roll films. With papers they give good results, but for some work a print developer may be better.

Universal developers use one of two reducing agent combinations: MQ – (metol/hydroquinone) or PQ (phenidone/ hydroquinone). The hydroquinone component is fast-working, vigorous, and gives high contrast. The metol or pheni-done component is slow-working and gives low contrast (phenidone being the more efficient). The two components together give a balanced developer of normal contrast. Alkali chemicals in the solution control reducing agent activity: mild alkali produces a soft, slow developer; strong alkali gives a very active, contrasty developer. Other chemicals are present to improve the keeping qualities of the developer.

General purpose developers

Despite their name, these developers are not suitable for papers. They are film developers best suited to large format and sheet films. When buffered so that their alkalinity remains stable, they are suitable for very fast, panchromatic films.

Fine-grain developers

All small and medium format films require fine-grain developers. These minimize grain clumping, producing a negative that can be enlarged to a good degree without breaking up. There are three main types, each having a different effect on grain and emulsion speed. Low alkalinity developers are now almost standard for roll film. They use MQ or PQ reducing agents with a slow working alkali to keep grain size low, with little loss of speed. These developers store well, and solutions may be replenished easily.

Solvent developers contain a silver solvent which dissolves some filaments as they form, keeping crystal size low. These developers give very fine grain, but noticeable loss of speed.

High-acutance developers offset the low-contrast effect of fine grain development. They produce the image close to the surface of the emulsion, improving visual sharpness. Speed is not reduced.

Print developers

You can use a universal developer for prints, but special print developers which are designed to suit your paper may give better results. They give good image color (whether a warm or cold black) and quality over a range of paper grades. Most liquid developers are diluted about one part in three for regular papers. You can use them in concentrated form to process high-contrast papers (except lith). Reversal bromide paper is processed like any other bromide paper, with universal developer.

Reversal development

You can develop any black and white negative film to form a positive image. Slow and medium speed panchromatic films give best results. Processing involves a first development, bleach, re-exposure, second development, fix, and wash. The first developer should be a solvent-type fine grain, or a general purpose formula. The second can be low alkalinity fine grain, or general purpose. The bleach is a permanganate/sulfuric acid type. Use a hardener in the fix (p.150), as bleach softens the emulsion.

High-speed developers

High-energy film developers increase emulsion speed by 1 or 2 stops, and also increase grain size especially with fast films, where they are most useful. Keeping qualities are poor; you should use one-shot development.

High-speed developers are also made for prints, mainly for press work. They develop a print in seven seconds.

Monobath film processing

A monobath is a mixture of developer and fixer, used to process film in one step. The developer and fix are stored separately, and the two solutions mixed before use. In a correctly balanced bath you cannot overdevelop. However a partially exhausted bath will leave the film looking milky, which means it is not fixed. You should immerse it at once in acid fixing solution (p.150).

Replenishment chemicals

For most amateur film processing, and all print processing, it is best to use developer by the one-shot method. Keep the developer concentrate stored in airtight bottles, and only dilute enough working solution for each task, discarding it after use. If you process large quantities of film, though, you may save time by reusing working developer solution, made up in larger quantities. During its working life, the solution will gradually become exhausted, and its action will slow. You can compensate (in some cases) by increase in development time. Or you can add replenishment chemicals to the working solution. Manufacturers sell these, in liquid form, to match their developers. You should follow their instructions.

Lith developers

High-contrast lith materials require their own special developers. Buy the developer designed for the particular lith film or paper you are using. Lith developers use the principle of "infectious development". Normally the oxidation products of a developer slow down its action, but in lith types they do the opposite. Highly reactive reducing agents called semiquinones are formed, and these accelerate the growth of black metallic silver, giving very high densities in exposed areas. Other areas are left as clear film. The developer is stored as two separate solutions. Once mixed, the useful life of the developer is only half an hour, whether it is used or not.

Chlorobromide print developers

Developers designed specifically for chlorobromide papers give a range of tones from warm black through brown/black to sepia or red. The effect is controlled by dilution of the developer, and development time. These print developers contain one extra chemical called chlorquinol.

Variable contrast print developers

You can obtain developers which are made up as two stock solutions, and then mixed in varying proportions to give different levels of contrast. They are designed for specific bromide papers, such as Ilford's Galerie.

Dye-image film processing

The new variable speed, dye-image black and white films are given color processing, in standard color negative chemistry. Development time is unaffected by the ASA rating used on the camera. You can buy the appropriate home-processing kits from the film manufacturers. Alternatively, you can use C41 processing, with which the films are compatible. This allows you to have only one set of chemicals, for both color and black and white negatives. (However, it is best to keep the working solutions separate.) These films are still rather expensive. But when mass-processed, they have the advantage that all silver is removed in processing, and can be recovered for re-use.

BUYER'S GUIDE

Names to look for
High-speed Kodak, Paterson
Reversal Ilford, Kodak, Paterson
Lith, Chlorobromide Ilford, Kodak
Variable contrast Ilford

Points to look for
- Small quantities (one-shot use)
- Liquid form
- Kits (reversal)
- Number of solutions and storage requirements
- Brand to match film and paper
- Effect on image color (lith, chlorobromide)
- Hardener in fix (if required)
- Emulsion speed most suitable (reversal best with slow film, high-speed best with fast film)
- Handling requirements (lith is caustic, reversal may involve mixing acid)

BUYER'S GUIDE

Names to look for
Agfa, Ilford (kits)
Agfa, Kodak (C41 process)

Points to look for
- Compatible kit (preferable for amateur use)
- C41 process (if already using for your color work)

Rinses and stop baths

A water rinse between processing stages reduces carry over of one solution into the next. This is most important between developer and fix: a fix solution, which is acidic, will soon lose strength if contaminated with developer, which is alkali. Stop baths have an additional function: they stop development from continuing in the fix, which could result in a silver stain. A stop bath between developer and fix is essential with film, and advisable with prints (though here a water rinse will do if changed frequently). You can make a stop bath from concentrated acetic acid; use a two or three per cent working solution for prints and negatives. For a more efficient stop, use sodium bisulfate (25 ml made up to 1000 ml with water). Add chrome alum hardener for high-temperature processing. You can also buy indicator stop baths, which change color when exhausted.

Fixers

After development, the image must be fixed (made permanent), by removing the remaining unexposed halides, which are still sensitive to light. Fixing solutions are acidic; they convert unused halides to soluble salts which can be washed away. Most fixers are sold in concentrated liquid form, and diluted as required for films or prints. There are two main types. The sodium thiosulfate ("hypo") type is rather slow for film, but makes a good acid fix for prints (used at half film strength). A hardener (potassium alum) can be added. Rapid fixers of the ammonium thiosulfate type are ideal for films. But with prints you must be careful to dilute them sufficiently, and avoid prolonged immersion of the print which may degrade blacks and reduce contrast. After fixing, you can if you wish use a hypo eliminator, to reduce washing time.

Intensifiers and reducers

Weak, thin negatives will not print well. Intensification converts black silver into a more opaque substance, improving density and contrast. The effect is greater on underdeveloped than on under-exposed film. The intensifier is made up from two stock solutions; it bleaches the negative, and then you wash and redevelop it. Chromium-based intensifiers are preferable to uranium or dye mordant types. Reducers remove some of the excess density from over-exposed or developed negatives. You can also use them, with care, to vary local density on prints. The process is irreversible, so test reducer strength on an old negative or print. Farmer's reducer is the most readily available, but other types are sold. You can make up intensifiers and reducers yourself, but take care when mixing acids (add acid to water, not vice versa).

Weak negative Intensified negative Dense negative Reduced negative

Darkroom

temporary, permanent, advanced set-ups/ print finishing area

The precision of the darkroom allows you to adjust errors made with the camera and to go beyond this to produce impressive special effects. This section covers darkroom planning at all levels. The chart below shows the minimum equipment required for different levels of darkroom work and should be used in conjunction with the set-ups shown on the following pages. The equipment itself is dealt with in Film Processing (pp. 159-164) and Printing (pp. 165-192).

Temporary set-ups
Home processing and printing need not take up a great deal of room. To process film in small quantities you do not even require a permanent darkroom. A light-tight changing bag and a daylight processing tank provide adequate protection from light for both black and white and color work. A tempering box is a valuable addition to this set-up if you want to process greater quantities of both black and white and color material. It gives your work precision by keeping solution temperatures stable.

Although it is not imperative, if you house this equipment in even the simplest of temporary darkrooms you will make your work easier. A converted bathroom, or similar space (pp. 152-3) will allow you to accommodate a simple enlarger for low-volume black and white printing.

Permanent set-ups
A permanent set-up of the kind shown on pp.154-5 is designed for processing and printing in black and white and for processing color material. To print in color you must have an enlarger with a color head. By adding cut-film tanks to the basic set-up, you can process large quantities, and different sizes, of films. For the greatest versatility, however, it is best to establish a darkroom that can handle both processing and printing in bulk. An advanced set-up (pp. 156-7), built around a good enlarger and processing system, will deliver both quantity and quality.

	Black and white		Color		Bulk black and white and color	
	Processing	Printing	Processing	Printing	Processing	Printing
Changing bag plus processing tank (pp. 152-3)	●					
plus **tempering box (pp. 152-3)**	●		●			
Basic set-ups (pp. 152-5)	●	●	●			
plus **color enlarger and accessories** (pp. 152-5)	●	●	●	●		
Advanced set-up (pp. 156-7)	●	●	●	●	●	●

Temporary set-ups

If you do not have a special room to set aside as a darkroom, you can convert a large closet, or make a temporary darkroom in another room. Film processing is easily done with a temporary or closet darkroom. You require a minimum of apparatus. A processing tank is the only essential item, though a tempering box and an automatic agitator help keep temperatures and agitation constant. Alternatively, you can process your films without a darkroom, by loading a daylight processing tank in a light-tight changing bag, right. More equipment is necessary for printing, and you should have the space to store it in a systematic order. You require an enlarger and a timer for black and white printing. For color work you should have additional equipment. As well as a color enlarger head, a transformer and a color analyzer are useful.

If you choose to adapt a closet, one about 3½ ft – 4 ft (1 m – 1¼ m) square, with a ceiling height of about 6½ ft (2 m) will be adequate. Try to select one without windows. Make the door light-tight, provide ventilation and install a sturdy workbench along two sides. You should divide the closet into a wet area and a dry area. Save space by storing your equipment under the bench when it is not in use. For safelighting, a small bench-top unit will

Daylight processing
You can process film without a darkroom, using a changing bag and a daylight roll-film tank, above. Load the film on the tank reel inside the bag, above, and put the reel in the tank. Once you have placed the lid on the tank, you can process the film in daylight. Before opening the film container in the bag, make sure all your equipment is inside.

Closet darkroom
A spacious closet can contain all the equipment you require in a small amateur darkroom. Keep the wet and dry sides separate and use the space under the benches to store your equipment. If you use compact equipment you will have enough space.

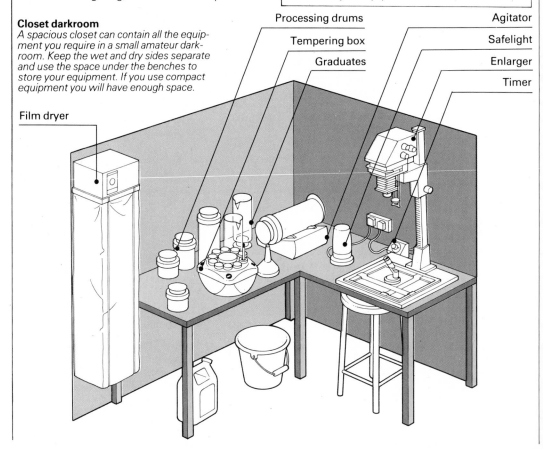

Film dryer

Processing drums
Tempering box
Graduates

Agitator
Safelight
Enlarger
Timer

suffice. A wall-mounted plastic-sleeve type dryer allows you to dry strips of film.

Running water is not essential in the darkroom. You can use buckets and trays to provide water, and set up your washing system in another room. It is more important to have a generous floor-to-ceiling height, so that you can accommodate both the bench and the enlarger's tall column comfortably. Store your equipment carefully and keep it dry. It is best to keep a cabinet for this purpose. Make sure this is damp-proof. You can place damp-absorbing silica gel crystals in the cabinet.

A bathroom also allows you to set up a temporary darkroom. Here safety is of prime importance. The room should allow you enough space to keep wet and dry areas apart. On no account should your electrical appliances come into contact with water. Bring power into the room from an outside source via an extension

cord and remove and disconnect this when it is not in use. Ensure that all electrical appliances are well-insulated, use rubber plugs, and be careful to avoid water when moving equipment.

Set the enlarger and its accessories on a cabinet at a comfortable working height. Cover the bath with a sturdy board hinged to the wall. This can act as the workbench for your wet area. You will be working quite low, so use a stool that makes all operations safe and comfortable. After every session clean the bath thoroughly.

Whether you use a room or a closet it must be light-tight. Seal windows with hardboard or specially-made blinds. Make doors light-proof with a heavy opaque curtain hung from a rail above the door frame. Install a louvered vent, with a light trap, in the door. Make sure the room is light-tight by staying in it for several minutes with the light out.

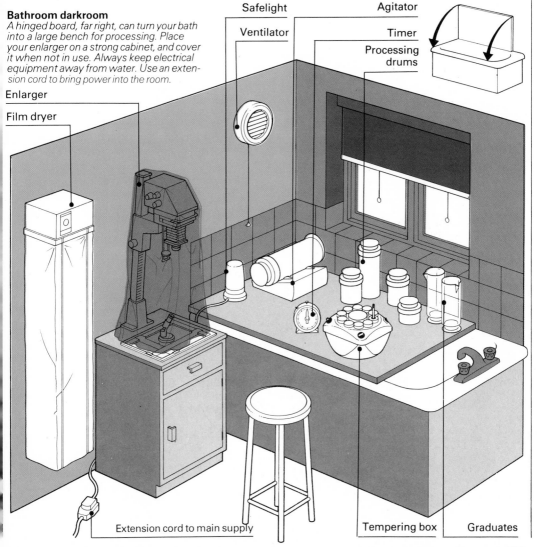

Bathroom darkroom
A hinged board, far right, can turn your bath into a large bench for processing. Place your enlarger on a strong cabinet, and cover it when not in use. Always keep electrical equipment away from water. Use an extension cord to bring power into the room.

Enlarger

Film dryer

Safelight

Ventilator

Agitator

Timer

Processing drums

Extension cord to main supply

Tempering box

Graduates

Permanent set-up

With your own darkroom you can print, copy, and enlarge at will. Choose a room that you can make light-tight, ventilate, and leave undisturbed as much as possible. It must have electricity and, preferably, running water, with adequate drainage. Make the door light-tight, paying special attention to the floor gap. For ventilation add a louver vent masked by a light trap. For a blind, use a dark fabric with a wooden backing. The blind should run in a grooved wooden frame attached to the window. Test light-tightness and the safelights by leaving a sheet of bromide paper face-up for half an hour. Print a good negative on this and on a sheet fresh from the box, and compare them for base fog. Paint the walls white for maximum safelight reflection and to avoid color casts when color printing. A pale floor helps you to find dropped objects under safelighting.

Divide the room into a wet and a dry side, making sure that controls and equipment are conveniently and safely positioned, and that you can read the clock easily. Store chemicals (in well-stoppered bottles) below the wet bench area, and paper (in a paper safe) beneath the enlarger bench. Keep all electrical equipment on the dry side, and use pull switches and sealed plug sockets for maximum safety. Place safelights of the correct strength and color at least 3 ft (0.9 m) from where you will use paper. Keep them away from the enlarging easel, otherwise the negative image may be difficult to focus. Heat the darkroom with a radiator or wall-mounted convector (never free-standing heaters). If kept at 66-68°F (19-20°C) most working solutions remain stable. Protect walls and floors from chemicals, particularly fixer, by regular cleaning. Always have a towel ready for wet hands, and absorbent paper to mop up spilled chemicals. Keep a record of filtration and exposure data used for printing, and store it with your negatives.

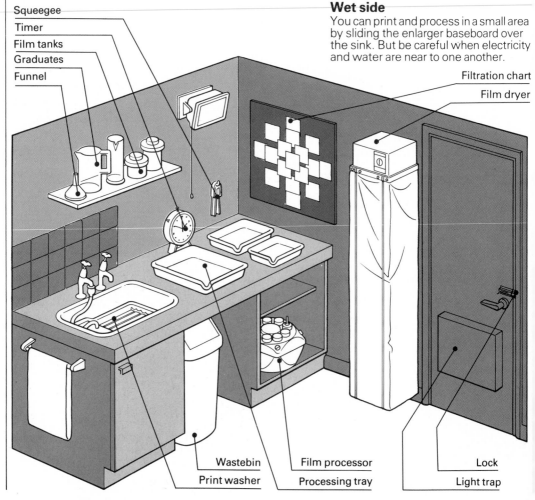

Squeegee
Timer
Film tanks
Graduates
Funnel

Wet side
You can print and process in a small area by sliding the enlarger baseboard over the sink. But be careful when electricity and water are near to one another.

Filtration chart
Film dryer

Wastebin
Print washer
Film processor
Processing tray
Lock
Light trap

Foldaway darkroom
If you lack permanent space, and want to save assembly time, choose a foldaway darkroom. When assembled, it provides an ample light-tight and dust-resistant working area.

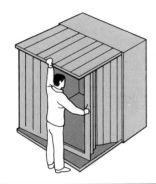

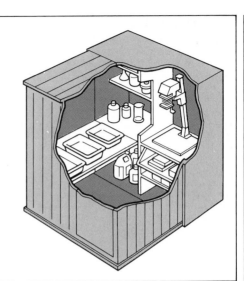

Space-saving darkroom
From an extended depth of 61 ins (1.5 m) this dark-room collapses to a convenient 24 ins (0.6 m) deep. It is 48 ins (1.2 m) wide, extended or folded, and has an interior height of 78½ ins (2 m).

Dry side
Give the enlarger and its bench as much height as possible. Keep the enlarger and the processing area away from the door and the safelight(s).

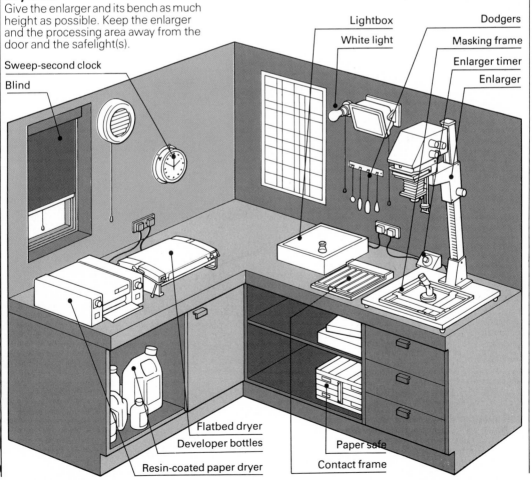

Sweep-second clock

Blind

Lightbox

White light

Dodgers

Masking frame

Enlarger timer

Enlarger

Flatbed dryer

Developer bottles

Resin-coated paper dryer

Paper safe

Contact frame

Advanced set-up

If you have the space to divide your darkroom, it is best to separate film processing from printing. This has several benefits. Safelight illumination is easier to keep constant. Trays and tanks have only one task, so that you can use the right size for each job. (This also helps you save on chemicals.) With separate areas for processing and printing you do not have to clear up when you change tasks, which makes your working routine easier.

If you use deep cut-film tanks in the processing area, you will be able to process either color or black and white films, of all sizes. For large-scale color processing, precise temperature control and nitro-burst agitation are essential. You can post filtration charts and manufacturers' information above each tank run, where they will be clearly visible. Alternatively, you can buy or make

a timed tape recording to guide you through the processing cycle. In the printing area, position the dry bench for the enlarger and contact printer as far as possible from the processing bench. With the growing use of resin-coated papers, especially for color, it is worth considering "dry" processing. Bench-type dry paper processors are clean and easy to use. A full system would include a quality enlarger, a color analyzer and meter, a processor, and a dryer. This equipment, plus a sink with running water, provides a good set-up for advanced print processing, but is expensive. If you have a limited budget, consider setting up either a good processing room or a printing room. You can then leave the other part of the operation to a competent laboratory.

Processing area

With the correct basket and large film tanks you can process films of all sizes. For small quantities of roll film, use steel roll-film tanks and a tempering box (p.184). You can use a flat dish for occasional sheet film.

Safelight
Cut-film tank
Graduate
Jug

Film clips
Squeegee
Roll-film tanks
Film dryer

Cut-film processor for color

Reel loader
Tempering box
Processing bench

Film washer
Water filter

Printing area

A system offering enlarger, analyzer/meter, and processor is best for color. You also require a black and white processing line, though a unit which processes both black and white and color papers can prove a useful alternative. A high-speed black and white processor can also complement the color set-up.

Light-tight door

You can make your own light-tight darkroom doorway, right. You can also buy purpose-made revolving or sliding doors. These can be electrically operated with a foot switch, leaving your hands free.

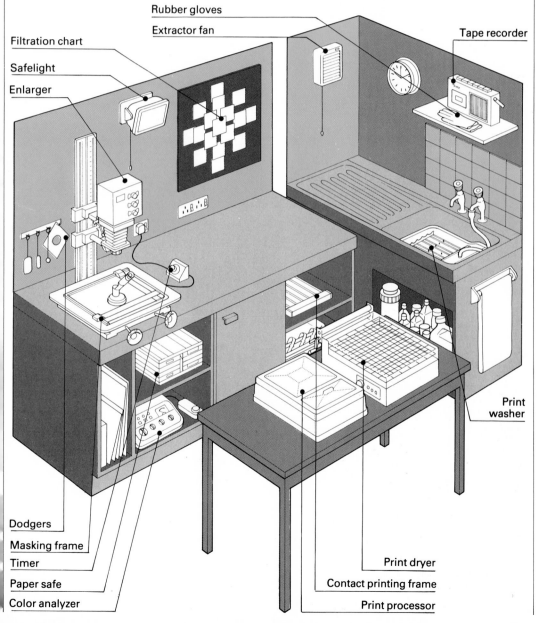

Rubber gloves
Extractor fan
Tape recorder
Filtration chart
Safelight
Enlarger
Print washer
Dodgers
Masking frame
Timer
Paper safe
Color analyzer
Print dryer
Contact printing frame
Print processor

Finishing area

It is useful to set aside a separate area or room for slide and print finishing. The bench space need not be large. A 6ft-8ft (2m-2.5m) run is enough, especially if it is set in a corner. Such an area will provide a clean, dry, well-lit working space where you can retouch and mount prints, and mount and arrange transparencies. It will also serve as a place where you plan your photography before shooting, printing and presentation. You should divide the area into two sections – one for print and one for slide finishing.

In the print finishing area you will require a rubber cutting mat, a directional lamp, and tools and dyes for retouching. If you can tilt the working surface through 30° it will prove more comfortable when you are working long sessions. Keep

your retouching materials stored beneath the bench when they are not in use, in order to avoid clutter. You can also store your trimmer and mounting board here. It is best to store mounting cardboard vertically. Use a bulletin board on the wall to keep references and data within reach.

In the slide section you should keep a magnifier, and a slide sorter or lightbox. You can store your slides beneath the bench, in hanging files (p.124). A hand viewer and a dry mounter should also be at hand. Store slide mounts, glasses, and brushes in a dust-free drawer or a sealed container. Choose a stool that allows you to work comfortably. Avoid fluorescent lighting, which can be tiring to the eyes. Keep the area clean and tidy, and use a garbage can.

Print side
You should keep all your equipment for trimming, retouching, and mounting on the print side, below. You require a strong adjustable light and a bench at a comfortable height.

Slide side
On this side you should allow ample space for slide storage. Keep a lightbox, a hand viewer, and a magnifier on the working surface, so that you can view your slides easily.

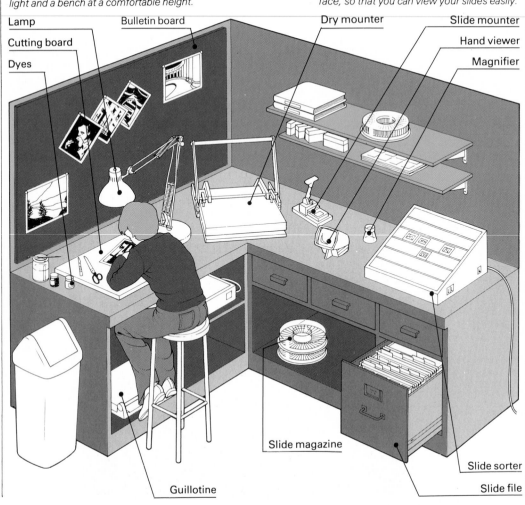

Lamp
Cutting board
Dyes
Bulletin board
Dry mounter
Slide mounter
Hand viewer
Magnifier
Slide magazine
Guillotine
Slide sorter
Slide file

Film processing
cut and roll-film tanks/film processors/washers/ dryers

When you expose a film to light from a subject, the sensitive halide crystals in the film react to light, and the basis of a photographic image is established. The image at this stage is not visible. You must process the film in order to produce an image that you can see. The first stage of processing, development, converts the exposed halides into a visible image. The following stages, of stop bath and fixer, ensure the degree of development is correct and make the image permanent.

Methods of processing
Most films require processing in complete darkness, or in the appropriate form of safelighting. One method involves using a set of open trays, with one tray for each processing solution. For roll-film this method is generally unsatisfactory. It is easy to scratch the film, and processing accuracy is difficult to achieve. It is much simpler to use a roll-film processing tank, as shown below. You can use all tanks for the whole processing cycle, including washing. If you process cut film regularly, you should use special deep tanks. Provided you process in sufficient quantity, the method is economical and saves you time. It also ensures consistency in the processing of each batch of film. Other advantages are the provision of baskets which allow you to process roll film in these tanks. It is also easy to adapt cut-film tanks for washing, with perforated tubes which you connect to the water supply.

Color processing
Color processing demands a greater degree of accuracy than black and white. To produce the best results both temperature and agitation must be exact, especially at the developing stage. A tempering box helps ensure that your solution temperatures are correct. You can also buy units which provide precise agitation. In addition to this equipment, you will also require measures, chemical containers, and a thermometer to check solution temperatures. Some method of drying your films is also essential. The amateur often finds film dryers costly. They also take up a lot of space. Cheaper, compact, wall-mounted models can solve this problem.

Roll-film processing
Roll film is easy to process in the small tank, right. You load the film in the dark, winding the film on a spiral. When you have inserted the spiral and attached the lid, you can carry out all further operations in normal lighting. Some larger tanks accept a number of films. Other designs enable you to load the film in normal lighting.

Cut-film tanks

Cut-film processing tanks made in rubber are suitable for black and white work. For color processing, tanks are available in hard plastic which stands up to color chemistry. Never use rubber for color. You will require three tanks for black and white processing, three or more for color. The tank consists of a body, an optional floating lid, and a covering lid. The floating lid reduces deterioration of the developer through air contact, prolonging its useful life. The covering lid must be light-tight so you can use lights when processing. When the tanks are not in use, keep them clean of chemicals and dry. Keep the tanks inserted in a processing bench (p.163), or on a drainboard laid in a sink. A common tank size is 15 liters (4 US gallons), but some hold more. Large tanks are also available for sheet film.

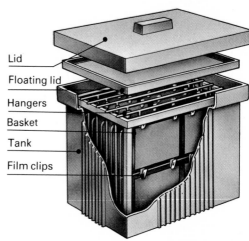

Lid

Floating lid

Hangers

Basket

Tank

Film clips

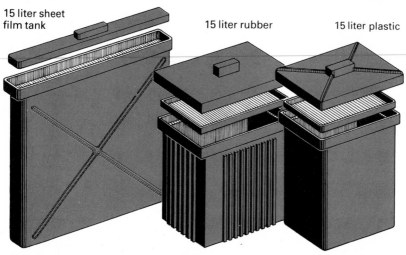

15 liter sheet film tank

15 liter rubber

15 liter plastic

Baskets, cages and hangers

Hangers hold film within clips or plastic sleeves during processing. Some accept glass plates and cut film. When processing a large quantity of films you can load several hangers into a basket which fits the tank. Baskets take cut film, plates, and prints, while cages take roll-film reels. Some baskets use nitrogen or air-burst agitation.

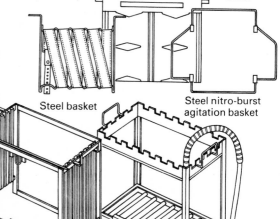

Steel (roll-film)

Plastic

Steel

Plastic cage

Steel cage

Steel basket

Steel nitro-burst agitation basket

Roll-film tanks

These tanks are used to process all roll films, from 35mm up to 2¼ ins × 2¼ ins. Made in plastic or stainless steel, they are available in a range of sizes to suit different sizes of film. Steel tanks are best for color processing, and plastic tanks for black and white. Never use plastic tanks for color, as color chemicals rapidly damage their reels. The tank consists of a body, which usually has a central agitator and a sealing ring if made in plastic, and a lid and a cap. It takes one or more film reels. You insert the steel or plastic reel (or reels) in the tank in darkness, but with the light-tight lid in place you can process in daylight. (Tanks which you can load in daylight are also available.) The lid allows you to pour chemicals in and out, and the cap prevents spillage when you invert the tank to agitate the contents.

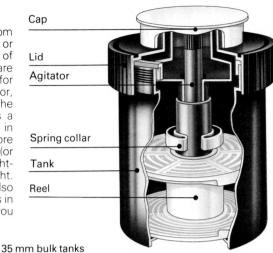

Cap
Lid
Agitator
Spring collar
Tank
Reel

Steel tanks and reels

Steel tanks are expensive but durable. Reels are center-loading and can bend if dropped, making loading difficult.

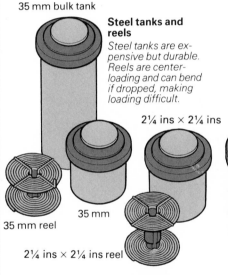

35 mm bulk tank

2¼ ins × 2¼ ins

35 mm reel

35 mm

2¼ ins × 2¼ ins reel

Plastic tanks and reels

These are cheaper and easier to load than steel tanks. Keep reels clean, as loading difficulties can occur. Adjustable reels are available for different film sizes.

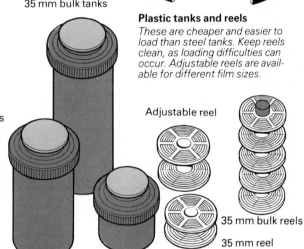

35 mm bulk tanks

Adjustable reel

35 mm bulk reels

35 mm reel

35 mm single reel tank

Daylight-loading tank

Use this tank to process film without a darkroom. You place the cassette in the loading chamber and thread the leader through a small slit. A knob or handle on the outside engages the film and winds it on the processing reel.

Loading machine

This machine loads both 35 mm and 2¼ ins × 2¼ ins film without marking its surface. You pass the leader through a guide and attach it to the reel. Then you black out the room and turn a handle to draw the film on the reel.

Loading machine

35 mm

2¼ ins × 2¼ ins

Processors and washers

A film will produce its best results only if you process it correctly. This depends on timing each step accurately, keeping solution temperatures constant, and agitating the film for the right amount of time. Inaccurate processing creates uncontrolled changes in density and contrast. Subtle tones may be lost in highlights and shadows. Pictures may appear soft, with low contrast, weak colors, or color casts. If you want to process your own film it is important to buy equipment that will give consistent results over a range of films. Specially designed processors are particularly helpful for regulating each stage correctly. These units hold all the solutions you require and accurately control temperature and agitation during processing.

None of these processors is fully automatic: you have to introduce the film manually to each solution and monitor timing yourself. The type of processor you buy depends on the quantity of

film you will be processing and the type and size of film. For roll films, including those for 110, 35mm, and 2¼ ins × 2¼ ins (6cm × 6cm) slides and prints, simple temperature control (tempering) units are suitable. These keep all your chemicals at the required temperature. Processors which incorporate a drum are intended primarily for producing paper prints, but you can also use them to process large format sheet film. All drum models give some degree of control over agitation. Processors for larger sheet film (see facing page), which you can also use for print processing, are usually designed as a free-standing bench that you connect to the water supply and main drainage. You can also buy compact three-tank units able to cope with all black and white and color processing, and give precise temperature control. Advanced models offer longer tank runs, control of both rinse and wash temperatures, and some form of controlled agitation.

Roll-film processors

Temperature control boxes for processing roll-film provide a jacket of water that surrounds the bottles and graduates containing processing solutions, right, above. A thermostat controls the water heat, to give a uniform temperature, usually accurate within ½°F. This degree of accuracy is suitable for all films. You can control temperature over a range of about 68°-113°F (20°-45°C), matching the requirements of all modern processes. Another unit is available which takes a drum, right, and rotates it for uniform agitation.

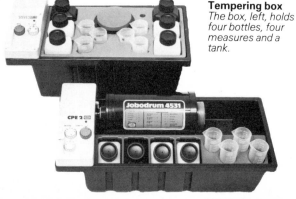

Tempering box
The box, left, holds four bottles, four measures and a tank.

Advanced unit
You can fit the advanced processor, right, with a drum for cut-film and printing paper. A water jacket keeps temperatures constant.

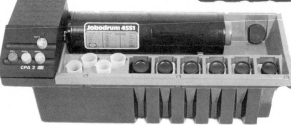

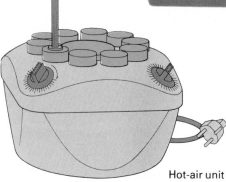

Hot-air unit

Hot-air unit
The high-speed hot-air tempering unit, left, keeps solution temperatures constant. The hot-air system has several advantages. It gives a wide temperature range – 68°-116°F (20°-47°C) – and includes a fan which circulates the air and helps it heat up very quickly to the required temperature. The use of hot air also means that you do not have to add water, making processing easier.

Roll film washers

Efficient washing makes your slides and negatives more durable. A purpose-built washer, below, consists of a circular plastic sleeve on a base. It can be used in any size and allows you to stack several reels for simultaneous washing. You can make a high-speed washer simply and cheaply by converting processing tanks with a special rubber hose.

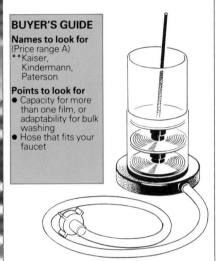

Adapted cut film washer

You can adapt a cut film tank, below, to wash all standard film sizes easily and efficiently. You fit water spray tubes to the tank and connect them with a hose to the faucet. Tubes fit on either the top or the base of the tank.

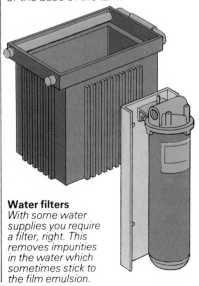

Water filters
With some water supplies you require a filter, right. This removes impurities in the water which sometimes stick to the film emulsion.

Cut-film processors

A processor for cut film consists of a series of tanks surrounded by water to maintain accurate temperature. Film is held in baskets (p.160) in these tanks. Smaller models contain three tanks, below. More advanced units allow you to drain water from the jacket and have a circulating pump to keep temperatures even. Most models accept nitrogen or air-burst units, for uniform agitation.

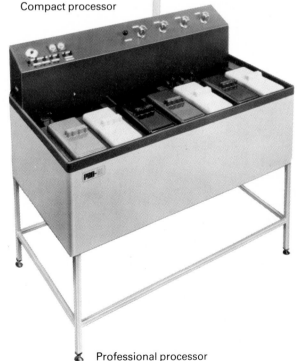

Compact processor

Professional processor

Dryers

Drying cabinets provide a safe and quick way of drying processed films. Most models are made of metal and have a heater in the top or base and a fan to circulate hot air around the films. The simplest types have a plastic sleeve which you drape from the heating head. Stronger compact table-top models are available. These save space but do not accommodate very long strips of film. The slender floor-standing cabinet is better for lengths of film, especially if it directs air from both the top and the bottom of the unit. The two-door dryers are best for large quantities of film and often use infrared heat which is efficient and safe. On most models a thermostat allows you to adjust temperature. More expensive dryers provide a visual temperature gauge on the door, and some have a secondary fan to remove damp air from the cabinet. With all dryers you will also require film clips and a squeegee or similar tool.

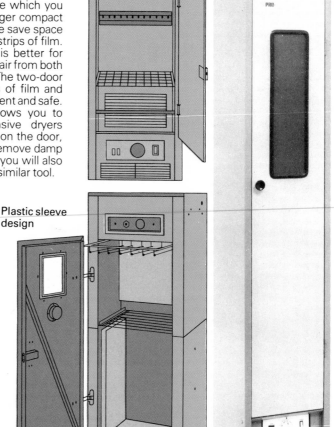

Table-top model

Large cabinet

Plastic sleeve design

Infrared cabinet

BUYER'S GUIDE

Names to look for
(Price range C-H)
 *Durst, Prinz
 **Pro-Co
***De Vere, Marrut

Points to look for
● Infrared heat system
● Easily visible control panel and "on" warning light
● External thermometer
● Glass window
● Corrosion-resistant exterior and internal fittings

Accessories

You will require film clips from which to hang your film. They must be made of good quality stainless steel. For each film use two clips: one at the top, the other to act as a weight to prevent the film curling into a spiral as it dries. A tong-type rubber squeegee or chamois leather is necessary to wipe excess moisture from films. This speeds up drying and reduces the risk of drying marks. Keep these items very clean, as any dirt can scratch the film.

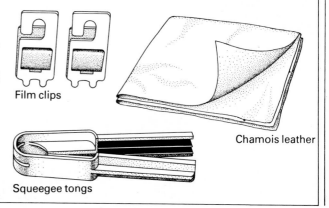

Film clips

Chamois leather

Squeegee tongs

Printing
enlargers/print processors/ washers, dryers, glazers/ print room accessories

Printing your own work extends your personal creative control over your photography, right through to the final image. You can start printing with very little equipment, adding accessories later. Before buying any equipment, however, you should try to gain some printing experience in a well-planned darkroom.

The enlarger
You can make reference prints the same size as your negatives, with a contact printing frame. But you will normally want to make prints bigger than the negatives. To do so you require an enlarger. This major item is the heart of the printing system, so buy the best you can afford. Make sure the model you choose suits the maximum size of negative that you want to print, and that the lens covers the negative area to give a full-frame image. It is best to buy an enlarger that will print both black and white and color, or at least

one that you can adapt for color later on. For most color work you can use a subtractive head. You can also adapt this for additive printing by using primary filters under the lens. You will also require masking frames to keep the printing paper flat and a timer connected to the enlarger on/off switch, for precise print exposure. For color work, the color balance of the enlarger must be correct. An analyzer helps you achieve this.

Processing and washing
To process the exposed paper you will require trays and some method of washing your prints. A high-speed washer is most convenient, but you can do the job much more cheaply with a cascade washing system that allows continual changes of water. It is best to process color paper in a drum preferably in conjunction with a tempering box and agitator, to ensure accuracy. Automatic processors are easier to use, but more costly.

The printing sequence
You place the negative (or slide), left, in the carrier, just below the enlarger's light source. The lens projects the image on the baseboard. Place printing paper in the masking frame, and give the correct, timed exposure. You then process the exposed print by passing it through developer, stop bath, and bleach/fix solutions, before washing and drying. A print processor, below, automatically carries out all but the last two stages of the sequence.

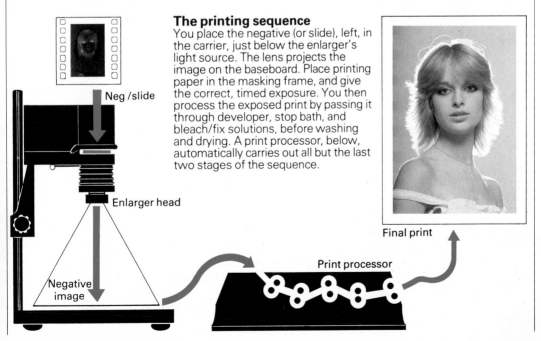

Neg /slide

Enlarger head

Negative image

Print processor

Final print

Enlarger principles

The enlarger is the most important piece of equipment in the darkroom. Its quality (particularly of the lens) and range of controls largely determine the standard of your prints. It works similarly to a vertically positioned slide projector: a lamp projects light first through a condensing lens (or a diffusing screen), then through the chosen negative or slide, and finally through the enlarging lens, to form a print on light-sensitive paper below.

The head contains the lamphouse, negative carrier, lenses, and in most models some form of color filter holder. It is supported above the baseboard on a column: the higher you position the head on the column, the greater the magnification (p.174) of the image. Cheap enlargers hold the head in place with a clamp. It is better to have friction-drive adjustment, which is more secure and more convenient. For very large prints you require a head that can be turned through 90° so that you can project the negative on a wall.

To obtain a sharp projected image you focus the enlarging lens as you adjust the head height. Some models do this automatically. You control brightness by adjusting the enlarger aperture, marked in f stops.

For black and white printing, you require a red safelight filter only. For color printing, you must interpose a range of color filters between the light source and the negative: complementary filters for subtractive printing, primary for additive printing methods. Simple subtractive enlarger heads hold as many as 21 acetate filters, of different strengths, in a filter drawer. Enlargers with a dial-in head allow you to program the appropriate filtration. More expensive models use dichroic filters, which, unlike acetate filters, do not fade.

Filter dials

Negative carrier

Focusing knob

Bellows

Height control

Lens

Lens filter

Reference scale

Magnification scale

Height scale (cms)

Column

Baseboard

Versatility
The enlarger, right, handles all types of work, including color prints from slides and negatives and black and white from negatives. It assesses exposure and color balance automatically: all you do is focus.

Choice of head
The chart, right, shows what type of head you require for a wide range of printing operations. For advanced filtration techniques (p.171) and big enlargements, use a black and white condenser or a color dichroic head.

	Black and white	Color	Color and black and white	Advanced black and white	Advanced color
Black and white condenser	●			●	
Black and white diffuser	●				
Color subtractive		●	●		●
Color additive					●
Color dichroic			●		●

Negative carriers

An enlarger has a carrier in the head to hold the film firm and flat during printing. Some designs have masks, below, to cut out light from the area surrounding the small sizes of image. Others may accept conversion kits to extend the negative size range. Many carriers are recessed to accept slide frames. Some large format carriers take interchangeable format inserts.

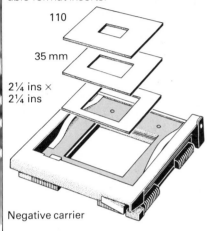

110

35 mm

2¼ ins × 2¼ ins

Negative carrier

Lenses

You must use the best quality enlarger lens you can afford. It should be at least as good as your camera lens and should be specifically designed for enlarging. It will then be heat-resistant and work well at close subject distances. Different focal lengths, below, cover variations in format and degree of enlargement.

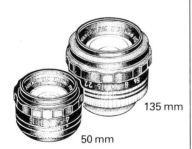

135 mm

50 mm

Safelight filter

Use the red safelight filter beneath the lens, right, with black and white paper, when you want to check image alignment or the placing of dodgers.

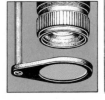

Enlarger movements

You adjust enlargement by moving the head up and down the column. There are three main types of enlarger column. A straight vertical column, right, is the simplest design, but it can easily shake when you are making adjustments. It also offers a limited range of enlargement. A sloping column, below left, will give larger magnifications. Autofocus enlargers often have a swivelling arm, below right. This allows you to make rapid adjustments to the height while the image stays in focus.

Vertical

Angled

Pivoted

Projection adjustments

Some enlargers have a tiltable head, below. This enables you to make extra large prints by projecting the image on a larger surface than the baseboard.

Projection
You can project on to the floor, below left, or on to a wall, below right, for an even larger image size.

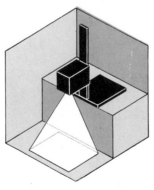

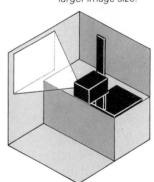

Image control
Tilting the enlarger baseboard, far left, or both head and baseboard, left, gives you extra image control. With this method you can distort the image, or correct the perspective of the original.

Diffusers and condensers

There are two types of enlarger light source – condensers and diffusers. The condenser type comprises a lamp and a condensing lens which collects light and directs an even beam through the negative. You must adjust the cone of light so that it covers the negative properly. Condensers give greater contrast than diffusers. Illumination is even and efficient, but the lamphouse gets hot easily, and scratches on the negative show up clearly on the print, particularly when you stop well down. Diffusers scatter the light inside the head before it passes through the lens. Illumination is soft and even, but light loss can be a problem and exposures tend to be long. Scratches on the negative show up less than with condenser heads.

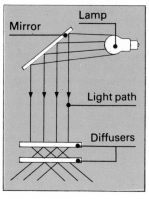

Diffuser head
The diffuser system scatters light within the head, so that in some systems only reflected light reaches the negative.

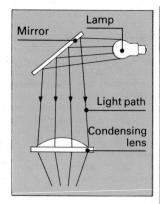

Condenser head
In a condenser system, above, the lamp focuses the light through the negative into the lens. This construction maximizes light power.

Enlarger heads

Most modern enlargers accept interchangeable heads. This facility allows you to produce black and white or color prints. It also gives you a choice of light sources. Enlargers for large format black and white printing may take both condenser and diffuser lamp housings. Alternatively an enlarger may accept both a black and white condenser and a color diffuser head. Heads for color printing vary in design. The simplest use a filter drawer or similar arrangement to introduce color correction (CC) filters into the light path. These filters can fade with frequent use. Other designs have a "dial-in" head (and sometimes a control unit) which allows you to vary filtration easily and precisely. Better dial-in heads use the more expensive dichroic filters, which are fade-resistant.

Three-color head
Most color heads use three filter colors – cyan, yellow and magenta. You dial in different color and density combinations.

Dichroic head
Non-fade dichroic filters transmit light to a mixing chamber, bottom, before it reaches the lens.

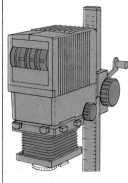

Filter drawer
You fit color correction filters in the drawer above, which slides between the lamp and the negative.

Additive head
This uses blue, green, and red filters. You make one exposure through each, and vary light strength with the lamp, above.

35 mm enlargers

The main factors which will influence your choice of enlarger will be the negative size you intend to enlarge, the degree of automation you require, and the cost. If you shoot 35mm negatives, it is best to buy a 35mm enlarger. But for flexibility, it is wise to look for a model that also accepts other negative sizes. You will certainly want to be able to use larger sizes if you become interested in special printing techniques. For this type of work (or for infrequent use) a manual enlarger is best. Automatic models are convenient for heavy, non-specialist use, but are more expensive.

The simplest 35mm enlargers are suitable only for black and white printing. If this is your choice, you should buy a well-known make. Cheaper models are likely to be poor in quality and awkward in use. Enlargers for both black and white and color are available in various designs, with either filter drawers or dial-in heads. Most models are manual, though ·autofocus is available. Enlargers for 35mm usually have a lamp of 50W or 75W (although some accept stronger lamps), and a 50mm or 55mm lens. The accessory range for your enlarger should include interchangeable lenses and heads, exposure meters and color analyzers.

Black and white enlargers

The number of good quality black and white enlargers is limited. They should have controls for both height adjustment and focus. To alter height you release the lock and move the head gently up or down the column. Most models use hinged carriers, some of which you can adapt to take 2¼ ins × 2¼ ins (6 cm × 6 cm) negatives. These enlargers usually have a magnification range of just below ×1 to about ×10.

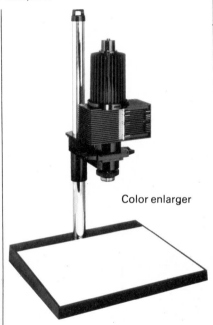

Color enlarger

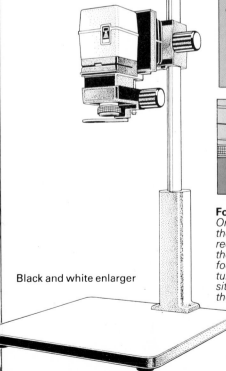

Black and white enlarger

Focusing
Once you have set the image size you require by adjusting the head height, focus the lens by turning the knob situated adjacent to the lens bellows.

Color enlargers

Most enlargers for 35 mm will print both black and white and color. The latter requires filtration to regulate color balance. Color heads use a variety of filter systems to achieve this. The enlarger above, designed for subtractive color printing, uses the filter panel system, below. Its reasonable price makes it ideal for amateur use.

Filter panel
The filters in the panel, right, are positioned between the lamp and the condenser lens. Their arrangement makes color balance corrections easy. You simply slide the filter(s) you require into place.

Interchangeable head models

Advanced 35 mm enlargers offer a choice of black and white and color mixing heads including dial-in, dichroic, and additive types. You can start with one head, and buy others later, as your budget allows. You can change heads very quickly and they will accept a range of negative sizes. Most allow swing movements (p.167) and the introduction of extra filters.

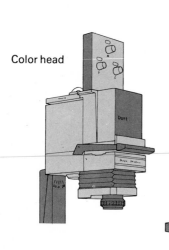

Color head

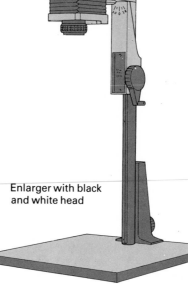

Enlarger with black and white head

Autofocus enlargers

An autofocus mechanism allows you to work quickly, particularly when you want different print sizes from the same negative. It uses a cam system to hold focus while you alter the head height. Some types will print both black and white and color, and most models allow you to make big enlargements by projecting on the floor.

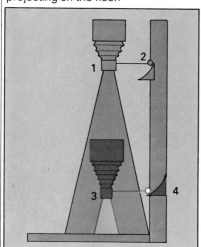

Autofocus principle
The diagram, left, shows the enlarger with the head (1) and the cam (2) set at maximum height, and the lens focused on the baseboard. When you lower the head (3), the cam moves (4), adjusting the lens-negative distance, giving sharp focus.

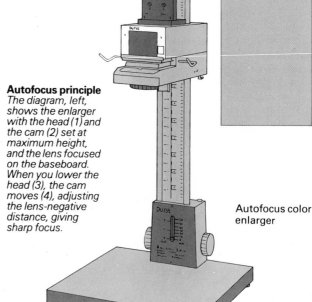

Autofocus color enlarger

Medium format enlargers

For the advanced amateur and the professional photographer a medium format (2¼ ins × 2¼ ins/ 6cm × 6cm) enlarger is the best choice. It allows you to print all sizes of roll film with one item of equipment, saving both time and money. All models allow you to produce both color and black and white prints. Enlargers usually have a negative carrier and lens panel included in the price, but you may have to pay extra for the lens and an additional negative carrier.

Medium format enlargers are available in several designs. Basic budget-priced models usually have good quality lenses and makers offer carriers taking a range of negative sizes. Alternative heads permit color printing. They are sometimes backed up by a special "starter" kit for black and white printing. Some local distributors also offer a darkroom "package". More advanced models may offer autofocus, and partial, or even full, automation. The latter type programs the exposure and color balance. Some models may be wall-mounted, and conversion to use as a copy camera may be possible.

The choice of heads for medium format work is wide. Some models use dichroic filtration, while others avoid light loss and diffusion by using fiber optics in the head. This also reduces heat and filters out ultraviolet light. Dial-in models are especially suitable for color printing. The majority of these heads use a tungsten halogen lamp which achieves good color balance and image brightness throughout its working life. These heads also give a wide range of filters and their control panels are often illuminated for easy reading in the darkroom.

Choosing an enlarger
As well as being capable of handling a wide range of formats – down to 110 – medium format enlargers offer a choice of head types. Condenser heads are designed for black and white work, while color-mixing, dial-in, and fiber-optic heads print both black and white and color.

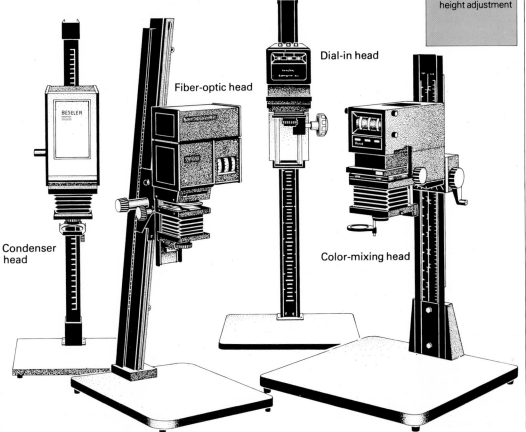

Fiber-optic head

Dial-in head

Condenser head

Color-mixing head

Wall-mounted enlargers

Wall-mounted units save bench space and allow you to produce big enlargements by adjusting the baseboard height. With some models you can extend the head-to-baseboard distance to make prints up to 40ins × 30ins (101cm × 76cm). A choice of heads and a wide range of accessories are available.

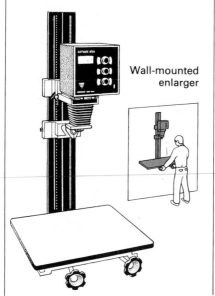

Wall-mounted enlarger

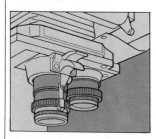

Dichroic head enlargers

Dichroic (non-fade filter) heads allow you to adjust filtration accurately. The enlarger, below right, has a control unit making correct color balance possible at any light level with a choice of aperture and exposure time settings. Some models have a filter drawer for adding further filters.

Dichroic enlarger

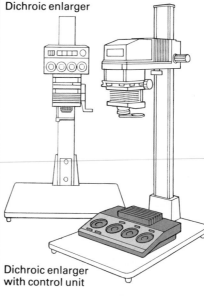

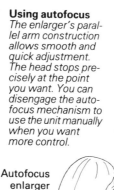

Dichroic enlarger with control unit

Autofocus enlarger

The enlarger, right, is very versatile. It maintains accurate focus automatically over a magnification range of ×2 to ×11. Manual adjustment allows a greater choice of magnifications and reductions. The enlarger is a high quality unit, with twin lenses to allow a choice of negative size and magnification. It also accepts a range of masks for different negative sizes.

Using autofocus
The enlarger's parallel arm construction allows smooth and quick adjustment. The head stops precisely at the point you want. You can disengage the autofocus mechanism to use the unit manually when you want more control.

Autofocus enlarger

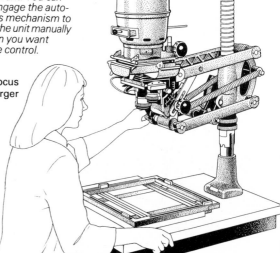

Twin lenses
The autofocus enlarger has a pair of lenses of different focal lengths. A simple sliding lens turret allows you to change lenses quickly and maintain automatic focus.

Large format enlargers

These enlargers are very adaptable accepting film sizes between 35mm and 4ins × 5ins (10.2cm × 12.7cm). Designed primarily for the professional, they offer high quality and reliability, but are expensive. They all have heads which tilt, providing a useful range of adjustments. Most offer a choice of condenser, or diffuser color mixing heads. Some are also adaptable for bench-top or wall-mounted use. Many manufacturers produce a whole enlarger system based on a large format unit. Such systems include a choice of heads, negative carriers, lens panels which accept a wide variety of focal lengths, an analyzer, a transformer, a copy back, and extension tubes for extreme degrees of reduction. You can use different lenses for changing degrees of enlargement. (With condenser heads you also have to change the focal length of the condenser.)

Enlarger construction

These enlargers are much stronger and more rigid than their smaller counterparts. Rack-and-pinion focusing is standard, and you usually adjust head height with a crank handle or a motor drive. Sturdy V-shaped rails provide a very smooth operation up and down the supporting column. Lamp housings are well-ventilated for continuous use.

Alternative heads
The diffuser model, center right, accepts other heads, including a medium format condenser type, right. The wall- or bench-mounting model, far right, offers a choice of diffuser, condenser, and copying heads.

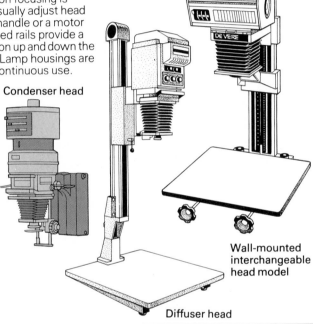

Condenser head

Wall-mounted interchangeable head model

Diffuser head

Advanced heads

The color head, below, offers both condenser and diffuser illumination. It has an electronic system for programming filtration. The head and control unit, right, are for printing multigrade paper. The control unit allows you to select different contrast levels, and "burn in" selected areas.

Multigrade head and control unit

Electronic head

Enlarging lenses

You can only produce good prints with a high quality enlarging lens. Buy one which matches the quality of your camera lens. Do not use camera lenses for enlarging, as they give their best performance over greater subject distances. An enlarging lens is designed to perform best at close range, and to provide good image contrast and a flat field. When choosing an enlarging lens, select a focal length that covers the negative sizes you want to use. The best length will be equivalent to the diagonal of the largest film format you will print. Different focal lengths allow you to vary enlargement. A wide-angle lens gives extra magnification. The quality of enlarging lenses varies greatly.

Amateur lenses commonly have only three elements and give good results over a limited magnification range. Professional lenses, with between four and six elements, perform very well over a wide magnification range and are especially suitable for color printing. If you plan to print using the convenient magnification of about × 8, an amateur lens will give good results. For larger magnifications, a professional lens is best.

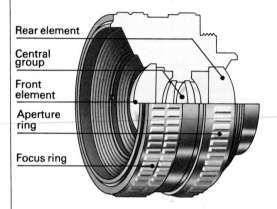

Rear element

Central group

Front element

Aperture ring

Focus ring

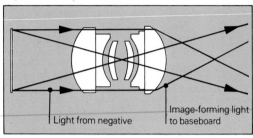

Light from negative

Image-forming light to baseboard

Enlarging lens principle
Light rays from any image point on the negative are collected by the lens and form a sharp image on the baseboard. Bringing the lens closer to the negative focuses the image farther away.

Using an enlarger lens

When you are focusing an enlarging lens, use the maximum aperture. At this setting, depth of field is at a minimum, but the extra image brightness makes critical focus easy to achieve. When you have focused the lens, stop down two or three stops. This setting will give improved image quality and increased depth of field. Stopping down involves using a longer exposure. But do not use exposures over 20 seconds, unless really necessary, as they make it easy to jar the enlarger, or for stray light to spoil the image. As you focus, the image size will change slightly from that set. If the image will not focus, you may have a blurred negative, or a misaligned lens. If you can focus either the edge, or the center, of the negative, but not both, the enlarger is out of square or the negative is not flat in the carrier.

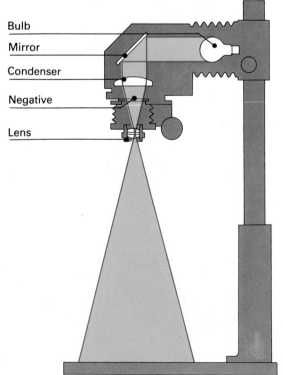

Bulb

Mirror

Condenser

Negative

Lens

Enlargement control
When printing you control enlargement by adjusting the distance from the lens to the baseboard, right. You alter the focus by changing the distance between the lens and the negative. The greater the lens-to-base-board distance, the shorter the lens-to-negative distance must be, for sharp focus.

Magnification

The height at which you set the enlarger head determines the magnification you obtain. As you raise the head, the image size increases, as shown below. A wide-angle lens, or the use of wall or floor projection, give greater magnification.

Magnification range
A good enlarger with a long column, right, will give a magnification range from × 2 to × 10. This provides a useful range of print sizes for most amateur work.

× 10
× 8
× 5
× 2

Covering power

A lens of a particular focal length covers an image circle of a given size. Within this circle, the lens can produce an evenly illuminated, sharp image. A negative with a diagonal that fits this circle will produce an acceptable result. For example, an 80 mm lens gives an image circle big enough for a 2¼ ins × 2¼ ins (6 cm × 6 cm) negative, below. The image circle of a 50 mm lens, bottom, suits a 35 mm negative.

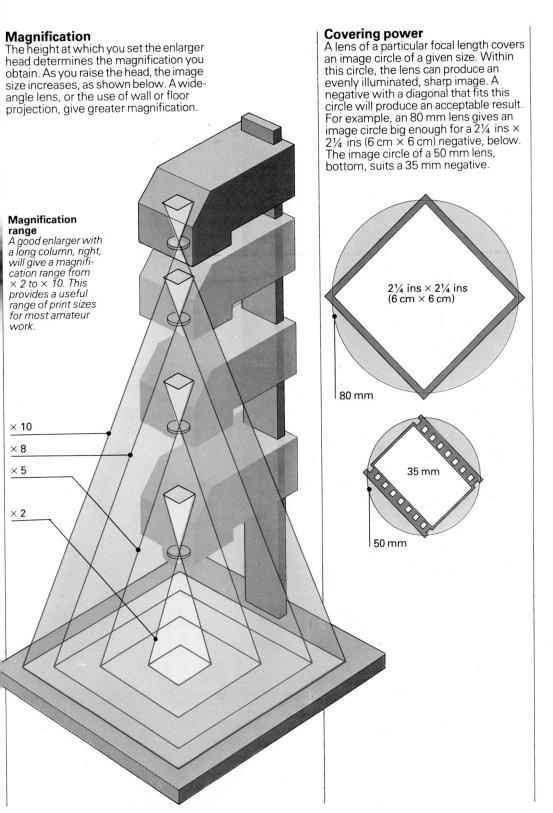

2¼ ins × 2¼ ins
(6 cm × 6 cm)

80 mm

35 mm

50 mm

175

Standard lenses

A standard enlarging lens has a focal length equal to the diagonal of the format for which it is designed. For example, a 50 mm lens is standard for 35 mm negatives. You can use each size to print smaller negatives, but magnification may be reduced. If you use a lens with a negative size which exceeds its covering power, vignetting will occur. The table below shows details based on one manufacturer's range of standard enlarging lenses.

85 mm 75 mm 50 mm

Focal length	Maximum f stop	Minimum f stop	Construction Groups-elements	Standard magnification	Magnification range	Covering power	Format (mm)	Weight	Length
50 mm	f2.8	f16	4-6	× 8	× 2 − × 20	46°	24 × 36	100 gm	39.5 mm
50 mm	f4	f16	3-4	× 8	× 2 − × 20	46°	24 × 36	100 gm	28 mm
75 mm	f4	f45	3-4	× 5	× 2 − × 10	52°	56 × 56	80 gm	32 mm
80 mm	f5.6	f45	4-6	× 5	× 2 − × 15	57°	60 × 70	150 gm	34.5 mm
105 mm	f5.6	f45	4-6	× 5	× 2 − × 10	56°	65 × 90	220 gm	39.5 mm
135 mm	f5.6	f45	4-6	× 5	× 2 − × 10	54°	90 × 120	260 gm	47.2 mm
150 mm	f5.6	f45	4-6	× 4	× 2 − × 8	54°	100 × 130	300 gm	55.5 mm

Wide-angle lenses

Wide-angle enlarging lenses give higher magnification, at the same column height, than standard lenses for the same format. They require six elements to achieve good image quality, and so are costly. Some of the shorter focal lengths should only be used with a diffuser light source.

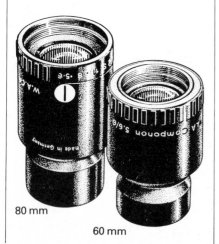

80 mm

60 mm

Zoom lenses

Zooms provide a range of focal lengths within one lens. They allow you to change magnifications easily. Once you have focused, at the minimum or maximum focal length, the zoom will give a range of magnifications without refocusing. Zooms are useful if you print a wide range of negative sizes.

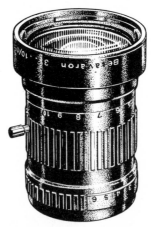

50 mm-125mm zoom

Special effects enlarging kit

Rodenstock produces a color enlarging kit. It helps you to create special image effects similar to those with camera filters, and can give your color printing greater accuracy. It consists of a group of filters, two lenses, and a color analyzer. The range of filters provides a variety of effects. Colors, soft-edge diffusers, prisms, diffraction gratings, center spots and multi-contrast filters are all available. The diffraction grating works best with a condenser light source. Each filter slides into the lens across the image path.

The color analyzer is designed to fit over the lenses in the kit, but a version is available which will fit other lenses. It is also possible to retune the analyzer to suit a range of neg/pos papers and films. The unit is easy to use: you read off the color balance on an LED display. Items from the kit are also sold separately.

Creative kit
The color analyzer, far left, can be attached to either of the two enlarging lenses available. The focal lengths of the lenses are 50 mm, left, and 75 mm, and the aperture ranges are, respectively, f2.8-f16 and f4.5-f22. Five sets of filters are offered: These produce a variety of results, including soft-focus, graduated, distortion, and diffraction effects, and flare (to reduce contrast).

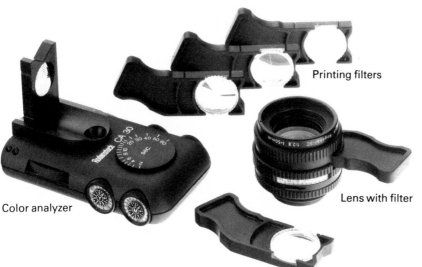

Printing filters

Lens with filter

Color analyzer

Creative filter effects
Rodenstock printing filters allow you to achieve interesting results at the printing stage. In the scene, right, a filter was used to produce a soft halo on a rather flat original, above.

Enlarger accessories

In addition to your basic enlarger and lens, you will require a range of extra items for printing. For accurate enlargement you must use a masking frame to align the image and hold the printing paper. To print negatives of different sizes, you may require extra interchangeable negative carriers, or a set of masks to fit the basic carrier supplied. For dense negatives or large prints, a focus magnifier will help you focus accurately. Timers and meters ensure accurate exposure. For color printing, a transformer, to give a constant power supply, and a color analyzer, to help you calculate filtration, are useful. For contacts, you will require a simple frame, or a printer. Light-tight safes are the best way of storing printing paper. You do not have to buy all these items at once. Buy the masking frame when you purchase the enlarger. If you want to print in color, you should buy a transformer as soon as possible and follow it with a color analyzer. Even the cheapest form of analyzer is more accurate than using test strips for gauging filtration. If you buy items singly make sure they are compatible with each other and with your enlarger.

Masking frames

A masking frame holds the printing paper in place on the baseboard. Fixed-frame designs are adequate if you print only one size. Multiple format models provide a range of popular frame sizes. Fully adjustable masking frames, right, are more useful. These have two or four masking strips which allow you to make any size of print within the basic frame size. Borderless models are available if you want to print the full paper area. Vacuum frames, below right, are for holding large sheets of paper flat while you set focus and during exposure. A foot switch allows you to use both hands for local shading.

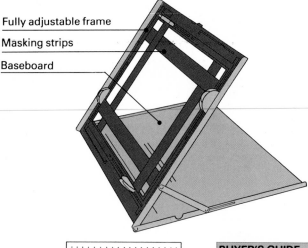

Fully adjustable frame

Masking strips

Baseboard

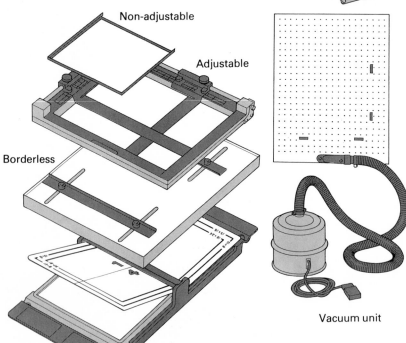

Non-adjustable

Adjustable

Borderless

Multiple format

Vacuum unit

Negative carriers

Most negative carriers have an adjustable mask to restrict illumination to the image area. Glassless carriers are adequate for small negatives, but with larger formats, the film may bend. A glass covering overcomes this problem, but you must keep the glass clean. Drawer-type carriers accept glass inserts for the large formats, as well as interchangeable masks for smaller negatives. Carriers are also available which take a whole reel of film, below.

Reel carrier

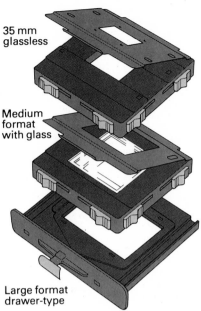

35 mm glassless

Medium format with glass

Large format drawer-type

Examining negatives

Before printing you will want to examine your negatives carefully, to decide which ones you want to print. Use a magnifier, below, and a lightbox, bottom. Folding magnifiers are also available. Buy a sturdy lightbox, and lean only on the edges when using it, to avoid breaking the glass. Make sure the negative is clean. If necessary, wipe it with an antistatic cloth.

Focus magnifiers

When the baseboard image is dim, or contrast is low, you may find it difficult to focus. A focus magnifier by enlarging the image grain makes this task easier. The magnified grain image is bright, and comes easily to focus when you adjust the enlarger controls. Models with angled construction allow you to use the enlarger head controls comfortably. Magnification strength is generally between × 5 and × 10, but some models allow magnifications up to × 25. Some designs also incorporate an exposure meter with a silicon cell.

Magnifier

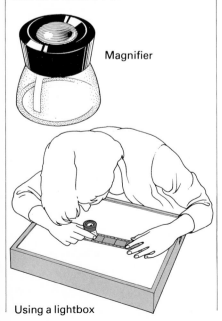

Using a lightbox

Screen magnifier

Using a focus magnifier

Focus magnifier

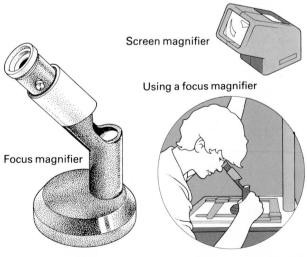

Exposure timers

An enlarger timer ensures accurate exposure and consistency of results in repeated printings. Most models are linked directly to the light source, and act as an on/off switch. For the beginner, a simple manual model, right, is adequate. A luminous dial makes the pointer easy to see in dim safelight conditions. A follow-pointer, which is also luminous, enables you to see at a glance how much time has elapsed. The timer has an exposure setting range of 0.1 to 60 secs. Other models have a greater range, sometimes as high as 1000 secs. An audible signal and a footswitch make shading easier.

Manual enlarger timers

Digital timer

This unit is accurate even for very short exposures, and can be programmed for up to eight successive periods. As each period finishes, an alarm warns you.

Programmable timer

The timer below allows sequences of varied intervals to be programmed on adjustable dials which are inserted in the unit. Its range of periods – 15 seconds to 29½ minutes – is useful for printing and processing. Dials can be stored to repeat programmes.

Digital timer

Programmable timer

Foot switch

A foot switch is useful when printing techniques occupy both your hands. This is often the case with shading. You can connect most models to a compatible exposure timer or directly to the enlarger.

Foot switch

Audible timer

This produces a sound signal once every second. It is ideal when you are doing complicated shading, or whenever clock-watching is distracting. On some models a buzzer indicates the end of the timed interval.

Audio timer

BUYER'S GUIDE

Names to look for
(Price range B-E)
 *Daimic, Omega
 **Beseler, Durst, Hauch, Jobo, Kaiser, Philips
 ***Leitz

Points to look for
● Good exposure range
● Low-level exposure scale (0.1-10 secs)
● Separate switch for focusing
● Illuminated dial and on/off switch
● Suits local voltage
● Preset exposure time can be changed during operation
● Memory
● Automatic control of safelight
● Click-stop switching
● Optional foot switch
● Volume control (audio models)
● Follow-pointer (manual models)

Exposure meters

It is best to assess printing exposure with a meter designed for photographic printing. Before use, the meter must be set to the speed of the paper. To make a reading, you place the meter (or probe) on the baseboard and adjust the aperture until the meter's LED lights up. Most meters have a diffuser, which you place under the lens to scramble the light, so that you can take a reading averaged for highlights and shadows. With a probe, you can also take spot readings. The unit below is a combined color analyzer, exposure meter, and timer.

Enlarger exposure meter

BUYER'S GUIDE

Names to look for
(Price range B-D)
*Paterson,
Unicolor
**Durst
***Kaiser

Points to look for
● Integrated and spot reading option
● Suitability for color and black and white
● Built-in timer
● Variable time settings
● Diffuser disk included
● Integral battery compartment (reduces number of cables)

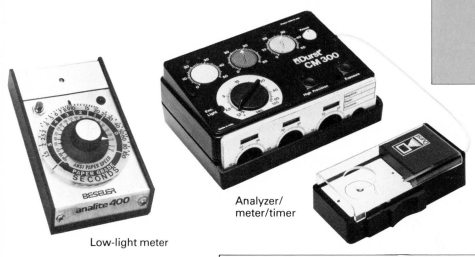

Low-light meter

Analyzer/ meter/timer

Meter/timer

Meter/timer

The unit above provides metering and timing. A baseboard probe measures the exposure required. When you attach the unit to the enlarger circuitry, it automatically switches off the light when the correct, metered exposure time has elapsed.

Transformer

Voltage fluctuations can cause changes in exposure level. Problems of color balance may arise since the enlarger lamp's color temperature can be affected. A transformer maintains balance by stabilizing the current.

Transformer

BUYER'S GUIDE

Names to look for
(Price range A-C)
Buy from your enlarger manufacturer

Points to look for
● Stabilization guaranteed to within 2 per cent
● Compatibility with your light source and electricity supply
● Enlarger and main connection leads included

Color analyzers

These units analyze the projected image and indicate the filtration required for a balanced print on the paper in use. (The simplest may be calibrated for one film/paper type only.) Most models incorporate an exposure meter, and some can be linked to an exposure timer. With some types, you place the unit and/or probe on the baseboard; others take readings from below the lens. Most analyzers give "integrated" readings. Those that also offer spot readings are more accurate, particularly with images of irregular color distribution. Calculator kits, below, provide a cheaper method of color analysis.

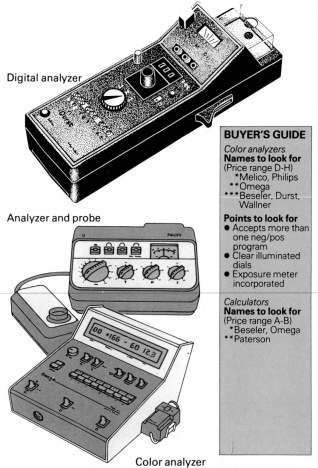

Digital analyzer

Analyzer and probe

Color analyzer

Filtration calculator

A simple calculator kit consists of yellow, magenta, and cyan filter matrices, and a neutral density wedge. You lay these over the projected image (first placing a diffusing disk under the lens), and match density and color to a sample test print supplied.

Choosing enlarger accessories

To make a print, all you really require is an enlarger, and for color work a set of correction filters. But you need a great deal of patience and skill to work regularly with such limited resources. The photograph, right, shows a working photographer's enlarging bench equipped with the accessories necessary for satisfying, accurate printing. The medium-format enlarger has the benefit of a good baseboard, and a transformer to overcome fluctuations in voltage supply. A dial-in color head, color analyzer and exposure meter allow fine control for color printing. The wall-mounted safelighting, and the clock and timer are essential items. A contact printing frame, a focus magnifier, masks, a negative file, a blower brush, and retouching tools are all useful.

Contact printing frames

The simplest method of printing is to make contact prints. You place negatives and paper emulsion in contact with each other and shine a light through the negatives. A contact printing frame has a flat rubber bed and a hinged glass cover. The cover is sometimes sectioned, to accept strips of film. A hinged clip at the open end of the frame closes to provide the pressure required. The frame must hold the negatives and paper in contact – even a slight separation will cause blur. When printing, ensure that the light source covers the whole frame.

Contact printing frame

Shading
When shading during contact printing, hold stiff, opaque cardboard between the light source and the negatives, above. Keep it moving to avoid hard-edged density changes.

Contact printers

Specially designed units, below, with a built-in light source are available for contact printing strips of roll film and large negatives. You place the negatives on the glass top, emulsion up, and put the paper on the negatives, emulsion down. You then fold down the lid to achieve contact, and switch on the light source. Models are available for different negative formats. Vacuum pump types ensure even contact on large negatives.

4 ins × 5 ins
contact printer

Multi-format contact printer

Paper safes

These provide a light-tight container for your paper. They reduce the risk of fogging, while keeping the paper accessible. The best designs allow you to remove a single sheet, right, and close automatically after removal.

Print processors

Processing drums and automatic processors are suitable for both color and black and white work. The drum system of print processing is particularly useful for color printing, since it helps you to achieve accuracy even when you are a beginner. Designs vary from the simple drum to more sophisticated, motorized units. To agitate the drum you simply roll it by hand during processing. The automatic models can give more precise agitation since you can set their rotation speed exactly and avoid manual error. They also use an electrically heated water jacket to keep all your processing chemicals at the correct temperature. Accuracy of both temperature and agitation is vital in all types of printing, especially in color work, where even slight errors at some stages can lead to poor quality results. In addition accuracy makes it possible to repeat prints later and be sure of getting the same results.

Processing drums

Drums provide a cheap and simple way of processing prints accurately. It is best to use them together with a tempering box and automatic agitator, but you can agitate them by hand, below. Sizes range from 8 ins × 10 ins (20 cm × 25 cm) to 12 ins × 16 ins (30 cm × 40 cm). Before using a drum you should preheat it with clean water slightly above processing temperature. Chemicals will not then cool before use.

Automatic drums

Recent designs combine a tempering box for chemical temperature control with a rotating drum giving accurate agitation, below. A motor on the side of the unit rotates the drum. The textured drum surface feeds fresh solution to the paper from a shallow tray in the unit's base. The drum is heated internally by warm water. Older types use a nylon blanket to hold the print externally on a textured surface.

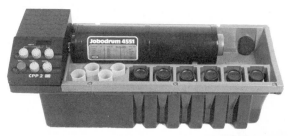

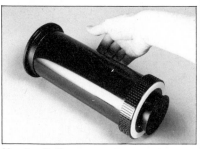

Hand agitation

Tempering box
A tempering box, left, with a drum and agitator, below, does the same as the automatic drum.

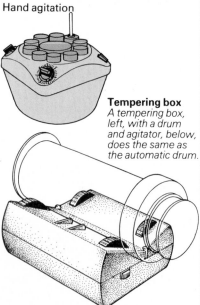

Color processor
This processor uses a water jacket to keep solutions at the correct temperature. A built-in pump ensures an even temperature, and the drum has variable speeds with automatic reversing, to give uniform agitation.

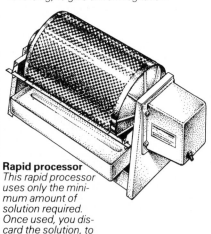

Rapid processor
This rapid processor uses only the minimum amount of solution required. Once used, you discard the solution, to give quick and consistent results.

Automatic processors

Various types of automatic processor are made. Some are designed only for color processing, but the most useful models enable you to process both color and black and white prints. The major advantage of all types is their accuracy and speed. On some machines you can process black and white prints in less than 10 seconds, while color processing usually takes about 7 minutes. You may have to fix and wash some results. All processors are easy to install, and once programmed require no control during processing. They are extremely accurate, even when coping with large print runs. Some take only their manufacturer's chemicals and paper.

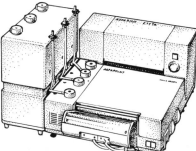

Black and white processor
The unit above processes black and white prints quickly and easily. You must use the manufacturer's materials, as the unit employs paper with some processing chemicals ready impregnated for very quick results.

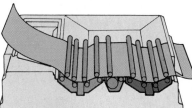

Paper path

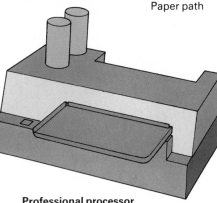

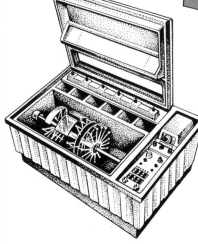

Professional processor
The professional unit, above, has a high throughput rate. There are models for both black and white and color, and some units also incorporate a print dryer. It is best to use the manufacturer's materials.

Rotary processor
The rotary processor, left, uses a water jacket to keep temperatures constant. It is most useful for professionals who want to process between 12 and 48 prints at the same time. The machine uses small amounts of chemicals to exhaustion, but some models enable you to recycle chemicals.

Advanced amateur model
You can use the roller processor, below, for black and white and color. It has automatic temperature control and an even running speed, and it processes all paper types. The cutaway drawing shows how the paper travels through three baths containing developer, bleach and stop. Once you have filled these baths, and brought the chemicals to the right temperature, the machine is ready to use. You feed in the exposed print in the dark and the machine delivers a print in 7 minutes, ready for stabilization and drying.

Print washers

Unless you use a professional processor/dryer unit (p.185), you must wash your prints to remove residual chemicals, and prevent stains, before drying. Resin-coated papers require a very short wash, but fiber-based papers absorb chemicals and you must wash them thoroughly. Whether you use a siphonic or rotary washer it is important that the prints receive a continuous supply of clean water and do not stick together when you leave them unattended.

Siphon

Long plug

Siphons
With a siphon or a long plug attachment you can convert a sink into a print washer. The siphon is best, as it ensures that contaminated water at the bottom of the sink drains away. All attachments must be lower than the overflow, to ensure drainage.

High-speed print washers
Use the flat tray-type washers to wash small quantities of resin-coated papers quickly. They usually hold one big print or up to four smaller ones. Adjustable separators prevent prints overlapping. The water flow cleans both sides of the print and escapes through an outlet into a waste pipe or sink.

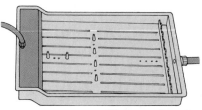

High-speed washer

Siphonic washers
Plastic types have a cradle to hold the prints, allowing both sides to be washed simultaneously. The big, open type of tank accepts a larger number of prints. Water enters through perforated feed pipes; this helps keep the prints apart, reducing the risk of sticking.

Siphonic tank

Siphonic tank with basket

Rotary washers
The rotary washer uses a swirling action to help keep the prints apart. You should avoid strong water pressures, which can damage the prints, and overfilling, which can cause blockages. Contaminated water normally escapes quickly through the low-level drain.

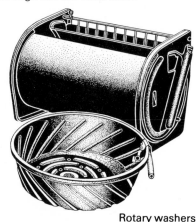

Rotary washers

BUYER'S GUIDE
High speed
Names to look for
(Price range A-C)
 *Paterson
 **Soligor-Jobo
***Kindermann

Points to look for
- Ribbed base with print separators
- Inlet pipe water-tight at faucet and washer
- Outlet that prints cannot flow over

Siphonic
Names to look for
(Price range C-D)
Local manufacturers
 **Paterson
***Kindermann

Points to look for
- Maximum print size accepted
- Inlet pipe that fits your supply
- Outlet pipe long enough to reach waste
- Large tank (best for fixed set up, but needs good water pressure)
- Corrosion-proof metal
- Plastic cradle type (best for small quantities of film)
- Plastic type (for portability)

Rotary
Names to look for
(Price range D-E)
Local manufacturers
 **Durst
***De Vere

Points to look for
- Long feed pipes
- Filler pipe included in price
- Dustcover included
- Acceptance of your maximum print size

Cascade system
It is easy to make your own cascade print washer. Place three dishes above each other at an angle, with the edges slightly overlapping, right. Clear water enters the top dish and drains through an outlet at the bottom. Place processed prints in the bottom tray and move them up at intervals during the wash.

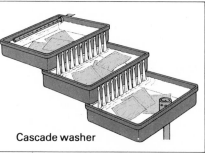

Cascade washer

Print dryers and glazers

To ensure that your prints dry flat, some form of heat drying is best. Hot-air dryers are effective with resin-coated papers (p.188). But direct-heat dryers, which hold the paper in contact with a heated surface, are best for fiber-based papers as these take longer to dry and may also require glazing. There are two main types of dryer/glazer. The flat-bed type is inexpensive but can only handle a small number of prints at a time. The rotary type has a continuous feed, and will dry and glaze prints for as long as you let it run. For glazing, you place the print face up, so that the emulsion faces the metal drum surface (on rotary units), or the glazing sheet (on flat-bed models). To dry the print, place it with the emulsion side facing the cloth belt or apron. Clean the glazing surface regularly with a 2 per cent solution of acetic acid and polish it until bright and dry. You should also keep the belt or covering sheet free of chemical stains by washing all prints thoroughly before they pass through the unit. This is important as a dryer stained with chemicals will contaminate new prints.

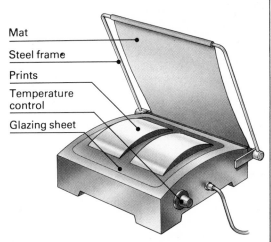

Mat

Steel frame

Prints

Temperature control

Glazing sheet

Flat-bed dryer/glazer
This unit provides an economical way of drying or glazing fiber-based prints. Variable temperature prevents overheating, and adjustable tension keeps prints flat and free of creases. Double-sided models speed up the process when you want to dry many prints.

Rotary dryer/glazers
These units can dry or glaze large quantities of prints on fiber-based paper. When you want to dry only one or two prints, you can use a manual handle on the side of the dryer to turn the drum. Dryers of this type are large and heavy. They require a stable base on which to rest. Sturdy metal stands are available for some models, to raise them to a comfortable working height.

Manual drying aids
Before using a flat-bed or rotary dryer with fiber-based papers, you must wipe the print to remove excess water. You can use two types of squeegee, below. If you have no dryer, place the print between photographic blotting paper, under a heavy weight (e.g. books) so it dries flat.

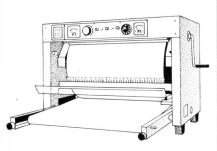

Roller squeegee

Squeegees
A roller squeegee, above, is often more convenient than the blade type, below right, which has a rubber strip in a holder. The roller helps you apply even pressure over the whole of the print surface.

Controls
Rotary models are fully adjustable to suit your processing program. The range of controls should include dials for adjusting temperature and speed. Both heater and motor should have pilot lights to show when they are on.

Blade squeegee

Drying racks

The cheapest way to dry prints on resin-coated paper is to use a print drying rack. Once you have removed the surplus water with a squeegee, the prints will dry quickly in a warm room, without any extra heat. You simply load the rack and place it on a drain board, or wherever the excess water can drain away. Most racks will take at least ten 8 ins × 10 ins (20.3 cm × 25.4 cm) prints, and some models will accept greater quantities of prints up to 11 ins × 14 ins (28 cm × 35.5 cm) in size. Some drying racks incorporate rollers. Other designs are more compact, and you can attach some to a wall.

Print drying rack

Roller rack
The unit below combines rollers with a drying rack in a compact drying system.

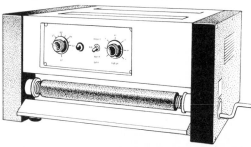

Roller rack

Automatic hot-air dryers

Automatic dryers for resin-coated papers use hot air to speed up the drying process. You pass the prints through a pair of rubber rollers at the front of the unit to remove excess water. The horizontal rack type, right, can dry only a limited number of prints at once, whereas the more sophisticated models, below, use a continuous feed system.

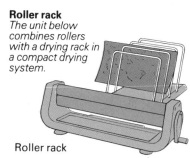

Horizontal rack model
The print dryer above incorporates rollers and a temperature control. It can dry three 11 ins × 14 ins (28 cm × 35.5 cm) or six 8 ins × 10 ins (20.3 cm × 25.4 cm) prints at a time. Prints take 2-3 minutes.

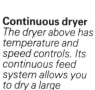

Continuous dryer
The dryer above has temperature and speed controls. Its continuous feed system allows you to dry a large number of prints.

Radiant heat dryer
The advanced automatic dryer, right, uses radiant heaters and fans to dry prints efficiently and provide a good quality surface.

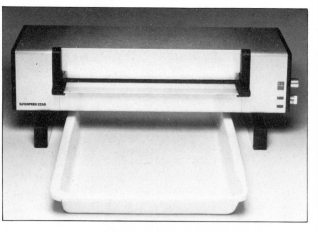

Print room accessories

In addition to the basic printing and print processing equipment, you will require several smaller items. Darkroom thermometers are purpose-made for different tasks, so be sure to use the correct type. For accurate processing, measuring vessels and thermometers are essential. For black and white work, you should have a set of processing trays. Correct safelighting for your materials is essential. For processing timing, use a darkroom clock or electric timer. You can use a watch instead, but this method may be less accurate. Other useful items include dodgers and film cleaning aids. Choose equipment that is strong, durable, and suited to the particular printing task.

Trays
To tray-process black and white prints, you will require at least three trays, each of a different color. Always use the same chemical in the same tray. Strong plastic trays, right, are best. They should be at least a size larger than your print, and the one for fixer should be bigger. The stand type, far right, is useful if you do not have a processing bench. For outsize prints, use a long tray with a roller, below.

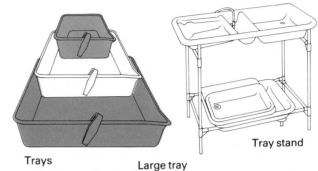
Trays Large tray Tray stand

Measuring equipment
You must measure solutions accurately with a graduate. A measuring jug and funnel are also useful. It is vital to have a thermometer calibrated for the processing temperature range. Use the dial type with processing drums and the flat type in a tray.

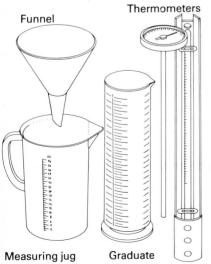
Funnel Thermometers
Measuring jug Graduate

Protective clothing
Processing solutions can create stains which are hard to remove, and cause skin irritation, so it is important to wear the correct protective clothing. An apron or white coverall will shield your clothes from chemicals, and rubber gloves protect your hands. If your fingers get sore, you should use a barrier cream straight away.

Gloves
Use heavy-duty rubber gloves for chemical mixing, finer gloves for print handling.

Beehive type

Bench top

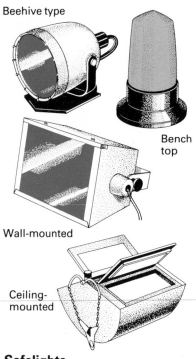

Wall-mounted

Ceiling-mounted

Safelights
When processing and printing, you must use correct safelighting. Fittings vary from simple bench-top to wall- and ceiling-mounted models. You can mount the beehive type on a wall or bench. All lights accept regular 15W or 25W bulbs. You make them safe by placing a filter over the light. For black and white processing, use an orange, yellow, or red filter. For color, use amber or bright "sodium", or work in darkness, depending on the material.

Cleaning equipment
It is very important to keep your enlarger clean. You should also clean your negatives each time you make a print from them. You can use a blower brush, or a simple camel hair brush to remove dust from the negative surface immediately before printing. Convenient aerosol units are also available. These give a jet of air which you can direct precisely with the aid of a nozzle.

Darkroom clocks and timers
A simple darkroom clock, right, with levers to stop, start, and reset the hands, is adequate for basic printing and processing. You can use a timed tape recording for more complex sequences. Electronic timers, below, which you can also link to the enlarger, are worth buying for frequent darkroom work. For advanced printing, programmable enlarger timers (p.180) are best.

Darkroom clock

Enlarger timer

Electronic timer

Dodgers
For print shading you can buy or make rigid matte masks of different shapes. Hold them with a wire handle and keep them on the move when you are dodging, to avoid a harsh outline on the print.

Aerosol

Blower brush

Cleaning brush

BUYER'S GUIDE
Safelights
Names to look for
(Price range A–C)
Local manufacturers
 *Paterson
 **Kindermann

Points to look for
● Correct color for materials (orange/yellow or red for black and white printing, dark green for panchromatic black and white film, amber for color printing)
● Housing that accepts all types of filter you may require
● No light leaks where filter fits housing
● Bench-top type (suitable for black and white)
● Wall-mounted and ceiling types (best for color)

Clocks
Names to look for
(Price range B–D)
 *Kodak
 **Gralab (Dimco-Gray), Philips

Points to look for
● Clear visibility
● Alarm
● Automatic reset
● Wide range of time intervals

Print finishing

When you have processed and dried a print it will probably require some form of finishing. There may be obtrusive spots, tones or colors which you want to remove. You can do this with careful use of retouching dyes. It is best to buy a ready-packaged kit which will contain all the items you require for retouching prints. If your prints have uneven borders, or if you want to trim their edges before mounting, some form of trimmer can be very useful. It enables you to get clean, straight edges quickly and easily. Guillotine-type trimmers allow you to cut through very thick card, but rotary models are available which are safer, though less versatile. For the dry mounting of prints, a specially-designed heated press gives the best results. Use it in conjunction with a tacking iron. This enables you to align the print on the mount before applying overall pressure.

Retouching kits
Buy a packaged kit to start with and add replacements as you require them. The kit should contain retouching dye, several camel hair brushes of different sizes, a pencil with interchangeable leads, an eraser, a scalpel, and a magnifying glass.

Trimmers
All types are available in a range of widths. The pressure-push scissor type, right, has a clean cutting action. The guillotine model, below, accepts thick card and is available in large sizes for commercial use. The rotary trimmer, below right, is the safest to use and is ideal for all papers and films.

Scissor trimmer

Guillotine trimmer

Rotary trimmer

Dry mounting presses
Both hard-bed and soft-bed types are heat presses, requiring a main supply. They use a thermostat to control temperature. The soft-bed model, below right, is best for the advanced amateur. The hard-bed press, right, with adjustable action, is ideal for commercial use. A tacking iron with stand, below, helps align the print.

Tacking iron

Hard bed press

Soft bed press

Print presentation

You should store prints so that you can locate them easily, while keeping them properly protected. Albums give good protection and provide a useful display system. Some allow you to dry mount prints, but most use plastic sealing covers. Alternatively, you can use small corner mounts. You can also buy stands for displaying prints. Plastic cubes and frames give good protection as well as keeping the print upright. For special prints, you can use a plain or decorative frame, together with mounting card. Ready-made frames are widely available to fit standard print sizes. Clear plastic provides an inexpensive alternative to glass for covering your print. For displaying large prints, you can use metal clips to secure the glass to the backing.

Frames
You can buy metal and wooden frames in standard sizes. Alternatively, use glass or plastic with metal clips (available as low-cost kits), or make your own in wood. In all cases, you should place the print between the cardboard mount and rigid backing, below.

Albums, cubes, and stands
The best albums use plastic sealing. Others are designed for dry, or corner mounting. (Corners are the least reliable.) Transparent plastic cubes and stands, below, give protection to prints on permanent display.

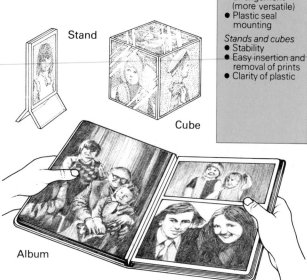
Stand

Cube

Glass Mount Print Backing

Wooden frame Metal frame Clips

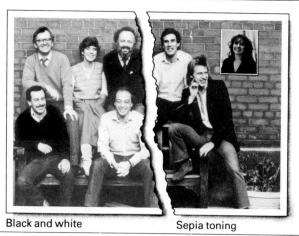
Album

BUYER'S GUIDE

Names to look for
(Price range A-B)
Local manufacturers

Points to look for
Albums
- Loose leaf arrangement (more versatile)
- Plastic seal mounting

Stands and cubes
- Stability
- Easy insertion and removal of prints
- Clarity of plastic

Sepia toning
Sepia toning is attractive and preserves your prints. First wash the print thoroughly to remove traces of fixer. Then bleach in a bichromate solution, rinse, and place the print in a sodium sulfide solution. This will produce a rich sepia tone, far right. The print will be much more resistant to fading through exposure to light.

Black and white Sepia toning

Appendices
manufacturers' coding/ fault finding/ buying secondhand/ films, papers, and chemicals/glossary

Manufacturers' coding

The letters and figures used to identify cameras, lenses, and other equipment remain a mystery to many photographers. However, a little research, particularly into cameras and lenses, reveals useful information for the prospective buyer.

Camera coding
The amount of information that is given on the camera varies from format to format. In general, 126, 110, and 35mm direct vision models display their format, while 35mm SLRs and larger cameras do so far less often. Many cameras up to and including the SLRs also bear letters which reveal important specifications. The coding "E", for example, indicates an electronic shutter, "A" that exposure is automatic, "AF" that the lens focuses automatically, and "EF" that there is integral electronic flash. Rangefinder focusing may be indicated by "R", while the fastest shutter may also form part of the coding, 500GX, for example, indicating a top speed of 1/500 sec.

Many cameras also reveal that they form part of a series. Kodak, for example, produce the "Ektra" range of 110s, Minolta the "Hi-matic" direct vision range, and Nikon the "F" series. In some cases, notably with Minolta's top-of-the-range multimode, the coding used in the USA is different from that employed in Europe. What is known as the XD-11 in the USA is referred to as the XD-7 in the European market. Cameras in the 35mm format and larger also carry a model number. It is important to have a note of this for insurance purposes or for when your camera is away for repair or maintenance.

Lens coding
Lenses are classified by their focal length and maximum aperture ("speed"). A lens described as 300 mm/f4.5 (or simply 300/4.5) has a focal length and widest aperture corresponding to those figures. The maximum aperture is often shown on the lens in the form 1: 4.5 or 1: 2.8, and so on. Other details concerning the lens' specifications may also appear. "MC", for example, often in combination with another letter, such as "S" for "super", indicates that the lens elements are multi-coated, to reduce flare.

Most manufacturers produce series of lenses. The coding can be in the form of letters. Canon, for example, uses the classification "FD" for lenses with a particular type of mount. Or there may be a special trade name – "Rokkor" for Minolta, "Nikkor" for Nikon, "Zuiko" for Olympus – or a combination of both name and letters. The description may also indicate whether the lens offers automatic diaphragm coupling. Most lenses do nowadays, and so you are likely to find only a few designated as "non-A1", non-automatic.

Almost all medium and large format lenses are sold as part of a series. They are often grouped according to focal length or covering power. As these specifications determine applications to a large extent, it is worth finding out what series names indicate. The Nikkor large format series are designated "M" (for standard covering power) and "SW" and "W" (for wide covering power). Hasselblad's wide-angle lenses are coded "Distagon", while the name "Sonnar" indicates long focal lengths.

Fault finding

Most well-known manufacturers produce reliable equipment. The top companies design cameras and accessories that will withstand long-term use by professional photographers. Budget-priced models are not intended to take this kind of pressure but, if correctly used and cared for, they will give long and problem-free service. If you find that you have bought a faulty camera or accessory, ask your supplier to exchange it immediately. Faults in SLR cameras usually occur in one of three places: the shutter, the film wind-on, and the mirror mechanism. Electronic faults are less common. Other formats of camera suffer from a variety of faults but again, these are usually mechanical, and so do not involve the circuitry.

The tables on the following pages list the most common problems that you will encounter in cameras, lenses, and darkroom equipment. They also point out the causes of a wide range of processing and printing failures. The causes of these problems are divided into two categories: equipment and user. This does not mean however that every fault has just one cause. You can often save time by making sure that you are using the equipment correctly. Do not assume automatically that the tools are at fault: the most common cause of picture failure lies in the way you handle your equipment.

Cameras and accessories

	Fault	Equipment cause	User cause
Camera	Shutter release does not fire	Shutter mechanism jammed Film wind-on jammed Mirror stuck Flash failure	Film not wound on Shutter lock on
	Wind-on jammed	Failure of wind-on mechanism Film torn	End of film Shutter must be fired
	Wind-on slack	Failure of wind-on mechanism	
	Re-wind tight	Film wind-on not disengaging	Re-wind button not fully depressed
	Re-wind slack	Torn film Film come free of cassette	Film wrongly loaded
	Blank focusing screen	Mirror stuck in "up" position	Lens cap left on
	TTL meter not working	Meter cells obstructed Batteries exhausted	Light level too low ASA dial incorrectly set Meter not switched on
Lens	Lens difficult to focus	Lens dirty Poor quality lens Mirror misaligned Dirty viewfinder Dirty or damaged mirror Auto-coupling faulty	Lens not properly fitted Effect filter on lens Lens stopped down Lens obstructed Subject too near Subject moving
	Lens makes near subjects unsharp	Lens settings inaccurate Mirror misaligned	Lens incorrectly fitted Careless focusing Subject movement Lens obstructed Aperture too wide Focusing with lens stopped down

	Fault	Equipment cause	User cause
	Lens makes distant subjects unsharp	Lens elements incorrectly aligned for infinity setting	Careless focusing Subject movement Aperture too wide
Flash	Flash fails to fire	Batteries exhausted Flash gun circuitry faulty Flash not compatible with camera Hot shoe malfunction Shutter not firing	Flash not switched on Flash not fully charged Off-camera synch lead incorrectly fitted Camera not set to flash
	Flash fails to recharge	Batteries/accumulator exhausted Flash circuitry faulty	Flash not switched on Recycle time incomplete
	Flash fails to synchronize	Synch setting on camera unreliable Slow flash ignition Shutter does not open fully	Wrong shutter speed set Wrong synch set
Motor drive	Motor drive fails or is too slow	Batteries exhausted Motor drive incompatible with camera	Motor drive incorrectly linked to camera Motor drive too fast for the shutter speeds used
	Flash fails with motor drive	Recycle time too slow for motor drive speed	
Lighting	Tungsten lamp failure	Lamp must be replaced Fuse blown Power supply faulty Extension lead faulty Switch loose	Lamp not connected to main Plug not fixed correctly
Metering	Off-camera meter not functioning	Batteries exhausted Needle unbalanced Cells obstructed	Mask in position Light too dim Meter not switched on
	Flash meter not functioning	Batteries exhausted Synch leads not attached Main flash not firing	Meter pointing in wrong direction
Tripod	Tripod movement	Tripod too light Locking collars worn Legs unbraced Feet slipping	Tripod jarred during exposure Camera too heavy for tripod Locking collars not tightened

Darkroom equipment

Enlarger	Enlarger lamp will not work	Lamp should be replaced Fuse blown Electrical connections to lamphouse worn	Power not on

Fault	Equipment cause	User cause
Dark projected image	Cold cathode light source near exhaustion	Negative too dense Lens stopped down Printing filters in light path Magnification too high
Baseboard image unsharp	Head and baseboard misaligned Poor quality lens	Unsharp negative
Enlarger overheating	Poor ventilation	Ventilation obstructed Light source left switched on for too long
Contact printer Contact printer out of focus	Weak pressure plate	Negative and paper not placed emulsion-to-emulsion
Contact prints light and dark on same sheet	Printing paper too hard	Uneven density of negatives

Processing

Fault	Equipment cause	User cause
Fogging	Film out of date Processing tank split Tank lid not fitting tightly Safelighting incorrect Darkroom door or window not light-tight Loading bag not light-tight Faulty film cassette Faulty camera back	Lid removed before fixing Lid not aligned correctly Film stored in high temperature Film exposed to light during camera loading or unloading
Color casts	Film out of date	Use of light source of the wrong color temperature Mixed lighting Reciprocity failure
Underexposure	Camera shutter inaccurate Lens aperture jammed near minimum setting Film out of date Processing chemistry out of date or exhausted	Metering error Filter in position Incorrect ASA setting Flash distance too great Incorrect time, temperature, or agitation of processing
Overexposure	Camera shutter inaccurate Lens aperture not stopping down	Metering error Incorrect ASA setting Flash too near Incorrect processing
Double exposure	Film wind-on not functioning Double exposure safety mechanism not working (usually on 110 and 126 cameras)	Film wind-on not advanced (on cameras with independent shutter-tensioning system)

Fault	Equipment cause	User cause
Blank film (clear negative or black slide)	Shutter not firing Mirror stuck in viewing position Film not winding on	Incorrect film loading (film slips off take-up spool) Negative fixed before development Prolonged exposure of film to daylight
Only one portion of the frame exposed	Flash not synchronizing Focal plane shutter not fully returning	Wrong flash shutter speed selected
High-density stripe on film frame	Uneven shutter travel	
Vignetting	Lens does not cover film format Poor quality lens Between-the-lens shutter sticking Incorrect lens hood Flash coverage not wide enough for lens	Excessive lateral camera movements (on view cameras)
Loss of contrast	Dirt on lens Flare (caused by dirt inside lens or camera) Poor quality lens	Filter left in position Film underdeveloped Use of very fast film in dim lighting conditions Extreme overexposure Lens aimed too directly at light source
Excessive contrast		Overdevelopment Contrasty lighting used with slow film
Unsharp image	Mirror misaligned Damaged lens Poor quality lens Inaccurate rangefinder	Camera shake Subject movement Careless focusing Dirty viewfinder Use of incorrect focusing screen
Scratches	Film pressure pad badly finished Dirt in cassette/loader	Careless film handling (especially during processing and storing)
Drying marks	Poor circulation of air in drying cabinet	Film splashed with water during drying Small traces of water left on the film when the rest of the film is dry (occurs when you loop film to fit drying cabinet)
White lines or spots on back of film		Insufficient washing, leaving processing solution on film Excessive lime in wash water

Printing

Fault	Equipment cause	User cause
Paper fogged	Safelight faulty Torn packaging Filter not fully covering lens Enlarger lamphouse not light-tight Paper out of date	Paper accidentally exposed to enlarger light Room lighting turned on with lid of paper box open Poor paper storage
Weak image	Exhausted developer Developer too dilute	Underexposed/developed Dense negative Contact paper used for enlarging
Dense image		Overdeveloped (warm developer, concentrate not diluted) Overexposed (lens not stopped down, changed to condenser head)
Low contrast	Wrong paper grade Exhausted developer	Underdeveloped (incorrect time or temperature) Use of cold cathode head for low contrast negative
High contrast	Wrong paper grade	Use of condenser head for high contrast negative
Unsharp image	Negative carrier, lens and baseboard not aligned Height or focus slipping Lens quality poor Negative buckled in glassless carrier	Lens not focused Aperture not stopped down Height or focus not locked Enlarger knocked during exposure Unsharp negative
Part area unsharp	Negative carrier, lens, and baseboard not aligned Negative buckled	Aperture too large
White spots	Dirty condensers Dirty negative carrier glass	Dirt on negative Fixer splashed on print before or during development
Black lines or spots		Scratched negative Faulty paper storage
Stains	Dirty dishes, drying belt, or work surface Exhausted developer	Prolonged development Developed print exposed to air before or during fixation
Mottled glazing	Damaged drum Dirt or chemical on drum No pressure from rollers	Glazer temperature too high
Vignetting	Condensers not compatible with focal length of lens Wrong focal length of lens for negative format Damaged reflector Blackening of tungsten filament lamp	

Buying secondhand

A wide range of photographic equipment is available on the secondhand market. If a secondhand item is in good condition it may be a better buy than a new piece of equipment, since for the same cost you can usually buy a better quality model. Photographic magazines often carry reviews and articles which re-examine equipment that has been on the market for some time. These will tell you the faults and virtues of particular items. You may also find the equipment you are looking for advertized for sale.

There are two sources of secondhand equipment, the dealer and the private seller. Dealers can usually offer an extensive choice of equipment at a variety of prices, often renovate it to a high standard before selling, and provide a short-term guarantee. Do not buy from a dealer who does not offer a guarantee. You can expect to pay less, sometimes considerably so, for items sold privately. But you must allow for the cost of having the equipment professionally checked and overhauled – well worth it for a major item. Always enquire why the equipment is being sold, and ask to see any repair or overhaul documents.

Take particular care when buying equipment that has belonged to a professional photographer. Professionals use their equipment a great deal. They pass a lot of film through their cameras and push all their equipment to its limits. A camera offered by a competent amateur usually makes a better buy.

When you are satisfied about its source, inspect the equipment carefully, preferably on your own. Use the information that follows as a guide to common signs of wear and abuse on cameras, lenses, accessories, and darkroom equipment. If, after this, you are satisfied, you should note down the item(s) you are buying and the agreed price, and get a receipt for any payment you make.

Cameras

Look first at the surface of the body. Small scratches take away a camera's "new" look, but are not necessarily a cause for concern. However, dents indicate that the owner has dropped or otherwise damaged the camera, and this may have affected the shutter or wind-on mechanism. If the camera has an imitation leather covering, look for traces of glue at the edges. These may indicate that a repairer has removed the covering to gain access to body screws. You should also examine visible screws for any signs of abrasion. If the camera has not been repaired they should be unmarked. The camera back must fit tight, and it should be firm under hand pressure when closed. The lens should fit smoothly, and there should be no movement once it is in place.

You should also examine the camera interior. The mirror should look clean and bright. If it has stuck in the past, abrasions will show on the edges. Examine the shutter blind closely. It should be free of holes and dents. The shutter should click sharply when you press the release:

a rattle indicates wear. Ideally you should have the shutter speeds tested professionally. Finally, inspect the film wind-on mechanism, looking for smooth movement and firm locking of the wind-on lever. If possible, shoot a length of film and have it processed before finalizing the purchase. Examine the film to see if metering and frame spacing are still accurate. Another clue to excessive use is wear on the shutter speed scale due to heavy use of the wind-on lever.

Lenses

When inspecting a secondhand lens, look carefully at the barrel. Compare the engraving on the aperture scale with that on a new lens. Wear often shows up here. Look also for dents. If they are excessive, avoid the lens. It may well have been dropped, causing misalignment of the elements. There should be no slackness of movement in the aperture and focusing rings. On the other hand, they should not be stiff. If this is the case, the rings may be misaligned. This explanation is particularly likely if the degree of stiffness varies at different settings.

The condition of the lens surface is very important. Hold the lens up to the light to see if it has any abrasions. Do not buy if such damage is visible. Creamy spots also occur in a lens sometimes. These appear when the camera balsam cement between the elements dries out following slight movement of the elements.

You cannot be sure of any lens until you test the picture quality carefully. Use a standard test chart or send the lens to a technician, who will supply you with test results and tell you if the lens is worth overhauling. A small charge is made for testing, but it can save you far more.

Darkroom equipment

Darkroom equipment is generally well-used before it comes up for sale, so you must examine it very carefully. If possible, use the equipment before you accept it. This is especially important with enlargers. The best test of an enlarger is to make prints from negatives the quality of which you already know.

The enlarger column should be strong and the head lock secure. Focusing must be smooth and the bellows in good condition. Examine the lamphouse, filters, and negative carriers carefully for wear. There should be no fraying of the cable where it enters the lamphouse. Find out if the enlarger takes different heads and if you can obtain these. Finally, check what is included with the enlarger, and whether the extras (lenses, heads, baseboard, easel) are easily available.

Darkroom trays can be a good buy if they are clean and not split or cracked. Always compare the price asked with that of new trays.

If you are considering buying a used processor, find out how long the model has been on the market and if compatible papers and chemicals are still available.

Films, papers, and chemicals

The lists on these and following pages contain only a sample of a much wider range of products. These have been selected because they represent categories or types of materials and, for every one mentioned, there may be many more available. Manfacturers replace processes, films, and papers from time to time, and so you should check with your local supplier that the material you want to use is available.

You can rate the new variable ASA film shown in the first chart below at speeds between 125 (or 400) and 1600 ASA (ISO). And you can use more than one rating on a single film, which you can then develop normally.

Black and white film

Brand	Speed (ASA)	Sensitivity	35 mm	Roll	Sheet	Special points
Normal contrast						
Adox KB17	40	Ortho	●			100 ft (30 m) rolls
Ilford Pan F	50	P	●			
Kodak Panatomic X	32	P	●	●		
Adox KB 21	100	P	●			100 ft (30 m) rolls
Agfapan 100	100	P	●	●	●	
Ilford FP4	125	P	●	●	●	
Kodak Plus X	125	P	●	●	●	
Agfapan 400	400	P	●	●	●	
Ilford HP5	400	P	●	●	●	
Ilford XP1	400 (Variable)	P	●			Final image in dye
Kodak Tri X	400	P	●	●		
Kodak Recording 2475	4000	P	●			
Kodak Royal X Pan	1250	P		●		
Kodak Prof Copy	25	Ortho			●	Available USA only
Kodak Gravure Pos	20	Ortho			●	
Agfapan Vario-XL Prof	Variable	P	●			Final image in dye
High contrast						
Kodalith type 3	12	Ortho	●		●	35 mm in bulk rolls
Kodalith Pan	40	P			●	
Specials						
Agfacontour		Ortho			●	Special effects
Agfa Dia-direct	100	P	●			Reversal slide film

Black and white papers

Brand	Grade	SW	MW	DW	G	L	M	Special points
			Weight			Surface		
Fiber base								
Agfa Brovira	0-5	●		●	●	●		
Ilfobrom	0-5	●		●	●	●	●	
Ilfobrom Galerie	1-3			●	●			
Kodak Azo	0-5	●		●	●	●		Contact paper, USA only
Kodabromide	1-5	●		●	●	●		
Kodak Polycontrast	Variable	●		●	●	●		
Luminos Bromide	2-4	●		●	●	●	●	
Agfa Portriga	1-3			●	●		●	Warm-tone
Kodak Ektalure	2			●		●		Warm-tone, USA only
Resin-coated base								
Agfa Brovira 310S	1-5		●		●	●	●	
Ilford Ilfospeed	0-5		●		●	●	●	
Ilford Multigrade	Variable		●		●	●	●	
Kodak Polycontrast	Variable		●		●	●		Warm-tone, USA only
Kodabrome II	Variable		●		●	●		Warm-tone, Europe only
Luminos Bromide RD	1-4		●		●	●	●	
Kentmere Kenthene	1-4		●		●	●		

G = Glossy L = Luster M = Matte

Color film

Brand	Speed (ASA)	Process	35 mm	Roll	Sheet	Special points
Slide films						
Kodachrome 25	25	K-14	●			No user processing
Agfachrome 50	50	Agfa 41	●	●		
Kodachrome 64	64	K-14	●	●		No user processing
Fujichrome 100RD	100	E-6	●			
Ektachrome 160	160	E-6	●	●		Tungsten balance
Ektachrome 400	400	E-6	●	●		
Special slide films						
Ektachrome IR	100	E-4	●			False colors
Ektachrome slide dupe	4	E-6	●		●	
Agfa Duplichrome		Agfa 41			●	
Color negative films						
Agfacolor 80	80	Agfa N	●	●	●	
Fujicolor F-11	100	C-41	●	●		
Kodacolor II	100	C-41	●	●		
3M color print	100	C-41	●	●		
Kodacolor 400	400	C-41	●	●		
Kodak Vericolor II	100	C-41	●	●	●	
Sakuracolor 400	400	C-41	●	●		
Special films						
Vericolor interneg	5	C-41		●		
Kodak Vericolor print		C-41		●		For prints from color negs
Kodak Vericolor slide		C-41		●	●	
Agfacolor print		Agfa 85		●		

Color papers (all resin-coated)

Brand	Process	Surface G	L	M	Special points
Negative/Positive					
Agfacolor PE Type 4	Agfa 81/85	●	●	●	
Agfacolor PE Type 5	Agfa 90/88/P	●	●	●	
Kodak Ekfacolor 78 RC	Ektaprint 2	●	●	●	
Unicolor type RB	Unicolor R2	●	●	●	
Positive/positive					
Kodak Ektachrome 14 RC	Ektaprint R14	●	●		Chromogenic, Europe only
Kodak Ektachrome 2203	Ektaprint R-1000	●	●		Chromogenic, USA only
Agfacolor MCN 310	61R	●	●	●	Chromogenic
Ilford Cibachrome A	P-12	●	●		

G = Glossy L = Luster M = Matte

Special papers

Brand	Features
Autone	Colored base bromide paper (fiber or resin-coated)
Opaline	Opalescent triacetate (polyester) film
Tura Photolinen	Bromide coated linen
Kentint	Colored base bromide paper
Kodak Panalure	Panchromatic bromide paper, Grade 2 resin-coated
Kodak Mural	Fiber-based paper for making large bromide prints
Kodak Ektamatic SC	Stabilizator machine processing (variable contrast)
Kodagraph Transtar (USA)/Kodaprove (Europe)	Direct reversal high contrast paper
Metone	Bromide coated aluminum
Tura Report Rapid	Warm-tone chlorobromide paper

Black and white film developers

Brand	Type	Form	Remarks
Agfa Rodinal	General fine-grain	Liquid	One-shot
Ilford Microphen	General fine-grain	Powder	Some speed increase
Kodak D-76	General fine-grain	Powder	Replenishable
Kodak Versatol (USA)	Films and paper	Liquid	One-shot
Kodak Universal (Europe)	Films and paper	Liquid	One-shot
Paterson Acuspeed	Speed-enhancing	Liquid	One-shot
Ilford Perceptol	Extreme fine-grain	Powder	Replenishable
Tetenal Neofin	Acutance	Liquid	One-shot
Kodalith	Lith	Liquid/Powder	One-shot
Kodak D-8	High contrast line	Powder	One-shot
Paterson Acutol	Acutance	Liquid	One-shot

Special black and white film developers

Brand	Features
Kodak DP film developing outfit	For reversal processing suitable black and white films
Tetenol reversal kit	For reversal processing suitable black and white films
Kodak Tanning developer	Forms relief image on dye transfer matrix film

Black and white paper developers

Brand	Image color	Form	Remarks
Agfa Neutrol NE	Neutral	Liquid/Powder	
Ilford Bromophen	Neutral	Powder	
Kodak Dektol/D163	Neutral	Powder	
Ilford Ilfospeed	Neutral	Liquid	Fast-working
Kodak Selectol	Warm-tone	Powder	
Agfa Neutrol WA	Warm-tone	Liquid/Powder	
Kodalith	Neutral/brown	Liquid/Powder	Lith paper only

Color film developer kits

Brand	Film/Process	35 mm films per small kit	Remarks
Agfa process N	Neg/Agfa	6	Type-B chemistry films only
Kodak Flexicolor	Neg/C-41	10	
Paterson Acucolor Universal	Neg/C-41	8	
Kodak Ektachrome E-6	Slide/E-6	10	
Agfa process 41	Slide/Agfa	12	Type-B chemistry films only
Tetenal/Beseler E-6	Slide/E-6	4	
Unicolor E-6	Slide/E-6	8	

Color print developer kits

Brand	Processes	N/P or P/P	Form	Remarks
Agfa process 85	Agfacolor	N/P	Powder	Type-B chemistry papers only
Tetenal high-speed PA	Agfacolor	N/P	Liquid	Type-B chemistry papers only
Kodak Ektaprint 2	Kodak 78	N/P	Liquid	
Beseler Two-step	Kodak 78	N/P	Powder	
Kodak Ektaprint R100	Ektachrome 2203	P/P	Liquid	
Unicolor RP-1000	Kodak R14	P/P	Liquid	
Ilford Ciba P12	Cibachrome	P/P	Liquid/Powder	SDB papers only
Agfa 61R	Agfa MCN 310	P/P	Powder	

Dual role	Features
Unicolor Totalcolor	Kit contains units which can be combined to process both negatives and neg/pos color paper

Glossary

Italics indicate glossary entry

A

Aberration The inability of a lens to produce a perfect, sharp image, especially at the edge of the lens field. Such faults can be reduced by compound lens constructions and by stopping down.

Absorption The process by which light falling upon a surface is partly absorbed by that surface and converted to heat.

Accelerator Chemical used in developing solution to speed up the slow-working action of the reducing agents.

Accessory shoe Metal or plastic fitting on the top of a camera which supports accessories such as viewfinder, rangefinder, or flash gun.

Acceptance angle See *Angle of view.*

Achromatic Term describing a lens system corrected for *chromatic aberration.*

Acutance Objective measurement of image sharpness. The steepness of the angle of the edge gradient between density boundaries in an image is used to express its degree of sharpness. The steeper the angle between these boundaries the greater the sharpness. As the angle becomes less acute the difference between the two densities becomes more diffuse and the image less sharp. Such measurements do not always correlate with subjective judgments as other factors play a part in the final effect.

Additive printing Printing process which produces an image by giving three separate exposures, each filtered to one of the three primary color wavelengths, blue, green, and red.

Aerial perspective The feeling of depth created in a landscape photograph by the tonal changes that occur with increasing distance and haze. It can be emphasized by using a long focus lens or reduced by using a haze or polarizing filter.

Agitation The method used to keep fresh solution in contact with the surface of the emulsion during photographic processing.

Alcohol thermometer Instrument used for measuring temperature. Inexpensive, but less accurate version of the mercury thermometer.

Analyzer Chart or instrument used to determine correct color filtration when making color prints.

Anamorphic lens Lens capable of squeezing an image either horizontally or vertically. Distortion occurs on the recorded image, but a similar lens can be used to project the image in its correct proportions.

Anastigmat A compound lens that reduces the effect of astigmatism.

Angle of coverage See *Covering power.*

Angle of view The widest angle through which a lens can accept light (angle of acceptance) and still give a full format, good quality image on the film.

Anti-reflection coating See *Coated lens.*

Aperture Circular hole in the front of the camera lens which controls the amount of light allowed to pass to the film. On all but very cheap cameras the size of the aperture is variable, and controlled by an iris diaphragm. It can be set to a series of "stops" calibrated in *f* numbers.

Aperture priority camera Semi-automatic camera on which the photographer sets the aperture and the camera automatically sets the shutter speed.

Aplanat Lens corrected for spherical aberration.

Apochromat Lens corrected for chromatic aberration in all three additive primary colors.

Artificial light All light not originating from a natural source. The commonest artificial light sources in photography are flash, and tungsten filament bulbs.

ASA Speed rating for photographic materials devised by the American Standards Association. The rating is based on an arithmetical progression using an average gradient system.

Auto film advance Device which winds film on automatically after each exposure.

Automatic aperture Aperture mechanism which stops down to a preset size as the shutter is fired, even though maximum aperture is used for focusing.

Automatic lens Lens which remains at full aperture whatever working aperture is set, until the shutter is released. This allows optimum focusing, without affecting metering.

Autowinder Film wind-on mechanism which moves the film on one frame each time the shutter is depressed.

Auxiliary lenses See *Supplementary lenses.*

B

B ("Bulb") Shutter speed setting on which the shutter will stay open as long as the release is depressed. Used for exposures longer than the numbered settings.

Back focus The distance between the rear of the lens and the focal plane. This distance is not always equal to the lens focal length, particularly in telephoto lenses and in wide-angle lenses given inverted telephoto (retro-focus) construction to gain more space behind the lens.

Backlighting Lighting coming from behind the subject. Special care in exposure estimation is required with scenes lit in this way. Some cameras have a backlighting compensation button which helps overcome this problem.

Back projection Method of projecting images on the back of a translucent screen to make a backdrop for subjects placed in front.

Bag bellows Short flexible sleeve used on large format cameras in place of normal bellows when short focal length (wide-angle) lenses are employed.

Barn doors Accessory used on spotlights and floodlamps to control the direction of light and width of the beam.

Barrel effect Lens aberration where straight lines in the subject are formed as curved lines in the image. These barrel-shaped lines are most noticeable along the edges of the frame.

Base Support for the photographic emulsion. It is usually made from glass, paper or plastic.

Baseboard camera Portable large format camera supported on a baseboard. Allows limited use of *camera movements.*

Batch numbers Set of numbers printed on packets of sensitive materials to indicate a common production coating. The batch number is given because a slight variations of contrast and speed occur between batches of the same type of photographic material. This information is particularly important to the photographer using color materials and where automated systems are being used for monochrome printing.

Beaded screen Projection screen consisting of glass beads embedded in a plastic support. Projected light falling on such a screen is returned along a narrow arc. The resulting image is much brighter than with regular, flat, white screens.

Bellows Light-tight, extendable sleeve which can be fitted between the lens and the film plane.

Between-the-lens shutter Shutter usually placed within the components of a compound lens close to the diaphragm.

Bleach Chemical bath used to remove all or part of an image. For example, it can convert a silver image into a halide, which may then be fixed away or toned.

Bleach/fix Chemical bath in which the bleach and fixer have been combined. Used in many color processes.

Bloomed lens See *Coated lens.*

Blur Unsharp image areas, created or caused by subject or camera movement, or by selective or too inaccurate focusing.

Bracketing The technique of shooting a number of pictures of the same subject and viewpoint at different levels of exposure. Half or one stop differences are usually selected depending on subject and film type.

Brightness range Subjective term describing the difference in *luminance* between the darkest and lightest areas of the subject, in both negative and positive.

Bromide paper Most common type of photographic printing paper. It is coated with a (normally *panchromatic*) light-sensitive emulsion of silver bromide, to reproduce black and white images.

Bulk film Film purchased in long lengths. Used in a bulk camera back (on occasions that demand fast, extensive use of film) or with a bulk film loader (to reload cassettes cheaply).

C

Cable release Flexible cable used for firing a camera shutter. It is particularly useful for exposures of long duration where touching the camera release by hand may cause camera-shake and subsequent blur.

Callier effect Term used to describe a contrast effect in photographic printing which is caused by the enlarger condenser system. Condenser illumination gives much high print contrast than diffuser illumination because its bright directional beam is greatly affected by extremes of negative density. The prescattered light given by diffuser enlargers is not so affected and the contrast effect is far less marked.

Camera movements Mechanical systems most common on large format cameras which provide the facility for lens and film plane movement from a normal standard position. The movements can create greater depth of field in specific planes, and can correct or distort image shape as required.

Cartridge Quick loading film container, pre-packed and sealed by the manufacturer.

Cassette Light-tight metal or plastic container holding measured lengths of 35 mm film, which may be loaded straight into the camera.

Cast Overall bias toward one color in a color photograph.

Catadioptric lens See *Mirror lens*.

CC filter Abbreviation for color compensating filter. CC filters are designed primarily for correcting color bias in subtractive color printing processes. CC20Y, for example, indicates a yellow filtration of 0.2 density. They are sometimes called CP (color printing) filters.

Centigrade Scale of temperature in which the freezing point of water is equal to 0°C and its boiling point to 100°C.

Changing bag Opaque fabric bag, which is light-tight and inside which sensitive photographic materials may be safely handled.

Characteristic curve Performance graph showing the relationship between exposure and density under known developing conditions. It can provide information on factors such as emulsion speed, fog level, and contrast effect. The study of photographic materials in this way is known as sensitometry.

Chemical fog An even, overall density on film or paper. It is exaggerated by over-development and is caused by unexposed silver halides being attacked by the reducing agents in the developing solution.

Chromatic aberration The inability of a lens to bring different colors of light reflected from the same plane in the subject to a common point of focus in the image. The aberration appears as a color fringe at the edge of the picture frame.

Chromogenic materials Color photographic materials which form dyes during processing (from the *oxidation products* of development and *color couplers*).

Cibachrome A *silver dye-bleach material*.

Clearing agent See *Hypo eliminator*.

Coated lens Lens whose air-to-glass surfaces have been coated in magnesium or sodium fluoride to reduce flare.

Coincidence rangefinder See *Rangefinder*.

Color balance Adjustment in color photographic processes ensuring that a neutral scale of gray tones is reproduced accurately, i.e. a gray subject will have no color bias.

Color coupler A compound which links with the *oxidation products* of a developer to form dye. Such compounds form the dye image in all *chromogenic* color materials.

Color sensitivity Response of sensitive material to the colors of the spectrum.

Color temperature The color quality (content) of a light source, expressed on a scale, usually measured in Kelvins, ranging from black through red, yellow, and white, to blue.

Compact camera Small fixed-lens 35 mm direct vision camera.

Complementary colors Two colors which, when added together in suitable proportions, make white light. The term is also used to describe the colors magenta, yellow, and cyan, because each is complementary to one of the primaries. (These three colors are also termed subtractive primaries because they are the basis of *subtractive color synthesis)*.

Compound lens Lens system constructed of two or more elements.

Concave lens Simple lens, or lens shape within a compound lens, whose surfaces curve toward the optical center. Such a lens causes light rays to diverge.

Condenser Simple lens system which concentrates light from a source into a beam. Condensers are used in equipment such as spotlights and enlargers.

Contact paper Printing paper used only for contact printing. It is usually coated with a silver chloride emulsion of very slow speed.

Contact printer Apparatus used for making contact prints. Equipment ranges from a contact printing frame to more sophisticated boxes with safelighting, exposing source and glass diffusing shelves all built-in.

Contrast Subjective judgment of the difference between densities and/or luminosities, and their degree of separation, in the subject, negative, slide, or print.

Converging lens A single or multi-element lens which causes rays of light passing through it to converge.

Convertible lens Compound lens whose elements can be unscrewed and rearranged to make lenses of different focal lengths.

Convex lens Simple lens, or lens shape within a compound lens, whose surfaces curve outward, away from the lens. Such a lens causes rays of light passing through it to converge.

Correction filter Filter which alters the color rendition of a scene to suit the color response of the eye. Most black and white *panchromatic* films, although sensitive to all the colors of the spectrum, do not have the same response to these colors as the human eye. Correction filters help compensate for this difference, and are usually yellow to yellow-green.

Coupled rangefinder Focusing system in which a rangefinder and the lens focusing mechanism are linked. As the lens is adjusted, a central area of the viewfinder indicates when lens focus is correct for the subject distance.

Covering power The maximum area of image of usable quality which a lens will produce. The angle subtended at the lens by this visible portion of the image circle is known as the angle of coverage.

Cross front Camera movement which allows the lens to be moved laterally from its normal position.

Curvature of field Lens aberration causing the plane of sharp focus to be curved.

Cut film Film available in flat sheets. The most common sizes are 4 ins × 5 ins (10.2 cm × 12.7 cm) and 8 ins × 10 ins (20.3 cm × 25.4 cm).

Cyan The color formed by mixing blue and green light. Cyan is complementary to red, and is one of the three colors used in *subtractive color synthesis*.

D

Darkcloth Cloth made of a dark material and placed over the head and camera back to facilitate the viewing of images on a ground glass screen, particularly on large format cameras.

Darkroom Light-tight room used for processing or printing, which incorporates safelights suitable for the materials in use.

Darkslide Light-tight film holder for large format cut film.

Daylight tank Light-tight container for film processing. Film is loaded in the dark after which all the processing steps are carried out in normal light.

Daylight loading tank A light-tight film processing tank specially designed for loading in normal light.

Dedicated flash Flash gun designed for use with a camera or cameras from the same manufacturer, and usually forming part of a camera system.

Definition Subjective term used to describe the clarity of a negative or print. It can also apply to a lens or photographic material, or the product of both, and commonly refers to the resolving power achieved.

Density Amount of silver deposit produced by exposure and development. It is measured in terms of the logarithm of opacity, where opacity is the light-stopping power of a medium.

Depth of field The distance between the nearest point and the farthest point in the subject which is perceived as acceptably sharp along a common image plane. For most subjects it extends one third of the distance in front of and two thirds behind the point focused on.

Developer Chemical bath containing reducing agents, which converts exposed silver halides to black metallic silver, so making the latent image visible. Other chemicals known as accelerators, preservatives and restrainers are added to the bath to maintain the action of the reducing agents.

Development The chemical or physical treatment that converts a photographic, invisible latent image into a visible form.

Diaphragm The device within, behind or in front of the lens which uses a set of interleaving blades to control the size of the aperture.

Diapositive Positive image produced on a transparent support by viewing with transmitted light, e.g. a transparency.

Dichroic Displaying two colors – one by transmitted, the other by reflected light.

Dichroic filters Filters produced by surface coatings on glass to form colors by interference of light. Since they contain no dye, these filters are fade-free, but are more expensive than dyed filters. Used in best quality filter heads.

Diffuser Any substance capable of scattering light passing through it.

DIN Deutsche Industrie Normen (German industrial standards). The DIN scale of film speed ratings indicates a doubling of speed by an increase of 3 in the rating.

Diopter Unit used in optics to express the light-bending power of a lens. The diopter value of a lens is calculated by taking the reciprocal of the focal length expressed in meters. The power of a convex lens is prefixed by a positive sign, that of a concave lens is prefixed by a negative sign.

Dissolve projector Projector with a dual lens system so aligned that successive slides appear out of each other during projection without a black interval.
Distance symbols Symbols used on the focus control of simple cameras, as a focus guide. The most common symbols (and distance ranges) are: portrait outline (3 ft to 6 ft) (0·9 m to 1·8 m), half figure outline (6 ft to 9 ft) (1·8 m to 2·7 m), full figure (10 ft to 20 ft) (3 m to 6 m), mountain (20 ft to infinity) (6 m to infinity).
Diverging lens See *Concave lens*.
Dry mounting Method of attaching prints to mounting surfaces by heating a shellac layer between the print and the mount.

E

Easel See *Masking frame*.
Electronic flash Artificial lighting produced by discharging an electronic charge through a gas-filled tube. A single tube will produce many flashes.
Electronic shutter Shutter system fired by an electrical impulse rather than by mechanical pressure.
Emulsion The light-sensitive material that is coated on different bases to make photographic film, or paper.
Enlargement Term used to describe a print larger than the negative used to produce it.
Expiry date Date stamp on most film boxes indicating the useful life of the material in terms of maintaining its published speed and contrast.
Exposure In photographic terms, the product of the intensity of the image-forming light and the time this light is allowed to act on the light-sensitive material. The lens aperture controls intensity or amount of light, and the shutter speed (or exposure duration in printing) controls the time.
Exposure latitude The amount by which you can over- or under-expose a light-sensitive material and, with standard processing, still produce an acceptable result.
Exposure meter Instrument for measuring the amount of light falling on or being reflected by a subject, and usually equipped to convert this measurement into usable information, such as shutter speed and aperture size required to take a reasonable photograph.
Exposure value (EV) Scale of values used to indicate the sensitivity range of a TTL or off-camera meter system within which accurate exposure measurement is guaranteed. The lower the number the more sensitive the meter is to low light. The higher the number, the more accurate its sensitivity to bright light. A typical EV range on 35 mm SLR through-the-lens meters is EV3 to EV18. This range provides sufficient sensitivity for most requirements.
Extension tubes Metal tubes added to small or medium format cameras, to extend lens-film distance, enabling magnification greater than × 1.

F

Fahrenheit scale Scale of temperature named after its German originator G.D. Fahrenheit. In this scale, the freezing point of water is 32°F and its boiling point is 212°F.
Fast film Film with an emulsion that is very sensitive to light. Such films have high ASA/DIN ratings.
Fast lens Lens with a wide maximum aperture.
Fill-in Light used to illuminate the shadow areas of a scene.
Film Photographic material consisting of a thin transparent plastic base coated with light-sensitive emulsion. Black and white film has effectively one emulsion layer, while color film has at least three, each sensitive to a different color of light.
Filter Transparent material such as glass or gelatin, which alters the nature, color or quality of the light passing through it.
Finder Abbreviated form of *viewfinder*.
Fine grain developers Film developers which help to keep grain size in the photographic image to a minimum.
Fisheye lens Extreme wide-angle lens with an angle of view exceeding 100° and sometimes in excess of 180°. Depth of field is practically infinite and focusing is not required. It produces highly distorted images.
Fix or fixer Chemical solution used for fixation. Two types in common use are sodium thiosulfate, and a more active type, ammonium thiosulfate.
Fixation Chemical process which converts unused halides to a soluble silver complex in both negatives and prints, making the image stable in white light.
Fixed focus Term describing a camera that has no method of focusing the lens. The lens is focused on a fixed point, usually at the hyperfocal distance. With the use of a medium size aperture (f11) most subject distances from 6 ft to infinity can be rendered reasonably sharp. Many cheap cameras use this system.
Fixed lens Lens permanently attached to a camera, and which cannot be interchanged for one of a different focal length.
Flare Non-image-forming light scattered by the lens or reflected from the camera interior. It is much reduced when glass-air surfaces within the lens system are coated (bloomed) with metallic fluorides and the camera interior is a matte black. Flare can affect film by causing a lowering of image contrast.
Flash Artificial light source giving brief but very bright illumination. It is produced by the combination of certain gases within a transparent tube. There are two types: electronic, which may be used repeatedly, and expendable in which the bulb can be used only once.
Flash factor A number which provides a guide to correct exposure when using flash.
Flash range Distance over which a flash unit will give adequate illumination.
Flash sensor Sensitive cell which measures the amount of flash light reflected from the subject so the unit can control flash exposure.
Flash synchronization Method of synchronizing flash light duration with maximum shutter opening. There are

usually two settings on a camera, X and M. X is the setting used for electronic flash, in which peak output is almost instantaneous on firing. M is for expendable flash, which normally requires a delay in shutter opening of about 17 milliseconds, to allow the bulb output to build up.
Floodlight Artificial light source with a dish-shaped reflector, producing evenly spread illumination.
f numbers Number sequence printed on a lens barrel, indicating the aperture settings. The scale applies to all lenses, and is derived from the focal length of the lens divided by its effective apertures. Each higher f number halves the exposure of the preceeding one. Aperture settings are also referred to as f stops.
Focal length The distance between the rear *nodal point* of the lens and the focal plane, when the lens is focused at infinity. The primary classification of a lens is by its focal length.
Focal plane Imaginary line perpendicular to the optical axis which passes through the focal point. It forms the plane of sharp focus when the lens is set at infinity.
Focal plane shutter Shutter consisting of two blinds which lie just in front of the focal plane. Light-sensitive film positioned at the focal plane is progressively exposed as the shutter blinds move in sequence across it. Exposure duration is determined by the gap between the blinds.
Focal point A point of light on the optical axis where all rays of light from a given subject meet at a common point of sharp focus.
Focusing System of moving the lens in relation to the image plane so as to obtain the required degree of sharpness.
Focusing screen Glass or plastic screen set in the camera at an image-forming plane, enabling the image to be viewed and focused.
Fog Density produced on a negative or print by chemical processing or accidental exposure to light, which does not form part of the photographic image.
Format Size of negative, paper or camera viewing area.
Fresnel magnifier Condenser lens used at the center of some ground glass viewing screens to aid focusing.
Fresnel lens Condenser lens used on spotlights to gather together the rays of light coming from a source and direct them into a narrow beam.
Front projection Method of projection allowing you to combine a figure in a studio with a previously photographed background scene. The background image is projected on the front of the scene.

G

Gelatin Transparent medium in which the light-sensitive silver halides of a photographic emulsion are suspended. It is coated onto the film base or printing paper. It is also used for making filters.
Glaze Shiny surface produced on some photographic printing papers by placing the emulsion side of a wet print in contact with a heated drum. The process darkens blacks and brightens color.

Grade See *Paper grade*.
Grains Exposed and developed silver halides which have formed black metallic silver grains, producing the visible photographic image.
Granularity The amount of grain clumping that has occurred within an emulsion. Also referred to as graininess.
Guide number Alternative term for *flash factor*.

H

High contrast developers/films Solutions and materials used to produce high contrast images.
High key Term describing a photograph which contains large areas of light tones, with few mid-tones and shadows.
Highlights Brightest, lightest areas in the subject or photograph. They may be general – such as pale-toned, brightly lit surfaces – or locally extreme, such as points of reflected light from glass or water.
Hot shoe Fitting on the top of a camera which provides a secure fastening for a flash gun, and links the gun to the camera shutter mechanism.
Hyperfocal point The nearest point to the camera which is considered acceptably sharp when the lens is focused on infinity. When a lens is focused on the hyperfocal point, depth of field extends from a distance halfway between this point and the camera to infinity. This principle is used in fixed focus viewfinder and box cameras.
Hypo Common name for a fixing agent, derived from an abbreviation of hyposulfite of soda, the misnomer applied to sodium thiosulfate during the nineteenth century.
Hypo eliminator (clearing agent) Chemical bath which removes traces of fixing agent from an emulsion.

I

"Ideal" format A film format in the proportion of 4 to 3, e.g. 6 cm × 4.5 cm. This ratio is considered an ideal shape for both vertical and horizontal composition.
Image plane A plane commonly at right angles to the optical axis at which a sharp image of the subject is formed. The nearer the subject is to the camera, the greater the lens-image plane distance.
Incident light Light falling on a surface (as opposed to reflected by it).
Incident light reading Measurement, by light meter, of the amount of incident light falling upon a subject. The light meter is placed close to the subject, pointing toward the light.
Infinity The focusing position (marked ∞) at which distant objects are in focus.
Infrared Light rays of wavelengths beyond the red end of the electromagnetic spectrum, which are invisible to the human eye. They can be recorded on specially sensitized films, producing images in black and white or color not usually obtainable on photographic material.

Integral tri-pack See *Tripack*.
Integrating Term used to describe a method of arriving at an exposure setting by taking an average of the light readings from the bright areas and the shadow areas of the subject.
Intermittency effect Phenomenon whereby a series of short, separate exposures will not produce the same photographic result as a single exposure of equivalent total duration.
Inverted telephoto lens Lens construction which gives a short focal length with a long back focus or lens-film distance. It enables wide-angle lenses to be produced for small format cameras, where space is required for mirrors, shutters, etc.
IR or R setting Mark, usually in red, found on many camera lens mounts. It indicates the focus change required for infrared photography.
Iris diaphragm See *Diaphragm*.
ISO International Standards Association. Used instead of ASA or DIN as prefix to film speeds. The scale is identical to the ASA scale.

J

Joule Unit used to quantify the light output of electronic flash. A joule is equal to one watt-second or 40 lumen-seconds. The measure is used to compare flash units in terms of light output.

K

Kelvin (K) Unit of measurement on the Absolute scale of temperature (calculated by adding 273 to degrees centigrade), used to measure the color temperature of light.
Key light Studio light used to control the tonal level of the main area of a subject.
Kilowatt One thousand watts. A measure of the power of an electrical light source, which is sometimes more useful than the watt.

L

Lamp General term used to describe an artificial light source.
Lamphouse Ventilated light-tight housing which contains the light source on an enlarger or projector.
Latent image The invisible image produced by exposure which can be made visible by development.
Latitude See *Exposure latitude*.
LCD (or Liquid crystal diode) Indicator light used to convey exposure information, flash readiness, etc.
Leader The beginning of a 35 mm or roll film, which is attached to the take-up spool in the camera during loading.
Leaf shutter Simple *shutter* composed of overlapping metal leaves, usually situated behind or within the lens.
LED (or Light-emitting diode) Type of indicator light similar in function to an *LCD*.

Lens Optical element made of glass or plastic and capable of bending light. In photography, a lens may be constructed of single or multiple elements. Basically there are two types of simple lens: converging and diverging. Converging lenses are convex and cause light to bend toward the optical axis. Diverging lenses are concave and cause light to bend away from the optical axis. Both are used in compound lenses, but the overall effect is to cause convergence of light rays.
Lens aberrations Lens faults which cause a loss of image quality, due to rays of light from the subject not being brought to correct focus.
Lens cap Plastic or rubber protective covering for lens surface.
Lens hood An opaque tube, usually metal or rubber, that prevents unwanted light from falling on the lens surface.
Lens system Term describing the type and quantity of lenses available for use with a particular camera. It also describes the construction of a particular lens type.
Lenticular screeen Thin layer of lens element placed on the surface of a film or photographic paper which breaks down the subject into two or more images. Used in some systems of direct viewing stereoscopy.
Lightbox Box of fluorescent tubes balanced for white light and covered with translucent glass. Used for viewing, registering, or correcting film negatives and positives.
Light source General term applied to any source of light used in photography, e.g. sun, tungsten filament, flash bulb, reflectors.
Light trap Device forming part of a darkroom, camera, or film cassette which stops unwanted light entering.
Line film High-contrast film which, after correct development, gives negatives of black and white only (with no grays).
Lith film An extreme form of line film, which produces very high contrast images when used in conjunction with a special lith developer.
Long-focus Term describing a lens in which the focal length is much greater than the diagonal of the film format with which it is used.
Low key Term describing a photograph in which tones are predominantly dark and there are few highlights.
Lumen Unit of light intensity falling on a surface.
Lumen-second Unit used to measure the light output of a photographic source.
Luminance Measurable amount of light which is emitted by or reflected from a source.
Luminous flux Intensity of a light source, measured in lumens.

M

Macrophotography Photography which produces an image larger than the original subject, without the use of a microscope.
Magenta The color formed by mixing blue and red light. Magenta is complementary to green, and is one of the three colors used in *subtractive color synthesis*.
Magnification Size of the image relative to the size of the subject used to produce it. Magnification x 1 is life-size.

Masking System of controlling negative density range, or color saturation, through the use of unsharp masks.

Masking frame (or easel) Flat board on which printing papers are held during enlargement.

Microprism collar Grid-type ring found in the center of a camera focusing screen, usually surrounding a split-image aid. Used to assist focus of non-linear subjects.

Mirror lens Compound lens that uses mirrors within its construction. This allows an extremely long focal length lens to fit within a short barrel. Mirror lens design may require a fixed aperture. Also known as reflex or catadioptric.

Mode The prime operating function of automatic SLR cameras, e.g. aperture priority mode, shutter priority mode.

Modeling light Light used to create or enhance a three-dimensional effect.

Monochromatic Reflecting light rays of a single wavelength. Also used loosely to describe a single color image, or a black and white image.

Monorail camera Large format camera construction on a single rail. Offers maximum *camera movements*.

Montage Composite picture made from a number of photographs or other pictorial elements mounted together.

Motor drive Automatic film wind-on mechanism which can be attached to some cameras. While the shutter is kept depressed the film will keep winding on after each exposure. The rate of wind-on varies between 1 and 5 frames per second.

Multimode camera 35 mm camera which will operate in several *modes*.

Multiple flash The use of more than one flash to light a scene.

N

ND Neutral density.

Negative The image produced on a photographic emulsion by the product of exposure and development, in which tones are reversed so that highlights appear dark and shadows appear light. (In a color negative, subject colors are also reversed, and appear as their complementaries.)

Negative carrier Negative holder used in an enlarger between the light source and the lens. It may be adjustable for different formats and is designed to exclude unwanted light from the edges of the negative (which would otherwise print black).

Negative lens Simple, concave lens that causes rays of light to diverge away from the optical axis.

Negative/positive paper Paper used to print a positive color image from a color negative.

Neutral density Unnecessary density of color filtration in subtractive printing caused by filtering to all three colors at once. Printing time can be shortened by removing from the color pack the filter of the lowest value, which indicates the level of neutral density within the pack. The other two color values are adjusted by subtracting an equal value from each.

Neutral density filter A gray camera filter which has an equal opacity to all colors of the spectrum and so does not affect the colors in the final image. It is

used to reduce the amount of light entering the camera when aperture or speed settings require this.

Nodal plane An imaginary line passing through the nodal point of a lens, perpendicular to the optical axis.

Nodal point There are two nodal points in a compound lens system. The front nodal point is where rays of light entering the lens appear to aim. The rear nodal point is where the rays of light appear to have come from, after passing through the lens. Nodal points are used for optical measurements, e.g. to calculate focal length.

Non-substantive film Color film in which the *color couplers* are not contained within the emulsion. Instead they are introduced during processing. Such films cannot be user processed.

Normal lens See *Standard lens*.

O

One-shot developer Developer that is used on a single occasion and then discarded.

Open flash Method of using flash where the shutter is opened, the flash is fired and then the shutter is closed. It is used when the shutter speed is unimportant because existing lighting is poor.

Optical axis Imaginary line passing horizontally through the center of a compound lens system.

Overdevelopment Term indicating that the amount of development recommended by the manufacturer has been exceeded. It can be caused by prolonged development time or an increase in development temperature, and usually results in an increase in density and contrast.

Overexposure Expression used to indicate that the light-sensitive material has been excessively exposed. This can be the result of light that is either too bright, or has been allowed to act for too long. Overexposure causes increased density and reduced contrast on most photographic materials.

Overrun lamp Tungsten light source specifically used at a higher voltage than normal to increase light output and achieve constant color temperature.

Oxidation product Chemical produced by a color developer during the conversion of exposed silver halides to black metallic silver. It is capable of creating a dye to allow primary color development. With modern color materials it is common for the oxidation product to be coupled with another chemical compound, known as a *color coupler*, so that a dye of precise and known character is formed. This procedure is known as *chromogenic* development.

P

Panchromatic material Photographic film or paper sensitive to all the colors of the visible spectrum, including red (although it may not react uniformly to all colors).

Panning Technique for photographing moving subjects. While the shutter is open, the camera is swung in the same direction as the subject is moving. This creates a blurred background, but a sharp subject. The technique works best with shutter speeds below 1/15 sec.

Panoramic camera Camera with a special type of scanning lens which rotates on its rear nodal point and produces an image of the scanned area on a curved plate or film.

Paper grade Numerical and terminological description of paper contrast: numbers 0-1 soft; number 2 normal; number 3 hard; numbers 4-5 very hard. It should not be assumed that similar grade numbers from different manufacturers have equivalent charateristics.

Paper safe A light-tight container for photographic papers. Fitted with an easy opening, positive closing lid for use in the dark.

Parallax The difference between the image seen by a viewing system and that recorded on the film. Variance occurs as subjects move closer to the taking lens. Only through-the-lens viewing systems avoid parallax error.

Pentaprism Optical device, mostly found on 35 mm SLR cameras, which corrects the image (reversed by the lens) and reflects it to the viewfinder, allowing eye-level viewing and focusing.

Perspective System of representing three-dimensional objects on a two-dimensional surface to give a realistic impression of depth.

Photoelectric cell Light-sensitive cell, of which two types are used in exposure meters. A selenium cell generates electricity in proportion to the amount of light falling upon its surface. A cadmium sulfide cell offers a resistance to a small electrical charge when light falls upon it. Cadmium sulfide cells are more sensitive than selenium, especially at low light levels. However, their sensitivity to red is poor by comparison.

Photoflood See *Floodlight*.

Photomicrography System of producing larger-than-life photographs by attaching a camera to a microscope. Magnification is x10 or more.

Pincushion effect Lens aberration causing parallel, straight lines at the edge of the image to curve toward the lens axis.

Polarized light Rays of light that have been restricted to vibrate in one plane only. Polarized light is often required in photomicrography, and can reduce glare in general photography.

Polarizing filter Filter which can polarize transmitted light.

Portrait lens Lens used specifically for portraiture, usually having a medium long focal length. Some also produce a slightly diffused image.

Positive A print or transparency in which light and dark tones and colors correspond to the tones and colors of the original.

Positive lens Simple lens that causes light rays from a subject to converge to a point.

Positive/positive paper Paper designed for direct printing of a color transparency to produce a color positive print. The paper is either of the silver dye-bleach or the reversal type.

Primary colors The three primary color wavelengths of the spectrum are blue, green, and red; all other colors can be

formed by mixing (adding) light of these colors (additive color synthesis). Color photographic materials record a subject in terms of its primary color content. (In painters' pigments, primary mixing is considered to consist of blue, yellow, and red. In subtractive color synthesis, yellow, magenta, and cyan dyes are used, and these colors are sometimes referred to as the subtractive primaries.)

Principal axis An imaginary line which passes through the centers of curvature of all the elements of a lens.

Print In photography, an image (normally positive) which has been produced by the action of light (usually passed through a negative or slide) on paper or similar material coated with light-sensitive emulsion.

Prism Transparent medium which bends light to varying degrees, depending on wavelength, so separating it into its component colors.

Process lens Lens designed specifically for high quality reproduction for printing.

Processing The sequence of steps whereby a latent photographic image is converted into a visible, permanent image.

Projection printing See *Enlarging.*

Projector Apparatus used to display enlarged still or moving images on a screen.

Proportional reducer Chemical used to reduce excess density and contrast from a photographic negative. See *Reducers.*

Pulling See *Uprating.*

Pushing See *Uprating.*

R

Rack and pinion focusing Mechanical focusing system used on large format cameras, particularly monorails. A pinion engages a rack on a slide. Focusing is achieved by turning a knob or wheel which moves the lens or image panel.

Rangefinder A built-in aid in some direct vision cameras. It assesses subject distance (usually by comparing two images), and displays this information in the viewfinder. The split-image type shows a discontinuous image across a fine central line, until focus is correct. The coincident type shows a double image until focus is achieved. Either type may be linked directly to the lens focus control, to give a *coupled rangefinder.*

Rebate Margin on photographic film surrounding the image area.

Reciprocity failure Loss of sensitivity of photographic emulsions, affecting color rendition on color films. It is caused by very long or very brief exposures.

Recycling time Time taken by flash unit to recharge, between firings.

Reducers Solutions which remove silver from negatives or prints. They are used to diminish density and alter contrast on a photographic emulsion.

Reflected light reading Measurement of the amount of light reflected off a subject (as opposed to falling on it), used to determine appropriate exposure. The light meter is pointed toward the subject, from the camera direction.

Reflector Any surface from which light

can be reflected. In particular a white or gray card, or a similar material, used to reflect light from a main source into shadow areas.

Reflex camera Camera with a viewing and focusing system that uses a mirror to reflect the image after it has passed through the lens, on to a focusing screen where it can be viewed. See also *Single lens reflex camera.*

Reflex lens See *Mirror lens.*

Replenisher Chemical added to a working solution to maintain its activity at a satisfactory level.

Resin-coated paper (RC) Printing paper with a water-repellent base. RC papers can be processed faster, requires less washing, and dry more quickly than fiber-based papers. They do not require glazing.

Resolution The ability of a lens (or, less commonly, a photographic emulsion) to resolve fine detail.

Retouching After-treatment carried out on negatives, slides, or prints to remove blemishes and/or change tonal values.

Retrofocus See *Inverted telephoto lens.*

Reversal material Film or paper designed to produce a positive result directly from exposure and processing, without a separate negative.

Rising front Camera movement enabling the front lens panel to be raised or lowered from its central position (on most view and monorail cameras). One of its principal uses is to maintain verticals in architectural photographs.

Roll film 120/620, or 127 format film which has an opaque paper backing and is supplied wound on an open spool (rather than in a light-tight cassette). The term may be applied to all camera films in roll form, including 35 mm cassettes.

S

Safelighting Darkroom lighting of a color to which the particular photographic material in use is insensitive, allowing safe handling.

Selenium cell Photoelectric cell used in some metering systems. It generates electricity in direct proportion to the amount of light falling upon its surface.

Scrim Lighting attachment which when placed in front of the lamp reduces its strength, usually by one stop.

Separation negatives Black and white negatives, usually prepared in lots of three or four, which have been taken through filters to analyze in terms of its blue, green and red content. They are used particularly in photomechanical color printing and dye-transfer printing processes.

Sheet film See *Cut film.*

Shutter Mechanical system used to control the time that light is allowed to act on a sensitive emulsion. The two types most common on modern cameras are the between-the-lens diaphragm shutter and the focal plane shutter.

Shutter priority camera 35 mm camera on which the photographer selects the shutter speed, and the camera automatically sets the corresponding aperture.

Silver dye-bleach (SDB) material Integral tripack printing material in which fully-formed yellow, magenta and cyan dyes are incorporated in the blue-, green-, and red-sensitive emulsion layers during manufacture. During processing, dye areas unwanted for the image are bleached away. Used to produce single-stage positive prints from slides. Also known as dye-destruct material.

Single lens reflex (SLR) camera Camera of 35 mm, medium, or, exceptionally, 110 format in which a system of mirrors shows the user the image precisely as the lens renders it.

Skylight filter Filter, usually very pale pink, used in color photography to reduce blue casts, particularly those associated with skylight. It may be left permanently on the lens to protect it from dust or abrasion.

Slave unit Mechanism which fires additional flash sources simultaneously when a photo-electric cell is activated by the light from a flash source on the camera.

Slide See *Transparency.*

Slow film Film which has an emulsion with limited sensitivity to light. Such films have low ASA speeds (e.g. 25 or 32 ASA).

Slow lens A lens with a small maximum aperture.

Snoot Cone-shaped shield used on spotlights to direct a cone of light over a small area.

Soft focus Diffused definition of an image, which can be achieved at the camera or enlarging stage.

Soft-focus lens Lens, uncorrected for spherical aberrations, used to produce a diffused image.

Spectrum Commonly, the visible part of the electro-magnetic spectrum. Also used to describe the seven colored bands, arranged according to wave-length, produced when white light is passed through a prism.

Speed Sensitivity of a photographic emulsion to light. Films are given ASA/ISO or DIN numbers denoting speed characteristics. The term is also used to denote the maximum aperture of a lens.

Spherical aberration Lens fault which causes loss of definition particularly at the edge of the frame.

Split image rangefinder See *Rangefinder.*

Spotlight Artificial light source using a fresnel lens, reflector, and simple focusing system to produce a strong beam of light of controllable width.

Spot meter Off-camera or integral meter used to take accurate light readings of a small part of a subject.

Squeegee Implement, with rubber roller or blades, used to squeeze water from wet prints or to press them into contact with a glazing sheet.

Standard lens A lens with a focal length approximately equal to the diagonal of the film format with which it is used. Also known as a normal lens.

Stereoscopy Method of creating a three-dimensional effect on a two-dimensional surface, using two or more images taken from slightly different viewpoints. Some systems require specially made stereo viewers.

Stock solution Chemical stored in concentrated form ready for diluting just before use.

Stop See *f numbers.*

Stop (bath) Chemical bath whose purpose is to stop development by neutralizing unwanted developer.

Stopping down Reducing the size of the lens aperture. This increases depth of field.

Substantive film Color film in which the *color couplers* are contained within the emulsion.

Subtractive color synthesis Process of producing a color image by subtracting appropriate amounts of unwanted primary colors from white light, using yellow, magenta, and cyan filters. Dye layers of these three colors (sometimes called the subtractive primaries) are also used in color films and papers to reproduce an image subtractively.

Subtractive primaries Yellow, magenta, and cyan: the complementary colors to the light primaries, blue, green, and red.

Supplementary lens Additional lens element(s) used in conjunction with the prime lens to provide a different focal length.

Swing back/front The moveable lens and back panels of most view and monorail cameras. They allow manipulation of perspective and depth of field.

Synchronized flash See *Flash synchronization.*

T

T ("Time") Shutter speed setting used for timed exposures longer than the numbered settings. The shutter opens when the release is pressed and closes when it is pressed again. Now largely superceded by *B ("Bulb").*

Tank Container for holding chemical solutions for processing films and plates. Some tanks are for darkroom use only; others must be loaded in the dark, but can be used in daylight, and some can be loaded and used in daylight.

Telephoto lens Long focal length lens, which enlarges distant subjects within its narrow angle of view. Depth of field decreases as focal length increases. Telephoto construction allows long focal length with short back focus, making for relative compactness.

Test strip Method of calculating exposure in photographic printing. A range of *exposures* are given to a strip of emulsion, from a selected area of the image, to help judge the correct exposure for the final print.

Thyristor flash gun An automatic flash gun which cuts off the flash when the exposure is correct. This conserves power, makes recycling quicker, and battery life longer.

Timer Device used to time processing or exposure. May be linked directly to the enlarger, switching off the light source automatically.

Toner Chemical used to change the color of a black and white photographic image. System of bleaching and dyeing converts the black metallic silver image to a dye image.

Transmitted light Light which is passed through a transparent or translucent medium.

Transparency Positive image, in color or black and white, which is produced on a transparent film.

Tripack Material, used in color photography, consisting of at least three emulsion layers of different color sensitivity, on a common base.

TTL (through the lens) metering A metering system in which light-sensitive cells within the camera body measure exposure from image-forming light that has passed the lens.

Tungsten filament lamp Artificial light source using a tungsten filament contained within a glass envelope.

Tungsten film Color film balanced to suit light sources (usually studio-type tungsten lamps) of 3200 or 3400K.

Tungsten halogen lamp Compact tungsten lamp which gives consistent color temperature as the glass envelope used is non-blackening.

Tungsten light Artificial light from either tungsten filament or tungsten halogen lamps.

Type-B color film Color film balanced to artificial light sources with a color temperature of 3200K.

U

Ultraviolet (UV) That part of the electromagnetic spectrum from about 400 nm down to 10 nm. It is invisible to the human eye, but most photographic materials are sensitive to it. It shows as increased haze, particularly in distant views and at high altitudes, and may give a blue cast to a photographic image.

Underdevelopment Reduction in the degree of development. It is usually caused by shortened development time or a decrease in the temperature of the solution. It results in a loss of density and a reduction in image contrast.

Underexposure The result of too little exposure in the camera or at the enlargement stage. On negative/positive materials, underexposure reduces density and may reduce contrast in the processed image.

Universal developer Name given to a number of developing solutions, indicating that they can be used, at different dilutions, for processing both films and papers.

Uprating An exposure technique in which the manufacturer's recommended film speed is deliberately exceeded, by setting a higher speed rating on the camera, so causing *underexposure,* and then compensating by *over-development.* Also known as "pushing" film. The reverse, shooting at an ASA rating below that recommended, and underdeveloping, is known as "pulling".

UV filter Filter which may be used to absorb UV radiation, to reduce its effect.

V

Vacuum easel Contact printing frame which ensures firm contact between the film and paper by excluding all air between the surfaces.

View camera Large format camera, which has a ground glass screen at the image plane for viewing and focusing.

Viewfinder Viewing aid in a camera, used for composing, and sometimes focusing the subject. It normally also displays exposure information.

Vignetting Fall-off in illumination at the edges of an image.

W

Washing Final part of the processing cycle, which removes the residual chemicals and soluble silver complexes from the emulsion.

Wavelength The distance from wave crest to wave crest between two corresponding waves of light in the electromagnetic spectrum. Wavelengths are measured in nanometers (nm) and Angstrom units (A). Different wavelengths of light appear as different colors to the eye.

Wide-angle lens Short focal length lens which gives a wide angle of view, reducing image size within it. Depth of field increases as focal length decreases.

Y

Yellow The color formed by mixing red and green light. Yellow is complementary to blue, and is one of the three colors used in *subtractive color synthesis.*

Z

Zoom lens Lens which is constructed to allow continuously variable focal length, without disturbing focus or f number, within a certain range (e.g. 80-200 mm).

Index

Entries in **bold** indicate major references.
Illustration key: b-bottom; c-center; l-left; r-right; t-top.

The author would like to thank the following: Richard Dawes and Chris Meehan for their guiding light, Calvin Evans and Phil Wilkinson for their sustained spadework, Joss Pearson and Stuart Jackman for their belief in the idea of this book and Gillie Holloway for her constant encouragement, help, and patience.

Dorling Kindersley Limited would like to give special thanks to: Michael Burman, Trevor Courtney, Anne Gatty, Jonathan Hilton, Michael Langford, Judith More, Val Nelson, Michelle Stamp, Dave Whelan.

Illustration: Norman Clarke, Rosamund Gendle, Nick Hall, Hayward & Martin, Industrial Artists, Alun Jones, Norman Lacey, Richard Lewis, Tony Lodge, Les Smith, Will Stephen, Venner Artists.

Photography: Mike Anderson, David Bradfield, Andrew de Lory, Calvin Evans, Mark Fiennes, Ian O'Leary, Tim Stephens, Andrew Watson.

Photographic services: Negs, Paulo Colour Processing.

Typesetting: Central Typesetting Service Limited, Qwerty Typesetting Limited

Reproduction: FE Burman Ltd

Technical assistance: Agfa-Gevaert Ltd, Bowens Ltd, Clyde Surveys Ltd, CZ Scientific Instruments Ltd, De Vere Ltd, DG Leisure Centres, Durst (UK) Ltd, Fujimex (UK) Ltd, Hanimex (UK) Ltd, Hasselblad (GB) Ltd, Ilford Ltd, Introphoto Ltd, Keith Johnson Photographic Ltd, Kodak Ltd, E Leitz (Instruments) Ltd, Linhof, Nikon (UK) Ltd, Olympus Optical Co (UK) Ltd, Osawa & Co (UK) Ltd, Paterson Products Ltd, Pelling and Cross Ltd, Pentax UK Ltd, Photax Ltd, Photopia Ltd, Polaroid (UK) Ltd, Pro-Co, Rollei (UK) Ltd, JJ Silber Ltd, Technical and Optical Equipment (London) Ltd, Vivitar (UK) Ltd

The Handbook of Photographic Equipment and Techniques

Adrian Holloway is a Senior Lecturer in Photography in London, and an Examiner for professional photographic courses. For some years he has been Photographic Consultant to the British Consumers Association and their consumer advice journal *Which,* involved in testing and reporting on new products. He has written for a wide range of photographic journals, and was co-author of *The Book of Colour Photography,* recently published in several languages. He also contributed to *The Book of Photography* and *The Photographer's Handbook.* Adrian Holloway learned his photography in the Royal Air Force, and then worked for six years as a professional, specializing in high speed photography, photo-micrography and technical and scientific projects. He has been teaching photography for more than 13 years, and has a particular interest in developing clear, practical reference books for amateur photographers and students.